W9-DBC-330

Eye of Newt and
 Toe of Frog,
Adder's Fork and
 Lizard's Leg

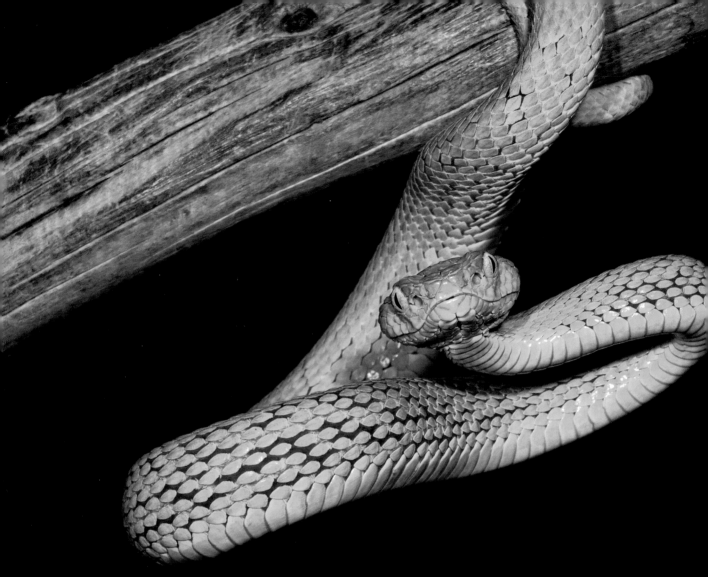

Eye of Newt and Toe of Frog,

Adder's Fork and Lizard's Leg

The Lore and Mythology of Amphibians and Reptiles

Marty Crump

In collaboration with Danté B. Fenolio

The University of Chicago Press :: Chicago and London

MARTY CRUMP is currently an adjunct professor of biology at Utah State University and Northern Arizona University; she has been a herpetologist for more than forty-five years. For at least that long, she has been intrigued with the folklore of amphibians and reptiles. She is the author of *In Search of the Golden Frog*, *Headless Males Make Great Lovers*, and *Sexy Orchids Make Lousy Lovers*, all published by the University of Chicago Press, as well as the recent award-winning children's book, *The Mystery of Darwin's Frog*.

The University of Chicago Press, Chicago 60637
The University of Chicago Press, Ltd., London
© 2015 by The University of Chicago
All rights reserved. Published 2015.
Printed in China

24 23 22 21 20 19 18 17 16 15 1 2 3 4 5

ISBN-13: 978-0-226-11600-6 (cloth)
ISBN-13: 978-0-226-11614-3 (e-book)

DOI: 10.7208/chicago/9780226116143.001.0001

Library of Congress Cataloging-in-Publication Data

Crump, Martha L., author.
 Eye of newt and toe of frog, adder's fork and lizard's leg: the lore and mythology of amphibians and reptiles / Marty Crump; in collaboration with Danté B. Fenolio.
 pages cm
 Includes bibliographical references and index.
 ISBN 978-0-226-11600-6 (cloth: alkaline paper) — ISBN 978-0-226-11614-3 (e-book) 1. Amphibians—Folklore. 2. Amphibians—Mythology. 3. Reptiles—Folklore. 4. Reptiles—Mythology. I. Fenolio, Danté B. (Danté Bruce), author. II. Title.
 QL644.C73 2015
 597.8—dc23 2015012981

♾ This paper meets the requirements of ANSI/NISO Z39.48-1992 (Permanence of Paper).

Major funding for color throughout was provided by

The Ecology Center, Utah State University

UtahStateUniversity
ECOLOGY CENTER

Additional funding was provided by

PARC

ARC

MCZ, Harvard University

Southern Nevada Herpetological Society

Evelyn R. Savitzky

And by

Chicago Herpetological Society

East Texas Herpetological Society

Tucson Herpetological Society

Save the Frogs!

Anonymous

Nancy Huntly, Thomas E. Lovejoy III, Alan H. Savitzky

North Carolina Herpetological Society

For Al

Contents

Talk to the Animals

One thing to remember is to talk to the animals. If you do, they will talk back to you. But if you don't talk to the animals, they won't talk back to you, then you won't understand, and when you don't understand you will fear and when you fear you will destroy the animals, and if you destroy the animals, you will destroy yourself.

—**CHIEF DAN GEORGE** (1899–1981), Tsleil-Waututh Nation, North Vancouver, British Columbia

On the other side of the world from British Columbia, an Aboriginal elder from Victoria, Australia, fishes from a riverbank with his young grandson. He begins, "Son, I have much to teach you. The rivers and lakes sustain us. The forest is the resting place of our ancestors and home of the spirits. If the land dies, if the water dries up, we, too, wither away. We depend on Rainbow Serpent, who taught us that we must care for the land, the water, and all animals." He continues:

> In the beginning, before life on Earth's surface, Rainbow Serpent and all the other animals slept underground. One day Rainbow Serpent awoke, crawled onto the surface, and surveyed the dry, empty land. She made rain.
>
> The rain soaked into the parched land. After years of rain, the water filled the tracks left by Rainbow Serpent's body and formed rivers, billabongs, and water holes. As she pushed her snout into the earth, Rainbow Serpent formed

hills, valleys, and mountains. Milk from her breasts fertilized the earth. Trees, shrubs, and grasses flourished.

When Rainbow Serpent was pleased with Earth, she slithered underground and woke the other animals. She led dingoes to the desert, kangaroos to the bush, eagles to the mountains, and emus to the plains. She guided frogs to ponds, turtles to lagoons, and insects, spiders, and scorpions to rocks and crevices.

Last of all, she woke up a man and a woman and took them to a place with abundant food and water. She taught them how to live. Most importantly, she taught them to respect all living creatures and to care for Earth. Before returning underground, Rainbow Serpent warned man and woman that they were not owners of Earth, but rather its guardians. She threatened that if man and woman abused Earth, she would reemerge and create a new world—one in which man and woman would have no place.

Grandparents continue to teach grandchildren traditional ways through animal stories. Such is the magic of folklore and the strength and passion of our bond with other animals.

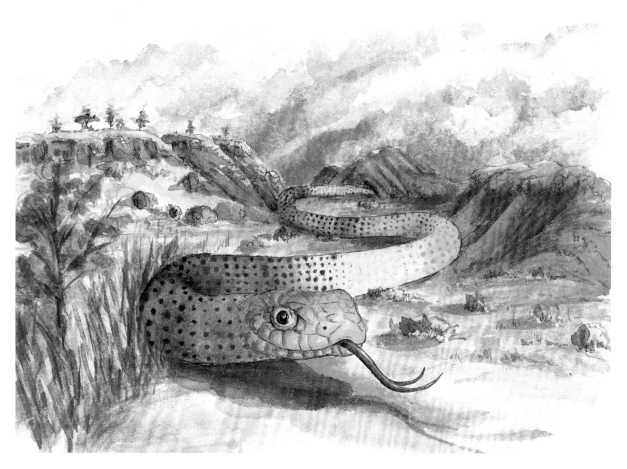

1.1 Rainbow Serpent formed riverbeds, gorges, valleys, and mountains as she slithered across the formless Earth.

I have long been intrigued by the complex ways that we interact with amphibians and reptiles, why we feel about them as we do, and what this all means for their future existence. Understanding that stories reflect our perceptions of animals, I began my investigation of amphibian and reptile folklore in 1966 as an undergraduate student at the University of Kansas, spending long hours ensconced in the underground stacks of Watson Library. Copy machines existed back then but were way too pricey for my

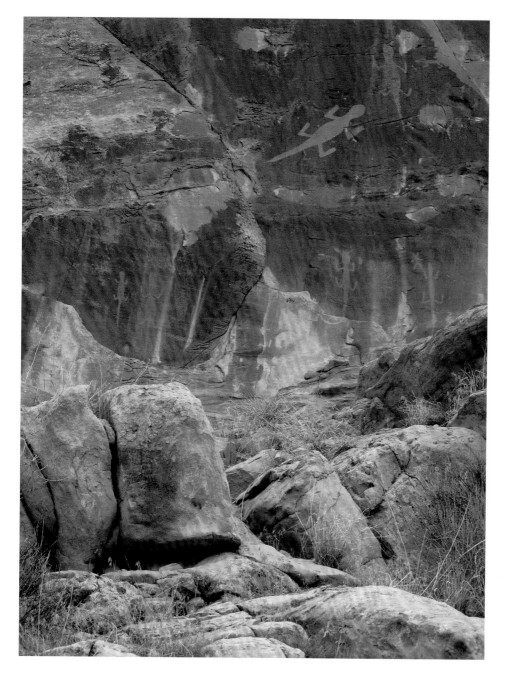

1.2 The Fremont people, who lived in the Cub Creek Area of what is now Dinosaur National Monument, Utah (United States), carved lizard petroglyphs into their rock surroundings a thousand years ago.

budget. I still have file boxes filled with handwritten notes from those days. Several years ago I decided the time was ripe to justify—in writing—all those hours spent in Watson Library when I should have been studying chemistry, all those hours spent in Marston Science Library at the University of Florida when I should have been fine-tuning lectures, and all those hours at Cline Library at Northern Arizona University when I should have been preparing handouts for my workshops in Latin America. The task of winnowing and synthesizing nearly 50 years of sleuthing has been immensely rewarding. And frustrating, because of what I had to leave out.

My premise—distilled and formulated from folklore and from my career as a herpetologist and conservation biologist—is that our perceptions matter a great deal for conservation. If a given animal has our respect and appreciation, the animal is more likely to be protected. Negative perceptions can lead to lack of protection or to outright killing. For these reasons, conservation biologists must acknowledge cultural-specific beliefs if we hope to communicate effectively and gain public support for campaigns designed to protect threatened species. We also need to understand the basis of these perceptions if we are to improve the way that people feel about the animals. Our values and attitudes come from both cognition and affect (emotions or feelings), though affect may play a more significant role in our perceptions than we care to admit.

Before we focus on amphibians and reptiles, let's look at the big picture of humans' relationships with other animals. Some we eat, and some eat us. We domesticate some to work for us, others to be our faithful companions. We designate animals as symbols of the gods or as gods themselves. Animals feature prominently in our folktales, music, art, literature, traditional medicines, magic, and witchcraft. We attribute supernatural powers to animals and believe that their spirits can act on our behalf. Our human souls transmigrate into the bodies of other animals. Some animals serve for our financial gain. Others we try to exterminate out of fear or because we consider them pests. Some animals we admire and love; others we fear and hate. Most simply exist as part of our surroundings, ignored unless they impinge on our well-being. In *Some We Love, Some We Hate, Some We Eat*, Hal Herzog sums up our interactions with other animals as inconsistent, paradoxical, and messy. How very true!

Many scholars have argued compellingly that, at the individual level, how we feel about given animals influences our behavior toward those animals. At the societal level, our perceptions influence legislation and public policy concerning animal welfare, animal rights, and other matters related both to domestic and to wild animals. It is valuable, then, to understand the origins of our attitudes concerning animals.

Evidence of our intimate relationship with other animals bombards us during everyday conversation. We say that so-and-so is a busy bee, an eager beaver, a cunning serpent, or a greedy pig. One can be mean as a rattlesnake, happy as a clam, or slippery as an eel. We drink like fish, become sick as dogs, and play cat and mouse. We

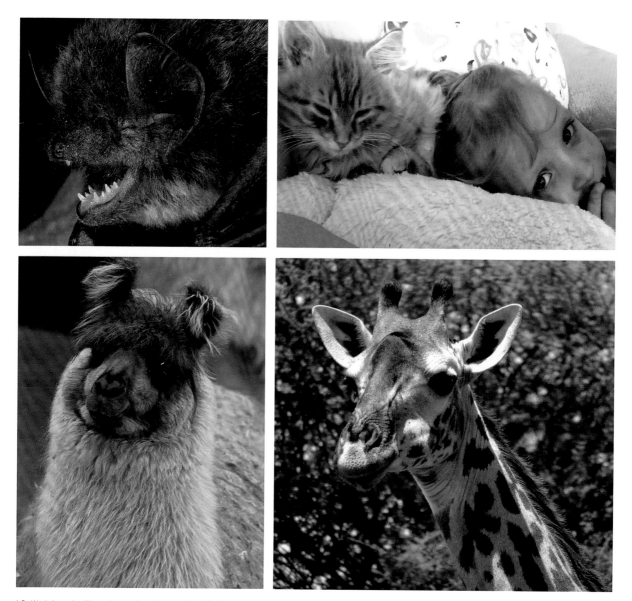

1.3 We interact with and perceive other animals in diverse ways. *Top left:* Many people dislike bats, from lack of understanding (Japanese pipistrelle, *Pipistrellus abramus*). *Top right:* We have domesticated some animals, such as cats, to be our companions. *Bottom left:* We have domesticated alpacas and other animals to work for us. *Bottom right:* Some animals, such as the giraffe, we find to be fascinating and wonderfully unique.

weep crocodile tears, share bear hugs, fish for compliments, wolf down dinner, and parrot what we hear. Some of us are loan sharks, militant hawks, or peaceful doves. Bull and bear markets on Wall Street determine our financial futures, and elephants and donkeys lead us in Washington.

We drive Beetles, Stingrays, Impalas, Mustangs, Jaguars, and Cobras. The Arizona Diamondbacks, Baltimore Orioles, Chicago Bears, and Miami Dolphins entertain us. We see animals in constellations: Hydra, the water snake; Lacerta, the lizard; Canis major and minor, the dogs; and Ursa major and minor, the bears. Some colleges

1.4 Animals are part of our day-to-day lives, including serving as college and university mascots (e.g., the Gator, University of Florida). We include them in our everyday language and even name our cars after them.

and universities boast powerful animals as mascots: wolves, cougars, and tigers. Others have chosen the burrowing owl, horned frog (actually a horned lizard), boll weevil, and banana slug. Charlie the Tuna, the Geico Gecko, the Budweiser Frogs, the Taco Bell Chihuahua, and the Energizer Bunny entice us to buy their affiliated products.

We name animals based on their association with or similarity to other animals: rhinoceros beetle, horsefly, crab spider, catfish, parrotfish, tiger salamander, bullfrog, rat snake, zebra finch, kangaroo rat, and mule deer. We give plants animal names: spider plant, toadflax, snakeroot, buffalo grass, lizard tail, cattail, and horsetail. And we name towns and topographic features for animals: Scorpion Blight, Australia; Mosquito Cays, Nicaragua; Trout Run, Pennsylvania; Frog Call Creek, Georgia; Toad Suck, Arkansas; Lizard Canyon, California; Alligator Alley, Florida; Rattlesnake Hills, Wyoming; Moose Town, Montana; Pig Eye, Alabama; Rabbit Ears Pass, Colorado; Monkey's Eyebrow, Kentucky.

In his 1984 book *Biophilia*, Harvard biologist E. O. Wilson hypothesizes that humans have an innate tendency to affiliate with nature—*biophilia*, literally "love of

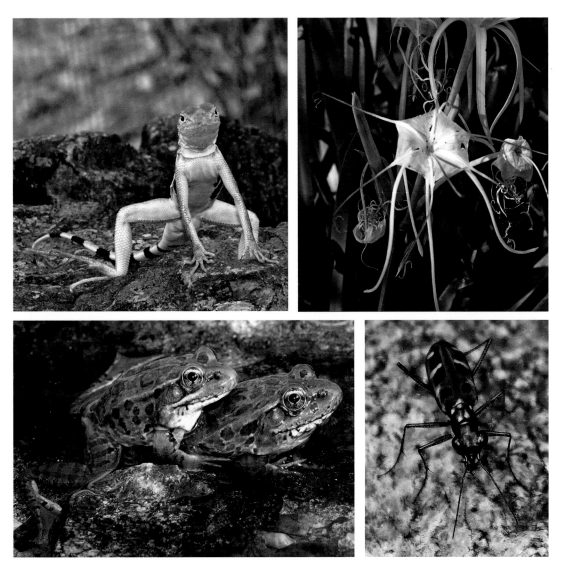

1.5 We give animals and plants common names that incorporate the names of animals, based on appearance. *Top left:* zebra-tailed lizard (*Callisaurus*); *top right:* spider lily; *bottom left:* Chiricahua leopard frogs (*Lithobates chiricahuensis*); *bottom right:* tiger beetle.

living things." Wilson argues that humans subconsciously seek connections with the rest of life, that we evolved with this trait, and that it is still ingrained in our genome. Hunting, fishing, hiking, and bird-watching are major pastimes. More people in the United States and Canada visit zoos and aquariums than attend football, basketball, and all other professional athletic events combined. Wilson has since revised his concept of biophilia, suggesting that our urge to connect with the natural world is also learned. Other scientists have argued that biophilia is primarily a learned state of mind, and as such we need to cultivate a love of nature in our children.

Many characteristics influence how we feel about animals. Most people feel more positively about animals that are close to us phylogenetically (other primates) or cog-

nitively (e.g., dolphins) than those that are distantly related and less intellectually endowed (e.g., slugs). We especially relate to animals with characteristics reminiscent of human babies, such as large foreheads, big eyes, and bulging cheeks: baby seals, kittens, and puppies. Exotic, endangered animals gain our sympathy: Australia's duck-billed platypus and China's panda.

We impose our values on other animals. Most of us admire animals we consider beautiful, graceful, intelligent, industrious, brave, or powerful; and we disdain those we consider ugly, clumsy, dull, lazy, cowardly, or weak. We respect animals that perform activities that are "helpful" to us: butterflies and hummingbirds that pollinate plants; bluebirds that eat grasshoppers in our gardens. We dislike animals that perform "disgusting" (though crucial) activities: turkey vultures that eat roadkills, and dung beetles that eat poop. Good parents—emperor penguins, elephants, and sea horses—fascinate us. We despise animals that harm us: parasites that suck our blood, absorb our food, or cause sickness; disease-spreading rodents and houseflies; venomous snakes and black widow spiders.

I am using "we" from a Western perspective because that is my background, but of course people of different cultures perceive a given animal in contrasting ways. James Serpell, an anthrozoologist at the University of Pennsylvania, has offered a simple model explaining cultural differences in how humans perceive animals. He suggests that our attitudes boil down to two dimensions. One dimension is affect—how we feel about the animal emotionally, including whether or not we identify with the animal. The second dimension is utility—whether we view the animal as useful or detrimental to our interests. Any animal can be imagined as lying within the two-dimensional space of a grid with four quadrants formed by a horizontal line representing utility and a vertical line representing affect. The position of the animal varies to a large extent with the culture.

How do cultural differences in our perceptions of animals evolve? What explains why in one place a given animal is revered and elsewhere it is persecuted? Fundamental aspects of our lives surely play a role: lushness vs. harshness of the environment, lifestyle (hunter-gatherers, farmers, pastoralists, fishermen, city folk), and standard of living.

Religious beliefs also influence how people perceive and treat other animals. Jainism teaches non-violence toward all living beings. Many Jains will not walk outside at night for fear of stepping on ants or other animals; some Jain monks wear masks to avoid inhaling microbes. Many first peoples from North America believe that all animals are sacred and possess spiritual power; hunters ask for forgiveness from the game they kill for food. Buddhists and Hindus are taught to treat humans and non-human animals with equal respect. Judeo-Christian philosophy teaches that humans have dominion over other animals; humans have the right to use other animals, but should care for them with kindness and compassion. Likewise, Islam teaches that although animals exist for human benefit, they should be treated with compassion.

Love, sympathy, identification

AFFECT

Detrimental to
human interests

UTILITY

Beneficial to
human interests

Fear, loathing, non-identification

1.6 Anthrozoologist James Serpell suggests that our attitudes toward animals boil down to two dimensions: affect (our emotional perception of a given animal) and utility (our perception of whether the animal is useful or detrimental to our interests). Each person's placement of, for example, elephants, dogs, leeches, and snakes on this grid depends on many factors, including culture. The placement here is that of an imaginary person who (1) realizes that elephants impact the environment by changing the landscape in often negative ways, but admires them for their emotional ties to family, response to death, and memories that likely surpass our own; (2) trusts and values dogs as companions; (3) detests leeches because of bad personal run-ins with the bloodsuckers; and (4) fears snakes but acknowledges that they play a key role in the food chain, including eating rodent pests.

Within a culture, individuals view animals differently. After all, we are independent thinkers. A given animal might evoke love, respect, admiration, neutrality, disgust, fear, or hatred, depending on the person. Gender, a person's age, and knowledge about a given animal influence perception. We feel the greatest kinship with diurnal animals active in places where we can see them, such as aboveground or in the air. We tend to understand less well, and therefore fear and distrust, nocturnal animals and those that live underground or in deep water.

Amphibians and Reptiles

Herpetology, from the Greek words *herpeton* (crawling thing) and *logos* (knowledge), is the study of amphibians and reptiles. But why are these animals discussed together, as if they belong to one group? The simple answer is historical inertia. Tradition! Carolus Linnaeus, the Swedish botanist and zoologist heralded as the father of modern biological classification, considered amphibians and reptiles as one class because they were neither fishes nor birds nor mammals.

Linnaeus didn't think much of amphibians or reptiles. In the tenth edition (1758) of *Systema Naturae*, he writes:

> These foul and loathsome animals are distinguished by a heart with a single ventricle and a single auricle, doubtful lungs and a double penis. Most amphibia are abhorrent because of their cold body, pale colour, cartilaginous skeleton, filthy skin, fierce aspect, calculating eye, offensive smell, harsh voice, squalid habitation, and terrible venom; and so their Creator has not exerted his powers to make many of them.

Perhaps we shouldn't fault Linnaeus for underestimating the rich diversity of amphibians (in January 2015, estimated at about 7,385 species) and reptiles (in August 2014, estimated at 10,038 species). After all, Linnaeus's landscape was herpetologically challenged. His native Sweden has only 13 species of amphibians and 6 species of reptiles. Dismissing them as foul and loathsome, however, was unwarranted.

Amphibians and reptiles (now recognized as separate classes) figure prominently in our everyday lives. Some are highly visible, abundant, or easy to watch or catch. Some exhibit fascinating behaviors, ranging from sophisticated parental care to menacing aggression—behaviors that remind us of our own strengths and shortcomings. We value their flesh, secretions, and other body parts. From the tiny to huge, beautiful to ugly, and soothing to frightening, these animals play a central role in our folklore, touching on human life and death.

The word "amphibian" derives from the Greek words *amphi* (double) and *bios* (life). Many amphibians live both in the water and on land, at least during part of their lives. The class Amphibia is divided into three orders: Anura (frogs), Urodela (salamanders), and Gymnophiona (caecilians).

Many of the 6,509 species of frogs undergo a dramatic metamorphosis from larval to adult form, a move from water to land. A creature that starts off as an algae-eating, swimming blob attached to a tail ends up as a large-mouthed predator hopping about on four sturdy legs. The tadpole's long, coiled intestine shortens. Skin glands mature, and legs develop. Eventually the tail shrinks to nothing. Even to an amphibian biologist, the process seems magical. Frogs' transformation evokes resurrection and rebirth, suggesting supernatural powers. The observation that frogs

1.7 The class Amphibia is divided into three orders. *Top left:* Anura (e.g., gopher frog, *Lithobates capito*, juvenile); *top right:* Urodela (e.g., cave salamander, *Eurycea lucifuga*); *bottom:* Gymnophiona (e.g., Congo caecilian, *Herpele squalostoma*).

mysteriously appear after rains and just as mysteriously disappear plus the fact that frogs shed their skin further suggest rebirth. Male frogs call to attract females for mating, and their joyful songs are believed not only to predict rain but also to bring rain. Such power suggests that frogs can withhold nourishing rains and cause floods. Most toads have dry, warty skin and short hind legs. Toads often are perceived as ugly and are associated with bad luck, filth, and evil.

Salamanders (675 species) superficially resemble lizards. Both have tails, and most species of both groups walk, run, or swim with four legs. Instead of reptilian scales, however, mucous glands cover salamanders' moist skin. The poisonous mucus of some species spawned the idea that salamanders have supernatural powers. When logs are thrown onto a fire, salamanders sometimes exit, giving rise to the myth that salamanders were created from fire and reinforcing belief in their supernatural powers. For those salamanders that have an aquatic larval stage, metamorphosis suggests resurrection and rebirth. Many salamanders can drop their tails (called autotomy, from the Greek words meaning "self-severing") when attacked and then regenerate

1.8 The tadpole stage differs more from the body form of an adult frog than the salamander larval stage does from the adult salamander. *Top:* tadpoles of the Concepcion toad (*Rhinella arunco*); *bottom:* larva of the reticulated flatwoods salamander (*Ambystoma bishopi*).

new tails. Autotomy plus the ability to shed their skin provide further "evidence" of salamanders' rebirth.

Caecilians, legless amphibians with bodies encircled by grooves, resemble giant earthworms. The 201 species of caecilians live only in the world's tropical and subtropical regions, mostly underground or in water. Because of where caecilians live and because they are secretive, people rarely encounter them.

The word "reptile" comes from the Latin word *reptilis*, meaning "a creeping, crawling animal." Four orders make up the class Reptilia: Testudines (turtles), Crocodilia (crocodilians), Rhynchocephalia (tuatara), and Squamata (lizards and snakes).

Turtles (341 species) are unique among vertebrates in having bony protective shells, into which most can draw their legs, tails, and heads at the first hint of danger—a behavior highlighted in much folklore. Tortoises (turtles that live on land) have stumpy, elephantine hind feet and high, dome-shaped carapaces (top shell).

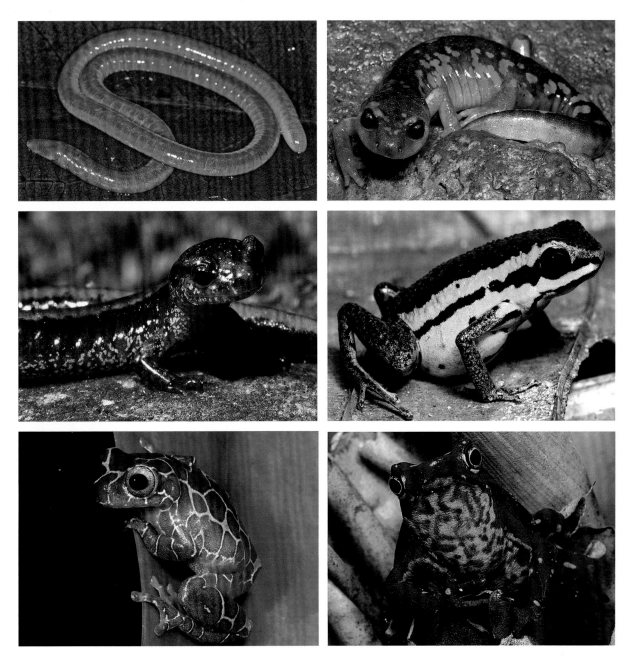

1.9 An amphibian celebration of color! *Top left:* Boulenger's caecilian (*Boulengerula boulengeri*); *top right:* Sierra Nevada ensatina (*Ensatina eschscholtzii platensis*); *center left:* western red-backed salamander (*Plethodon vehiculum*); *center right:* Pongo poison frog (*Ameerega pongoensis*); *bottom left:* Beireis' treefrog (*Dendropsophus leucophyllatus*); *bottom right:* Pebas stubfoot toad (*Atelopus barbotini*).

Most aquatic turtles have fairly flat carapaces, allowing them to swim efficiently. Turtles and dinosaurs roamed Earth together, but turtles watched the dinosaurs go extinct (except for the birds, which lived on). Because they are such hardy survivors, both in geological terms and in having long life spans, we associate turtles with patience, immortality, wisdom, persistence, and good luck. We also ridicule turtles for their slowness and "cowardly" behavior of hiding in their shells.

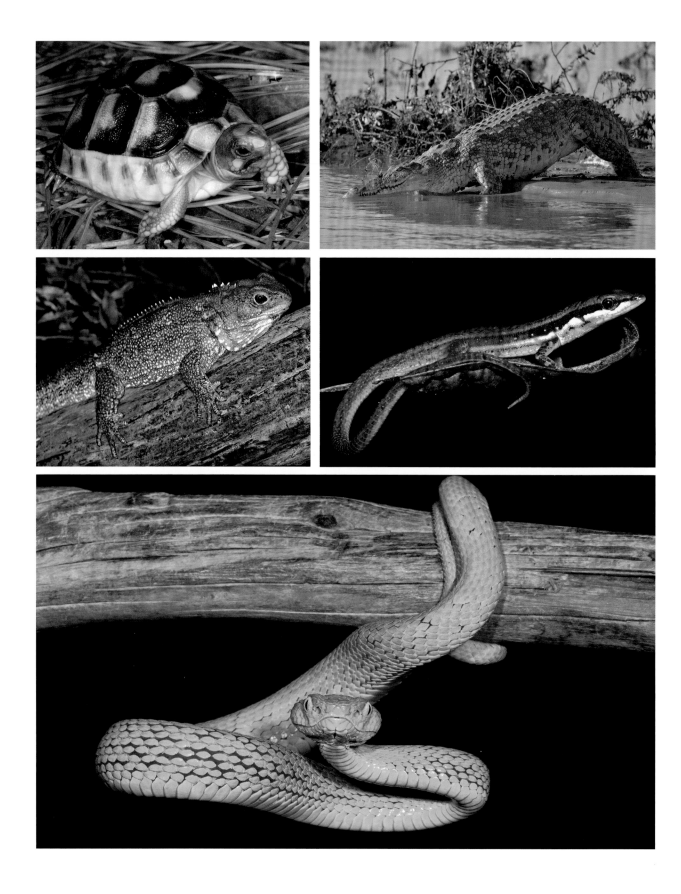

The 25 species of crocodilians—crocodiles, gharials, alligators, and caimans—appear prehistoric, with their short, strong legs, webbed feet, long snouts, strong jaws, powerful tails, and protective armor of bony plates. Crocodilians are excellent swimmers, and they can gallop surprisingly quickly on land. A few species eat people. Humans have long attributed supernatural powers to crocodilians because of their strength, sinister appearance, and threatening behavior.

The single species of tuatara currently lives only on small islands off the coast of New Zealand. Tuatara superficially resemble lizards, but they differ in dental, cranial, and other characteristics. Tuatara are the only surviving members of the order Rhynchocephalia. These "living fossils" haven't changed much since the days they lived alongside the dinosaurs over 200 million years ago. With spines running down the centers of their backs, these 2-foot-long (0.61 m) reptiles generate fear in some people, which has led to belief that these reptiles house evil spirits and cause misfortune. On the other hand, their "third eye" (parietal organ) on the tops of their heads suggests that they see in another dimension; as such, they are keepers of knowledge and divine guardians. Because of the tuatara's restricted distribution, most folklore about them comes from native New Zealanders, the Maori.

More species of lizards (about 5,987 species) live on Earth than all other reptiles combined. Lizards come in a wide diversity of shapes, sizes, and colors. A rich folklore has developed around these reptiles. Their abilities to shed their skins and autotomize their tails link them with rebirth and good fortune. Lizards that look "evil" and those that are large, "ugly," or perceived as threatening are associated with bad luck, death, and the Devil himself. Some other lizards are believed to possess divine wisdom, bestow good health and happiness, serve as messengers to the gods, and house spirits of dead ancestors.

About 100 million years ago, snakes evolved from lizard-like reptiles that had legs. There are about 3,496 species of snakes alive today. More folklore concerns snakes than of all the other reptiles and the amphibians combined. Many folktales and beliefs center on snakes as phallic objects. Because some snakes kill with fangs and venom and others with constricting coils, many people view all snakes as dangerous. Danger signifies power. Snakes are very different from us: they slither, are naked, and feel cold to the touch. Their unpredictable appearance and disappearance startle us. Snakes shed their skin, seeming capable of resurrection and rebirth. They cannot blink or close their eyes; their stares both unnerve us and suggest vigilance. Snakes symbolize immortality and death, healer and killer, god and devil, good and evil.

1.10 The class Reptilia is divided into four orders: *Top left:* Testudines (e.g., marginated tortoise, *Testudo marginata*, hatchling); *top right:* Crocodilia (e.g., Nile crocodile, *Crocodylus niloticus*); *center left:* Rhynchocephalia (tuatara *Sphenodon punctatus*); *center right:* Squamata (suborder Lacertilia, e.g., elegant eyed lizard, *Cercosaura argulus*); *bottom:* Squamata (suborder Serpentes, e.g., Mexican palm viper, *Bothriechis rowleyi*).

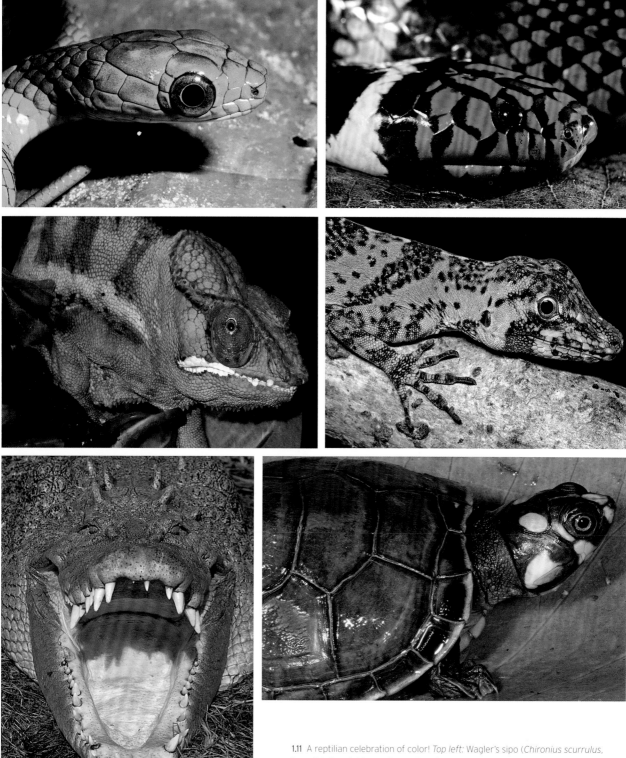

1.11 A reptilian celebration of color! *Top left:* Wagler's sipo (*Chironius scurrulus*, juvenile); *top right:* aquatic coral snake (*Micrurus surinamensis*); *center left:* panther chameleon (*Fucifer pardalis*); *center right:* banded tree anole (*Anolis transversalis*); *bottom left:* saltwater crocodile (*Crocodylus porosus*); *bottom right:* yellow-spotted Amazon River turtle (*Podocnemis unifilis*).

Serpell's Model as a Framework

James Serpell suggested that our perceptions of animals can be explained using a simple model of two dimensions: how we feel about a given animal emotionally (affect), and whether we view the animal as detrimental or beneficial to our interests (utility). I will use Serpell's model as a framework for examining our perceptions about amphibians and reptiles—through history and throughout the world. I will ponder the affect dimension through folktales and folk beliefs, which are deeply ingrained within a culture; and I will address the utility dimension by surveying the many ways in which we use the animals.

Folklore

We are all storytellers, and we all love to hear stories. Every human culture tells stories, and every aspect of culture uses stories to convey beliefs and knowledge. Think about the widespread use of stories in religion, science, medicine, politics, and education. We tell stories to understand our surroundings, shape our experiences, entertain, share ideas, and bond with one another. Stories connect the past to the future and keep memories and values alive.

Cognitive scientists have documented that humans are hard-wired to learn through stories. Think about your own experiences, and you'll probably find that you've learned more from stories than from endless memorized facts. Stories plant seeds that encourage reflection. Because animals play a central role in our lives, we have developed alternative perspectives of animals in the form of folklore. Animals act as creators, messengers of the gods, reincarnated ancestors, guardians, teachers, and advisers. They support the world, yet cause earthquakes and floods. Animals are tricksters, culture heroes, and role models.

The English antiquarian William John Thoms coined the term "folklore" in 1846, proposing the word as a substitute for "popular antiquities." The term includes both folktales and folk beliefs, and refers to both the mass of traditions of the world's people as they appear in stories, customs, beliefs, magic, and rituals, as well as the field of study that addresses these topics. I particularly like Theodor H. Gaster's definition of folklore from *Funk & Wagnalls Standard Dictionary of Folklore, Mythology, and Legend*:

> Folklore is that part of a people's culture which is preserved, consciously or unconsciously, in beliefs and practices, customs and observances of general currency; in myths, legends, and tales of common acceptance; and in arts and crafts which express the temper and genius of a group rather than of an individual. Because it is a repository of popular traditions and an integral element of the popular "climate," folklore serves as a constant source and frame of reference for more formal litera-

ture and art; but it is distinct therefrom in that it is essentially of the people, by the people, and for the people.

Folktale is a general term referring to many types of traditional narratives, handed down from one person to another. It is useful to differentiate among some forms of folktales, despite considerable overlap. Legends generally are told as fact, believed by the teller. In contrast, fairy tales are almost always fictional in intent. Animal tales are anecdotes about the adventures of animals usually portrayed with human characteristics. Some animal tales explain a phenomenon: why the raven is black, why the frog croaks. In most animal tales, the animals talk and think logically. They might solve problems, foresee approaching danger, or serve as trusty guides. When animal tales convey moral lessons, we call them fables. Myth is a general term often referring to a tale that concerns the world in some past age and attempts to explain a phenomenon. Creation myths, for example, concern formation of the world or origin of part of the world. Myths have many different functions and offer diverse insights, from revealing the values and principles of a society, to explaining the origin of the universe, to sharing universal truth. Although the word myth is often used as a synonym for fiction or an untrue explanation or phenomenon, myths in the traditional sense are stories that attempt to explain reality. I will use myth in the traditional sense.

A folk belief is defined as a common belief that, although not grounded in scientific evidence, is widely accepted as truth by many members of a group or culture. Folk beliefs often are so ingrained in people's imaginations that even scientific evidence to the contrary will not alter the beliefs. Examples of folk beliefs include such statements as "You'll catch a cold from being wet and chilled" and "Handling a toad causes warts."

Why is folklore still relevant in the twenty-first century? Folklore provides a window into the soul of a culture. In all its many forms, folklore reflects a culture's fears, hopes, and dreams. Humans everywhere share many of the same doubts and desires; thus, many themes are repeated throughout history and by widely geographically separated cultures. But because the landscapes in which humans live are very different—think tropical rain forest vs. savannah or desert—much folklore is unique to a given culture. Because folklore describes who we are as a people and how we interact with our environment, we can learn much about how diverse cultures perceive amphibians and reptiles through their tales and beliefs.

Ways We Use Amphibians and Reptiles

By examining the utility dimension—if and how we use particular amphibians and reptiles for our benefit—we can better understand what these animals mean to us. Amphibians and reptiles have been and still are revered. Some serve as gods, others

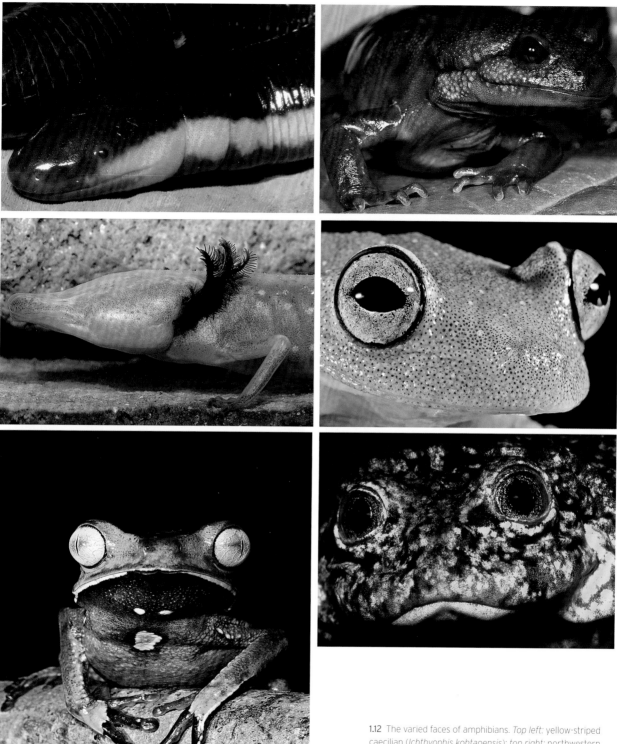

1.12 The varied faces of amphibians. *Top left:* yellow-striped caecilian (*Ichthyophis kohtaoensis*); *top right:* northwestern salamander (*Ambystoma gracile*); *center left:* Texas blind salamander (*Eurycea rathbuni*); *center right:* Demerara Falls treefrog (*Hypsiboas cinerascens*); *bottom left:* white-lined leaf frog (*Phyllomedusa vaillanti*); *bottom right:* Lake Titicaca frog (*Telmatobius culeus*).

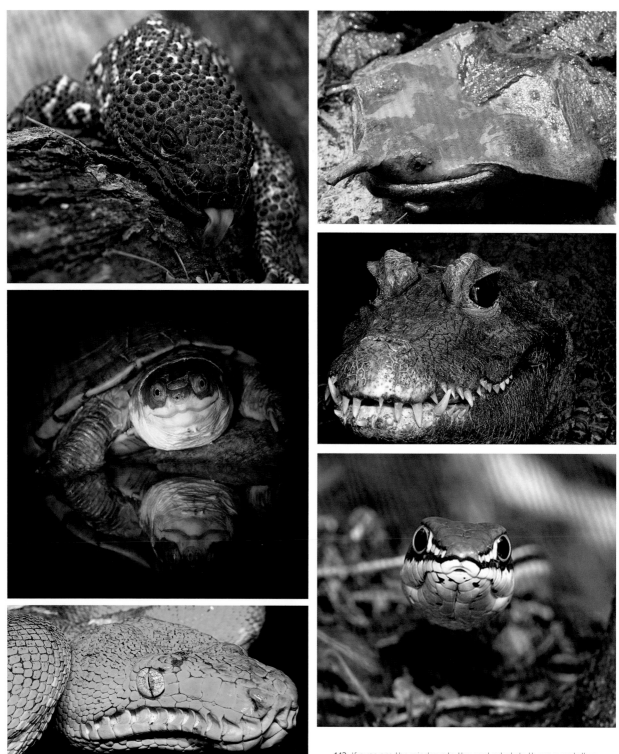

1.13 If eyes are the windows to the soul, what do these eyes tell you about each reptile? *Top left:* beaded lizard (*Heloderma horridum*); *top right:* matamata (*Chelus fimbriatus*); *center left:* yellow mud turtle (*Kinosternon flavescens*); *center right:* West African dwarf crocodile (*Osteolaemus tetraspis*); *bottom left:* western emerald tree boa (*Corallus batesii*); *bottom right:* Sonoran whipsnake (*Coluber bilineatus*).

as messengers to the gods. Cultures worldwide believe that these animals can heal or cure human ailments but also cause disease and bring bad luck. Thus, amphibians and reptiles are used in traditional medicine and white magic as well as in witchcraft and black magic. We find the skins of crocodilians and snakes attractive, wearing purses, belts, and shoes made from them, and we keep amphibians and reptiles as pets. We eat them, smoke them, and use their venoms and poisonous secretions for modern medicines.

But do we value amphibians and reptiles for the ways in which they enrich our lives? Or do we take them for granted?

In 1953 naturalist and founder of the Golden Nature Guides series Herbert Zim and herpetologist Hobart Smith published the *Golden Guide to Amphibians and Reptiles*. I and many kids in my generation carried the little paperback in our pockets as we explored the outdoors. I loved the book and used it to identify the salamanders, frogs, and snakes I found in my corner of southwestern Pennsylvania.

Now, over a half century later, I am astounded by several sentences in my mud-stained, water-damaged copy. Under a section entitled "Values of Reptiles": "As a group they are neither 'good nor bad,' but are interesting and unusual, although of minor importance. If they should all disappear, it would not make much difference one way or the other." Under a section entitled "Values of Amphibians": "Frogs and other amphibians are used in scientific experiments. We eat frogs' legs, and frogs consume quantities of insects. Here the usefulness ends. Yet, like the reptiles, these animals are part and parcel of the animal world. They are curious reminders of animal life of long ago."

Today such a philosophy would not be expressed in a guide to amphibians and reptiles. Rather, one might read that in 2015 an estimated 31 percent of amphibians and 21 percent of reptiles are threatened with extinction and that if we lose amphibians and reptiles, cascading effects will ripple through our ecosystems, impacting both predator and prey species. If these animals disappear, we lose a part of ourselves, our heritage, and our future.

A Few Final Comments Before Beginning

- What you are about to read is an eclectic sampling of folklore featuring amphibians and reptiles. In some cases, the tales and beliefs illustrate the universality of human perceptions. In other cases, the tales or beliefs reflect diverse perceptions from disparate cultures. I have barely scratched the surface of captivating folklore highlighting these animals. The stories and beliefs retold here originate from around the world, yet many geographical areas have been left untouched. I have addressed a diversity of topics, but many have been neglected. No doubt I have omitted many readers' favorite stories and beliefs.

Hopefully I have shared many unfamiliar ones and increased readers' understanding of human perceptions of amphibians and reptiles through folklore.

- Multiple versions of a given folktale exist, so do not be surprised if what you read here differs from a story you recognize. Stories change through time because folklore is an oral tradition. Storytellers embellish their favorite parts and downplay others. Tales morph to become more relevant with cultural change. Different versions arise as folklore travels with migrating peoples. New environments mold and frame the stories to reflect the exotic landscapes and belief systems. When outsiders translate folklore, they sometimes interpret the stories within their own frames of reference, further modifying the stories.
- The myths, legends, fables, and other stories you will read here are retold by me, often in greatly condensed form. I take full responsibility for any bias or misinterpretation I might have inadvertently introduced.
- I make no claim that amphibians and reptiles appear more frequently than any other animals in folklore. When I write, for example, that reptiles figure prominently in origin of death myths, I do not mean to imply that they are more prominent than other animals. I leave those comparative analyses to the folklorists. Folklore is replete with tales of many animals. Amphibians and reptiles are just part of the mix.
- For a conservation program to be effective, it must involve the local people. They must care about the animals, and they must perceive some personal or community benefit of protecting the habitat or species, be it economic or life-sustaining and enriching.
- We kill, or make no effort to protect, animals that we associate with evil or that inconvenience us, and we protect animals that we admire or that benefit us. For this reason, conservation biologists sometimes try to change people's perceptions. But is this ethical? Do we have a right to challenge people from a different culture about their folk beliefs in the name of conservation? Think about this question as you read about how other cultures view amphibians and reptiles.
- I encourage you to question your own attitudes, assumptions, and perceptions of amphibians and reptiles. Try to analyze why you have negative feelings, if you do. Are you comfortable with your perceptions?

Throughout the book, I have sprinkled quotes from two special people. One is the late Dr. Archie Carr, friend and colleague from my years on the Zoology Department faculty at the University of Florida. Archie was one of the great biologists and naturalists of the twentieth century. He was also a gifted writer who captured the hearts and imaginations of biologists and non-biologists alike. He spent much of his life studying sea turtles, and he championed their conservation. Archie has been an inspiration to me, both through his science and the telling of his science. The other is my

1.14 We can learn much about how we form our perceptions of other animals from watching the *tabula rasa* accumulate beliefs, just as we can learn much from the sages, who show us by example what it means to love nature. *Left:* Archie Carr, biologist, naturalist, writer, and champion of sea turtles; *right:* Fionna on her "unicorn" Andi.

granddaughter, Fionna, four years old as I finish writing this book. Fionna personifies the naive sense of wonder about nature. Every animal is a curiosity and a treasure. Fionna represents the future—the next generation to interact with amphibians and reptiles and to decide whether to protect the animals or ignore their welfare.

Join me on a journey blending fantasy and reality to visit the ways in which we perceive amphibians and reptiles through folklore and through their use in traditional medicine, magic, spirituality, and more. As you read the stories and beliefs, imagine our distant ancestors trying to understand their world through talking to the animals, creating tales that have been retold for hundreds or thousands of years. Like pebbles tumbling in a creek, the tales have become smooth and polished, magical treasures still shared through intimate oral tradition. Embrace the spirits, dragons, demons, deities, heroes, and tricksters—and allow yourself to view the world of amphibians and reptiles through a different lens.

2.1 Many amphibians and reptiles are closely associated with water. *Top:* amplectant pair of rococo toads (*Rhinella schneideri*); *bottom:* two-striped garter snake (*Thamnophis hammondii*), a fish-eater.

In the Beginning

Creation Myths

Just as children ask, "Where did I come from?" adults continue to try to fathom the beginnings not only of their own existence, but also of all of their surroundings. At the same time, these stories [creation myths] represent a way of knowing and a way of structuring experience.

–EVA M. THURY and MARGARET K. DEVINNEY, *Introduction to Mythology*

The sun is melting!" sputtered my two-year-old granddaughter. Fionna's interpretation for the gray and gloomy sky, based on her frame of reference (no doubt melting ice cream), reminded me of creation folklore. So, too, people worldwide have explained cosmic phenomena based on frames of reference within their environment. People yearn for a sense of identity, to understand their place in the world. And so virtually all cultures tell creation myths—sacred stories about the establishment and ordering of the universe, where the people came from, who put them in their homelands, and why.

Amphibians and reptiles feature prominently in creation myths for several reasons. One is that the animals are closely associated with water, and because water is crucial to life, it is central to most creation myths. Amphibians' complex life cycle from aquatic larva to terrestrial adult and snakes' ability to shed their skin suggest resurrection and rebirth. Large, formidable reptiles such as anacondas, pythons, and crocodilians reflect

power and creative energy. We associate turtles and large snakes with strength and endurance, well suited to support the world.

Amphibians and reptiles play both constructive and destructive characters as forces of change in creation myths. These opposite roles likely reflect our dual perceptions of these animals—love vs. hate, admiration vs. fear—a major theme of this book. By examining creation myths, we gain a sense of how people from diverse cultures view the amphibians and reptiles around them, or at least how their ancestors viewed these animals. A positive perspective of an animal through its creator role surely affords that animal a degree of respect. A negative perspective may lead to apathy or even persecution.

Amphibians and Reptiles: Their Disparate Roles in Creation

Creation from Water and/or Mud

Book 1 of the *Rig Veda*, the oldest (composed between 1700 and 1100 BCE) and most sacred text of Hinduism, tells how the powerful serpent Vritra played a negative role in Earth's early history. Vritra was despised because he swallowed all waters and caused devastating droughts. Indra, the storm god, killed Vritra with a thunderbolt. As he opened Vritra's belly, water poured out, filled the rivers, and refreshed the earth. This heroic act elevated Indra to King of the Gods. Meaning "he who tightens and imprisons," Vritra likely embodied the python, a powerful snake that constricts its prey.

Ancient Egyptians from the city of Hermopolis told a story about how eight creator deities formed the world, with its center at Hermopolis. These deities represented the primeval forces of nature—water, eternity, darkness, and air. A pair of deities was associated with each primeval force, a god and goddess that represented the male and female aspects of each power. The four gods were represented as frogs or beings with frog heads, and the four goddesses as snakes or beings with snake heads. When the frogs and snakes converged in the primeval waters of chaos, a great explosion produced the pyramidal mound, giving rise to the sun and all else. Scholars suggest that this mound represented the piles of fertile mud left by the receding Nile after the annual floods. In ancient Egyptian mythology, both frogs and snakes represented fertility and the cycle of death and rebirth, so it was natural they should play major roles in creation.

In a Babylonian creation story, Tiamat—a monster with the body of a python, jaws of a crocodile, wings of a bat, legs of a lizard, and horns of a bull—embodied chaos. Marduk, the storm god, sliced Tiamat in half, resulting in victory of order over chaos. Once Tiamat was destroyed, the old world was replaced with a new one. Marduk created the sky from one-half of Tiamat's body and the earth from the other half. He created mountains from her head and breasts, and he channeled the Tigris and Euphrates Rivers from her eyes.

A similar story was told by the early Aztecs, who often depicted Tlaltecuhtli, Earth Mother Goddess, as a hairy, squatting toad with a gaping mouth and massive fangs. She gave birth to new life in this position, and from her mouth emerged dead souls, symbolizing the cycle of life and death. Tlaltecuhtli was the sole survivor after the original world was destroyed by flood. Quetzalcoatl, the plumed serpent god, and Tezcatlipoca, the magician-jaguar god, set out to re-create the universe. When they found the monstrous-looking Tlaltecuhtli floating on the primordial sea, they proclaimed that she could not exist in their universe. After transforming themselves into huge serpents, they coiled themselves around Tlaltecuhtli and tore her in two. They threw half upward to create the sky. The other half remained below and became the land. Her hair became flowers, grasses, and trees. Mountain ridges formed from her nose, and rivers and caverns emerged from her mouth.

The Aztecs believed that Tlaltecuhtli still resented her fate and that Earth shook when she complained. When she cried, demanding blood and hearts, Aztecs calmed her with human sacrifices. In turn, she provided the people with basic necessities and fed them from the earth. Every evening Tlaltecuhtli swallowed the sun, and every morning she vomited it back up. The cycle of life and death continued. Clearly, Tlaltecuhtli had great power over the people and no doubt reflects how they perceived toads—ugly, but powerful.

For the Gwikwe of Namibia and Botswana, in the beginning the world was empty except for the Supreme Being Pishiboro and a puff adder. The snake fatally bit Pishiboro. When Pishiboro died, water flowed from his body and formed the rivers. His blood formed the hills and rocks. Valleys resulted from his violent death throes, and his hair became moisture-laden clouds. Puff adders are responsible for a large percentage of lethal snakebite in Africa. No wonder, then, that the Gwikwe attribute such power—the power to initiate creation—to puff adders. Although the snake plays what might be interpreted as originally a negative act, the fatal bite was constructive in that it created Earth.

In Chinese mythology, the goddess Nëwa is depicted as a powerful snake with the head of a beautiful woman. Nëwa existed at the beginning of the world, before other living creatures. Out of loneliness, she molded clay into animals: chickens on the first day, dogs on the second, sheep on the third, pigs on the fourth, cows on the fifth, and horses on the sixth. On the seventh day, she sculpted humans from yellow clay. After she had carefully handcrafted hundreds of humans, each a wealthy noble, she grew bored and impatient, knowing she needed to make more. To expedite matters, she dipped rope into the fertile clay and flicked it about. Each blob of clay became a poor, common person.

Many Native American tribes from North America have "earth-diving" sacred creation stories that involve a girl, woman, or goddess falling or being pushed from the sky and tumbling into primal waters. She needs someplace to rest so an aquatic animal dives to the bottom of the water and brings up mud from which Earth is cre-

ated. The animal—often an otter, beaver, toad, or turtle—represents the creator's spirit breathing life into the world.

The following Iroquois sacred story features a toad, a natural because of its association with mud: The first people lived in the heavens with no land beneath. One day Great Spirit's daughter became ill. A wise old man suggested that the roots of a certain tree might cure her. As the people dug around the base of the tree, both the tree and the girl fell through the hole into the vast sea below. Swans rescued the girl. Great Turtle declared the tree and the girl a good omen. He told all the animals to search for the tree and bring up soil attached to its roots to provide an island for the girl. Only Old Toad was successful. She spit out a mouthful of mud and then died. The mud became a vast landmass, but there was no light yet. After the girl told Great Turtle about light in the world above, Turtle instructed the animals to bore holes in the sky to let light shine through. They did, and there was light. In time, the girl gave birth to the first humans on Earth.

Large, Powerful Reptiles as Creators and Creator-Helpers

Crocodilians, monitor lizards, and large snakes seem naturals to play creator or essential helper roles because of their perceived power. These creation myths reflect reverence for the animals, whether from fear or admiration. An Egyptian myth tells that Sobek (Sebek), Crocodile God and Lord of the Nile, crawled out of the primordial water and laid eggs on the bank of the Nile. The eggs hatched, beginning all of creation. In a Babylonian myth, it is said that where the waters came together in the region between the Tigris and the Euphrates Rivers, two giant serpents gave birth to Sky and Earth. The Pumé of the Llanos of Venezuela say that in the beginning Puana, the water serpent (presumably an anaconda), created land and everything on land.

According to a Pelasgian (ancient people of the Greek world) myth, the goddess Eurynome emerged naked from chaos and divided the waters from the sky so that she could dance on the waves. As she danced, she created the wind. She caught the north wind, and when she rubbed it, the wind became a serpent, Ophion. After Eurynome and the serpent coupled, she laid the world egg. Ophion coiled around the egg to protect it. Eventually the egg hatched and released the sun, moon, stars, Earth, plants, and non-human animals. Eurynome and the serpent lived on Olympus until Ophion grew arrogant, bragging how he had fathered all of life. Angry, Eurynome broke the serpent's teeth, flattened his head,

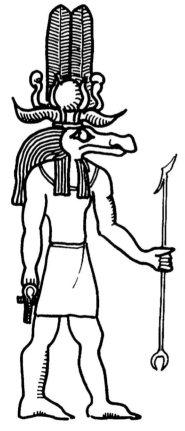

2.2 Sobek, the ancient Egyptian Crocodile God usually depicted in human form with a crocodile head, was associated with fertility and considered "Lord of the Nile."

and banished him to the darkness beneath Earth. Later, without Ophion's help, she made the first human, Pelasgus. Although this myth gives the snake a major, positive role in creating the universe, it creates distance between humans and snakes by banishing the snake before the creation of people, reflecting both our positive and negative perceptions of snakes.

Australian Aborigines believe that all of life can be traced to the Spirit Ancestors of an ancient sacred era known as the Dreamtime. These Spirits were part human, part other animal, such as crocodile, goanna (monitor lizard), turtle, snake, emu, or kangaroo. In the beginning, Earth was formless, dark, and silent. As the Spirits journeyed over the barren land, their meandering created waterways, valleys, and other topographical features. They urinated and formed lakes. When their creative work was done, these beings became the plants, animals, and landforms they had created, and they retain an intimate connection with Earth to this day. Because of this belief, many Australian Aborigines profess a duty to protect the land and all of nature.

Many Australian Aboriginal cultures tell stories in which Rainbow Serpent is a major Spirit Ancestor, as, for example, the story that introduced chapter 1. This water spirit, named for the resemblance between the shape of a rainbow and a snake, connects the water of Earth and sky. Depending on the particular story, Rainbow Serpent is depicted as either male or female. Another Rainbow Serpent sacred story says that long ago in the Dreamtime, Rainbow Serpent searched for his own people. As he twisted and slithered, his heavy body formed mountains and carved valleys, streams, and gorges. Each time he heard people, he crept close to their campfires and listened to their voices. One day he understood what they were saying.

"I am Rainbow Serpent," he announced. "You are my people." The people welcomed the snake into their tribe, and he taught them many things, including how to dance more gracefully.

One rainy day, two boys who had been out hunting ran into camp and begged for shelter. No one offered a dry retreat. Rainbow Serpent opened his mouth wide, resembling the entrance to a hut. The boys ran in, and Rainbow Serpent swallowed them. Rainbow Serpent left and slithered north.

When the people realized that Rainbow Serpent had eaten the boys, they followed the snake's tracks and found him asleep, coiled atop Bora-bunara Mountain. They slit open the snake's skin and freed the boys. A cold wind blew into Rainbow Serpent's mouth and woke him. When he saw his wound and found that the boys had escaped, he swished his tail and flicked his tongue, causing the mountain to break into pieces that formed the small mountains present today. Terrified, some people ran fast and remained people. Others transformed into other animals and hid in underground holes, hunkered under stones, or flew away. Rainbow Serpent filled the air with thunder, lightning, and flying boulders, and then slid into the sea, where he still lives today.

The goanna (monitor lizard), a Spirit Ancestor from the Dreamtime, is another large, powerful reptile. For Aborigines of the Bundjalung Nation in far eastern New South Wales, a tall hill known as Goanna Headland represents their mythological place of origin. Their story tells that long ago, Rainbow Serpent tormented a bird. As a powerful spirit, Goanna chased Rainbow Serpent across the formless land to punish him. As they ran, the two spirits created riverbeds, hills, and mountains. Aborigines of the Bundjalung Nation say that Goanna Headland is Goanna's body and that the patch of red on the hilltop reflects the wound inflicted when Rainbow Serpent bit Goanna.

Moving now to the other side of the world, the Navajo creation story is a journey of emergence from the underground First World of darkness, through successive worlds to the Fifth and present one. A powerful water serpent plays a major role in this sacred story, as he unleashed a flood that forced the people to move into the current world.

One version of the sacred story tells of three beings who existed in the dark First World: First Man, First Woman, and Coyote. Unhappy in that world, the three climbed into the Second World, where they found Sun, Moon, and other people. There, Sun tried to seduce First Woman. She refused, and Coyote advised everyone to climb into the Third World to avoid discord.

The Mountain People who lived in the Third World warned the newcomers that all would be well as long as they didn't disturb Tieholtsodi, the water serpent. Coyote did exactly as he was advised against—he went to the sea and found the serpent's children. They were so attractive that Coyote ran off with them. Angered, Tieholtsodi flooded the land. The people stacked the mountains of the four directions on top of each other and started climbing. The water rose and covered the first mountain, then the second and third. Huddled atop the fourth mountain, the people planted a giant reed that grew into the sky. Just as the water reached them, they climbed the reed into the Fourth World.

Once in that world, men and women each claimed to be the more important of the two. Unable to resolve their disagreements, the men left for four years. No one was happy. The women couldn't grow corn because they didn't know the proper corn-planting rituals. They had no meat, because they didn't know how to hunt. The men had no corn because, although they knew the corn-planting rituals, they had no idea how to cultivate corn. They hunted, but their teeth fell out from chewing raw meat because they didn't know how to cook. Men and women finally got back together, and many, many children were born the following year.

The good life was short-lived, however, because Coyote still had Tieholtsodi's children. Floodwaters from the Third World seeped into the Fourth. The water rose until the people once again stacked the four mountains on top of each other. Again they planted a giant reed atop the highest mountain, and they climbed into the Fifth World. The people ordered Coyote to return the children to Tieholtsodi. After he did,

the water serpent was pacified. Still they had a problem: too much water flowed in the Fifth World. After people prayed to the Darkness Spirit for a solution, the Spirit dug a ditch to drain the water. This drainage ditch still exists, now known as the Grand Canyon of the Colorado River.

People from divergent cultures tell that after they were created, large and powerful snakes led them to their homeland. In the mythology of the Desana from the northwest Amazon, Sun created the first people in the Underworld. He appointed a supernatural being to lead the people upriver to their present homes in a great canoe—an anaconda's body. The Kim, from Cameroon, say that they were led to their homeland by following a python's tracks.

Creator Strength

Turtles seem well designed to carry burdens on their backs, and because they symbolize strength and endurance, legends from many parts of the world tell of huge turtles that support islands, entire continents, or the world. An Indian myth has Earth resting on the backs of four elephants that stand on the shell of a giant tortoise named Akupara. If the tortoise gets too tired to support its heavy load, it will sink into the ocean. At that point, Earth will be flooded and destroyed. Turtles are creation figures for many first peoples, who refer to North America as Turtle Island and view the turtle as the oldest symbol for Earth, which it carries on its back. In Balinese mythology, at the beginning of time the only living creature was Antaboga, the world serpent. Through meditation, Antaboga created the world turtle, Bedawang. All other creatures came from Bedawang. Two snakes coiled on the turtle's back to form the world's foundation.

The Fon of West Africa have a myth telling how Python (Cosmic Serpent) carried the creator on his back as the creator made Earth. When they stopped each night, Python's excrement formed mountains. Fearing that Earth might sink into the ocean because the mountains added so much weight, the creator asked the snake to put his tail in his mouth and coil around Earth to support it. Python obliged, and the creator surrounded the snake with oceans to keep him cool. To this day,

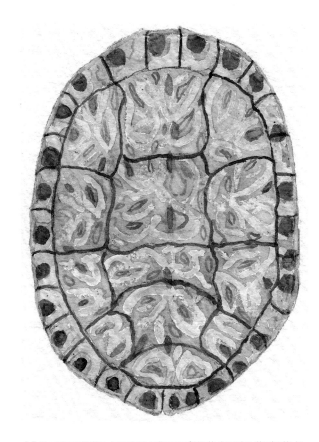

2.3 In various Native American cultures of North America, the turtle is believed to carry the yearly thirteen moons or lunar months on its back. Each of the turtle's thirteen central scutes on its carapace represents a lunar month associated with nature's seasonal cycles.

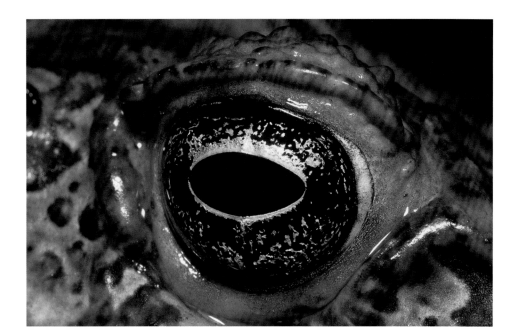

2.4 In folklore, frogs remind us that things aren't always as they appear. Small beings can overcome challenges and accomplish great feats. The glimmering golden eye of an "ugly," warty toad conveys achievement, value, wisdom, energy, and power. Pictured here is the eye of a cane toad, *Rhinella marina*.

whenever Python shifts his weight, he causes earthquakes and tidal waves. Python still sustains the world with 3,500 coils around Earth and 3,500 coils below Earth. His coils must not be loosened, for if they are, Earth will slide into the ocean and disappear forever.

Frogs also have supportive roles, despite their small size and innocuous aspect. Perhaps they have been viewed as powerful supports because of the seemingly supernatural nature of their transformation and "rebirth." According to an ancient Mongol story, in the beginning there was only ocean. One day when Buddha, Lord of the Universe, flew over the water looking for a way to create land, he saw a golden frog swimming. Buddha threw sand on the frog's back and created Earth. He shot the frog with an arrow. The arrowhead that passed through the frog's left side became an area rich in minerals. The shaft protruding from the frog's right side became forest. Fire that sprang from the frog's mouth created an area of fire to the north, and water that gushed from the frog's rear end kept the south as ocean. Earth still rests on the back of the golden frog, and earthquakes happen when the frog shifts position.

Central Asians tell a creation story that combines several key elements: earth diving, mud and water, and a frog that supports Earth. The creator god Otshirvani and his helper god, Chagan-Shukuty, spotted a frog in the water. Chagan-Shukuty caught the frog and flipped it onto its back. He dove to the bottom of the water, surfaced with some mud, and placed it on the frog's underside. The frog sank, exposing only the mud. Pleased, Otshirvani and his helper rested on the newly created Earth. While they slept, the Devil approached. Hoping to destroy the two gods and Earth, the Devil picked up the gods and ran toward where he assumed water to be. But the farther he

ran, the more Earth grew until finally the Devil dropped the gods. Otshirvani and Chagan-Shukuty awoke and praised the expanding Earth for saving them.

Amphibians and Reptiles as Our Ancestors

In some creation myths, amphibians or reptiles themselves are our ancestors. One unusual story is that told by the Wa, an ethnic group inhabiting Myanmar who consider themselves descended from tadpoles. As tadpoles the Wa spent their early years in Nawng Hkeo, a high-elevation lake. After they transformed into frogs, they lived on Nam Tao hill. In time the frogs became ogres and lived in a cave. They ate deer, wild pigs, goats, and cattle. As long as they ate only these animals, they had no offspring.

2.5 Tadpoles might seem unlikely human ancestors, but because they represent fertility and symbolize transformation and rebirth, they serve as ideal animals for the Wa creation story involving several transformations to reach the human form.

Eventually, two Wa roamed to a place where humans lived. They captured and ate a man and brought the skull to their cave. By eating the man, the Wa became fertile. They produced many ogrelets—all in human form. The parents taught their children that they must always have a man's skull in their settlements. And so the Wa became headhunters, believing that the skulls protected them against evil spirits.

The Kikori from southern Papua New Guinea say that in the beginning, there was only water and the Crocodile God. Crocodile gave birth to First Man and First Woman. Because there was only water, Crocodile allowed the couple to live on his back. In time they had so many descendants that there was no room left on Crocodile's back. He ordered them to leave. The only inhabitable places they found were islands made from Crocodile's dung. But all was well because the land was fertile and the fishing was superb. These dung islands became known as Papua New Guinea, the original home of all humankind.

Another sacred story from Papua New Guinea, from the Iatmul who live along the Middle Sepik River, tells of the saltwater crocodile's role in the creation of land and all living beings. As in the Kikori story, in the beginning the world was covered with water and the only living creature was Crocodile. After he created dry land, Crocodile made a crack in the earth—the first female. He mated with her, and from their union came all plants and animals, including humans.

The Andamanese, from the Andaman Islands in the Indian Ocean, tell stories in which First Man is a monitor lizard. In *The Way of the Animal Powers*, Joseph Campbell describes the monitor: "This large, prolific reptile can swim in water, walk on land, and climb trees, and was thus the obvious local candidate for the classic mythological role

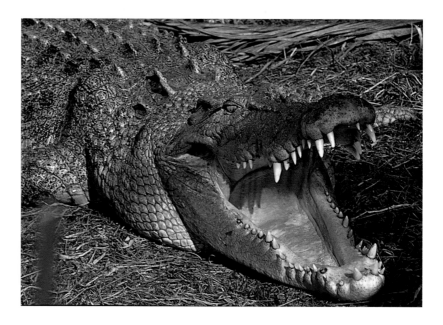

2.6 The Iatmul from Papua New Guinea still revere the crocodile's creative powers. As part of their male initiation ceremony, a saltwater crocodile (*Crocodylus porosus*) symbolically swallows the boys and regurgitates them as men. Each boy's skin is cut to represent crocodile tooth marks.

of master of the three worlds." In one story, as Sir Monitor Lizard was hunting for pigs in the jungle, he climbed a tree and got entangled by his genitals. Lady Civet Cat climbed the tree and freed Sir Monitor Lizard. The two married, and their offspring are the ancestors of the Andamanese. Sir Monitor Lizard is the Andamanese water monitor (*Varanus salvator andamanensis*), and Lady Civet Cat is the Andamanese palm civet, both found only on the Andamanese Islands. This story showcases two endemic animals and catapults them to the status of powerful entities—one's own ancestors.

You might be wondering how Sir Monitor Lizard got entangled by his genitals, when in fact male lizards have paired hemipenes that are stored, inverted, at the base of the tail. You don't see the hemipenes until they are engorged with blood and everted. Animals in myths don't have to reflect correct biological attributes, and they often have human characteristics. That's part of their mystique. The Aztec Earth Mother Goddess Tlaltecuhtli is depicted as a toad, yet she has hair. The Kikori Crocodile God gave birth to First Man and First Woman yet crocodiles lay eggs. So, why can't First Man monitor have external genitals that get entangled around branches? I like to think the myth's originator had an unconventional sense of humor.

In South America, the anaconda (*Eunectes murinus*), the Western Hemisphere's largest snake at about 25 feet (7.6 m), plays the ancestor role for various cultures. The Cubeo of Colombia say that they were the first people and were born from the Río Vaupés. They began as anacondas but became people when they shed their skins. The Cubeo feel a sense of uniqueness, power, and importance from their connection with the giant snake. Another Amazonian group views the anaconda as their mythological ancestor who swam up the Amazon River and vomited the first people onto land.

Second Stage of Creation: Destruction

Creation myths frequently include tales of destruction, second stages, or additional refinements of creation: re-creations. Destruction generally happens because the creator becomes disillusioned with people's behavior. Better to wipe the slate clean and start over. The instrument of destruction is frequently a flood. Often the creator designates one human—for example, Noah—to preserve life for post-flood re-creation. This flood hero might ride out the flood in a boat with a wife and pairs of animals. The fact that this motif is so widespread suggests that we have a common vision of our imperfections—and of our chance for redemption in a new beginning.

Frogs and snakes play major roles in destruction myths because they symbolize rebirth. The Chiriguano from southeastern Bolivia tell a story about the supernatural being Aguará-Tunpa who caused a torrential rain to drown the Chiriguano. The people placed two babies—a brother and sister—on a huge maté leaf, which they floated on the water. The rain continued, flooded all of Earth, and extinguished all fire. All the Chiriguano, except for the two babies, drowned. At last the rain stopped. Fish and other aquatic animals survived, but without fire the babies couldn't cook the

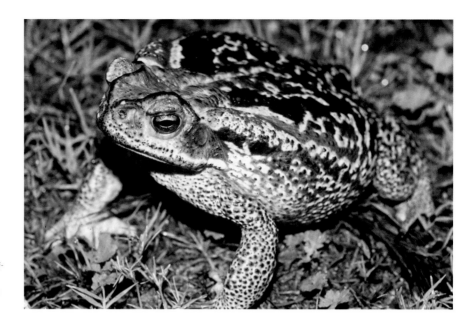

2.7 The rococo toad (*Rhinella schnei-deri*), found in southeastern Bolivia, might well have served as the model for the Chiriguano re-creation story.

animals for food. A large toad came to the babies' rescue. Before the rain had flooded the land, the toad had squeezed into a hole, taken some live coals, and had blown on them to keep them glowing. Once the rain stopped and the land dried, the toad left his hole and gave the babies the gift of fire. The babies roasted fish they caught and in time grew to adulthood. The present-day Chiriguano arose from the babies' incestuous union, thanks to the opportunity for re-creation afforded by the toad.

In Chile, the Araucanians have a story about a great flood that resulted when two huge serpents quarreled. As one snake kept raising the level of the floodwaters, the other kept raising the mountain that gave humans refuge. After the flood, the human survivors conceived offspring who became the ancestors of present-day Araucanians. The human population survived thanks to the benevolent snake.

Ancient Chinese myths tell of Fu Xi and his sister Nü Gua, snake spirits associated with the power of water. These beings had the lower bodies of snakes and the upper bodies of humans. A great flood wiped out the human race, but these deities survived the flood by floating in a gourd. Through primal incest, they restored the world and became the ancestors of all humankind. To restore the form of the cosmos, Nü Gua cut off a turtle's legs and used them as pillars at the four limits of Earth.

Amphibians and Reptiles as Bearers of Death

Amphibians and reptiles—especially frogs and snakes because of their association with rebirth—play roles in creation myths as bearers of death, another aspect of creation. A Yuma (United States) sacred story of death involves a struggle between good

and evil. In the beginning, when there was only water and emptiness, the creator arose from the water as twins. The evil twin Bakotahl caused sickness and imperfect creations, and he still aggravates the People. Kokomaht, the good twin, made First Man and First Woman. They were perfect and are the Yuma's ancestors. Kokomaht taught the Yuma how to live and procreate. Knowing that Frog was jealous of him and wanted to kill him, Kokomaht decided that death must be part of creation. He began the cycle by allowing Frog to suck out his breath. As Kokomaht lay down to die, he taught the People about death.

All across Africa, tales explain how death came to humankind. According to the Soko story from the Democratic Republic of the Congo, once the water covering Earth dried, plants appeared. The only animal on Earth was a toad. In the sky there was only the moon. The moon told the toad that he planned to create a man and a woman. The toad argued that since he lived on Earth and the moon lived in the sky, it was his— the toad's—prerogative to make the first people. The moon countered that his creations were everlasting and perfect, while the toad's creations would be short-lived. When the toad insisted, the moon warned that if the toad made man and woman, his creations would die and that he—the moon—would kill the toad. The toad followed through with his plan anyway, and indeed his creations were inferior. The moon descended, consumed the toad, and improved on the toad's creations by giving humans longer lives and greater intelligence. He taught them many things and gave them the ax, fire, and cooking pots, but he couldn't reverse the fact that they were mortal.

African folktales frequently blame snakes for humans' mortality. The Kono of Sierra Leone tell that the Supreme Being promised the first man, woman, and their baby boy that they would never die. Instead, when they grew old, they would just slip on new skins. He put these skins in a bundle and told Dog to deliver the skins to the first family. Dog set off on his errand, but along the way he joined a feast and left the bundle unattended. During the meal, he was asked what was in the bundle. Dog explained that he was delivering skins from the Supreme Being to the first family so that they would never die. Snake overheard the conversation. He slipped out from the feast, stole the bundle, and distributed the skins to other snakes. To this day, humans die and snakes live forever. Snake got his comeuppance, though. He was driven away from towns and must live alone. Worse, when people find snakes, they try to kill them.

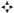

Similarities spring to mind from this brief selection of creation myths from around the world. Snakes sometimes play evil roles associated with floods and droughts; the animals must be overcome before life can exist. Some amphibians and reptiles are seen as powerful forces that formed Earth; others support Earth. We are at their mercy because they can cause natural disasters such as movements of Earth's crust and floods. In some stories, we depend on the animals for our well-being and exis-

tence. In others, they are the reason we die. These contrasting roles reflect our dual perceptions of amphibians and reptiles as positive and negative.

Similarities of myths repeated in geographically diverse parts of the world arise in part because stories are dispersed through human migration. But parallel stories also exist because of the common human experience—birth and death, joy and despair, health and sickness, comfort and fear. We all observe the sun and light of day, and the moon, stars, and darkness of night. We all try to comprehend the past and wonder about the future.

Another shared human experience is that we all live with other animals. Our observations of animals produce folklore themes repeated worldwide. Snakes shed their skins and represent rebirth. They coil and strike; venomous and constricting snakes can kill us. Snakes signify awe-inspiring creative energy and power. Crocodilians' bony scales form a protective armor; these reptiles are strong and invincible. Giant lizards claw the earth and modify land formations. Turtles dive to the bottom of waters, collect mud on their carapaces, and grow algal gardens on their shells; they mirror microcosms of a primitive earth. Tortoises are strong, capable of supporting heavy weights. Frogs are fecund, they transform, and they shed their skins; they symbolize fertility and rebirth, a second chance. Everywhere that humans share their environment with amphibians and reptiles, we acknowledge their powers through creation myths.

But why do some cultures incorporate amphibians and reptiles into their folklore in positive ways, whereas others give the same animals negative roles? Perceptions no doubt stem from the particular animals with which people interact. Some snakes are more threatening than others; some frogs and lizards are more attractive than others. I suspect that environments in which venomous or unattractive amphibians and reptiles are abundant are more frequently associated with folklore in which the animals play negative roles than environments in which the amphibians and reptiles are, for the most part, harmless and attractive. Such an in-depth, comparative analysis would be intriguing.

As I accumulated creation myths, I wondered how much an animal's role influences local people's current perceptions of the animals. Is a positive creation role necessarily associated with respect for the animal? Is a negative role necessarily associated with disdain? I considered a two-by-two matrix (positive vs. negative creation role by positive vs. negative human perception) and used snakes as protagonists. I found examples for each cell in the matrix, suggesting that folklore might or might not influence current perceptions. Nonetheless, if one gathered considerable anthropological data and performed a quantitative analysis, I suspect the two most frequently represented cells would be (1) positive creation role and positive perceptions and (2) negative creation role and negative perceptions. Following are four examples from my matrix.

One relationship is an animal that plays a negative role in a creation myth and

continues to generate bad feelings. Recall the creation myth from India, in which Vritra, a python, is perceived as evil because he swallowed all waters. Many Indians currently persecute and kill pythons out of fear and distrust or kill them for their skins or flesh, yet worship dangerous cobras because of their positive association in Hindu mythology with the gods.

A second possible relationship is an animal with a negative role in a creation myth that is respected by the local culture. In Tanzania, East Africa, the Wafipa tell of

2.8 Worldwide, amphibians and reptiles are seen as powerful creators: crocodilians, fierce and formidable; large snakes, strong and symbolic of rebirth; tortoises, capable of supporting heavy loads; frogs, fertile and symbolic of transformation. *Top left:* Orinoco crocodile (*Crocodylus intermedius*); *center left:* reticulated python (*Malayopython reticulatus*); *bottom left:* yellowfoot tortoise (*Chelonoidis denticulatus*); *right:* Malayan horned frog (*Megophrys nasuta*).

one day when the god Leza asked all the animals, "Who wishes never to die?" All the animals were asleep except for Snake, who responded, "I do!" For this reason, snakes gain renewed life every time they shed their skin. It was man's fault that he slept through the crucial moment. Nonetheless, one would think that the Wafipa might resent the snake. Instead, members of this culture believe in continuity of the spirit and that after their chiefs die they become snakes. Wafipa respect and revere snakes when they encounter them.

Third, an animal that plays a positive role in a creation myth might be revered. Recall that in Fon mythology, Python carried the creator on his back, made mountains, and supported Earth in his coils. Snake worship was widespread in Dahomey, West Africa, in the mid-1800s. Devotees watched over sacred pythons, and anyone who harmed or killed a python was severely punished. Many descendants of Fon captured for the slave trade live in the New World. Continuing reverence for the python is reflected in their modern-day spiritual and ritualistic beliefs. Many Fon in Africa still revere pythons.

A fourth possible situation is that even though an animal plays a positive role in a creation myth, the local culture does not revere the animal. Recall that in the Pumé creation story, a water serpent (presumably an anaconda) created Earth. Pei-Lin Yu, an anthropologist who lived among and studied the Pumé of southwestern Venezuela, found that they dislike all snakes. They have so many bad experiences with venomous snakes that they take no chances and kill every snake they encounter.

There is a fifth possible outcome, and I suspect this one is common. For many cultures, there is a disconnect between what people view as make-believe stories told by their distant ancestors and their existence in the twenty-first century. The creator animal is just another being in the environment, neither respected nor despised.

3

Snakes

"Good" or "Evil"?

The snake is always double: real and mythic, male and female, deity and demon, fire and water, circle and line, killer and healer, power and potential, the highest wisdom and the deepest instinct. It is good and evil, wisdom and its shadow, cunning. It is both the Yin and the Yang in an eternal, sacred, circular, slithering, weaving dance. It is god and devil, savior and enemy, life and death, creation and destruction, worm and dragon, cosmic and chthonic. The serpent tempted Eve and protected the Buddha. It is death, and it is immortality. It is sublime myth, and it is terrifying reality.
—DIANE MORGAN, *Snakes in Myth, Magic, and History*

Iridescence of gold, copper, blue, green, and purple caught my eye—a rainbow boa (*Epicrates cenchria*) on a sunlit log. My mind drifted between aesthetics and science. The colors of this snake rivaled the splendor of a *Morpho* butterfly or a golden-tailed sapphire hummingbird. Its iridescent sheen came from microscopic ridges on its scales—ridges that act as tiny prisms and refract the light into rainbows of color. As I admired the snake, I thought about how fortunate I was to be in this Ecuadorian rain forest, to have stumbled upon this treasure, and to be one of those rare persons who sees beauty in snakes.

As a kid, I begged my mother for permission to keep each garter snake I caught, but the answer was always an adamant *no*. I had more than my share of tadpoles, frogs, salamanders, and caterpillars, but no snakes. My mother so disliked snakes that she never would accompany me into the

3.1 The rainbow boa (*Epicrates cenchria*) has microscopic ridges on its scales that act as tiny prisms and refract the light into rainbows of color.

reptile house at the Pittsburgh Zoo. Years later, when I set off to Ecuador for field-work, Mom warned me, "Be careful of snakes." She never knew, because I never told her, that during that year I frequently handled venomous snakes. Fast-forward fifteen years, when she visited me in Costa Rica. One afternoon at my field site, I spied a spectacular green vine snake lazily draped around a branch. After I calmly announced its presence, Mom planted her heels and cautiously peered into the brush. After a few seconds, ashen-faced, she said she'd had enough. I knew then that if that attractive, harmless snake couldn't win her over, no snake could. Snakes are either appreciated for the aesthetic, anatomical, physiological, behavioral, and ecological wonders they are, or they are disliked out of fear or misunderstanding.

Perhaps more than any other animal, snakes engender the extremes of human emotions. Benjamin Franklin—one of the Founding Fathers of the United States, scientist, and inventor—was so impressed with the beauty and demeanor of rattlesnakes that he considered them the perfect emblem for America. The particular individual he described even had thirteen rattles, firmly united together—exactly the number of colonies united in America. In a letter published in the *Pennsylvania Journal* in December 1775, Franklin wrote under the pseudonym "An American Guesser":

> I recollected that her eye excelled in brightness, that of any other animal, and that she has no eye-lids. She may therefore be esteemed an emblem of vigilance. She never begins an attack, nor, when once engaged, ever surrenders. She is therefore an emblem of magnanimity and true courage. . . . [S]he is beautiful in youth and her beauty increaseth with her age.

In extreme contrast, naturalist Charles Darwin maligned a venomous snake from Brazil, probably a Patagonian lancehead (*Bothrops ammodytoides*), in *The Voyage of the Beagle* (1839):

The expression of this snake's face was hideous and fierce; the pupil consisted of a vertical slit in a mottled and coppery iris; the jaws were broad at the base, and the nose terminated in a triangular projection. I do not think I ever saw any thing more ugly, excepting, perhaps, some of the vampire bats.

Virtually every human culture, even those in areas where snakes are not found, has serpent symbols, reflecting our longtime fascination with these animals. Two of our modern-day snake symbols evoke the same meaning they did for our prehistoric ancestors. The ouroboros (also spelled uroboros or orobouros, from an ancient Greek word meaning "he who devours his tail") is depicted as a snake rolled into a circle with its tail in its mouth. The snake in this coiled position symbolizes eternity, continuity, the never-ending cycle of life and death, woman, the egg, and union between earth and sky. The second symbol, the serpentine *S*-shape, represents flowing, continuous energy. In this shape the snake represents phallus, arrow, and thunderbolt.

I have separated examples of human perceptions of snakes into "evil" and "good," but the categories are artificial. Many perspectives fall in between, and the extreme

3.2 The ouroboros, depicted as a snake with its tail in its mouth constantly re-creating itself, has long symbolized eternity in mythology and religion worldwide. The earliest evidence of this symbol is from ancient Egypt.

views often become interwoven to evoke simultaneous feelings of respect and hatred. We fear what we don't understand, as well as what we perceive as "evil." Snakes suffer on both counts.

For an in-depth analysis, see theologian James H. Charlesworth's book *The Good and Evil Serpent*. One thread running through the book is that perceptions of snakes have changed through time. For example, before Christianity the serpent generally represented power and divinity; after Christianity became established, it assumed an evil connotation. Another thread is that multiple perceptions exist simultaneously within cultures. For example, in the ancient Greek and Roman worlds, the snake represented evil and death (e.g., as expressed in mythology), but also life, health, healing, and rejuvenation (e.g., as in the Asclepian cult).

Snakes Are "Evil"

The view that snakes are evil goes back a long time. One of the first written references to snakes appears in Book 1 of the *Rig Veda* from ancient India. The snake appears as the demon Vritra, who swallowed all of the world's water and caused devastating droughts (see chapter 2). The story is one of good overcoming evil, as the storm god Indra kills Vritra and releases the water.

In ancient Egyptian mythology, serpents represent chaos. Apep, a huge serpent, leads the perpetual war of darkness against the forces of light. Every night the sun god Ra descends into the realm of serpents and demons, where Apep and his serpent warriors try to obstruct Ra's passage through the aquatic Underworld on his nightly 12-hour voyage. But each morning, the sun rising over the horizon reveals that Ra overcame the darkness demons, conquered Apep, and renewed the world. Other monstrous serpents, some with two heads at each end, live in the Underworld, creating a vision of terror for the ancient Egyptians, who believed that their spirits had to pass through the Underworld before they could reach the afterlife.

In traditional interpretations of Christianity, the serpent symbolizes evil, personified by the Devil. In the Genesis story, after God created Adam and Eve, he forbade them from eating of the Tree of Knowledge. A serpent in the garden tempted Eve to eat the forbidden fruit, which she shared with Adam. When God asked if they had eaten the forbidden fruit, Adam blamed Eve for giving it to him. Eve blamed the snake for tempting her. God cursed the snake: "Because you have done this, cursed are you above all cattle, and above all wild animals; upon your belly you shall go, and dust you shall eat all the days of your life." Some people point to the biblical story as "proof" that snakes are evil, and they believe that snakes have no legs as punishment for tempting Eve.

God said to Eve, "I will greatly multiply your pain in childbearing; in pain you shall bring forth children, yet your desire shall be for your husband, and he shall rule over you." To Adam, God said: "In the sweat of your face you shall eat bread till you

3.3 In Albrecht Dürer's engraving *The Fall of Man* (1504), the diabolical and seductive snake offers the forbidden fruit to Eve. (Engraving housed in the Allen Memorial Art Museum, Oberlin College, Ohio.)

return to the ground, for out of it you were taken; you are dust, and to dust you shall return." Some people take these words literally and believe that childbirth is painful and that we die because of God's punishments—all the snake's fault.

At the time Christianity developed, many people in the Middle East worshipped snakes. Because Christian monotheism forbids worship of additional gods, proponents of Christianity tried to stop the idolatry. One effective means was by portraying snakes as evil, such as in their negative role in life after death. The church taught that the dead are rewarded according to their behavior on Earth. During the Middle Ages, preachers described Hell as a place of torture, fire, eternal suffering—and snakes. One story claimed that a young girl who had repeated her mother's bad behavior saw her mother in Hell. Flames penetrated her naked body and exited through her mouth.

Snakes pierced their fangs into her cheeks, lacerated her face, and wriggled out from her breasts. Not a place one would choose to spend eternity.

Writers and poets, people positioned to influence others, have long maligned snakes. Consider, for example, words of the Latin poet Aelian, who writes *On the Characteristics of Animals* in the second century CE:

> The spine of a dead man transforms its putrefying marrow into a snake. This snake emerges, the most ferocious of all beings born from the most gentle. I should say, even so, that good people go to their rest undisturbed, while those who have done evil suffer this strange fate. This all may be a fable; I do not really know. But it seems to me fitting, if it is so, that a bad man should give birth to a snake in this way.

Eighteen centuries later, ornithologist Alexander Skutch offers a similar perspective of snakes. He killed most he encountered because they ate birds, including the nestlings he so loved to watch. In *A Naturalist on a Tropical Farm*, Skutch writes:

> The serpent is stark predation, the predatory existence in its baldest, least mitigated form. It might be characterized as an elongated, distensible stomach, with the minimum of accessories needed to fill and propagate this maw—not even teeth that can tear its food. It crams itself with animal life that is often warm and vibrant, to prolong an existence in which we detect no joy and no emotion. It reveals the depths to which evolution can sink when it takes the downward path and strips animals to the irreducible minimum able to perpetuate a predatory life in its naked horror. The contemplation of such an existence has a horrid fascination for the human mind and distresses a sensitive spirit.

Folklore worldwide portrays snakes as villains to be dispatched. In Greek mythology, Typhon—a 100-headed creature whose lower body is a serpent—destroyed cities and tore up mountains, hurling them at the gods during fits of rage. At first the Olympian gods fled in fear. Finally Zeus, King of the Gods, threw lightning bolts and pinned the monster under Mount Aetna, where he remained alive, belching smoke, fire, and lava. The ancient Greeks believed that Typhon's writhing movements caused volcanic eruptions, earthquakes, and tidal waves.

Being somewhat oversexed, Zeus often visited Earth to seduce or rape mortals. Hera, Queen of the Gods and Zeus's wife, resented her husband's extramarital exploits. She hated her illegitimate son, Heracles (Hercules in Roman mythology), Zeus's son by a mortal woman. When Heracles was an infant, Hera arranged for two huge snakes to be put into the bastard's crib, assuming they would kill him. Instead, Heracles strangled the snakes with his bare little hands. Hera continued to make Heracles' life miserable. Finally, driven mad by Hera, Heracles threw his three sons into a

3.4 Brown thrashers aggressively defend their nests from intruders and predators. In 1829 John James Audubon witnessed a large black snake menacing a thrasher nest and re-created the scene in this well-known painting, part of *The Birds of America*.

fire and killed them. To atone for the crime, he served his rival half-brother, King Eurystheus, for twelve years and carried out twelve labors. His second labor was to kill the Lernaean Hydra, a nine-headed water serpent that grew two heads for each one cut off. The eleventh labor was to kill the 100-headed, immortal serpent-like dragon that guarded the golden apples in the Garden of Hesperides. Heracles' final labor was

to kill Cerberus, the three-headed dog draped with venomous snakes that guarded the entrance to the Underworld to prevent the living from entering and the dead from escaping. The fact that three of Heracles' punishments were associated with snakes suggests the power and fear that snakes held for the ancient Greeks.

And, of course, there was Medusa. Poseidon, the sea god, raped a lovely young girl named Medusa who had golden hair flowing in ringlets. The desecration happened in Athena's temple, and Athena was furious. Because Poseidon had already fled, Athena directed her vengeance toward the victim and transformed Medusa into a monster: her hair became living venomous snakes, her body was covered with scales, and her teeth were boar-like tusks. She would never again attract a lover, and anyone who looked at her would turn to stone.

In the Norse story "Ragnarok" ("Doom of the Gods"), the World Tree, an ever-green ash called Yggdrasil, structured and supported the universe. Its fresh, green leaves spread over Earth, its roots extended into the Underworld, and its branches reached into the heavens. The tree, a symbol of order, nourished and guarded all of creation. All was not well, however, for deep in the earth a serpent named Nidhogg gnawed at the tree's roots. The serpent's attempt to destroy the World Tree represents its desire to reintroduce chaos into the universe. Midgard, a terrible sea serpent, lay coiled around Earth, waiting for the hour of doom. As evil prevailed and good vanished, the gods prepared to die. Nidhogg severed the tree's roots. Although Thor, the thunder god, killed Midgard with his sword, Thor died from venom vomited by the expiring serpent. Earth sank into the ocean.

Following complete destruction, Earth arose from the ocean a second time. The gods arose from the dead, and a brighter sun shone upon the new world. Nastrand ("strand of corpses"), the new Hell, was a huge cave whose walls were formed of snakes, venom flowing from their fangs. As the wicked waded through venom, fangs pierced their hearts. The serpent Nidhogg fed on corpses of the damned.

In Japanese folklore, the serpent is generally depicted as a wise creature that helps humans, in contrast to its usually evil portrayal in Western folklore. Nonetheless, some Japanese myths portray the snake as evil, such as the huge eight-headed serpent Yamata-no-orochi that demanded regular sacrifice of virgins. In one version of the story, the trickster god Susano-o disguised eight jugs of sake to resemble women—eight daughters from the ruling clan who were next in line to be sacrificed. Thinking they were the virgins he had demanded, the serpent devoured all eight jugs. Once all eight heads became drunk, Susano-o severed the creature's heads and saved the virgins.

Because snakes' eyes are always open, they have long been associated with vigilance. In mythology snakes are often portrayed as villains that are left to guard treasures or secrets that others desire. In the Greek myth "Jason and the Golden Fleece," Jason must retrieve the stolen magical ram's golden fleece before he can claim his rightful throne. The catch: a sleepless giant serpent-dragon guards the fleece. With a

3.5 Dragon, serpent, and serpent-dragon are often used interchangeably in folklore. *Top:* welcoming golden dragons at a Buddhist temple in Thailand; *bottom:* dragon on a tomb in Guangxi, China.

little help from his friends, Jason showers the beast with an herb-based potion, which causes the creature to fall asleep, allowing Jason to seize the fleece. Hindu mythology tells of Nagas (cobras) that guard treasure in underground lairs or at the bottom of rivers, lakes, or wells. Mythology of northern Spain has giant winged serpents called Cuélebres that guard treasure in caves. Urcaguay, the Incas' serpent god of the Underworld, also guards treasure in a cave. All of these are "evil" serpents.

"Dragon" and "serpent" often are used interchangeably in mythology and literature, or the creature is described as a "serpent-dragon," such as the creature that guards the golden apples of Hesperides. In the Old English epic poem *Beowulf*, the hero slays the dragon that has been terrorizing the realm because a slave stole a golden cup from the dragon's lair. In J. R. R. Tolkien's fantasy *The Hobbit*, Bilbo Baggins seeks to uncover treasure guarded by the dragon Smaug. Norse mythology tells

of a serpent-dragon named Fafnir who guards gold. Siegfried slays the creature and steals the treasure. Richard Wagner's "Ring" cycle of operas, which features an evil serpent-dragon, is based loosely on this Norse mythology.

Ireland has no snakes and never did, because of its geographical location and glacial history. Nonetheless, the Irish tell tales regarding the absence of snakes in their homeland. According to one legend, the Gaels migrated to Ireland from Scythia, a region that probably included southeast Europe and adjoining parts of Asia. When one of their remote ancestors, Gaodhal Glas, was a child, he was cured of a venomous snakebite and promised that no serpent or other venomous creature would live on the island that his future descendants would someday inhabit.

Better known is the legend of St. Patrick, which claims that Ireland has no snakes because during the fifth century CE, a Christian named Patrick chased all the existing snakes into the sea. Supposedly, snakes attacked him while he was absorbed in a 40-day fast atop a hill. The legend is an allegory, in which snakes represent early pagan faiths, including snake worship brought to the island by invading peoples and traders. In various Celtic religions, the snake was a symbol of rebirth, knowledge, and healing. In contrast, Christianity demonized snakes.

Patrick was born in late Roman Britain about 389 CE. When he was sixteen, Irish raiders took him as a slave to Ireland. Patrick escaped after six years and returned to Britain. After religious study in France, Patrick returned to Ireland. Presumably his exposure to Irish pagan religious practices drove him to convert the Irish to Christianity. Although Patrick did not literally chase snakes from Ireland, he did chase away the symbolic snakes. In fact, he did such a good job of converting the Irish to Christianity that most pagan beliefs died out.

Even children's literature portrays snakes as villains. One nineteenth-century example is "Rikki Tikki Tavi," Rudyard Kipling's short story in *The Jungle Book*. Rikki Tikki Tavi, a brave young mongoose, saves a British family from the cobras Nag and Nagaina, which are planning to kill the humans and take over the garden. The mongoose dispatches the snake couple and destroys their eggs by biting off the tops and crushing the baby cobras. All ends well, as no other cobras dare enter the garden. The story's message: the triumph of good over evil.

A recent example of "evil snakes" in young adult literature is in the Harry Potter fantasy series by J. K. Rowling, about good wizard Harry Potter's quest to overcome his archenemy Lord Voldemort, the dark wizard. To become stronger, Voldemort milks his pet snake, Nagini, and drinks her venom. The stronger and more powerful that Voldemort grows, the more snake-like his features become—a flat nose with slit nostrils and snake-like pupils. He speaks Parseltongue (snake language), an ability long associated with dark wizards. Rowling represents the Slytherin House, which produces the largest number of dark witches and wizards, as a serpent. Evil seems to lurk everywhere in the wizarding world in the guise of a snake.

It seems appropriate to end this section with one explanation of why snakes

and humans don't get along. Aesop, the semi-historical Greek figure who won his freedom from slavery by telling fables, told a story about a snake biting a farmer's son and killing him instantly. The anguished father takes an ax to the snake, hoping to kill it. Instead, he merely amputates the tip of its tail. Terrified, the farmer tries to appease the snake with cake and honey. The angry snake hisses that there can never be friendship between the two because every time he looks at his tail he will be in pain and every time the farmer looks at his son's grave he will also be in pain. The moral: One cannot put aside thoughts of revenge as long as he sees a reminder of his pain. To this day, snakes and humans are enemies.

Fear and the Perception of Evil

No doubt humans have always feared snakes because some can kill us. Fear and perception of evil are tightly interwoven. A 2001 Gallup poll of adult Americans revealed that their greatest fear wasn't the dark, flying in an airplane, the boss, or lightning, but snakes. Fifty-one percent of Americans said they were afraid of snakes—a fear dubbed "ophidiophobia." Second was public speaking, with 40 percent. For people with severe ophidiophobia, the sight of a snake causes panic, cold sweat, and nausea. From the standpoint of risk, Americans' fear of snakes is unjustified. A study by Lilly Bellman and colleagues reported that from 1979 to 2005, an average of 5 people in the United States died from venomous snakebite each year. Eighty percent of the victims were males. Many cases involved alcohol, delayed treatment (often by owners of venomous snakes who feared losing their pets), or refusal of treatment (usually religious snake-handlers). In contrast, about 33 Americans die every year from being mauled and bitten by dogs, sometimes their own pets.

In many other parts of the world, people have good reason to fear venomous snakes. During monsoon season in India, snakes seek higher ground and come into more frequent contact with people; the result is an estimated 40,000 people dead from venomous snakebites per monsoon season. Across the world—mainly in Africa, southern Asia, and in Central and South America—an estimated 5 million people are bitten by venomous snakes each year. Of those, over 94,000 are likely to die; another 400,000 will have limbs amputated or otherwise be permanently disabled.

In *Green Hills of Africa*, the intrepid Ernest Hemingway, hunter of big game, admits to having ophidiophobia. One evening, eager to return to camp and the awaiting hot bath and whiskey, Hemingway and his safari buddies bushwhacked across the mountainside instead of retracing the trail they had taken earlier. Hemingway writes: "So in the dark, following this ideal line, we descended into steep ravines that showed only as wooded patches until you were in them, slid down, clung to vines, stumbled and climbed and slid again, down and down, then steeply, impossibly, up, hearing the rustle of night things and the cough of a leopard hunting baboons; me scared of snakes and touching each root and branch with snake fear in the dark." At camp

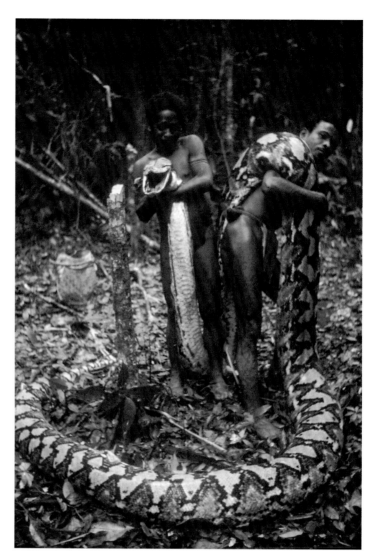

3.6 During a 1960s-1970s study of the hunter-gatherer Agta Negritos from Luzon, Philippines, anthropologist Thomas Headland found that the people were frequently attacked by pythons. Some Agta escaped with bites; others were eaten. Adult male Agta averaged about 91 pounds (44 kg); female reticulated pythons can weigh 165 pounds (75 kg). At nearly 60 percent the mass of a large female python, an adult male Agta is not a particularly large meal by python standards, whose prey include 130-pound (59 kg) pigs. The freshly killed reticulated python pictured here in 1970 with two Agta men measured 23 feet (7 m) in length, with a 26-inch (66 cm) circumference. Whenever the opportunity arises, the Agta turn the tables on the snakes and eat them.

Hemingway tells his buddies: "I'd be as scared of snakes if we did it every night for a year. . . . They scare me sick. . . . They always have."

Hemingway was in good company. Many well-known people have confessed an intense fear of snakes. Although Albert Schweitzer avoided stepping on insects, the good missionary doctor killed snakes that crossed his path. Marjorie Kinnan Rawlings, author of *The Yearling*, was so terrified of snakes that even looking at a picture of one gave her "the all-overs." She eventually overcame her phobia while on a collecting trip with herpetologist Ross Allen. In an essay entitled "The Ancient Enmity," Rawlings writes: "I took the snake in my hands. It was not cold, it was not clammy, and it lay trustingly in my hands, a thing that lived and breathed and had mortality like the rest of us. I felt an upsurgence of spirit." Once back home in Cross Creek, Florida, Rawlings said that she had done battle with a great fear, and that victory was hers.

The film industry plays on our fear of snakes. *King Cobra* (1998) features a snake—half king cobra, half eastern diamondback—that terrorizes residents of a small California brewery town during their beer festival. In *Venomous* (2001), snakes that have been genetically altered to deliver a lethal virus survive a terrorist attack, escape, and threaten a town in the Mojave Desert. *Boa vs. Python* (2004) stars a huge, deadly python that takes over a sewer system. An FBI agent enlists a giant boa constrictor, implanted with a computer chip in its brain, to kill the python. *Snakes on a Train* (2006) features a Mexican woman cursed with a litter of flesh-eating snakes in her belly. She boards a train to Los Angeles to visit a Mayan shaman who can remove the curse, and of course snakes escape on the train. In *Snakes on a Plane* (2006), hundreds of venomous snakes are released on a plane in hope that they will kill a trial witness before he takes the stand against the killer. Predictably, the snakes don't discriminate among the passengers, whose Hawaiian leis have been sprayed with a pheromone to make the snakes aggressive. *Vipers* (2008) features scientists using venomous snakes to develop a cure for cancer. When the vipers escape from the laboratory, all hell breaks loose. The plots differ, but the message is similar: Snakes are out to kill us.

Fear of snakes can make men think twice about peeing in the bushes. In *Snakes in Myth, Magic, and History*, Diane Morgan writes that in Austria a pervasive stench of urine surrounded local rest stops and highway restaurant parking lots. Rather than walk a few extra steps to use free toilets, men peed in the bushes. In desperation, officials placed signs in German, Polish, Czech, and English: "BEWARE! MORTAL DANGER! SNAKES!" accompanied by a cobra image. A roadway restaurant manager is quoted as saying, "We tried other signs, but they were useless. These signs, though, have really worked. You see men coming up to bushes, getting ready to have a pee and then quickly zipping up their trousers again when they see the signs."

Fear and dislike of snakes lead people to blame the animals for all sorts of bad things that happen—even Ebola hemorrhagic fever, a deadly disease caused by a virus spread by human-to-human contact. In 2014 West Africa experienced the worst outbreak of Ebola yet to date. In a remote village of Sierra Leone near the border with Guinea, the story is told and retold that a lady had a snake in a bag. Someone opened the bag, and the lady died. Someone else opened the bag, and that person died. The snake escaped into the bushes, and the rest is history: Ebola is an evil snake and kills everyone who looks at it.

Fear and hate often translate into killing. Many Australians (like many people elsewhere) consider every snake a threat and embrace the mind-set that "the only good snake is a dead one." When they try to kill snakes, people get bitten. Patrick Whitaker and Richard Shine distributed 1,000 questionnaires to determine when, where, and how people respond when they encounter two large, diurnal, venomous snakes—eastern brownsnakes (*Pseudonaja textilis*) and common blacksnakes (*Pseudechis porphyriacus*)—in an agricultural landscape in New South Wales, Australia. One hundred thirty-eight people responded that they had encountered at least

one of these venomous snakes within the previous year. About half of these people approached the snake, and 37 percent of the encountered snakes were killed, most beaten with a spade, shot, or run over with a vehicle. People were at least 20 times more likely to advance toward one of these venomous snakes as a snake was to ad-

3.7 Snakes are different from us. They have staring eyes, forked tongues, and two penes (each called a hemipenis). They can eat prey much wider than their heads, and they swallow prey whole. Some have faces that many people perceive as "mean." *Top left:* blackneck garter snake (*Thamnophis cyrtopsis*); *top right:* red-necked keelback (*Rhabdophis subminiatus*); *bottom left:* eastern hog-nosed snake (*Heterodon platirhinos*) eating a toad; *bottom right:* eyelash viper (*Bothriechis schlegelii*).

vance toward a person. A person was 100 times more likely to attack a snake than a snake was to attack a person.

Why are people so afraid of snakes? We fear what we don't understand, and snakes are different from us. They don't have arms or legs; they slither. Snakes don't chew their food; they swallow prey whole, and they can eat prey that are much wider than their heads. They lack eyelids. They don't blink—they stare. Snakes have forked tongues and two copulatory organs. They have no voice, though they can hiss. Snakes show no facial emotion. They cannot smile, laugh, wink, or sigh. They shed their skins. Snakes are secretive and unpredictable, suddenly appearing and disappearing out of nowhere. They lurk in the shadows and then strike. Some venomous snakes can kill their prey in less than an hour, and large constrictors can squeeze the life from a deer or pig. Most people have never touched a snake and assume they are slimy. Snakes are cold to the touch, but they most definitely are not slimy.

Which plays a bigger role in development of fear: nature or nurture? Scientists have considered this question for over 200 years. Some have argued that evolution shaped the primate brain to include a built-in snake detector, and that because it is difficult to distinguish between venomous and harmless species, natural selection favored individuals who avoided all snakes. On the other hand, children younger than about five years neither fear nor love snakes. They simply wonder—unless they are taught to be afraid, either verbally or by watching other people's body language or emotional response. At three years old, Fionna matter-of-factly informed me that there are two kinds of snakes: "The little skinny ones are nice. The big, fat, juicy ones can bite." After about the age of five, many kids begin to fear snakes. Researchers suggest that humans learn very quickly to fear snakes, and peer pressure reinforces the response.

Experiments reveal mixed results regarding whether fear of snakes is innate or learned in non-human primates. Some studies suggest that fear of snakes is acquired through experience. For example, Susan Mineka and her colleagues found that wild rhesus monkeys were terrified of snakes, whereas monkeys born in captivity showed no fear of them. Once the naive captive-reared monkeys watched wild-caught relatives react to snakes, however, they immediately feared snakes. In contrast, some studies argue that monkeys have an innate fear of snakes. Gordon Burghardt and his colleagues tested the reaction of adult captive Japanese monkeys that had to reach in front of a snake cage to get food. Even though they had never seen a snake before, many of the monkeys were terrified. Other studies reveal that vervet monkeys from Africa innately recognize dangerous snakes—and they respond appropriately. In response to pythons and venomous snakes such as cobras and mambas, vervets give a characteristic alarm call that researchers term a "chutter," which warns nearby vervets of the danger. Presence of harmless snakes does not elicit the chutter.

As a final phenomenon that reflects our fear and perception of snakes as evil, consider the "reptilian" cult. A subculture of people believe in the existence of shape-

shifting creatures called reptilians (also called reptoids or draconians). Reptilians generally are envisioned as half snake, half human, and they are thought to have come from the Alpha Draconian star system. These bipedal 5- to 9-foot (1.5–2.7 m) creatures are said to be covered with green or greenish-brown scales. Their mouths are wide and lack lips, and they have no teats or navels. Reptilians live in underground bases. They drink human blood.

David Icke, a lead conspiracy theorist, claims that reptilians have controlled Earth for centuries by assuming human form to gain political power and manipulate societies. Icke contends that most politicians—including George Washington and over 40 other U.S. presidents, as well as the entire British Royal Family—are direct reptilian-lineage descendants. Conspiracy theories concerning reptilians have supporters in 47 countries. Perhaps reptilians are a contemporary version of the mythological Nagas from India—creatures whose bodies were often depicted as half cobra, half human (see later in this chapter). Whereas Nagas were believed merely to cause earthquakes and volcanic eruptions, reptilians control Earth—another example of an evolving myth.

Fear of snakes doesn't necessarily translate into a perception of them as evil, of course. Many people who are afraid of snakes are also fascinated by them and appreciate them from a safe distance. My mother notwithstanding, many people who fear snakes stand in front of glass enclosures in serpentaria, mesmerized while watching the animals.

Snakes Are "Good"

Many people admire and respect snakes for their perceived powers to provide and protect, as evidenced by widespread use of snake "bodyguards"—amulets, charms, and talismans. Amulets protect their owners from harm, evil forces such as witches and sorcerers, or disease. Charms bring good luck, cure illness, heal injuries, and convey other benefits. Talismans both protect against negative forces and attract good fortune. Egyptian Pharaohs often wore headdresses with emblems of rearing cobras (called the *Uraeus*)—regarded as a badge of divinity and royalty but also credited with power to destroy enemies. Archaeological work has revealed an abundance of snake jewelry from ancient Greek and Roman times, when snakes represented beauty, protection, and comfort. Grecian women wore snake-shaped bracelets to ward off illness. Modern-day Arabs wear snake bodyguards to bestow strength to men and fidelity to women. Around the world, people still wear snake bodyguards to heal, bring good luck, and ward off evil.

Although the snake represented the Devil in traditional Christian faith, some Gnostic sects honored the snake. Instead of viewing the snake as an evil seducer that led Adam and Eve into sin, these religious groups saw the serpent as a liberator that brought knowledge to the first human couple by encouraging them to eat fruit from

the Tree of Knowledge. By gaining knowledge, Adam and Eve became truly human.

Legends tell of evil snakes guarding treasures and secrets, but snakes also served as benevolent guardians. Ancient Egyptians pictured the Nile as originating in a great cave where the river's guardian spirit, a serpent, lived. In ancient Greek and Roman civilizations, the snake guarded healing knowledge. Ancient Greeks also believed that spirits in the form of snakes guarded and protected every structure or locality, from man-made walls, doors, and hearths, to trees, rivers, and mountains. In the ancient Near East, archaeologists have uncovered many vessels used to hold water, milk, or wine that had snakes carved on the lids, symbolizing protection.

Snakes also are believed to guard people. The ancient Romans' guardian spirits, genii, assumed the body form of snakes. Thus, Romans encouraged snakes in their homes and fed them. In ancient Greece, serpent genii were human males' guardian angels. The serpent spirit sprang into being when a baby boy was born, stayed with him in life, and died with him. These spirits carried men's prayers to the gods and interceded for them. To show appreciation, men offered wine, flowers, and incense to their genii on their shared birthdays. The Montol of northern Nigeria allow non-venomous snakes to live in their homes in the belief that a snake is born every time a human baby is born—both of the same sex. If the snake is killed, the person dies at the same time. Zulu believe that every man is helped and guarded by an ancestral spirit, an *ihlozi*, in the body of a snake. In Burkina Faso, pythons are revered as village guardians. People in India welcome non-venomous snakes into their homes because snakes bring good fortune; saucers of milk are left for resident snakes as thanks for watching over human babies.

Many people consider snakes to be prophetic. In fact, the words for "divination" in Hebrew, Arabic, and Greek also denote serpent. Cultures around the world have long believed that snakes reveal the will of the gods. Ancient Greeks sought oracles from snakes kept in their temples. In New Guinea, the Tami regularly consult snakes, thought to be prophetic ancestral spirits. The Nandi of East Africa

3.8 Snake charms, such as this one from Japan, are valued by people worldwide for attracting good luck.

3.9 Whether or not snakes are guardian spirits, these reptiles play a major role in ecosystems by controlling rodent populations. Pictured here is a captive eastern diamondback rattlesnake (*Crotalus adamanteus*) dispatching a mouse.

believe that if a snake climbs onto a woman's bed, it is an ancestral spirit come to reassure her that her next child will be born safely.

Snakes are associated with wisdom. After all, they know the secrets of life and death, and their assumed immortality implies they've accumulated wisdom over a long time. The biblical serpent was identified with wisdom, when it lured Eve with the promise of forbidden knowledge. The ancient Persian mythical creature Shahmaran (in Farsi, *shah* means "king," and *mar* means "snake.") is half woman, half snake. Her human upper half is venomous, but her snake lower half is full of wisdom. Various ancient gods and goddesses associated with wisdom were affiliated with snakes. The Minoan Snake Goddess, source of all wisdom, held a snake in each hand. Athena, Greek goddess of wisdom and learning, often was depicted with a large snake as a symbol of her knowledge.

Other benevolent gods and goddesses are associated with snakes. Isis, Egyptian goddess of life and healing, was often depicted as an upraised cobra with hood ex-

tended, or as part snake, part human, holding a cobra in one hand. The Egyptian god Thoth, source of all wisdom and god of health, was sometimes symbolized as a serpent; in other representations he leans on a stick encircled by a snake. The Buddhist goddess Benten, associated with music, has snake attributes. People left offerings of eggs in her shrines, because snakes were believed to be fond of sucking eggs. Manasa, a Hindu snake goddess depicted as a human female covered with snakes, or as a cobra, was worshipped for her protection from and cure of snakebites. She also was associated with fertility, so childless women requested her blessings. Some ancient Japanese sea gods were depicted as water snakes. White (albino) snakes still hold special significance for the Japanese and are venerated as messengers of the gods. The Menominee from North America considered rattlesnakes sacred and symbolic of their gods. Worldwide, many agricultural fertility gods and goddesses are associated with snakes.

Nagas played a prominent role in ancient Hindu mythology. Depicted either as cobras or as half cobra, half man, Nagas lived in rivers, pools, and water beneath Earth's surface. Most Nagas were considered demons that caused droughts, earthquakes, volcanic eruptions, and high winds and tides. Some, however, were worshipped because of their positive association with the gods. For example, Shesha, a 1,000-headed snake, accompanied Lord Vishnu, one of the three aspects of the Hindu Supreme Being. Symbol of the earth, Shesha supported the world on his heads as he cradled the resting Vishnu.

Vasuki, Shesha's brother, is another good Naga. In Hindu mythology, the gods and demons constantly fought with one another to dominate the world. When the gods appealed to Vishnu for strength, he told them to join forces with the demons to recover the Elixir of Immortality (the nectar that gave the gods everlasting life), lost during the deluge that had destroyed the first world. Together, they should collect samples of all of the world's plants, throw them into the cosmic Milky Ocean, and churn the ocean to release the elixir. They should use Mount Mandara for a churning rod and wrap the serpent Vasuki around the mountain for a rope.

As part of his role as protector of life, Vishnu assumed various forms called avatars, or incarnations, to fight the evil forces that threatened the world's balance. In this particular fight, Vishnu transformed into Kurma, a huge tortoise. Kurma dove down and supported Mount Mandara on his back, his carapace serving as a base and pivot for the churning activity. After 1,000 years of churning, thanks to the teamwork of the tortoise and the serpent, the precious objects that had been lost in the flood appeared at the surface of the Milky Ocean: among others, the moon, the cow of plenty, the goddess of wine, and the Elixir of Immortality.

Shiva, the Hindu god associated with death and destruction, was also worshipped as the god of fertility and was associated with the *lingam* (Sanskrit for phallus). Hindus celebrated and worshipped the *lingam*, which represented male creative energy. Depending on the depiction, Shiva wore from one to three snakes, Vasuki always

3.10 Two venomous snakes commonly handled by members of some Pentecostal churches in the United States include the copperhead (*Agkistrodon contortrix*; *top*) and the timber rattlesnake (*Crotalus horridus*; *bottom*).

coiled around his neck. The snakes denoted wisdom and eternity, protected Shiva, and conveyed the message that the god controlled death.

Various cultures have used snakes in religious ceremonies. One of the more unusual is snake-handling, an integral part of some Pentecostal churches in the southeastern United States, in which congregants handle copperheads and timber rattlesnakes (and, less often, cottonmouths) as a test of their faith. Snake-handling began in 1909 in Grasshopper Valley, Tennessee, when farmer George Hensley felt the call to test verses 17–18 in the sixteenth chapter of Mark: "And these signs shall follow them that believe: In my name shall they cast out devils; they shall speak with new tongues; They shall take up serpents; and if they drink any deadly thing, it shall not hurt them; they shall lay hands on the sick and they shall recover."

Hensley caught a large rattlesnake and found it easy to handle. He took it to church, where he convinced other congregation members to prove their faith by

handling the snake. The cult soon spread to other churches in the area. By 1934 snake-handling had spread to Kentucky, where Holy Roller sects added the practice to their rituals of healing by the laying on of hands and speaking in tongues. Snake-handling continues to this day, mostly in Ohio, Kentucky, Tennessee, Alabama, Georgia, northern Florida, and West Virginia. Alabama, Kentucky, and Tennessee have outlawed the practice, but religious snake-handling is legal in West Virginia.

In *Them That Believe*, Ralph W. Hood Jr. and W. Paul Williamson describe a typical two- to three-hour church service. After congregation members greet one another, they pray in unison. One person begins to sing, and soon others strum guitars, beat drums, clash cymbals, and shake tambourines as they clap and praise God. Someone approaches the pulpit, opens one of the wooden boxes, and removes a snake. Other believers remove additional snakes from their wooden boxes and pass them among those who feel the call to participate. People hold multiple snakes and dance with the snakes, shaking them as they leap up and down, seemingly daring the snakes to bite. As part of the "drink any deadly thing," participants sip poisonous liquid (commonly strychnine or carbolic acid) from a mason jar located on the pulpit. The congregants worship God in solitude and reverence, and then administer to the sick and spiritually needy through prayer and the laying on of hands. Afterward, congregants offer songs, personal testimonies, and extemporaneous sermons.

Fatal bites occur during the snake-handling rituals, but less often than one might expect. Between 1930 and 2006, there were 89 incidences of deaths to religious snake-handlers reported in the United States. Skeptics, of course, wonder why there are not more fatalities. People familiar with the churches claim that most of the snakes used are freshly caught and have not been altered in any way. The continual passing of a snake from hand to hand might disturb the animal so much that its normal defensive behavior shuts off. Furthermore, the timber rattlesnake is one of the more mild-tempered rattlesnakes, and copperhead venom is fairly weak. Snake-handlers who get bitten refuse all aid, except prayer. To accept medical help would be to admit weak faith. Cultists in southern Georgia and northern Florida sometimes handle the eastern diamondback—a larger snake with a more irritable disposition. George Hensley died in Florida at age 75, bitten by an eastern diamondback. He claimed to have survived 446 bites during his 45 years of handling venomous snakes.

On February 15, 2014, Jamie Coots—a third-generation snake handler and pastor in Middlesboro, Kentucky—died from a rattlesnake bite during a church service. The news was high profile, as Coots had been featured in the National Geographic Channel reality show *Snake Salvation* just a few months earlier. Although religious snake-handling has been illegal in Kentucky since 1940, authorities rarely enforce the law because of reluctance to prosecute people for their religious beliefs.

Some cultures worship the snakes themselves, which is known as ophiolatry. Ancient Egyptian religion involved symbolic worship of sun and serpent, especially the cobra. Mythology tells of many associations between the gods, including Wadjet

and Renenutet, and serpents. The sun god Ra was sometimes referred to as the "Egg within the Serpent's Coil."

Cobras, considered manifestations of the Hindu fertility god Shiva, have been worshipped in India and Pakistan since at least 1600 BCE. Remnants of ancient snake-worship still persist, where cobras are believed to convey fertility to women, assure bountiful crops, and represent immortality. Believers in cobra power worship at shrines and celebrate the snakes at annual festivals. Women who wish to get pregnant leave milk, saffron, and honey near a cobra's resting site.

In 1893 W. Crooke, a district officer in the Bengal Civil Service, wrote that the snake was worshipped in northern India for many reasons. One was that the snake was a dreaded enemy, feared for "its stealthy habits, its sinuous motion, the cold fixity of its gaze, the protrusion of its forked tongue, the suddenness and deadliness of its attacks." But the snake was worshipped for positive reasons as well: respected as protector of the home and guardian of the village temple, and revered for its wisdom and connection with clouds and rain. The snake symbolized life, eternity, and sexual power. Indians worshipped the snakes at special shrines, carved snakes into temple stones, and revered snakes that wandered into their homes, viewing them as returned dead ancestors. The Greek historian Plutarch (ca. 46–120 CE) wrote that Indians sacrificed old women as offerings to the serpent gods. The women, previously condemned to death for crimes, were buried alive by the Indus River.

Many peoples throughout Africa respect and revere snakes. For example, it is commonly believed that dead souls return as snakes; souls of chiefs reside in pythons. A snake seen by a grave is assumed to be the spirit of the person buried there. The Dinka, who call snakes their brothers, wash snakes with milk and anoint them with butter. Many Dinka keep pythons in their homes; killing one would bring bad luck to the household. They also respect puff adders, because they believe that these venomous snakes house divinities; to kill a puff adder would incite the divine spirits to strike the killer. The Bari, who believe they are descended from black vipers, revere these venomous snakes and offer them milk.

Ophiolatry is deeply rooted in Benin (formerly Dahomey) in western Africa. Pythons were believed to control the water supply, Earth's productivity, and human fertility. During the 1700s and 1800s, each village had its own captive python. Priests fed the snakes, and priestesses entertained them with song and dance. People took python worship seriously. In the mid-1800s, any child touched by a python spent a year in a fetish school to learn the dances and songs of serpent worship. If a person killed a python, even accidentally, he or she was placed under a hut in a hole thatched with grass greased with palm oil. The offender was drenched with oil, and the hut set aflame. The snake-slayer had to break out of the hole and rush through the flames to the nearest water. As he ran, Serpent Priests beat him with sticks.

Residents of the British Isles also practiced ophiolatry. A serpent symbolized Hu (Pridain), god of the Celtic nations. Britain was the main seat of the Druidical serpent

3.11 Figures of python heads peer out from the corners of homes in the Republic of Benin (formerly Dahomey) in western Africa, where pythons are still revered. This one, in the collection of Butch and Judy Brodie, is 17 inches (43 cm) long.

and sun worship. In Ireland, monuments were built to worship the sun and serpent. In County Meath, Ireland, relics related to worship of the Persian sun god, whose symbol was a serpent, have been found in a cave: stones carved with mystical figures resembling coiled serpents.

Ancient, enormous snake-shaped earthen structures found in Wisconsin, Michigan, Iowa, Ohio, and Missouri reveal that some first peoples of North America revered snakes. Great Serpent Mound, in southwestern Ohio, is the largest snake effigy mound yet discovered in the world. Its uncoiling body stretches nearly 1,350 feet (411.5 m) and rises 3 feet (0.9 m) high. The serpent's outstretched neck is slightly curved, and the open jaws appear to be swallowing an oval shape, perhaps an egg. The oval area may have been the focal site for ceremonies associated with the mound. Archaeologists and others are still debating the date of construction, identity of the builders, and purpose of the mound, but judging by the tremendous effort taken to build the effigy, it must have been profoundly meaningful.

Morgan's quote at the beginning of this chapter captures the duality of our perceptions of snakes. Throughout history and worldwide, people have viewed snakes as good or evil, or more often as a combination of these extremes. It's no wonder that some of us appreciate snakes and others do not.

How can snake enthusiasts convince people who dislike snakes that these animals are worth protecting? Education is critical. We need to empower people with knowledge to distinguish venomous from harmless snakes. A person not knowing whether the snake in front of him/her is venomous will likely assume it is and be afraid. Fear leads to hate. The next step is teaching people what they should do when

they see a snake. Give it space. Watch it from a distance—you'll find it fascinating. Do not harass or try to kill it; doing so may be illegal, and it greatly increases the chance of getting bitten. We also need to share with the public what it is about snakes that makes them so special in their own right, and how critical they are to both aquatic and terrestrial ecosystems. A person who can identify the snakes he/she encounters, know how to respond when finding them, and appreciate their biology is more likely to respect the animals than someone naive to the ways of snakes.

But we are less rational than we like to admit. We buy the traditional six-bedroom, three-car garage home because we find it attractive, even though we know we should have gone with the four-bedroom energy-efficient home featuring solar panels. We buy the hottest stiletto shoes for the sexiest looks, not because they are comfortable. Because people's first reaction to snakes often is based on affect (feelings, emotions) rather than cognition, we need to change how people feel about snakes.

In a chapter in *Snakes: Ecology and Conservation*, Gordon Burghardt and his colleagues suggest that one way to save snakes might be to reinstate reverence toward them, such as that demonstrated by many indigenous cultures. Perhaps when interacting with the public, scientists shouldn't distance themselves from spiritual values. Modern scientific understanding of snakes could be enveloped in a spiritual message, an approach advocated for all of nature by conservationist E. O. Wilson. In *The Creation*, Wilson suggests that scientists and religious leaders should unite in an effort to preserve nature, to save creation. Similarly, Burghardt and his colleagues write:

> It is necessary to respect the human populations who need, and find value and meaning in, stories that explain the big picture. What we want to achieve is that sufficient numbers of people value snakes and strive to conserve them and their habitats. Herpetologists should recall what initially fascinated and intrigued them about snakes, especially the kinds of emotional experiences with snakes that we do not feel comfortable talking about in our quest to be objective scientists.

For me, watching that rainbow boa in the Ecuadorian rain forest was just such an emotional experience, vacillating between scientific explanations and aesthetic appreciation and wonder. If only I could bottle up that emotion and share it with people who dislike snakes.

Parallel to Burghardt's suggestion, Eva M. Thury and Margaret K. Devinney, in their *Introduction to Mythology*, write: "Scientists study myths because they do not want to become so wrapped up in their own world view that they fail to notice a different perspective on the question at hand." I suggest that we should study myths more than we do. I suspect that if we better understood cultural perceptions, we could work those attitudes into education efforts and ultimately improve conservation for snakes and other maligned animals.

4

Songs and Thunderbolts

Frogs, Snakes, and Rain

I like the look of frogs, and their outlook, and especially the way they get together in wet places on warm nights and sing about sex.

—ARCHIE CARR, *The Windward Road*

Many of my favorite memories from the field involve watching frogs during drizzling rains. Add to that the thrill of discovery, and you have a magical evening. One particular evening stands out.

It was early rainy season, and an afternoon downpour had filled the pond at my northern Argentina study site. Male llanos frogs (*Lepidobatrachus llanensis*), waxy monkey frogs (*Phyllomedusa sauvagii*), Chacoan horned frogs (*Ceratophrys cranwelli*), weeping frogs (*Physalaemus biligonigerus*), and mud-nesting frogs (*Leptodactylus bufonius*) created a deafening cacophony of croaks, chuckles, squawks, whines, and whistles. My eyes and ears focused on the mud-nesting frogs. Part of their nesting behavior was known, but no one had reported who closed the nest opening—Mom or Dad—or how it was done.

I watched several males push mud into hollow cone-shaped mounds at the pond edge, then climb inside through the top openings and begin to call. In time, a female wriggled into each nest and disappeared. For over two hours, attacked by bloodthirsty mosquitoes, I stared at the blobs of mud. Finally, two frogs exited one nest. Dad hopped away. Mom pushed

mud with her front feet, along the side of the nest up onto the top, working all around the sides. Other females likewise closed off their nests. Mud used to cap off the top was much wetter than the surrounding mud, suggesting that the females urinated to moisten the dirt and render their construction material more workable. A magical evening, indeed!

The association between frogs and rain is obvious to anyone who lives where there are frogs—and most of us do. They often appear after a rainfall and forage for

4.1 Mud-nesting frogs (*Leptodactylus bufonius*) make hollow, cone-shaped nests in the mud of depressions (*top*). After a pair lays and fertilizes eggs inside the nest, they exit the nest and the female covers the opening with mud (*center*). In time, rain floods the nest and the tadpoles are released into the newly formed pond. *Bottom:* adult mud-nesting frog.

4.2 Frogs often appear, seemingly out of nowhere, after a rain. Males call to attract females, and before long the orgy begins. *Top:* male green treefrog (*Hyla cinerea*) calling; *bottom:* amplectant pair of boreal toads (*Anaxyrus boreas*).

insects. Their thoughts turn to sex. As ponds and puddles fill with water, males call to attract females, and egg-laden females soon choose their partners.

Although some species of frogs can tolerate dry conditions, most require moist environments. Frogs' skin is highly permeable, and water exits the skin easily. Thus, frogs desiccate quickly in arid environments. Frogs breathe through their skin, but this works only if the skin is moist. The advantage of highly permeable skin is that frogs absorb water quickly by sitting on a dew-covered leaf or damp soil—a good thing, because frogs don't drink water. Frogs also need water for reproduction. Their eggs are surrounded by layers of gelatinous capsules that absorb water quickly, but because they also lose water quickly, the eggs must develop either in water or in moist sites. Rain allows frogs to breed, by filling depressions for aquatic breeders and by dampening the ground for terrestrial breeders.

We also associate snakes with water and rain, for several obvious reasons. First, many kinds of snakes—including pythons, cottonmouths, water snakes, and anacondas—live either in or near fresh water. Second, many snakes prey on frogs that live around water. Third, snakes often become more evident following rain as they search for dinner. Some of their prey, such as rodents, eat insects. Insects increase in activity after rains; thus, rodents are more active at that time as they forage. Fourth, after rains, snakes emerge from flooded retreat sites and enter our homes in search of dry, warm shelter. Fifth, snakes' long, winding bodies and their rippling, sinuous movements remind us of rivers and other flowing water. Snakes' connection with rain has led to their association with rainbows, lightning, and thunderbolts.

Frog Songs

People likely have associated frogs with rain and therefore with agricultural fertility ever since agriculture began about 11,000 years ago in the Middle East. One of the earliest great civilizations arose in Egypt's Nile River Valley about 5,000 years ago. For these early farmers,

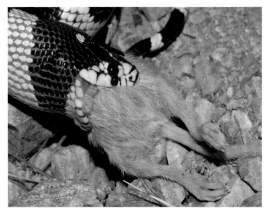

4.3 Some snakes become more active following rain as they search for rodents that are likewise more active after rain as they feed on insects that are also more active after rain. *Top:* California king snake (*Lampropeltis californiae*); *bottom:* red diamond rattlesnake (*Crotalus ruber*).

too little rain at crucial times caused crop failure. Too much rain caused devastating floods. Rains at just the right times and in just the right amounts were crucial to people's very existence. Every year, beginning in July, the Nile overflowed its banks. By September, the floodwaters receded and deposited a strip of rich black soil 6 miles (10 km) wide along each bank. As farmers plowed and seeded the fertile soil, they noticed that frogs congregated at puddles that formed during and after the flooding. Within a few months, tiny baby frogs covered the ground. Frogs were so abundant along the Nile that the frog became the symbol for *hefnu*, an immense number, or 100,000, one of the principal numerals in Egyptian hieroglyphics.

The association between rain and calling frogs is so strong that folklore worldwide connects the two, almost always in ways that reflect well on frogs. "Why the Korean Green Frog Has a Sad Croak" features a contrary frog that did the opposite of whatever his mother asked him to do. One day Green Frog's mother knew she was about to die. She wanted to be buried in the mountains. But how could she be sure that her contrary son would honor her wishes? She told her son, "Whatever you do, don't bury me in the mountains. Bury me in the river." When his mother died, Green Frog felt terrible about how contrary he always had been to his mother. He obeyed her wishes and buried her in the river. Every time it rained, the river rose. Green Frog always sat on the riverbank during those times and worried that his mother's grave would wash away. As long as he lived, he fretted in a low, sad voice every time it rained. To this day, green frogs croak in sad voices when it rains.

People of some cultures believe that frogs call down the rain. An ancient Hindu hymn from the *Rig Veda*, composed over 3,000 years ago, refers to frogs singing and the coming of rains: frogs are "moistened by the rain," lifting up their voices. "The music of the frogs comes forth in concert like the cows lowing with their calves beside them." The hymn ends with: "The frogs who give us cows in hundreds lengthen our lives in this most fertilizing season." Clearly, the ancient Hindus valued frogs' ability to bring nourishing rain.

The toad was a spiritual rain symbol for the ancient Vietnamese. Toad representations are found on many antiquities, including a drum dating back about 2,500 years. A Vietnamese legend tells that long ago, Toad and other animals went to Heaven to protest to God that Earth was too dry. God told Toad that whenever Earth needs water, Toad should grind his teeth. Vietnamese farmers still rejoice when toads "grind their teeth," meaning that the rains will come soon. The Vietnamese have a saying that shows respect for toads: "*Con Cóc là câu ông Trời. Neu ai dánh nó thì Trời danh cho*": "Toad is God's uncle. Beat him, God beats back."

Native American cultures of the southwest United States have associated frogs with rain for at least the last 1,000 years, as evidenced by frog motifs painted on pottery. The Hopi believe that frogs are connected with rain both directly and indirectly. They honor frogs as sacred beings and say that when frogs call, they are praying for rain, critical for growing crops in the Arizona high desert. Frogs also are associated

4.4 Cultures worldwide have long represented frogs on ceremonial and utilitarian objects because of the animals' association with rain and fertility. Pictured here is a frog pipe from one of the mound-builder cultures of North America. From the collection of Butch and Judy Brodie.

with kachinas, mythical ancestors of the Hopi who became spirits of rain and rain clouds. Kachinas function as intermediaries between the spirit world and humans. These beings live on the San Francisco Peaks, near Flagstaff, Arizona, but they leave the peaks and stay with the Hopi from the end of winter until the end of the growing season in late July. While with the Hopi, the kachinas influence rain, fertility, and harvest. Sacred stories tell of frogs asking kachinas for rain on behalf of people, and Hopi ceremonial bowls feature representations of rain clouds, frogs, and tadpoles.

Like the Hopi, Zuni believe that frogs have both direct and indirect connections with rain. Frogs have power to bring rain, and they also convince supernatural beings to send rain. A Zuni sacred story says that when the People left the Underground in search of a home, women carried the children on their backs across the river. The children bit and pinched so hard that the women dropped them into the water, whereupon they transformed into turtles, water snakes, frogs, and tadpoles. These beings eventually became the Council of the Gods, to whom Zuni prayed for rain to nourish their crops. Zuni still decorate their water-holding pots with representations of frogs and tadpoles to honor these animals.

In a Navajo folktale, "Frog Creates Rain," Coyote accidentally started a conflagration on Fire Mountain when the world was new. The fire headed toward the village of the First People. There was no water on Fire Mountain, so First Woman asked who would carry water to the mountain and quench the fire. Each animal offered an excuse why he or she could not carry water, beginning with Mockingbird, who feared that the smoke would silence her voice. Beaver, Otter, Mink, and Muskrat refused to deliver their river water because they worried that their home might become a desert. Turtle said that if he poured his lake on the mountain, it would cause a flood so large that the village would be washed into the ocean.

4.5 For the Zuni from the southwest United States, the frog represents a common bond among all life-forms because of its association with water. Frogs are honored and frequently represented on Zuni pottery because they are believed to bring rains that promote growth of crops.

Finally, First Woman asked Frog if he would take his swamp water to the mountain. Frog croaked, dove into the swamp, and soaked up water. White Crane carried Frog to the mountain, where Frog released one-fourth of the water on each side—north, south, east, and west—and thoroughly quenched the fire. First Woman declared that rain was needed all over the land, and she chose Frog to call the rain. To this day, Frog brings rain by croaking.

Pre-Columbian Mesoamericans considered frogs to be rain spirits and custodians of rain. In tribute, artisans produced frog figurines using the lost-wax casting technique. They fashioned stylized wax figures of frogs, encased the figures in clay, and heated them to melt away the wax. The artisans poured molten gold into the molds and produced stunning pieces that they placed on hilltops or wore as jewelry, believing that the solid gold frogs would ensure rain.

In many parts of the world, people still believe that frogs bring or withhold rain. South African rain frogs (*Breviceps*) are one such example. These small puffball-shaped frogs spend most of their lives underground. After torrential rains, they emerge en masse to forage and breed. Once the soil begins to dry, they disappear underground once more. South Africans show rain frogs great respect because of their purported power to bring or withhold the rain so crucial for crops. If a person accidentally digs up a rain frog, he or she reburies it with a little human food as propitiation.

People have devised ingenious methods of using frogs to bring rain. In the Old World, people in the Kumaon district of northern India viewed toads as water spirits. When rain was needed, they hung toads by their mouths to the tops of trees or bam-

4.6 *Top:* These Costa Rican reproductions of pre-Columbian frog artifacts reflect some of the diversity of figurines fashioned from solid gold to keep the rains coming.

4.7 *Bottom:* South African common rain frogs (*Breviceps adspersus*) appear after heavy rains and disappear underground once the soil dries. No wonder the frog is believed to bring and withhold rain.

boo poles in the belief that when the god of rain saw the hanging spirits, he would send rain out of pity for the toads. In parts of what used to be British India, some people still tie frogs to rods covered with leaves and branches from the *nim* tree. They carry the captive frogs from door to door singing: "Send soon, O frog, the jewel of water! And ripen the wheat and millet in the field." Likewise, Malayans swing frogs from the ends of cords to bring rain. In Southeast Asia, farmers ask the gods and spirits to bring the rains on time and to end the rains when their crops are ready to be harvested. One way to attract rainfall is to invite a toad, considered an incarnation of Bodhisattva (an enlightened being), in from its swamp to hear a recitation of holy writings.

In some parts of India and Bangladesh, villagers hold marriage ceremonies between male and female frogs as rituals to the rain gods. After a priest marries the frog couple, the human guests enjoy music, dancing, and traditional wedding food: rice, lentils, fish, and sweets. Once the priest blesses the happy couple, the villagers release the frogs into a nearby pond. If all goes well, the heavens soon release nourishing rain and the villagers can plant their crops.

South Americans likewise have used and still use frogs to bring rain. Early Caribs of Venezuela believed so strongly in frogs' power to send rain that they kept frogs under pots. Simply their presence would do the job. During times of drought, the captors beat their frogs for insubordination. Although the people didn't always treat their captives with respect, they believed that frogs were lords of the waters, and thus it was taboo to kill them. During times of drought, Quechua living around Lake Titicaca in high-elevation Peru enclosed frogs in ceramic pots. The pots were left on hilltops, where the gods would interpret the frogs' distress calls as pleas for rain and respond by soaking the land.

Folklore from diverse cultures tells of frogs guarding the springs and wetlands and thus ensuring water for everyone, but frogs can also impound water and cause drought if offended. The idea is similar across cultures: a selfish frog hoards fresh water, some person or animal comes to the rescue, and the villain releases the water. In some stories, release of the water causes flooding. The stories, whether they involve flooding or not, reflect the power that people attribute to frogs.

The Kalapuya of the Willamette Valley in Oregon (United States) tell that long ago the Frog People controlled all fresh water. To get water for drinking, cooking, or washing, one had to beg the frogs to release water from their dam. One day Coyote realized that a rib bone from a deer skeleton looked like a big dentalium shell, a tusk seashell highly valued for making jewelry and other ornaments. Coyote decided to resolve the water problem by bribing the Frog People. "Give me a long drink of water in exchange for this dentalium shell," he said. The Frog People agreed. Coyote explained that he was going to keep his head underwater for a long time because he was very thirsty. And he did. Concerned that Coyote was doing something improper, as he was wont to do, the Frog People asked several times how Coyote could drink so much

water. "I'm thirsty," Coyote responded. Finally, Coyote stood up and declared, "That was what I needed." Just then the dam collapsed. All the time that Coyote had had his head underwater, he had been digging beneath the dam. As the water rushed down the valley and filled the dried streambeds, Coyote declared that now water belonged to everyone.

An Australian Aboriginal legend says that a long time ago Tiddalik, a giant and obese frog, woke up one morning with a powerful thirst. He drank all the water from the lakes, rivers, and billabongs. Animals and plants began to die for lack of water. Wise old Wombat suggested that if they could make the bloated frog laugh, he would expel the water. One after another, each animal tried to make Tiddalik laugh, but none was successful. Not even Kookaburra's funniest story did the trick. Finally, Nabunum the eel balanced on his tail, danced, and twisted himself in knots and ludicrous shapes. This was too much for Tiddalik. His eyes lit up, and as laughter rumbled up from his belly, water gushed from his mouth and filled the lakes, rivers, and billabongs once more. In some versions of the story, after Tiddalik released the water, a great flood covered the land. These versions reflect people's appreciation of the delicate balance between too little and too much rain.

The Tiddalik legend likely was inspired by the Australian water-holding frog, *Cyclorana platycephala*. Water-holding frogs spend the dry season—sometimes several years during droughts—buried deep underground. Before burrowing underground, these frogs absorb water into their tissues and fill their bladders with water that

4.8 The Australian water-holding frog (*Cyclorana platycephala*) likely inspired the legend of Tiddalik, an obese frog that drank up all the fresh water.

can be reabsorbed as needed later. Once underground, they slough outer layers of dead skin around themselves, forming impervious cocoons. During times of extreme drought, Aboriginal Australians on walkabout dig up these frogs, gently squeeze out the water—up to a cup per frog—and drink the fluid to quench their own thirst. They carefully replace the frogs in their underground burrows and cover them with dirt. Although reburying the frogs shows respect, I wonder if the unfortunate creatures survive the dry season with their water tanks on empty.

Aboriginal inhabitants of the Andaman Islands tell a story of a great drought that plagued their islands long ago. One day a woodpecker, enjoying a honeycomb high in a tree, looked down and saw a toad watching longingly. The woodpecker lowered a vine and invited the toad to grab hold, promising to haul him up so he could share the sweet feast. Just before the toad reached the honeycomb, the trickster woodpecker released the vine, sending the toad crashing to the ground. Enraged, the toad drank the remaining fresh water from all the rivers. Afterward, he was so pleased with his revenge that he danced for joy. As he danced, water poured out from his body and spread across the land, ending the drought.

Belief that frogs can predict the weather goes back a long time. The Greek natural historian and philosopher Theophrastus (ca. 371–ca. 287 BCE) wrote that when frogs croak more than usual, rain is on the way. Likewise, early Roman writers noted that the incessant croaking of frogs meant imminent rain. In 44 BCE Cicero said that freshwater frogs announced coming rain through their strident croaks "when they talk like orators." About the same time, the Roman poet Virgil claimed that frogs croaking from the edges of marshes portended a gathering storm.

The expressions "frog rain" and "raining frogs" refer to at least two different phenomena. One is the sudden appearance of newly metamorphosed frogs following rain, when the moist ground and vegetation provide ideal conditions for emergence from the aquatic larval environment onto land. The other phenomenon is the seemingly mysterious event during which frogs fall from the sky. Such events have been reported for thousands of years. No doubt most are apocryphal, but it is possible that strong winds during major storms could lift the animals and drop them some distance away.

Thunderbolts

Folklore reveals an intimate association between snakes and water. Mesopotamians imagined the Euphrates River as a male snake. Ancient Egyptians believed that the god living in the Nile River was a benevolent snake that caused the river's annual flooding, thereby increasing soil fertility. The Chinese represented the god of the Yellow River—the second longest river in China and the cradle of Chinese civilization—as a golden snake. Indians envisioned the sacred Ganges River as half man, half snake. In many cultures, the snake links rivers to the sky. Snakes are often associated

with rainbows, as, for example, in Rainbow Serpent mythology from Australia. In Fon mythology from Africa, the double rainbow symbolizes the snake that supports Earth. At the end of the rainbow, one can find "snake's riches" (gold) to be dug from the mountains.

As powerful creatures, snakes evoke images of thunder and lightning. Some scholars suggest that snakes were the first thunderbolt symbol. The zigzag is recognized as the universal symbol for snakes, water, and lightning. Lightning has been imagined as fire in the sky, flickering from a gigantic creature. Cultures as diverse as those found in Finland and Mexico (the Aztecs) have likened lightning to a serpent. In North America, rattlesnakes in particular have long been associated with thunder and lightning. The Shawnee compared thunder to the hissing voice of a celestial rattlesnake. The Sioux imagined lightning as a rattlesnake striking its prey. A Micmac legend explains that thunder is produced by seven rattlesnakes as they fly through the sky waving their tails, and that lightning occurs when the snakes dive to strike prey. The Klamath said that thunder results when rattlesnakes shake their rattles. Farther south, Opata Indians from Sonora, Mexico, see a thunderbolt as a rattlesnake's strike. The Toltec thunder god holds a golden serpent, representing lightning.

Snakes symbolize agricultural fertility because of their association with rain. Some fertility gods and goddesses were depicted as snakes. The ancient Egyptian goddess of nourishment and harvest, Renenutet, was a cobra. Granaries frequently had small shrines dedicated to Renenutet. What animal could be better to protect grain from rodents and birds than an endotherm-eating snake? Pachamama, Earth Mother of the Incas, is still revered by the Aymara and Quechua, descendants of the Incas, in the Andes. This goddess begets, nourishes, and protects all of life. As a fertility goddess, Pachamama oversees planting and harvesting and is responsible for the weather. Pachamama is often depicted as a large snake or as a three-headed creature with a turtle on her front, a frog on her back, and a snake coiled around her legs.

The Acoma Pueblo (United States) believe that the mythical horned water serpent is the spirit of rain and agricultural fertility, and they tell a story that explains the disappearance of their presumed distant ancestors, the Anasazi, in terms of this mythical being. One night the horned water serpent became angry and deserted the people. Anasazi priests offered prayers and pleaded for the serpent to return, but he would not. The Anasazi could not survive the drought without the serpent's rain, so they followed the serpent's trail, which ended at a mighty river. And there the Anasazi established their new home. (The Anasazi's homeland was the Four Corners area—southeast Utah, southwest Colorado, northeast Arizona, and northwest New Mexico. One prominent theory for why the Anasazi left this area is a 300-year-long drought that began about 1150 CE. Anthropologists still debate whether the Anasazi "vanished" from their homeland and were lost forever, or whether they migrated to areas with higher rainfall and are the ancestors of the various Pueblo peoples.)

The Aztecs of central Mexico viewed snakes as companions of Tlaloc, god of rain

and agriculture. Tlaloc was depicted with goggle-like eyes and jaguar fangs. Early representations of the god show two intertwined rattlesnakes crawling down the sides of his mouth. A snake's tongue curls out from underneath one of the fangs. In some myths, Tlaloc had a sky serpent companion who held all the water of Heaven in his belly. The two controlled the rain, storms, wind, and lightning.

Tlaloc had a significant presence in Tenochtitlán, founded around 1350 CE and later the capital of the Aztec empire. At its center sat the Templo Mayor. Two sets of stairs each led to a shrine. The northern shrine housed Tlaloc; the southern shrine housed Huitzilopochtli, the war god generally depicted with a black or blue face, a hummingbird body, and holding a fire serpent as a weapon. The presence of these two gods at the temple reflects the interdependence between agriculture and war in Aztec culture. The Aztecs saw these gods as having equal power in their lives, both needed to preserve the Mexica state and both associated with snakes.

The Templo Mayor reflected the two seasons that the sun carried on its back as it journeyed on its annual path. Tlaloc's shrine marked summer's rainy season; Huitzilopochtli's shrine, winter's dry season. The space between the two shrines represented the spring and fall equinoxes. When the sun shone in Tlaloc's shrine, it was time to plant crops, tend fields, and feed people. When the sun moved to Huitzilopochtli's shrine, it was time to make war and feed the non-human cosmic beings that demanded human sacrifices. These victims nourished the sun, so that the world would not wither into darkness. In time, the victims went on to live inside the bodies of hummingbirds.

4.9 The Aztecs of central Mexico viewed snakes as companions of Tlaloc, their god of rain and agriculture. Tlaloc was revered because he brought the rains so critical for growing their crops, but also feared because of his ability to destroy crops by dumping too much rain.

Food was offered to Tlaloc and his associated lesser rain deities as propitiation for rain. In front of Tlaloc's shrine sat a *chacmool*, a stone statue of a human in a reclined position holding a bowl over its stomach. Scholars believe that the Aztecs placed human sacrificial hearts and blood in the bowl for Tlaloc. During the dry season, they sacrificed babies and young children to nourish the gods. The sharing of food with the gods was both to thank the deities who made all food possible and to appease them, for they had power to send blight, killing frosts, and drought. When mothers of the sacrificial children cried during the ritual slayings, everyone rejoiced because the tears promised that rain would fall.

Tlaloc was known as Cocijo by the pre-Columbian Zapotec civilization in southern Mexico. This rain and agricultural deity wore a grotesque mask with fangs and a long, forked snake tongue protruding from open jaws. Zapotec legend has it that in the beginning Cocijo exhaled, and the sun, moon, stars, earth, plants, and animals emerged from his breath. As late as the 1540s, the Zapotecs made human sacrifices—mostly children—to Cocijo as payment for giving them the rain so necessary for growing crops and as a bribe for averting floods and other natural disasters.

Many other cultures, past and present, have believed that snakes are capable both of providing nourishing rains and of causing climatic destruction. The Kato from California sing rattlesnake songs to stop torrential rains. In Japanese mythology, the snake offers fertility in the rice paddies, but if treated unfairly by humans, it causes flooding. In Hindu mythology, the Nagas, portrayed as cobras or as human-headed snakes, could inflict almost instantaneous death, but they also guarded water and controlled the rain clouds. If properly appeased, the Nagas would bring beneficial rain and protect people from lightning and flooding. People prayed to them for rain during times of famine. In India, people still view cobras as nature spirits that bring rain and agricultural fertility. When mistreated, cobras cause drought, floods, tidal waves, earthquakes, and plagues. Thus, cobras generally are treated with respect. Many Indians believe that if a cobra is killed, the snake's mate will hunt down the killer, no matter how far he or she must travel for revenge. There is no escape.

Some cultures have envisioned destructive forces of nature such as tornadoes, hurricanes, whirlwinds, and waterspouts as serpents. The Zulu saw their tornado god, Inkanyamba, as an enormous snake that writhed and twisted between sky and Earth. Typhon, the Greek god of the storm winds, had 100 heads and a snake's tail. He was thought to cause whirlwinds, as was Mixcoatl, the cloud serpent of the Aztecs.

Despite being limbless, many snakes are excellent climbers. They slither and zigzag through their environment, able to hide in seemingly invisible crevices. Perhaps these characteristic movements explain why many cultures view snakes as links between the lower and upper worlds, capable of carrying messages between people and the gods.

The Hopi from the high desert in northern Arizona use snakes as messengers to carry their prayers for rain to the gods to ensure bountiful crops. Each August,

4.10 Many snakes, such as this Texas rat snake (*Pantherophis obsoletus lindheimeri*), are excellent climbers, an ability that might explain why many cultures view snakes as links between the upper and lower worlds, capable of conveying messages between people and the gods.

snake-priests (men of the Snake Clan) catch bull snakes, desert striped racers, and rattlesnakes. During a sacred nine-day ceremony, the snake-priests bless the snakes, ceremonially wash them in bowls of water containing the roots of *hohóyaonga* (bladderpod, a member of the mustard family), and exchange spirits with them. The final festivity is the Snake Dance, during which the snake-priests dance while holding live snakes in their mouths. After the dance, women scatter white cornmeal on the ground. Snake-catchers drop the snakes onto the cornmeal and allow them to become covered with the meal. Finally, the Hopi release the snakes below their mesa homes to carry their prayers for rain to the gods.

Many rain and water myths reflect people's fear and awe of snakes' power. In some Amazonian indigenous tribes, menstruating women are warned not to gaze at a rainbow, believed to be a huge boa, lest it impregnate them. A widespread belief throughout the Amazon region is that the anaconda, chief of the water spirits, rises into the sky and takes the form of a rainbow. Mothers keep their children inside whenever a rainbow appears because anyone who looks at the rainbow anaconda becomes sick. The Huastecs from Mexico normally buried their dead faceup. If the person died from a venomous snakebite, however, he or she was buried facedown. Otherwise, devastating rains would pour down from the sky for four continuous days.

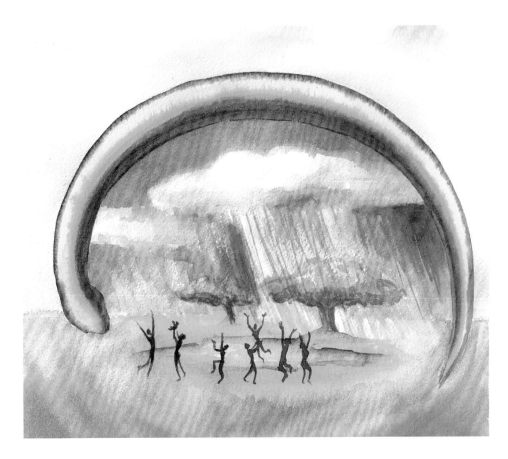

4.11 According to Shoshone legend, Snake brought rain to a parched Earth by scraping ice from the sky with his curved spine. Snake remained in the sky and still moistens Earth. Each time it rains on a sunny day, Snake's curved body shines like a multi-colored ribbon.

Recall the Australian Aboriginal creation myths of gigantic water snakes called rainbow serpents. A diverse mythology surrounds these creatures. Usually they stay in the water, writhing in darkness, but when they surface, their movements can upset the balance of nature. Their actions are both positive and negative: creator when they provide gentle rains that renew the earth and nourish crops, and destroyer when they cause devastating floods. Thus, people both revere and fear them. In some areas, people still believe in rainbow serpents, considered the most powerful of all spirits. Permanent water holes are avoided for fear of attack by rainbow serpents. If the serpents are offended, the water holes might overflow and drown the village.

The Shoshone tell how a long time ago, the lakes and rivers dried up, and plants died; the people were thirsty and desperate. Snake offered to use his powers to bring rain. He had the people throw him into the sky as high as they could. Once in the sky, he uncoiled and grew longer and longer. When both his head and tail curled back toward Earth, he began to scrape blue ice from the sky with his curved spine. His body became red, yellow, green, and purple. The shaved-off ice melted and fell to Earth as rain. Rivers and lakes filled with water; flowers bloomed. The people cleansed themselves in the refreshing rain and danced in honor of Snake, who stayed in the sky. Each time it rains on a sunny day, you can still see Snake's curved body shining like a red, yellow, green, and purple ribbon. In the summer, the abraded ice falls as rain. In the winter, it falls as snow. When Snake is angry, the ice falls as hail.

How did ancient peoples view frogs and snakes as long-term drought devastated their civilizations? The cliff-dwelling Anasazi in the Four Corners area of the United States weren't the only people impacted by prolonged drought. Persistent, long-term drought is a prominent theory for the collapse of the Akkadian empire in Mesopotamia about 4,200 years ago, the decline of the Mochica culture from coastal Peru about 1,500 years ago, the collapse of the Maya civilization in Mesoamerica about 1,200 years ago, and the end of the Tiwanaku culture from the Bolivian-Peruvian altiplano region about 1,000 years ago. Did the sufferers of these regions believe that frogs and snakes had abandoned them when the rains repeatedly failed to materialize? If that were their conclusion, they must have wondered what they had done to incur the animals' wrath. Had they offered insufficient propitiation? Maybe if they'd danced more, sung more, prayed more, or offered more human sacrifices, the animals would have dished up just the right amount of rain on schedule.

Consider the ancient Maya, who depended on highly seasonal rainfall for successful crop harvest. Chaac (Chac), chief of the Mayan rain gods, often was depicted as an old man covered with reptilian scales. (Chaac was equivalent to Tlaloc of the Aztecs.) Chaac held either a snake or a snake-shaped stick in his hand; the snake symbolized thunder and lightning. By striking clouds with the snake or stick, Chaac produced rain. Chaac and his associated rain deities, collectively called the chaacs, also caused

water to fall from the sky by tipping their gourds filled with rainwater. They controlled all of nature: water, clouds, thunder, lightning, earth, heavens, plants, and animals. The Maya believed that water was a gift of the gods, and they celebrated Chaac in rituals and ceremonies. Following intense drought, they sacrificed children to give thanks for the rain.

The ancient Maya associated frogs with agricultural fertility, as evidenced in the Madrid Codex (records of the pre-Columbian Maya civilization, written in Maya hieroglyphics on bark cloth). One page shows a frog using a planting stick to dig furrows in the soil and sowing seeds. After the first heavy rains of the wet season, frogs that lived with the Maya "mysteriously" appeared and formed large breeding aggregations, as they do to this day. No wonder, then, that the Maya considered frogs, especially one species of burrowing frog they called *uo* (*Rhinophrynus dorsalis*), to be attendants, messengers, and musicians of the chaacs. Through their low-pitched "*wh-o-o-o-e*" calls, these rotund black frogs with orange racing stripes running down the centers of their backs summoned the chaacs to tip their gourds of water. (A local name for the *uo* is *sapo borracho* [drunk toad] in reference to their call, which sounds like a drunk heaving.)

I wonder if drought and outside forces impacted the ancient Maya's view of frogs and snakes. Given the significance of these animals for them, did people from the southern reaches of their range blame frogs and snakes as their world shriveled during the prolonged drought of the eighth and ninth centuries? Maya from the northern reaches had their beliefs about snakes sorely tested when the Spanish invaded in the early 1500s. The Catholic conquistadores and priests were outraged by the human sacrifices and idolatry practiced by the Maya, including worship of the feathered-serpent deity, Kukulkan. In the Christian view, snakes represented the Devil. Invad-

 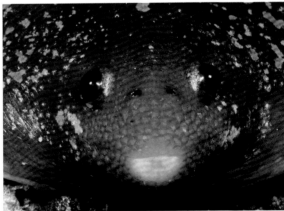

4.12 *Uo*, Mexican burrowing frogs (*Rhinophrynus dorsalis*), considered by the ancient Maya to be musicians of the rain gods, spend the dry season buried underground. The Maya believed that during this time the frogs stuffed their bodies with corn, explaining their rotund physique.

ers smashed idols, ravaged pyramids and murals, and destroyed the sacred codices, viewed by the Spaniards as telling lies of the Devil.

How do contemporary Maya feel about frogs? Some Maya still revere the *uo* and continue to associate them with the onset of rain. Farmers who accidentally unearth the frogs from their fields rejoice in these beings that resist drought and symbolize humans' ability to survive drought. Maya living in the Mexican states of Yucatán and Quintana Roo still perform the *ch'a chaac* (Bring Rain) ceremony to generate goodwill with the chaacs and to ask for rain. Four young boys are tied, each by his right leg, to the corners of a rectangular altar piled with food to be offered to the rain gods. The boys mimic the heaving calls of *uo* and the trills of *totmuch* (cane toads, *Rhinella marina*), announcing forthcoming rain. In contrast, many contemporary Maya perceive other frogs as most of the rest of us do. They are just part of the landscape—neither positive nor negative.

How do contemporary Maya view snakes? In *The Amphibians and Reptiles of the Yucatán Peninsula*, Julian Lee reports that most rural Maya today fear snakes and kill every one they can—harmless or venomous. For many modern-day Maya, snakes personify the Devil and carry sickness sent by sorcerers. These viewpoints reflect ideas brought to the region by Europeans, illustrating how human migration can modify folk beliefs.

This small sampling of frog and snake associations with rain and agricultural fertility suggests the wide geographical scope and long historical significance of these beliefs. People venerate frogs and snakes for their perceived ability to provide nourishing rains, but they also fear them for their perceived powers to cause droughts and floods. Fear can lead to hate, but it can also lead to respect. In some cases, respect for frogs and snakes stems from the fear that unless the animals are bribed, they will not provide the rain so desperately needed, and in the appropriate amount. No wonder, then, that many cultures sacrificed their own members to appease the gods. Although we may be horrified by such practices today, sacrifice was viewed as a sacred activity by those performing it, necessary to ensure that the rain gods looked kindly upon Earth. Sacrifice was an attempt to control nature.

I suspect that people always have wanted more control over nature. Belief in the power of other animals to bring much-needed rain, or serve as messengers between humankind and the gods and thereby influence rainfall, gives humans the illusion of having some control—if we stay on the animals' good sides. So, the stories pass on through generations.

5

A Second Chance

Frogs, Snakes, and Rebirth

And strange to say, after six months of life they [frogs] melt invisibly back into the mud, and again in the waters of spring-time are reborn what they were before, equally owing to some hidden principle of nature, as it occurs every year.

–PLINY THE ELDER, *Historia Naturalis* (77-79 CE)

Thunder rumbled across the northern Arizona sky. Jagged lightning bolts crackled and flashed. The heavens opened up and dumped a "frog-choker rain"—the first rain for five weeks. That July evening I opened the door to a cacophony of snore-like "*wah-wah-wah*." The vacant lot across the street had flooded, causing what herpetologist Arthur Bragg called gnomes of the night—Great Basin spadefoot toads (*Spea intermontana*)—to emerge from underground.

The noise was deafening—"*wah-wah-wah*" belted out by hundreds of pug-nosed male spadefoots bobbing in the water, catlike eyes peering out from inflated-balloon bodies. One night later, silence replaced the monotonous chorus of hoarse voices. Thousands of eggs attached to emergent stems replaced the bobbing bodies. The gnomes of the night had disappeared underground once more. They would resurface only after the next torrential rain, which could be many months away, or perhaps not until the following monsoon season.

5.1 American spadefoot toads (*Scaphiopus, Spea*), "gnomes of the night," live underground, emerging after heavy rains to breed.

Ever since we began to contemplate our surroundings, humans likely have pondered the meaning of sudden appearances and disappearances of frogs. The conclusion: Frogs are born and reborn, if not literally at least figuratively.

Humans also have long observed that snakes shed their skins and have connected shedding skin to rebirth, rejuvenation, and immortality. The Greek philosopher Aristotle (384–322 BCE) said that snakes gain immortality through shedding their skin. Egyptian mythology depicted snakes as immortal: old snakes eventually sprout wings and fly away.

Frogs and Rebirth

For people the world over and throughout history, frogs symbolize rebirth and renewal. This association reflects three aspects of frogs' biology, one of which is their very essence: "Here today, gone tomorrow." Frogs appear from nowhere following a hard rain and then disappear. In temperate areas, they emerge with warmer spring temperatures and vanish in the fall when temperatures plummet. The Roman scholar Pliny the Elder claimed that frogs were reborn from mud during the annual spring rains. Ancient Egyptians associated frogs with rebirth because after the annual flooding of the Nile River, frogs that were assumed to be dead mysteriously reappeared.

5.2 Frogs symbolize rebirth in part because they slough their outer skin, revealing a fresh layer. Here, a Sambava tomato frog (*Dyscophus guineti*) is eating its shed skin.

The river's gift of rich, black soil was in itself renewal, and frogs seemed an integral part of the process. People so closely associated the appearance of frogs with the Nile's annual flooding that they believed frogs originated from the coupling of the land and water. Ancient Egyptians buried dried frog carcasses with their deceased and folded frog-shaped talismans within mummy wrappings to ensure rebirth and renewal.

Second, frogs symbolize rebirth because periodically they slough their outermost layer of skin, revealing a fresh skin underneath. The skin splits down the middle of the back, beginning on the head and progressing to the rear. Many frogs loosen and remove the shed skin with their legs and retain the nutrients by eating the skin. The Olmec who lived in the eastern lowlands of Mexico between 1300 and 400 BCE revered a toad god of rebirth, depicted as devouring its skin; by eating its skin, the god perpetuated the cycle of death and rebirth. This aspect of rebirth is reflected in folklore that features handsome princes who emerge from toads' skins.

Third, frogs symbolize rebirth because many species experience a "magical" metamorphosis: transformation from an aquatic, gill-breathing, swimming tadpole into a terrestrial, lung-breathing, leaping frog. We are fascinated with frog metamorphosis, perhaps because the change parallels our own transition from fetus bathed in amniotic fluids to baby's entry to the outside world. Just as frogs, we also pass through critical stages in our lives. For nearly 2,000 years, the stages of egg, tadpole, and adult

5.3 Frogs also symbolize rebirth because many species transform from legless swimming tadpoles to completely different-looking animals that jump about on land. This necklace, made by artist Lexi Dick (www.lexidickjeweller.co.uk), captures our fascination with amphibian metamorphosis.

have represented the cycle of life, death, and resurrection. Egyptian Copts, leaders in developing the early Christian church, adopted the frog as a symbol of resurrection. They sculpted frog figures onto their monuments in the catacombs of Alexandria alongside the Coptic Cross, drawing a parallel between amphibian metamorphosis and Christ's resurrection from the dead. Frog figures adorned Coptic pots, dishes, and flasks.

Associated with their perceived rebirth, frogs symbolize immortality. Ancient Asian legends portray toads as custodians of the secret to eternal life. Chinese legends focus on Liu Hai, a real person who had been a minister of state during the tenth century but who abandoned politics and became a wandering hermit seeking everlasting life through Taoism. One legend tells how Liu Hai found a toad in a garden well, unable to escape, wounded, and left with only three legs. Liu Hai rescued

十洲三島任遨遊常伴
金蟾會眾仙
陳逸

5.4 The three-legged toad Ch'an Chu revealed the secret of eternal life to the wandering hermit Liu Hai in return for his friendship.

the toad, and from that day on the two traveled together. In exchange for the man's friendship, the three-legged toad, named Ch'an Chu, revealed the secret to eternal life to Liu Hai. For the Japanese, the wandering sage Kosensei traveled with his wise counselor, a three-legged toad, riding on his shoulder. Kosensei—warty-faced, with disheveled hair and a hunched body—could change shapes, even transform himself into a youth and become reborn. He sometimes gave the elixir of immortality to his toad companion. In many of these Asian legends, the elixir is the fungus *ling chih* (Chinese) or *reishi* (Japanese), which sprouts from the three-legged toad's forehead. In the real world, this fungus (*Ganoderma lucidum*) grows on decaying logs and tree stumps and has been used in Traditional Chinese Medicine for over 2,000 years, valued as a supplement to promote longevity.

Asian lore also associates Ch'an Chu with the moon. Instead of a man in the moon, the Chinese see a toad. Legend has it that in the third millennium BCE, when Shun assumed the emperor's throne, nine false suns threatened to scorch Earth. Shun gave an archer named Shen I a magic bow, and the archer shot the nine false suns out of the sky. The gods rewarded Shen I with the Pill of Immortality and a permanent home on the real sun. By and by, the archer's wife, Heng O, stole the pill, swallowed it, and fled to the moon to escape her husband's wrath. There, she was transformed into the three-legged toad Ch'an Chu. Shen I dearly loved his wife and built her a palace on the moon. On the fifteenth day of each month, the archer still visits his wife in her moon palace, accounting for the exceptional brilliance of the moon once each month. Ch'an Chu, still causing trouble, occasionally tries to swallow the moon—and causes an eclipse.

As symbols of rebirth, frogs feature prominently in tales where humans find themselves locked inside non-human bodies and later become "reborn" in their true form. A common theme in transformation stories involves an ugly toad or frog that, after encountering a beautiful girl or princess, turns into a handsome young man or prince. Inherent messages suggest that things aren't always what they seem, coupled with the notion that change can be positive and results from acceptance, love, or compassion. In some cases, the transformation arises through violence, such as the girl throwing the frog against a wall. In other tales, the frog spends the night on the girl's pillow or receives her kiss.

The best-known frog transformation tale is the Brothers Grimm's "The Frog Prince." One morning a young princess dropped her golden ball into a spring. She lamented, "If only I could get my ball back, I would give away everything I own." A frog lifted his head out of the water and said that he didn't want her jewels or fine clothes, but if she would love him and allow him to eat off her plate and sleep in her bed, he would retrieve her ball. The princess agreed, though she had no intention of keeping her part of the bargain. The frog dove into the water, resurfaced with the golden ball in his mouth, and threw it onto shore. Overjoyed, the princess picked up the ball and ran home.

That night, the frog tapped on her door and reminded the princess of her promise. She slammed the door and told her father what had happened. After the king insisted she keep her word, the princess allowed the frog to eat from her plate and sleep on her pillow. This continued for three nights. The third morning, when the princess awoke, she found, instead of the frog, a handsome prince, who explained that a spiteful fairy had changed him into a frog and that the only way he could ever be transformed back was if a princess let him eat from her plate and sleep in her bed for three nights. The two married and lived happily ever after.

In the Korean tale "The Toad-Bridegroom," a poor fisherman despaired because each day he caught fewer fish. One afternoon, a large toad crawled out of the fisherman's shallow lake. The man cursed the toad, assuming it had eaten all the fish. The

toad responded, "Do not be angry with me. Let me live in your home, and I will bring you good fortune." Annoyed, the fisherman hurried home alone. Not to be deterred, the toad arrived at the fisherman's doorstep that evening. The fisherman's wife welcomed the toad, made a bed for him in the corner of the kitchen, and fed him worms and table scraps. The childless couple loved him as a son, and the toad grew to be as big as a boy.

Near the fisherman's house lived a wealthy man with three daughters. One day the toad told his foster parents that he wished to marry one of the daughters. The fisherman's wife called on the neighbor woman, and when she relayed the toad's request, the infuriated neighbor had her servant beat the woman. The toad felt very badly that he had caused his foster mother harm. That night he tied a lighted lantern and a long string to a hawk's foot. The toad climbed a tall tree and warned in a loud voice that the Heavenly King would give the couple one day to reconsider the marriage proposal. If the proposal was not accepted, the family would be destroyed. As the rich man peered out the window, the toad released the string and the hawk soared through the sky with the lantern tied to its foot. Convinced that the message was truly from Heaven, the man resolved that one of his daughters should marry the toad. The oldest two daughters refused, but the youngest agreed. On the wedding night, the toad asked his bride to cut the skin on his back using a pair of scissors. She made a long slit along his back, and out stepped a handsome young man.

To keep his cover, the next morning the bridegroom donned his toad skin. At noon all the men from the village left for a hunting trip on horseback, bows and arrows in hand. The toad joined them on foot, without weapons. After the hunting party returned home empty-handed, the toad, still in the forest, waved his hand and a white-haired man appeared. The toad bade the old man to bring 100 deer, which he did, and the toad drove them to the village. Once home, he stripped off his toad skin. Everyone was startled to see the deer and even more shocked to see the handsome young man. The bridegroom rose to Heaven, carrying his bride and his foster parents with him.

Some transformation stories go in reverse—a person gets changed into a frog or toad as punishment. In the Italian tale "Those Stubborn Souls, the Biellese," one stormy day a farmer journeyed to Biella. He passed an old man, who greeted him, saying, "A good day to you. Where are you going in such a hurry?" Without slowing down, the farmer answered that he was going to Biella. The old man responded, "You might at least say, 'God willing.'"

The farmer snapped, "Even if God isn't willing, I am still going to Biella." Now it just so happened that the old man was God . . . and he wasn't happy. God instructed the farmer to jump into a nearby swamp and stay there for seven years. Then he could go to Biella. And with that, the farmer turned into a frog and jumped into the swamp.

After seven years, the frog emerged from the swamp, reverted to a man, and

continued walking to Biella. The farmer soon met the old man again, who asked him where he was going. "To Biella," the farmer answered.

Again the old man said, "You might at least say, 'God willing.'"

Without missing a beat, the farmer said, "If God wills it, great. If not, I know the routine and can return to the swamp unassisted."

Another type of frog transformation story tells of change from ugliness to beauty, as for example in the Peruvian tale "The Little Frog of the Stream." The story involves three characters. A frog that lived by a stream, seeing herself as ugly, longed to be beautiful like her brothers and sisters. Along one side of the stream rose a majestic mountain where Condor, King of Birds, lived. Condor had a servant, a little shepherdess he had kidnapped named Collyur, whose name meant "Morning Star."

One morning, Collyur begged Condor to let her wash her clothes in the stream. At first Condor said no, fearing she might escape. Collyur argued that as long as he could hear her beating clothes against the rocks, he would know that she had not run away. Condor relented. Collyur carried her clothes to the stream and, sobbing, began to beat them against the rocks. A voice interrupted her crying: "Don't despair. I will help you." Collyur looked around and saw a frog, the one who thought she was ugly, perched on a rock. The girl admired the frog's kind eyes and sympathetic voice. The little frog told Collyur that she possessed magical power that allowed her to transform into the body shape of anyone she wanted to help. She offered to assume Collyur's form and beat the clothes on the rocks. Meanwhile, Collyur should run to her parents' home.

After thanking the little frog and kissing her on the forehead, Collyur ran home. Meanwhile the frog-turned-Collyur beat the clothes against the rocks. After a time, Condor flew to the stream and squawked for Collyur to return. The frog-turned-Collyur walked into the water, transformed back into a frog, and disappeared. Condor shrieked for Collyur to come back but saw only his own reflection in the water. Enraged, he flew back to his mountainside.

When the frog returned home, she saw surprised looks on her brothers' and sisters' faces. "What is it?" she asked.

They answered, "You have a beautiful star-shaped jewel on your forehead." Sure enough, in the spot where Collyur had bestowed her thank-you kiss, the frog now wore a jewel resembling the morning star. From that day on, the little frog was called Queen of the Stream, and she never again worried about her looks.

We seem to be obsessed with the notion of frogs representing change and rebirth, as we keep inventing new versions of the transformation story. The 2009 Walt Disney animated movie *The Princess and the Frog*, set in 1920s New Orleans, incorporates Voodoo spirits and an unusual twist: after the female heroine kisses a prince who has been turned into a frog by an evil witch doctor, she becomes a frog herself.

Frogs symbolize rebirth in people's spiritual lives, used as a "familiar" (a personal spirit or totem companion) for effecting change and improving personal conditions.

In *Animal Magick*, Deanna Conway describes how to work with familiar animals for spiritual growth from a European pagan perspective. She describes the "magickal" attributes of frogs: "A symbol of initiation and transformation. Cleaning out negativities and distractions and replacing them with positive energy. Joy in a new cycle of life. Being reborn after a period of seeming-death, when undergoing an initiation of transformation. Beginning a new life cycle by dispensing with negative thoughts and deeds." To better understand and incorporate frogs' powers during rituals and visualization, Conway suggests reciting the following power chant:

5.5 Frogs: a symbol of rebirth. Pictured here is a horned marsupial frog (*Gastrotheca cornuta*).

> *Your singing marks the season*
> *Of new life and new beginning,*
> *A time of wonder and of joy,*
> *A time of rebirth and of Light.*
> *Like the tiny frog in Spring renewing,*
> *I joyfully face my new beginning.*
> *Boldly stand upon the threshold,*
> *And leave confusion for the Light.*

Snakes and Rebirth

The outermost layer of a snake's skin, dry and covered with scales, must be shed periodically for a snake to grow. A few days prior to shedding ("ecdysis" in scientific terminology), a snake becomes lethargic, its colors dull, and its eyes assume a cloudy appearance. After the milkiness clears, the old skin begins to peel around the jaw edges, and the snake typically rubs its head on a rock, the ground, or a log. The paper-thin skin folds back, and the snake literally crawls out of its old skin, turning it inside-out in one piece. The shedding process can last several hours. Depending on the kind of snake and environmental conditions, a snake sheds every few weeks or months. Because of their periodic shedding, snakes have long symbolized renewal.

As a symbol of renewal, the ancient Greeks associated the snake with health. By shedding its skin, a snake becomes young and well again. According to legend, Asclepius, the Greek god of healing, learned the secrets of healing and immortality

5.6 Snakes symbolize rebirth and renewal because they literally crawl out of their old, lackluster skins and seemingly become young again with transformed, shiny scales. *Top:* Western coachwhip (*Coluber flagellum testaceus*) shedding; *bottom:* shed snakeskin, hung up in the bushes.

after watching a snake deliver herbs to a fellow snake. Asclepius served as a great healer, bringing people back from the brink of death, until Zeus, father of the gods, killed Asclepius with a bolt of lightning to prevent him from allowing humans to become immortal. The Greeks depicted Asclepius with a snake entwined around his staff. Beginning in about 300 BCE, the cult of Asclepius became popular in Greece. Snakes participated in healing rituals, and non-venomous snakes crawled on the floor in buildings where the sick were attended. Still today, the staff with its coiled snake symbolizes the Western medical profession.

The Lernaean Hydra myth reflects the ancient Greeks' belief that snakes can rejuvenate. An enormous, nine-headed serpent, the Hydra had breath so foul that anyone who inhaled it keeled over dead. As the second of Heracles' twelve labors, King Eurystheus sent him to kill the Hydra. Every time Heracles cut off one of the Hydra's heads, two more grew back in its place. Finally, Heracles cauterized the base of each head as he chopped it off, and he buried the middle head—the immortal one—under a rock.

Fast-forward to the twentieth century. While studying religious snake-handling in the 1950s, the Freudian-oriented American anthropologist Weston La Barre noted the abundant folklore featuring immortality of snakes based on their ability to shed their skins. He speculated that as part of the human search for eternal life, at some point we concluded that the snake purchased immortality by sacrificing part of itself—by sloughing its skin. Early humans must have wondered how they likewise could purchase everlasting life. The solution: circumcision. In their book *Venomous Reptiles*, Sherman Minton and Madge Minton write of La Barre's hypothesis:

> Man observed that his penis not only resembled a snake but had some magic powers of its own, so he excised his foreskin in an effort to emulate the snake and gain immortality. This symbolic act did not win for him his immediate objective, but he was loath to surrender his expectations and eventually rationalized his failure by assuming that God's original plan had gone awry. Clearly He had meant that man should be immortal, but somewhere along the line a serious mistake had occurred, and the snake had cheated man of his birthright.

The practice of circumcision seems to have originated in ancient Egypt, but why it began is anyone's guess. One speculation is that it may have been a ritual of rebirth among snake worshippers. Still today, in many cultures circumcision marks the rite of passage—rebirth—of a young male from adolescence to manhood.

Whether you buy La Barre's speculation or not, people worldwide have asked: "Why do snakes seem to live forever, but we do not?" Diverse cultures have concocted the same story: Snakes tricked humans out of immortality and kept it for themselves. Recall the tale of the Wafipa from Tanzania (chapter 2). A similar story is told by the Hutu and Tutsi from Rwanda. A long time ago, Imana, the Supreme Being, informed a chosen man that he should not sleep that night, as he, Imana, would bring the man

renewed life. A snake overheard the conversation. The man accidentally fell asleep that night, and the snake received Imana's message: "Although you will die, you will be reborn; although you will grow old, you will shed your skin. And it will be so for all your descendants." When the man awoke and waited but did not receive Imana's message, he asked Imana why he had not come. Imana realized that the snake had taken the man's place and received the message, but he could not undo what he had said. Ever since, people die and snakes shed their skins and are reborn. This tale concludes that in consolation, Imana declared that people would henceforth kill snakes—an act that continues today.

Ecdysis is more obvious and impressive in snakes than in frogs. Thus it's no wonder that snake transformation tales reflect their uncanny ability to crawl out of their skins, whereas frog transformation stories more often reflect their metamorphosis. Snake transformation tales assume many forms, with snakes playing both "good guys" and "bad guys." Because of the association of snakes with the phallus, snake transformation stories frequently involve lust and sex. The Ifugao of Luzon in the Philippines believe the Philippine cobra (*Naja philippinensis*) to be a were-snake, transforming itself into female human form to enslave men's souls and hasten their demise. On the Arabian Peninsula, Bedouins say that the desert cobra (*Walterinnesia aegyptia*) calls with a woman's voice and lures men to their death.

Other snake transformation stories involve love. "The Fairy Serpent," a Chinese tale, begins with a man bringing home flowers every day for his three daughters to use as embroidery patterns. One day as he roamed the woods searching for flowers, he unknowingly invaded the fairy serpent's home. The angered serpent refused to release the man until he promised one of his daughters in marriage. After returning home, the man told his daughters of his promise. The elder two daughters refused to marry the snake, but the youngest daughter agreed to marry the fairy serpent—someday.

One day as the girls were embroidering, a wasp flew into the room and sang, "Who will wed the snake?" The girls stuck him with their needles, and he fled. The next day, two wasps sang the same song. Again the girls stabbed the wasps, and they fled. The next day, three wasps came, then four, and so on until finally the girls couldn't stand the irritating buzzes. The youngest daughter agreed to marry the fairy serpent—immediately.

The youngest daughter found silk clothes and jewels in the serpent's palace, which was built especially for her. She admired the snake's eyes, but she found his skin objectionable. At first she wondered how she could live with this husband, but in time she forgot that she had once found him repulsive.

One day, the young woman found her husband dying of thirst. As she poured water on him, he arose and transformed into a strong, handsome man. The girl's kindness had broken the wicked fairy's spell and freed him from his snake guise.

As an example of royalty from India who often traced their ancestry to serpents,

5.7 As formidable animals, cobras were sometimes chosen as assumed ancestors for royalty from India. Here, an Indian cobra (*Naja naja*) threatens in a spread-hood stance.

the rulers of Nagpur claimed to be descendants of a serpent god who loved a guru's daughter. To win the girl's love, the serpent god turned himself into a handsome prince. After they were married, she complained bitterly about his foul breath and grew suspicious about his forked tongue. Angry about her complaints, he transformed back into his cobra form and plunged into the palace pool. She was so shocked and frightened that she died of premature labor. Others at the palace found the newborn infant on the grass, guarded by a huge cobra. The dynasty that was descended from this infant adopted a crest that featured a cobra with a human face.

Some people value snakes as spiritual familiars because of their association with rebirth. For example, adders, the only venomous snakes found in much of northern Europe, are believed to be capable of effecting change. In *Animal Magick*, Deanna Conway describes the "magickal" attributes of adders: "Shedding something in favor of something better. Wisdom, cunning, reincarnation. When needing to get rid of a person, situation or attitude that is holding you back." Conway suggests reciting the following power chant during rituals and visualization:

I watch you shed the old for new,
Little adder, as you renew your skin.
Like you, I shed old things for new,
Another cycle to begin.

And so we see through our folktales and traditional beliefs that frogs and snakes play prominent roles that reflect their "magical" abilities to be reborn. All of us experience major changes during our lives and emerge from crises in transformed states, so perhaps we feel a kinship with these animals on some level. The phenomena of metamorphosis and ecdysis have long fueled our imaginations and encouraged us to daydream of the possibility that we, too, might enjoy a second chance at life.

Look at a tadpole superficially, and it's nothing but mouth, guts, and tail. Look at the tadpole in detail, and it's still mostly mouth, guts, and tail. The magical transfor-

5.8 Do you suppose cave children raised tadpoles in rock pools and marveled at the end products? I like to think they did, and I'll bet they found the transformation just as magical as I did raising tadpoles as a kid. How fun to watch a tadpole erupt its front legs, passing from the stage in the top image to the one in the bottom image!

mation from tadpole to frog turns an algae-eating, swimming blob with a finny tail into a big-mouthed, leaping predator with no tail at all.

Naturalist William Beebe shares his experience with anuran metamorphosis in *Edge of the Jungle*. Beebe scooped up four tadpoles from a pool in the Guiana jungle. The largest of the four he named Guinevere. "She was waited upon as sedulously as a termite queen. And she rewarded us by living, which was all we asked." Beebe described Guinevere as a "mumbling mouth and an uncontrollable, flagellating tail, connected by a pinwheel of intestine." Less than three weeks later, Guinevere's hind legs had become miniature but perfect frog's limbs.

He describes how Guinevere appeared days later: "Looking at her from above, two little bulges were visible on either side of the body—the ensheathed elbows pressing outward. Twice, when she lurched forward in alarm, I saw these front limbs jerk spasmodically; and when she was resting quietly, they rubbed and pushed impatiently against their mittened tissue." Beebe left the aquarium to eat lunch, and when he returned he found that Guinevere had become a quadruped. "Here in this little glass aquarium the tadpole Guinevere had just freed her arms—she, with waving scarlet

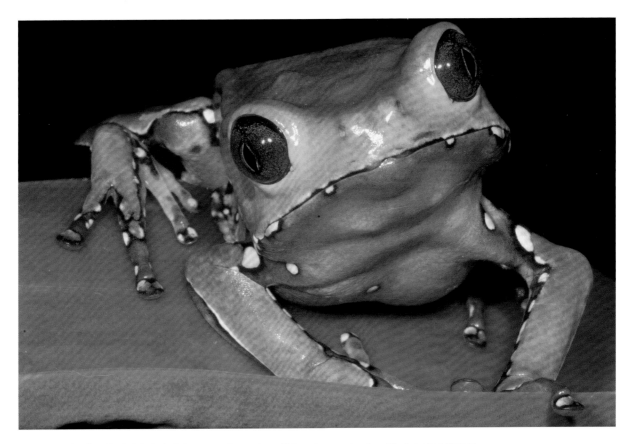

5.9 Naturalist William Beebe's tadpole Guinevere metamorphosed into a giant monkey frog (*Phyllomedusa bicolor*).

fins, watching me with lidless white and staring eyes, still with fish-like, fin-bound body. She danced upright, with new-born arms folded across her breast, tail-tip flagellating frenziedly, stretching long fingers with disks like cymbals, reaching out for the land she had never trod, limbs flexed for leaps she had never made." By six o'clock the next morning, Guinevere had metamorphosed into a giant monkey frog (*Phyllomedusa bicolor*).

Now, imagine if we could crawl out of our skins and be rejuvenated like a snake. No more Botox injections to prevent wrinkles! No more anti-aging creams to fade those brown spots! No more worries about sagging skin and frown lines! Many of us have come across shed snakeskins abandoned on the ground or entangled in a bush. The snake's perfect ghost remains behind while the resurrected being, glistening in its newfound garb, is off somewhere else. Muscles expanding and contracting. Heart beating. Tongue flicking.

An even bigger thrill is to stumble across a snake in the process of being reborn, as reflected in Raymond L. Ditmars's enthusiastic description of a shedding blacksnake: "The eyes become white, like bubbles filled with smoke. Then they clear as an oily secretion forms under the old epidermis loosening it over the entire body." The snake rubs against a rock and pushes the loose skin back over its jaws, "then crawling forth catches the moist, tissue-like garment in the stubble and slowly crawls out of it, turning it wrongside out the entire length of the body clear to the tip of the tail. . . . The skin slips backward and delicate as it is there is not a tear. It is an exquisite job, skillfully and slowly performed."

It seems ironic that these animals that represent a second chance—frogs and snakes—are depicted as contemptible, evil, and dirty in our transformation stories. Perhaps this apparent contradiction is yet another example of our complex real-world perception of frogs and snakes as simultaneously good and evil.

6

Of Love, Morals, and Death
Amphibians and Reptiles in Folktales

Men noticed very early that women regularly and mysteriously bled from their genitals in a manner that suggested they were snakebitten. However, women seemed to suffer few ill effects at such times, though they might reject males and wander off by themselves. Men suspected that their women might actually be consorting with snakes—perhaps sharing their magic secrets and practicing mystic rites of their own. They began to feel afraid of women and to develop a deep dread of menstrual blood.

—SHERMAN A. MINTON JR. and MADGE R. MINTON, *Venomous Reptiles*

Folktales reflect our observations, questions, and pondering about the world around us. This chapter focuses on tales of love (and lust), ethical behavior, and the origin of death. The stories shared here reinforce the fact that we view amphibians and reptiles as both good and evil.

Humans have long tried to understand death, reflected in worldwide folklore that explains why we die. I imagine that in many cultures these tales are told to children as they experience the deaths of loved ones and pets. I wish I had thought to share a death folktale years ago when my eight-year-old son lost his pet iguana, Iggy. Rob assumed a stoic front, but the pain in his eyes betrayed his emotions. He was devastated. Iggy was his first pet and his first intimate experience with death. Why did Iggy have to die? What was this irrevocable thing—death?

6.1 Ivan, a 10-year-old pet green iguana (*Iguana iguana*), has the run of the house—under supervision. He is nosy (one step up from curious), begs to have his head and jowls stroked, and loves dandelion greens and cilantro.

Another popular folktale is the fable—an animal tale that conveys a moral. Fables generally involve talking animals, often in humorous situations. Through understanding the animals' thoughts and emotions, we learn societal values and appropriate behavior—how to treat ourselves, other people, other animals, and the environment. Why are fables so effective in conveying morals? Recently, while reading story after story to Fionna, I realized all over again how strongly children empathize with animals that feel badly or are in trouble. Fionna's sighs and worried brow revealed her compassion. Both children and adults relate to these stories because we see ourselves reflected in the animals' behaviors. Fables teach without being preachy.

And what about those tales of love? As the quote at the beginning of the chapter suggests, snakes and human fertility/sexuality have long been interwoven. I'll focus on snake/love tales here. Many tales have male snakes raping, seducing, or falling in love with women; others have female snakes seducing or falling in love with men. In some tales, the snakes are snakes; in others, the snakes are men or women disguised

as snakes. Some tales titillate our imaginations; others involve transformations and teach us to be tolerant and compassionate; while still others inspire us as love stories. These tales reveal that whether snakes are cast in positive or negative ways, they are always portrayed as powerful.

Snakes as Seducers and Lovers

Both menstrual blood and snakes are feared, but the combination is brutal. The Yuki of California believe rattlesnake venom to be the deadliest of all toxins because it contains menstrual blood. Some Navajo and Pueblo from the southwestern United States believe that rattlesnakes bite menstruating women because they are so offended by the smell of blood. Young Greek and Italian peasant women experiencing their first menstrual cycle are told not to wander in the vineyards for fear of attracting snakes. A folk belief in northern Argentina warns that when a menstruating woman combs her hair, she must quickly burn the loose hairs before they turn into venomous snakes. Bolivian Quechua tales tell of snakes attracted to the vaginas of sleeping or drunk menstruating women. In one tale, a snake rapes a woman and feeds on her menstrual blood. After the woman aborts a brood of baby snakes, the culprit is discovered and bludgeoned. There's not much question how this tale portrays snakes!

In a tale from the Caribs from northern South America, one day a large snake violated a menstruating woman as she bathed in a pond. Afterward, every day she gathered a bag of seeds from a tree, but she never took an ax to chop branches. After a while, her brother secretly followed her. He watched a snake slither from her vagina, climb the tree, and turn into a man. There the man shook down the seeds, after which he reverted to a snake, crawled back down to the ground, and slithered back into the woman's vagina. The next day, the woman's brother returned with his friends. They attacked the snake as it crawled back down from the tree and cut it into small pieces. After the woman buried the pieces under fallen leaves, each piece grew into a Carib. The story ends well, as that is how the Caribs came to be—created from bits of the phallic snake.

With our fear of snakes, it's no wonder people worldwide imagine that snakes seduce and violate women. Intercourse between maidens and serpents is an often-repeated theme in tales told by aboriginal tribes in India, where, inevitably, the woman's outraged relatives kill the snake, but not before he fathers little serpents. A widespread South American myth warns women not to bathe in lakes and ponds lest water snakes violate them (the Carib story is just one of many). Young Japanese girls are told not to nap in the fields because snakes might crawl into their vaginas. Once inside, supposedly the snakes cannot be extracted because of the orientation of their scales.

In ancient Japan, people believed that supernatural venomous snakes guarded volcanoes. When warriors were away from their villages, these snakes morphed into

human form and seduced the warriors' wives. This belief led whole villages to claim descent from snakes, an assertion reinforced because babies were sometimes born with dry, scaly skin. Although ophidian ancestry makes a great story, the condition was probably caused by the skin disease ichthyosis, so named because the thickened or flaking skin resembles fish scales. Because ichthyosis is an inherited genetic condition, small villages where inbreeding was common might have experienced high frequencies of the disease.

The Cubeo of Colombia fear boa constrictors, which are perceived as lustful. Cubeo women give birth in their manioc gardens, and any difficulties they experience during childbirth are blamed on boas. Worse yet, when a woman dies during childbirth, she is assumed to have fornicated with a boa. When the snake comes to fetch his newborn child and discovers it is human, he carries away the mother's soul. The Cubeo also warn that boas rape menstruating women at the riverbank and father broods of snakes. I find this perception of boas intriguing, because the Cubeo believe their people began as anacondas and became human when they shed their skins (chapter 2). They are proud of their anaconda ancestry, so why should they perceive boa constrictors so differently?

Snakes are often associated with women because of their curvy, sensuous bodies, and, in fact, many folktales tell of snakes posing as females to seduce men. In Hindu mythology, female cobras masquerade as seductive women who sexually attack men. In Tatar folklore from Eurasia, the legendary creature Yuxa is a 100-year-old shape-shifting snake that turns into a beautiful woman who seduces men so she can bear children. Succubus demons from medieval mythology, often depicted with wings and snake-like tails, appear at men's beds at night to seduce them and suck their energy or blood.

Many cultures in both the New and Old Worlds warn of the dangers of female sexuality, and snakes often feature in these tales. An extreme example of male paranoid fantasy is the widespread folk belief in the *vagina dentata* (toothed vagina), found in Hindu, South American, and other cultures' mythology. (It also is the focus of a 2007 comical horror film *Teeth*.) The theme of *vagina dentata* tales is that certain women house teeth in their vagina, capable of dismembering their partners' privates during intercourse. The myth is sometimes told as a warning for men to avoid sex with unfamiliar partners and to discourage rape. One version of *vagina dentata* told by Tsimshian and Kwakiutl Indians of the northwestern Pacific coast (United States) tells of a woman whose vagina is a rattlesnake's mouth. Her vagina reverts to human form when a tribal hero chews an herb and spits on her genitals. In another Native American legend, female spirits entice lonely hunters. During intercourse, the men die from live rattlesnakes that live in the spirits' vaginas.

Not all snake-human love tales depict snakes as evil. Snakes are portrayed as good in the oldest-known Japanese snake lover tale, recorded in the eighth century. After a beautiful girl named Ikutama yori-hime becomes pregnant, she tells her par-

ents that an unknown, handsome lover has been visiting her. To identify the lover, the girl's parents tell her to sew a hemp thread to the hem of his garment. In the morning, she should follow the thread. The girl does this and finds that the thread passes through the keyhole of her bedroom door. She follows the thread to the shrine of the deity of Mount Miwa, a sacred mountain. The girl's lover turns out to be the Miwa deity Omononushi in snake form. Ikutama yori-hime bears a half-god, half-human son, who becomes the first priest of the shrine. From then on, his descendants served the shrine, explaining the presumed semi-divine ancestry of the family that guarded the shrine in ancient times.

In some folklore, snakes appear as women who live with men but are not recognized as snakes. In a popular Japanese tale, a man saves a snake from being killed. That night a beautiful woman comes to his home. She has lost her way and asks to spend the night. The man takes her in, falls madly in love with her, and asks her to marry him. She agrees on one condition: that he not look into the room while she is giving birth to a child they might have. The couple lives blissfully for many months, and the woman brings good luck and prosperity. When time for the woman to give birth, she retires to the birthing hut. Peeping through the cracks in the wall, the man is horrified to see that his wife has become a snake. When the woman realizes that her husband has seen her in her true snake form, she returns to her water world because the taboo has been broken. Good luck vanishes from the home.

6.2 The open mouth of a rattlesnake, fangs rotated, makes the perfect *vagina dentata*! Pictured here is the eastern diamondback rattlesnake (*Crotalus adamanteus*).

In a similar European folktale, Raymond, lord of a castle, encounters a beautiful woman in the forest. He asks her to marry him, and she consents on one condition: that he never enter her chamber on Saturdays. If he does, all the prosperity and blessings that she gives him will vanish. He agrees, they marry, and all goes well for several years except that their children are born with deformities—the first has three eyes, another has a lion's foot growing out of his cheek, and a third bears a huge tusk. One Saturday Raymond spies on his wife while she is bathing and sees that she has a snake's body from the waist down. She forgives him for his broken promise, but later when he calls her a "vile serpent" in front of his court, she leaps out the window. Her falling body transforms into a winged dragon and disappears into the sky. Raymond loses his wealth and happiness. Such is the power of the snake.

Some snake-human folktales are sentimental love stories, such as the Indian tale "The Girl Who Married a Snake." A Brahmin and his wife longed to have a child.

6.3 In a popular Japanese tale, when the snake-woman's husband sees his wife in her true snake form, she returns to her water world and good luck vanishes from the home.

Eventually, the wife gave birth, but instead of an infant human, it was a baby snake. Everyone tried to convince the couple to dispose of the creature. The mother refused and lovingly cared for her son. Once the snake grew to adulthood, the mother wanted to find him a bride. Her husband searched the countryside, without success, for a woman who would marry a snake. In time, he visited his best friend, who promised his beautiful daughter's hand in marriage. The Brahmin urged his friend to first meet his son, but the friend insisted it was not necessary. The girl kept her father's word, and the couple married. She lovingly cared for her new husband, who slept in a box in her room. One night, the girl found a handsome man in her room. Frightened, she started to run away. The man climbed back into his snakeskin to prove he was her husband. And that began a new pattern: every night her husband shed his skin,

and they spent time together as man and wife. Every morning he slipped back into his snakeskin. One night the father heard noises coming from his daughter's room. He peered through a crack and watched the snake turn into a handsome man. The father dashed into the room and tossed the snakeskin into the fire. His son-in-law thanked him, explaining that he was now freed from a curse that forced him to live in the snakeskin. The antidote was someone destroying the skin without being asked to do so.

Play by the Rules

Many fables have been told and retold for more than 2,000 years. They never lose their charm because they illustrate truths that anyone, anywhere, can recognize. The stories, and their lessons, stick in our minds. Amphibians and reptiles appear in many fables, though the reason for their presence isn't always obvious. Some stories incorporate real characteristics, such as frogs' skittishness and turtles' slow movement, or real sentiments, such as human distrust of snakes. Other fables could feature any of a great number of animals to make the point. Whether the behavior displayed in the fable is real or imagined isn't important. What matters is that we relate to the animal and learn a lesson.

Aesop, a Greek who lived from about 620–564 BCE, won his freedom from slavery through his wit, intelligence, and storytelling. Once freed, Aesop traveled extensively and continued to compose fables. (Some say no such person existed, and the tales we call Aesop's fables were told by several people.) The following five herpetological fables are attributed to Aesop. Their morals are self-evident.

The Boys and the Frogs

One day a gang of boys threw pebbles at frogs swimming in a pond. The frogs panicked. Several were killed. One brave frog poked his head above the water and shouted, "Before you throw any more stones at us, stop and think about what you are doing. It might seem like sport to you, but to us it is a matter of life and death."

The Frog and the Ox

While eating grass in a swampy meadow, an ox tromped on some frogs. One frog escaped and hopped back to his mother. He croaked, "Mother, the biggest animal I've ever seen crushed and killed some of my brothers and sisters."

Mother puffed herself up with air and asked if the animal was that big.

"Oh, much bigger," said her little one.

Mother puffed herself up even bigger. "Now?" she asked.

"Oh, a hundred times bigger."

Angered at the thought that any creature could be bigger than herself, Mother frog sucked in a huge breath, filled her lungs, and thought, "Bigger, bigger," until she burst.

The Hares and the Frogs

One day some hares decided that life was not worth living. Men shot arrows at them; dogs chased them; eagles carried them off for dinner. To end their misery, they hopped down to a lake to drown themselves. A family of frogs sunning on the bank leaped into the water. One hare declared, "Things aren't as bad as we thought. We lived in fear because we thought that everyone else was bigger and stronger than we are, but these frogs were afraid of us! Let's try to be as big and brave and strong as they think we are!"

The Tortoise and the Hare

When speedy Hare makes fun of poky Tortoise, the reptile challenges the hare to a race. Hare agrees, confident he will win. Of course, Hare quickly leaves Tortoise behind in the dust. Hare is so sure he will win that he naps midway through the course. Tortoise plods on. When Hare awakes, he discovers Tortoise already past the finish line.

The Farmer and the Snake

One snowy evening, a farmer found a snake lying cold and stiff by the roadside. Feeling sorry for the animal, he picked it up, took it home, and warmed it by the fire. The snake wriggled, raised his head, and flicked his tongue in and out. Suddenly he darted forward and bit the youngest child in the leg. The farmer asked the snake, "Why do you repay my kindness in this way?"

The snake answered, "You and I are old enemies, so why should you trust me? Why should I forget our relationship just because you are soft-hearted?"

The farmer sputtered, "I know better now!" as he killed the snake.

Moving from Aesop to more recent storytellers, one of my favorite frog fables is the Tlingit story "The Woman Who Married a Frog," in which "ugly" frogs remind us that excess pride has consequences. The story begins with a chief's daughter who thought she was too good for all the men vying to marry her. One day, while walking with her sister along a lakeshore, she picked up a muddy frog. "You're so ugly, even another frog wouldn't marry you!" she declared, and tossed the frog into the water. That night she saw a handsome man, decorated with green beads. He asked her to go with him to his father's house, for he wanted to marry her. She agreed, because he was the most

handsome man she had ever met. They walked to the lake and disappeared beneath the water's surface.

The next day the young woman's family saw her footprints leading to the lake and assumed she had drowned. They held a death feast. In the spring, a man saw frogs congregated on the lakeshore, with the chief's lost daughter in the center of the group. When the man approached the frogs, they leaped into the water carrying the young woman with them. The man reported back to the chief, who, with his wife and other daughter, hurried to the lake. When they approached, again the frogs disappeared with the young woman. The other daughter explained, "Because she insulted the Frog People by calling them ugly, they have taken her."

The chief begged the frogs to forgive his daughter, and he offered them food and robes. The Frog People accepted the gifts but refused to release the young woman. In desperation, the chief and others dug a trench to drain the lake. The frogs fought hard to refill the trench with mud, but the chief of the Frog People realized it was hopeless and returned the young woman to her parents.

For a long time the young woman could speak only in frog language: *"Huh, huh, huh."* When she eventually spoke Tlingit again, she revealed, "The Frog People understand our language, so we must not insult them." From that day on, the people respected the frogs. Still when the people hear frogs calling, they say that the Frog People are telling their children about the story of the young woman who married a frog.

In a Chinese tale, one day a boy found an egg and took it home. It hatched into a small, thin snake. Years later, before the young man left home to seek his fortune, he asked the snake for a gift in return for the tender care he had provided over the years. The snake spat out a huge, precious pearl. The young man took it to the capital and offered it to the emperor. In gratitude, the emperor appointed the young man chancellor, his second in command. But now the young man was discontent because he had no pearl. He returned home and asked his former pet for a second pearl. The snake opened his mouth wide. Thinking the snake was about to spit out another precious pearl, the chancellor stepped forward. The snake swallowed his former owner. Although any of a number of predatory animals could have conveyed the fable's lesson about generosity, perhaps the snake was chosen because people both revere and fear them.

As in other types of folktales involving crocodiles, the predaceous nature of these "bad guy" reptiles provides the action in fables and reinforces the negative stereotype of the animals. The Vandau of South Africa tell of a large crocodile that killed sheep, cattle, and their herders. The king called a meeting of his frightened subjects and his chiefs to discuss how they could kill the villain. Fox came to the meeting and offered: "I wonder why you wait for your enemy to grow big and strong. Do what I do: Eat crocodiles while they are still in their eggs. Kill your enemy before he is stronger than you are."

6.4 The Mandarin rat snake (*Euprepiophis mandarinus*) might have served as the model for the Chinese tale of the snake that spat out a pearl in return for tender care over the years. Here, one is emerging from its egg.

Many monitor lizards are large and intimidating, and some are drab in color. As such, they provide a great protagonist for a story from the Luo of Kenya and Tanzania that encourages compassion. Opondo's wife continually gave birth to monitor rather than human babies. The couple discarded each hideous lizard. One day, however, Opondo and his wife kept the baby monitor. He thrived and as a teenager loved to bathe alone in a river. Each time before jumping into the water, he shed his skin. While swimming naked, he was a normal-looking boy; his skin was merely a superficial covering. One day a passerby saw the boy swimming and told the boy's parents. Opondo and his wife secretly watched their son swim and saw that he was truly human. They destroyed their son's skin, and from then on everyone in the community accepted and loved the boy. Opondo and his wife deeply regretted having thrown away all of their other monitor children simply because they had appeared different.

Another monitor tale, this one from Komodo Island, Indonesia, says that a long time ago a mythical dragon princess named Putri Naga lived on Komodo. She married a man and gave birth to twins. One, a boy named Si Gerong, was raised among people. The other, a female baby Komodo dragon named Orah, grew up in the forest. Neither

6.5 Although Komodo dragons are frightening, the legend of Putri Naga convinces some Komodo islanders not to harm their resident giants. Here, two male Komodo dragons fight in a territorial battle.

knew about the other. Many years later, after Si Gerong shot a deer in the forest, a large monitor seized the deer. The young man tried to chase the lizard away, but the monitor bared its teeth and hissed. Just as Si Gerong raised his spear to kill the lizard, Putri Naga appeared and told him not to kill it. "She is your sister, Orah. I bore you together as twins. Consider her your equal." The myth continues that from then on, the Komodo islanders treated the monitors with respect and kindness, even feeding aging "brothers" who could no longer feed themselves. To this day, some people on Komodo believe that if a dragon is harmed, its relatives who appear in human form will also be harmed.

Why Do We Die?

Worldwide, folktales suggest that death is unnatural and is the fault of some animal. Often amphibians and reptiles serve as the scapegoats. Snakes, especially, have long been blamed for the fact that people die.

A passage from the Babylonian heroic epic poem *The Epic of Gilgamesh*, one of

the earliest known works of literature at more than 4,000 years old, tells how Gilgamesh, king of Uruk, yearned to overcome death. After learning of a magical rejuvenating plant at the bottom of the ocean, Gilgamesh bound heavy stones to his feet and walked the ocean bottom. He found the plant, cut the stones from his feet, and bobbed to the surface. Gilgamesh planned to take the plant to Uruk, give it to the old men, and eat some of it himself to restore his youth. That night, Gilgamesh stopped to bathe in a well of cool water. A serpent lying deep in the water sensed the sweet plant, arose from the water, and stole it. As the snake departed with the booty, it shed its skin. Gilgamesh wept, for he knew he had lost all chance of immortality. In a strange twist of fate, however, Gilgamesh got his immortality, for his story is one of the oldest the world knows.

In a Greek myth told by the poet Nicander (second century BCE), after Prometheus stole fire from the sky, mortals betrayed him and told Zeus. In gratitude, Zeus sent humans a donkey carrying the herb of immortality. The donkey stopped to drink at a river guarded by a snake. In return for the water, the snake demanded the donkey's load. The snake ate the herb of immortality, and to this day the snake has eternal youth while people grow old and die.

African folklore tells many stories of amphibians and reptiles being blamed for humans' mortality. I'll use a variety of African stories to illustrate the taxonomic diversity of the scapegoats as well as the different ways these animals are perceived. I suspect cultures that blame these animals for death view the animals less favorably than they might otherwise. For example, upon hearing that people die because of a frog's action a long time ago, a child might dislike frogs. But the relationship works the other way as well. Storytellers probably chose as whipping boys those animals that were not particularly admired by the culture in the first place.

According to the Efe from the Democratic Republic of the Congo, the Supreme Being Muri-Muri gave a heavy pot to a toad. Death was shut up in the pot. He told the toad not to drop the pot, for if it broke, people would die. The toad hopped away and met a frog. When the frog offered to carry the heavy pot, the grateful toad handed it over and admonished the frog to be careful. The frog dropped the pot, it broke into fragments, and death escaped. Ever since, humans have been mortal.

A Zande myth from Sudan links people, the moon, a frog, and a toad with death. A human corpse and the moon's corpse lay by an open grave. It was said that if a frog could jump over the grave while carrying the moon, and if a toad could jump over the grave while carrying the human, the moon and people would never die again. The frog successfully made his jump with the moon's corpse, but the toad fell into the grave with the human corpse. Thus, the moon lives forever and people die.

The Kavirondo from Kenya blame the chameleon for snakes' immortality and humans' mortality. One day Chameleon instructed a man to bring him a pot of beer. The man did as told, and the lizard plunged into the beer. After he climbed out, Cha-

6.6 Does the Matschie's dwarf chameleon (*Kinyongia tenuis*) from Kenya look like the sort to demand that a person drink beer in which he, the chameleon, had been swimming? Personally, I don't think we can blame humans' mortality on this animal.

meleon told the man to drink the beer. The man refused because he hated chameleons and believed their skin to be poisonous. In spite, Chameleon declared that all people should die. Just then a snake appeared. Chameleon ordered the snake to sip the beer. After the snake obliged, Chameleon declared that snakes would live forever by shedding their skins.

In some African tales, two animals take contradictory messages concerning immortality to the creator. The message that humans do not want to live forever arrives first. In Togo and Ghana, people tell how Dog was sent to God with the request that when humans died they wanted to be reborn. Meanwhile, Frog took his own message to God that humans preferred not to be reborn after death. Dog dawdled along the way. Frog arrived at God's doorstep first and delivered his message. Soon afterward, Dog arrived and announced that humans desired immortality. After mulling over the dilemma, God complied with Frog's request since he had heard it first. Although humans die and remain dead, frogs die during the dry season and come to life again with the first rains. In robbing humans of immortality, Frog gained it for himself.

The Isoko and Urhobo from southern Nigeria have a dog/toad story that incorpo-

rates overpopulation. Oghene, the world creator, intended for people to live forever. By sloughing their skin, as snakes do, old people would rejuvenate. A problem arose, however. In time, humans overpopulated Earth. Because of its intimate association with people, Dog argued that Oghene should extend Earth's frontiers to accommodate the increasing human population. Toad argued that because space was limited, once a person dies, he/she should remain dead. The people told Dog and Toad to take their views to Oghene. Whoever arrived first would have his view ratified by the creator. The two set out on their race to heaven. Dog soon outran Toad, stopped to eat, overate, and promptly fell asleep. Meanwhile, Toad hopped toward heaven. He arrived and expressed his view to Oghene that people must die. Dog awoke and hurried to heaven, but when he arrived, he found that Oghene had already accepted Toad's view. Oghene's proclamation was binding: Humans would die.

The Bura of Nigeria tell how long ago, before there was death, everyone was happy. One day a man got sick and died. No one knew what to do with the body, so they told Worm to go to Sky and get advice. Sky said to hang the corpse in the fork of a tree and throw mush on it until it revived. After that no one else would ever die. A lizard named Agadzagadza overheard Sky's message. The lizard wanted to deceive people, so he ran to the village and announced that because Worm couldn't travel fast enough, Sky had sent Agadzagadza instead. He gave the message to dig a grave, wrap the body in cloth, and bury it. The people did as told. Once Worm arrived and the people told him that they had buried the body, he relayed what Sky had really said. Worm advised the people to dig up the body and follow Sky's instructions. The people were lazy, however, and declared their work finished. Although the lizard gets blamed for humans' mortality, the tale suggests that people share the blame.

In many African origin-of-death tales, two animals relay opposite messages from God to people. One animal says that God is granting immortality; the other says that humans will die. Only one message ever reaches people, or the first one received takes effect. The chameleon is often blamed for stealing immortality from humans because he walks so slowly. According to the Zulu of southern Africa, God sent Chameleon to people with the message they would not die but would live forever. Chameleon dawdled along the way. He climbed a tree, basked in the sun, filled his belly with flies, and snoozed. Meanwhile, God changed his mind and decided to make people mortal. He sent a different kind of lizard to people with the message that they would die. This lizard scuttled off and quickly delivered his message before Chameleon arrived. The people accepted their fate from the speedy lizard.

Snakes in the scapegoat role of origin-of-death tales are understandable given the widespread dislike of snakes, but why frogs and lizards? Because frogs, lizards, and snakes shed their skins, frogs metamorphose, and lizards drop and regenerate their tails, these animals have long symbolized resurrection and rebirth for many cultures.

6.7 Lizards represent rebirth and rejuvenation both because they shed their skins and because they can regenerate their tails. *Top left:* Trinidad gecko (*Gonatodes humeralis*) shedding skin; *top right:* desert spiny lizard (*Sceloporus magister*) with broken tail; *bottom left:* Tucson banded gecko (*Coleonyx variegatus bogerti*) with regenerated tail; *bottom right:* regal horned lizard (*Phrynosoma solare*) shedding skin.

6.8 For Africans who blame chameleons for humans' mortality, the gaze of this Parson's chameleon (*Calumma parsonii*) might seem sinister.

Storytellers have extended the idea and added a twist: to gain their own immortality, these animals must have stolen it from humans.

Why are chameleons so often the scapegoats in origin-of-death tales? For some of us, they are charming, fascinating animals. In contrast, people from various African cultures consider chameleons poisonous, capable of supernatural powers, messengers of evil spirits, or bad luck. Folklore and the culture that creates the tales and beliefs are inseparable.

In turn, traditional, negative feelings embodied in African folklore influence how people feel about chameleons today. Some Zulu dislike and kill all lizards because the speedy lizard was directly responsible for death in humans. Other Zulu direct their vengeance specifically toward chameleons, blaming them for death because the chameleon messenger dawdled. The chameleon-dawdling tale is told in similar form by other African tribes, again with repercussions. The Ngoni of east-central Africa still begrudge the chameleon for his delay. When a person encounters a chameleon, he or she teases it until the animal opens its mouth. The person tosses a pinch of tobacco onto the chameleon's tongue and watches with delight as the lizard writhes and changes color from orange to green to black as it dies—all to avenge the chameleon's ancient ancestor who robbed humans of immortality.

Imagine listening to tribal elders share these tales of love, morals, and death. Experience the magical give-and-take between storyteller and listener. Feel the tension, resentment, revulsion, and fear. Embrace the joy and wonder. Laugh, giggle, sigh, and whisper. Do some stories reinforce your fear and dislike of snakes? Do others inspire you to empathize and respect snakes? Do you admire the poky old turtle for his persistence? Do you empathize with the ugly frogs and unattractive monitor lizards? How do you feel about the animals that stole our immortality? If you were a member of the respective culture and heard these stories repeatedly, would they influence how you feel about amphibians and reptiles? Think about this last question again as you read the next chapter: tales of tricksters and "how" and "why" stories.

7

The Lighter Side

Trickster Tales and "How" and "Why" Stories

A story about a frog would be biological. A story about a prince would be historical. But a story about a frog-prince is magical and therein lies all the difference.

–JANE YOLEN, *Touch Magic*

Jane Yolen has captured the essence of a folktale in a very few words. Folktales truly are magical, which explains why we love them. They briefly transport adults into the world of fantasy. Children's imaginations allow them to spend much of their time in that world, blurring the lines between magic and reality. Dragons, mermaids, elves, and the tooth fairy are real. When two-year-old Fionna asked her dad if he likes caterpillars, he answered yes and asked if she knew what they turn into. She answered with total conviction, "Of course, caterpillars turn into unicorns."

Join me on another folktale journey around the world. In this chapter, we'll visit trickster tales and "how" and "why" stories, where amphibians and reptiles often play charming, genial, engaging characters. By and large, these two genres offer a lighter side of folklore—not much pondering about the future, not much violence, not much death.

7.1 "Of course, caterpillars turn into unicorns!"

Trickster Tales

Br'er Rabbit, Coyote, Anansi, Loki—all are tricksters who provide comic relief. Although trickster stories are humorous and the characters are clever, amusing, and likable, the tales generally offer insight. Some allow us to see our problems in a different light, convey wisdom, or explain why something exists or happens. Some help us understand human nature or the essence of other animals. Trickster stories are both popular and good at conveying lessons because they are funny. We love to laugh, and we remember humor.

One common trickster theme is a slow-moving animal outwitting a speedy one to win a race. In the tale "Turtle Racing Beaver," told by the Seneca in North America, long ago Turtle lived a wonderful life in the most perfect pond he could imagine. One spring, he overslept his winter hibernation. When he awoke, he found the water much deeper than when he had fallen asleep in late fall, and his pond was twice its normal size. His sunning spot was underwater, and the large alder trees had been cut down and transformed into a dam. Turtle saw a strange, flat-tailed animal swimming toward him and demanded, "What are you doing here?"

The strange animal answered, "I am Beaver. This is my pond. You must leave."

"No, this is my pond," argued Turtle. "I will fight you if you don't leave."

"Good, we'll fight, then," agreed Beaver.

Turtle noticed Beaver's long, yellow teeth. "No, it would be too easy for me to win. Instead we should race from one side of *my* pond to the other. The loser will leave forever." Beaver agreed. Turtle offered, "I'm such a speedy swimmer that I will give you a small head start." Beaver nodded, and Turtle positioned himself alongside Beaver's tail.

Beaver was so fast that Turtle could barely keep up. Halfway across the pond, Turtle grabbed Beaver's tail in his jaws. Beaver felt the pinch but was too busy swimming to look back. He jerked his tail to the right and left, but Turtle hung on. When Beaver was almost to the other side, Turtle bit harder. Beaver swung his tail out of the water to shed whatever was pinching him. As Beaver reached the top of his tail swing, Turtle let go, flew through the air, and landed on shore. As he reached shore, Beaver looked up and saw Turtle waiting. Beaver left and never returned to Turtle's pond.

Another slow-moving trickster is the toad, as featured in the Jamaican story "The Race Between Toad and Donkey." One day the King offered a substantial prize for the winner of a 20-mile (32 km) race. Toad entered the race boasting that he would win. "No way!" Donkey declared. The King proclaimed that every racer should sing out to indicate his position at every milepost so that the King could follow everyone's progress.

The night before the race, Toad gathered up his 20 children, each the spitting image of Dad. He took them to the racecourse, hid one at each milepost, and told them that as soon as they heard Donkey announce his arrival, the toadlet at that position should likewise call out.

Donkey was so confident he would win that he stopped to eat some grass, sweet potato tops, and gungo peas. When he reached the first milepost, Donkey called out, "Ha-ha, I'm faster than Toad."

The first toadlet called, *"Jin-ko-ro-ro, Jin-kok-kok-kok."*

Donkey ran the next mile faster, stopping only to drink a little water. When he arrived at the second milepost, Donkey called out, "Ha-ha, I'm faster than Toad!"

The second toadlet called out, *"Jin-ko-ro-ro, Jin-kok-kok-kok."* Now Donkey worried.

By the time Donkey arrived at the fifth milepost and heard the toadlet's *"Jin-ko-ro-ro, Jin-kok-kok-kok,"* he was very tired from galloping—and very angry. He grew more exhausted and angrier with each milepost until finally he quit, knowing he could not win the race. To this day Donkey trots slowly, defeated by Toad's trickery.

Sometimes pranks backfire. In an African folktale, one day Lion declared that he no longer wanted to be king because sitting on the throne was lonely. He held a race to the throne and declared that the winner would replace him. All the animals wanted to be king. The chameleon knew that the cheetah was the fastest animal, so

he climbed onto the cheetah's tail and clung tightly. Of course, the cheetah reached the throne first. But just as the cheetah prepared to sit, the chameleon jumped onto the throne. Everyone assumed that the chameleon had won the race fair and square, and he became the new king. Several days later, the chameleon regretted his prank as he learned how truly lonely it was to sit isolated on the throne—a story that mirrors a feeling shared by leaders worldwide.

Many frog trickster stories reflect the idea that from small creatures come great beings, as in the Chinese tale "The Frog Who Became Emperor." One day a woman gave birth to a frog. She kept him, though at first she was tempted to dispose of the creature. Years later, the frog announced to his parents, "I know everything under Heaven. Our country is in great danger. We cannot resist the invaders. I must go to the Emperor and save our country."

The father took his frog son to the capital to seek an audience with the Emperor. Once in the city, they read an imperial decree: "We are in danger from invaders. Whomsoever repels the enemy will be granted my daughter in marriage." Without hesitation, the frog tore down the decree and swallowed it. The guard could hardly imagine a frog accepting such a responsibility, but he duly delivered the frog to the palace.

After the frog explained his mission, the Emperor asked how many horses and men he would need to drive away the enemy. The frog answered, "Only a heap of hot, glowing embers." Throughout three days, the frog devoured the glowing embers and then instructed the Emperor to tell his troops to lay down their bows and arrows and open the city gate. As the invaders poured in, the frog spat fire down on them from the gate tower. The enemy fled in panic. Overjoyed, the Emperor made the frog a general and announced a victory celebration.

The frog married the princess. By day he was a frog, but every night in the privacy of their bedroom, he removed his green skin and became a handsome young man. After the princess could not keep their secret and told her father, the Emperor asked his son-in-law, "Why do you wear that horrid frog skin by day?"

The frog answered, "Ah, my frog skin is priceless. It warms me in winter, cools me in summer, and protects me from wind and rain. Most importantly, by wearing it every day, I will live for one thousand years."

"Let me try on the skin!" demanded the Emperor.

Quickly, the frog slipped off the skin. The Emperor removed his dragon-embroidered robe and donned the moist, green skin. Once on, he couldn't take it off. The frog put on the imperial robe and became Emperor. The greedy father-in-law lived the rest of his life as a frog.

A widespread Native American story from North America tells of Turtle going on the warpath. As he crawled into the enemy's camp, someone grabbed him. "Look, Turtle is on the warpath! Let's toss him into the fire!"

"Great! I'll kick out hot coals and burn you," said Turtle.

"Okay, then, we'll toss you into a pot of boiling water," said the people.

"Wonderful," said Turtle. "I'll thrash about and scald you."

"Fine, then, we'll throw you into the river."

"Oh no," gasped Turtle. "Not that!"

"He's afraid of water!" shouted the people, and they threw Turtle into the river.

Turtle surfaced and laughed. "Ha-ha, I tricked you!" After that, every time anyone drew water from the river, Turtle surfaced and taunted, "Ha-ha, I tricked you! The river is my home!"

Sometimes tricksters perform their mischief for someone else's benefit, as in the following story that reflects chameleons' ability to change colors. The Yoruba of Nigeria tell a tale where one day Olokun, King of the Sea, challenged God to appear in his finest dress. Olokun would do the same, and the people would proclaim the winner. God sent his messenger, the chameleon, to fetch Olokun. When Olokun emerged from his underwater palace, he saw that God's messenger was dressed as splendidly as himself. Olokun dove back down and changed into even finer clothes and more coral beads. When he resurfaced, he found that the chameleon had changed into Olokun's same outfit and had also piled on more coral beads. Seven times Olokun changed into finer clothes, each time thinking he had outdone the chameleon, but each time the chameleon's outfit matched that of Olokun. The King of the Sea finally gave up, declaring, "If God's messenger is so splendid, surely God is much more splendid."

Crocodilian trickster tales incorporate predatory behavior, but the punch line is humorous. We laugh instead of shudder with fear. One crocodile trickster plays the

7.2 Chameleons, including this graceful chameleon (*Chamaeleo gracilis*), change color rapidly in response to predators, prey, and conspecifics; temperature and light changes; and physiological state. Male graceful chameleons are green, brown, or yellow when resting, but become bright green when expressing dominance to other males.

lead role in a song often sung around the campfire: "Crocodile Song." A crocodile gives a young woman a ride down the Nile. He seems tame, and thus the perfect way for her to spend a sunny summer day. "The croc winked his eye as she bade them all good-bye, wearing a happy smile." Later the croc lives up to his reputation. "At the end of the ride, the lady was inside, and the smile was on the crocodile!"

"How" and "Why" Stories

Humans no doubt have always wondered how and why other animals are the way they are. Both science and folklore address "how" and "why" questions. Although both require imagination and creativity, they go about answering the questions in very different ways. Scientific study, a powerful way of knowing, generally begins with a question based on an observation. Scientists propose hypotheses (educated guesses) to explain the observation, and then they test these hypotheses with experiments. The answer to one question leads to new questions. Science builds on the information gleaned from questions already answered.

In contrast, non-scientists worldwide have concocted stories to answer "how" and "why" questions—generally not meant to be serious explanations, but rather musings and entertaining commentaries. These oral stories often tell truths about ourselves, and they reveal the breadth and magic of our imaginations. Most of these stories give animals human characteristics and reflect some basic archetypal personality, such as conceited, boastful, or self-absorbed. Again, as with trickster stories, the characters frequently are comical and likable.

People worldwide and throughout history have pondered the mystery of amphibian metamorphosis. As a young child, I assumed that my pet tadpoles sprouted legs and lost their tails because they had magical power. I never asked my parents for an explanation, I just knew—much like Fionna knew that caterpillars turn into unicorns. My favorite "how" story of frogs' transformation is also magical: a Sukuma tale from Africa, "How Frog Lost His Tail."

Frog felt miserable. He was squat, and his eyes bulged like doorknobs. Every evening at sundown, when the African forest and savanna animals came to drink at Frog's water hole, he watched them swish their fancy tails. Frog wanted a tail. The animals teased Frog and told him he was ugly. Frog went to Sky God and begged, "Please give me a tail." Sky God agreed—if Frog would guard a magical well that never dried. Frog agreed and got a tail.

Frog loved to show off his new tail, flapping it about as he hopped, jumped, and leaped. He grew conceited because of his newfound beauty and position of responsibility. Frog never forgave the animals for being mean to him in days past. When all the water holes and wells except for the magical one dried up, Frog refused to let the animals drink from his well. "Go away!" he shouted. "There's no water here."

When Sky God heard about this, he visited the well. Frog shouted, "Go away!

There's no water here." Sky God was so angry that he took away Frog's tail. As further punishment, every year Sky God reminds Frog of his spitefulness. Each spring when Frog hatches as a tadpole, he has a lovely, graceful tail. But as the tadpole transforms into a frog, its tail shrinks until it disappears.

On the other side of the world, the Salishan of British Columbia and the northwestern United States tell a trickster story that also shows that it is the frog's own fault that it doesn't have a tail. Again, Frog was conceited. One day Mud Turtle and Frog agreed to race. Turtle bet his shell against Frog's tail. For three days, Turtle informed his friends of the race. Meanwhile, convinced of his jumping prowess, Frog collected bets that he would win. On the third day, Turtle was given a head start. Instead of starting when instructed, Frog dithered. By the time Frog began jumping, he saw Turtle way up ahead. Frog jumped as fast as he could, but Turtle crossed the finish line first. It took six turtles stationed at intervals to win, but Frog never knew that. Because Frog lost the race, tadpoles must lose their tails before they can become frogs.

I suspect that everywhere turtles live, people have wondered how the turtle ended up with its protective armor. The shell of most turtles consists of two layers. The inner layer is part of the animal's bony skeleton. Scutes, made of keratinized skin tissue, cover the bony layer. That's the scientific description of a turtle's shell, but to understand why turtles have shells, we turn to folklore. Aesop's version was that Zeus, ruler of the Greek gods, invited all the animals to his wedding. Tortoise was the only no-show. When Zeus demanded to know why, Tortoise responded, "There's no place like home." This disobedience so angered Zeus that he made Tortoise carry around his home forever.

Another explanation, this one from North America, comes from an Anishinaabe Native American legend. One day the spirit Nanaboozhoo woke up cranky and hungry. He went to the nearby village to find breakfast and came across men cooking fish. The men gave Nanaboozhoo a fish, warning that it was hot. The spirit ignored the warning, grabbed the fish, and burned his hand. Nanaboozhoo ran to the lake to cool his hand and on the way tripped and fell on his friend Mishekae, the turtle. Back in those days, the turtle was soft and exposed. After Mishekae complained and grumbled that Nanaboozhoo should watch where he was going, the spirit pondered how he could right things with his friend.

Nanaboozhoo picked up two large shells from the lakeshore and placed Mishekae in between the shells. He told her she would be safe now. In the face of danger, she needed only to pull her legs and head into her shell. He also told her that her shell was round, like Mother Earth, and that her four legs represented the four directions—north, south, east, and west. She now could live both on land and in water, and wherever she went she would have her home. Pleased, Mishekae continues to honor Mother Earth by proudly wearing her shells.

People also have wondered why turtles' shells appear cracked. Scutes account for

7.3 Turtles are endowed with a unique suit of armor. *Top:* box turtle (*Terrapene carolina*), with a highly domed carapace. *Bottom:* Al Savitzky, wearing a sea turtle shell at the Hiwasa Chelonian Museum CARETTA in Tokushima Prefecture, on Shikoku Island, Japan. Visitors are encouraged to try on the shell, part of an education exhibit, to imagine what it would be like to carry around a shell.

the cracked appearance, but widespread folklore suggests that some animal dropped the turtle, which fell and cracked its shell. One such story, from the Bemba of Africa, tells how Vulture visited his best friends, Mr. and Mrs. Tortoise, at least once each week. One day after Vulture returned home, Mr. Tortoise said to his wife, "It is rude that we do not visit Vulture. He always comes to our home."

"But how can we?" Mrs. Tortoise asked. "We cannot fly to the high hill where Vulture lives."

Mr. Tortoise had an idea. "Before Vulture visits next time, wrap me in a bundle. Tell him we have no grain in the village. Ask him to take the bundle, full of tobacco leaves, to his home and trade the tobacco for grain."

Mrs. Tortoise agreed. The next time Vulture visited, after he finished his tea, he grasped the bundle in his talons and flew toward home. Just as Vulture was about to land, Mr. Tortoise called from inside the bundle. "Hey, it's Mr. Tortoise here! I said I would visit you one day, and here I am!" Vulture was so surprised that he dropped the bundle. It fell on a rock, and Mr. Tortoise's shell cracked into a crisscross pattern.

Various folktales tell how painted turtles (*Chrysemys picta*)—handsomely decorated with spots and stripes of red and yellow on their shells, heads, necks, legs, and feet—came to be so lavishly colored. The following Sauk tale from North America is told to young men as a warning of what might happen to them if they "act like turtles." A long time ago, the people lived in a village near a large lake. A young man named Jesus lived with his grandmother on one side of the village. On the other side of the village, Turtle—a ladies' man—lived alone. Not only did Turtle flirt with every woman who would look at him, but he also lured girls away from their sweethearts and wives from their husbands. He was a troublemaker.

Men hesitated to hunt because they feared leaving the women alone in the village with Turtle. Women were afraid to gather wild plants for fear that Turtle would bother them. Grandmother advised Jesus that

7.4 Painted turtles, such as these western painted turtles (*Chrysemys picta bellii*), spend hours on sunny days basking. Their seemingly hedonistic behavior—plus their handsome red, orange, or yellow stripes and spots—makes them the perfect protagonist for the Sauk tale from North America that warns against womanizing.

he needed to do something about Turtle. And so he did. After turning himself into a beautiful young woman, Jesus-woman took Turtle a bowl of corn soup. Turtle was painting his face when Jesus-woman arrived—a red dot on each cheek and a red dot on his forehead. "Come on in," said Turtle. Once Jesus-woman was in the house, Turtle spat into the fire. His spittle turned into pearls and diamonds. "Pick them up," he scoffed.

Jesus-woman picked up the jewels as Turtle painted red lines on his legs. Turtle spat into the fire a second time, and again the spittle turned to pearls and diamonds. "You can have those too," Turtle said. "And if you'll walk with me in the woods, I'll give you something better."

"Oh, I don't know if I should," said Jesus-woman coyly. "Grandmother says that's the way girls get into trouble."

Turtle boasted, "Look at me. Don't you think I'm handsome with my red paint? Do you think I would get a girl into trouble?"

Jesus-woman consented, and the two set off into the woods. When they reached a clearing, Turtle leaned against a tree. "Come and sit beside me." Jesus-woman sat, and Turtle put his arm around her. Turtle slid until he was lying down. "Lie beside me," said Turtle. Jesus-woman lay down.

At that point, Jesus-woman bewitched Turtle. He closed his eyes and fell asleep. Jesus-woman rolled a rotting log next to Turtle—a log with angry red ants swarming underneath. Turtle sleepily hugged the log. The ants at first tickled Turtle, then began to bite. Turtle awoke and watched the beautiful woman with long black hair turn into Jesus's own form. Jesus told Turtle, "You've caused enough trouble. From now on people will always recognize you as a womanizer because you will be the permanently painted one."

7.5 *Left:* the beadlike skin of a Gila monster (*Heloderma suspectum*) resembles multi-colored pebbles. *Right:* horned lizards, such as this mountain short-horned lizard (*Phrynosoma hernandesi*), carry reminders of saltgrass spikelets on the backs of their heads.

Some "how" and "why" stories leave the listener just plain feeling good! The Tohono O'odham from Arizona (United States) offer a delightful explanation for how Gila monsters (*Heloderma suspectum*) acquired their unusual beadlike skin of black and pink- or peach-colored scales. Long ago, humans and other animals were invited to the first saguaro cactus wine festival. Naturally, all wanted to look their best. Gila Monster piled multi-colored pebbles onto his skin to make a dazzling and durable coat. He still wears his cactus wine festival coat today.

Horned lizards (*Phrynosoma*) are distinctive, with their flattened bodies and horns rimming the backs of their heads. Predators often find it difficult to swallow horned lizards, so that's a benefit of being spiky, but how did horned lizards get their horns? The Cocopa from North America offer an explanation based on a story from their ancestors, who lived in the mountains overlooking Lake Cahuilla, where the Gila and Colorado Rivers flowed into a valley. Over time, the temperatures warmed and less rain fell. Hiesh, a horned lizard, was sent to see if the waters had receded. When Hiesh reached Laguna Salada, he rejoiced that more land was exposed and the nourishing saltgrass was ready for gathering. Hiesh broke off grass spikelets and stuck them on his head to announce the good news. To this day, horned lizards carry reminders of saltgrass on their heads.

A third feel-good story, this one from India, explains how the Indian cobra (*Naja naja*) got its characteristic pattern on its hood—a pair of ocelli (marks resembling eyes) connected by a curved line. One day the cobra Muchilinda spread his hood over Buddha while the Enlightened One meditated in the desert. As thanks for protecting him from heatstroke, Buddha laid his hand on the cobra's spread-out hood and blessed him. That left a mark on the backside of the hood that resembles a pair of spectacles. To this day, Indian cobras bear this mark and are called spectacled cobras.

Anyone who has seen a snake up close has watched its narrow, forked tongue flick in and out of its mouth. A snake uses its tongue to pick up airborne scent molecules, and then it transfers the scent from the tongue tips to its odor-sensitive Jacobson's organ located on the roof of its mouth. But are two tongue tips better than one? Aristotle reasoned that the forked tongue provides snakes with double the gustatory pleasure. The seventeenth-century Italian

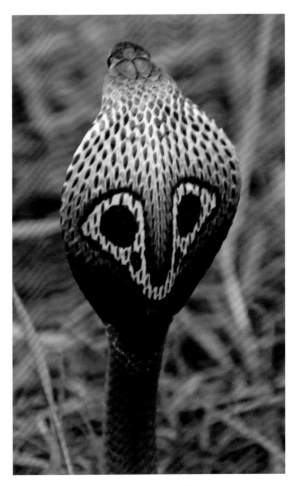

7.6 According to folklore, the Indian cobra (*Naja naja*) acquired the spectacled pattern on the back of its hood when Buddha blessed the cobra Muchilinda with his hand.

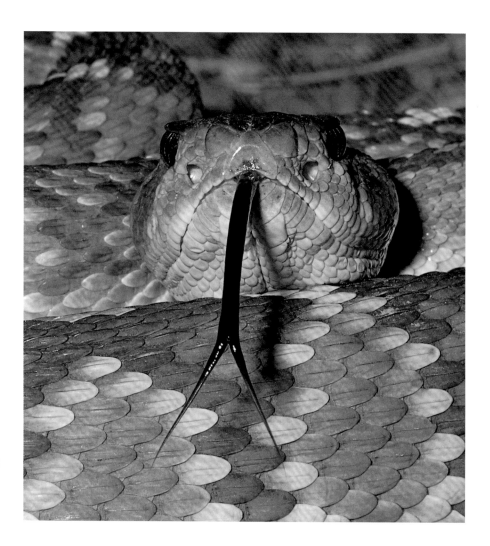

7.7 Thanks to drinking the gods' Elixir of Immortality, snakes became immortal, but the potent elixir split their tongue-tips into two, as illustrated by this black-tailed rattlesnake (*Crotalus molossus*).

scientist Hodierna suggested that snakes, always groveling in dirt, use their forked tongues for picking dirt out from their noses. Fast-forward to the present, and research suggests that having a forked tongue allows snakes to trail their prey more effectively by using the two tines to follow the edges of a scent trail.

But how did snakes acquire their forked tongues? According to an Indian myth, Garuda, King of the Birds in Hindu mythology, hated snakes because they guarded his mother, Diti, who had been imprisoned by one of his father's wives in a faraway region. When Garuda tried to free his mother, the serpents demanded ransom: a cup of the gods' Elixir of Immortality. Garuda drank up the rivers and doused the roaring fire surrounding the mountain cave where the elixir was housed. He stole a goblet of the ambrosia and flew with it back to where his mother was imprisoned. The gods followed him. Indra, King of the Gods, struck Garuda with a thunderbolt. Feeling no pain, Garuda continued on his journey and released his mother. Just as the guarding serpents were about to drink the elixir, Indra reappeared and snatched the goblet. The

snakes slurped the little bit that had spilled—enough to make them immortal—but the elixir was so potent that it split the tips of their tongues.

Venomous snakes have a cocktail of deadly proteins and enzymes stored in glands on the upper jaw, but how did they get venom in the first place? Whereas scientists talk about a series of evolutionary steps from other proteins and enzymes, folklore offers magical explanations. One Australian story says that in the old days Snake was harmless, and Goanna (monitor lizard) was venomous. Goanna had an insatiable appetite for human flesh. All the tribes convened to decide what should be done about Goanna. No one wanted to risk Goanna's deadly bite, until finally Snake offered to sneak up and capture Goanna's bag of venom. Snake grabbed the bag and was declared a hero. But when the people demanded the venom bag so they could destroy it, Snake refused and taunted, "I have the venom now. I am the most powerful animal." That's the end of the Australian tale, but the story continues because scientists in Australia recently discovered presence of venom glands in some monitor lizards. Snake didn't steal the entire bag of venom after all!

From North America, a Choctaw tale explains that when the world was new, a poisonous vine grew beneath the water surface in the bayous where the Choctaw bathed. Anyone who touched the vine sickened and died. The vine liked the people and regretted causing pain and sorrow. One day the vine convened the chiefs of the little animals. It told the bees, wasps, and snakes of the swamps that it wanted to give away its toxin. These creatures had no way to protect themselves from people, so they agreed to share the toxin.

"I will only use the venom to defend my hive," promised Bee, taking a small amount. "If I must use it, I will die. Therefore, I will use the venom carefully."

"I will keep the venom in my tail and use it to protect my nest," said Wasp. "I will buzz close to a person as a warning before using the venom."

"I will only use my venom if a person steps on me," promised Cottonmouth. "I will keep the venom in my mouth. When threatened, I will open my mouth and show the white lining. People will recognize that I am venomous and know to stay away."

Rattlesnake declared, "I will take all the remaining venom. I too will hold it in my mouth. I will warn people who get too close by shaking my tail, 'intesha, intesha, intesha.'"

And so, from that day on, the shallow waters of the bayous were safe for the Choctaw—if they paid attention to the animals' warnings.

Prehistoric-looking crocodilians have lumpy, bumpy skin covered with osteoderms (bits of bone in the skin). Herpetologists will tell you that osteoderms help to protect against the bites of other crocodilians. Aboriginal Australians tell stories that explain both how the crocodile got its osteoderms and why people and crocodiles do not get along. The Gunivugi people from the Northern Territory lived by the beautiful Liverpool River. Contrary to Gunivugi law, a handsome young man named Pikuwa fell in love with a married woman. The elders told Pikuwa that he was behaving badly, but

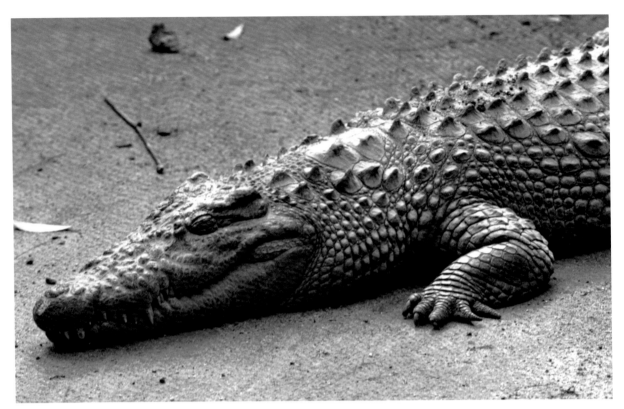

7.8 Crocodiles have bony osteoderms in their skin that serve as defensive armor. Aboriginal Australians tell a story in which the crocodile, formerly a young man named Pikuwa, got its osteoderms from spearheads sunk into Pikuwa's back as punishment for consorting with a married woman. Pictured here is a lumpy, bumpy Nile crocodile (*Crocodylus niloticus*) from Africa.

he kept consorting with the woman. Great Spirit said that if Pikuwa continued to see the woman, he would be severely punished. After Pikuwa and the woman were seen together again by the river, the woman's husband and many warriors plunged their spears deep into Pikuwa's back. He fell into the water and disappeared.

Pikuwa hadn't died, however. Several weeks later, a monstrous creature crawled out from the river. It was Pikuwa, covered with the spearheads that had sunk into his back. The Gunivugi drove Pikuwa back into the river. Great Spirit announced that Pikuwa was condemned to live in the water because he had broken the law. His children and the children of the Gunivugi would never play together. And so, from then on, whenever the Gunivugi bathed in the river, a crocodile would attack them. And whenever a crocodile left the water, the Gunivugi would attack it and drive it back to the river.

In another tale, Pikuwa seduced two young virginal sisters. Their enraged father beat Pikuwa's head with his wooden club and finished him off with a blow to the forehead. He cut off the crocodile's head and carried it back to camp. Later, the family feasted on the creature. To this day, crocodiles have a lump on their foreheads to remind them of the penalty for seducing young women.

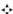

Cultures worldwide tell trickster stories that reveal how the people think they should or should not behave. For the most part, stories featuring amphibians and reptiles incorporate what we perceive as positive attributes of these animals, even if they break the rules, cause trouble, and manipulate others. Although the stories are humorous, beneath the comic layer the tricksters' actions often impart messages and teach ethics. Their diverse natures mirror the range of human personalities. Some are deceptive, such as the crocodile that helps himself to a meal in return for performing a good deed. Others are boastful—Toad, who bragged he could run faster than Donkey. Some are generous—the chameleon that tricked the King of the Sea on God's behalf. In contrast, Turtle, who raced Beaver, is selfish, cheating only to benefit himself. Although snakes are often the brunt of tricksters' jokes, they often play selfish roles as tricksters themselves, as when they trick humans out of immortality. The frog that became emperor was clever; the chameleon that cheated in the race for the throne was shortsighted.

7.9 Frog folklore often reflects our positive feelings for the animals, even a joie de vivre.

In our quest to interpret the world around us, we concoct stories to explain what we do not understand—why frogs have no tails, why snakes' tongues are forked, why turtles have shells. As in trickster tales, the amphibians and reptiles featured in "how" and "why" stories often reflect human strengths and foibles. Just in the few stories shared here, the animals are portrayed as grateful, generous, thoughtful, conceited, spiteful, self-absorbed, unscrupulous, and exploitative. On another level, many of these "how" and "why" tales illustrate the consequences of human behavior. Frog, who yearned for a tail, teaches us that conceit and spiteful behavior are punished. The turtle that skipped Zeus's wedding reveals that self-absorption can lead to a permanent load hanging from our shoulders. On the other hand, Mishekae the turtle validates the beauty of safety. The turtle that hid in Vulture's bundle is a reminder that furtive behavior, even if well-intentioned, can lead to harm. Both the crocodile and painted turtle demonstrate that womanizing demands a penalty.

The frequent presence of amphibians and reptiles in trickster and "how" and "why" stories and their particular roles reflect the part of us that likes these animals. We see ourselves in the animals and therefore identify with them. Amphibians and reptiles in these stories, the lighter side of folklore, engage us partly because, as likable beings, they take us to the world of fantasy and allow us to become children again. Anything is possible, even caterpillars turning into unicorns.

8

Tailless Wonders, Naked Serpents, and Fire Lizards

Perception of Amphibians through Folk Beliefs

Among the Bribri, Cabécar, Boruca, Changina, and Chiriquí, when the chicha has been drunk, the night grows late and dark, and the fires die down to burning embers, the wisest old man of the tribe tells his engrossed listeners of a beautiful miraculous golden frog that dwells in the forests of these mystical mountains. According to the legends, this frog is ever so shy and retiring and can only be found after arduous trials and patient search in the dark woods on fog shrouded slopes and frigid peaks. However, the reward for the finder of this marvelous creature is sublime.

–JAY M. SAVAGE, "On the Trail of the Golden Frog"

The legend of the golden frog (*Atelopus zeteki*), told by Panamanians and Costa Ricans, says that anyone who sees this miraculous frog is at first astounded by its beauty and overwhelmed with excitement. Hold the frog, and happiness will follow. Few people find the golden frog, however, and even fewer manage to carry it with them. Jay Savage writes, "Like the Indians of Talamanca and Chiriquí, each human being is also on a mission searching for the golden frog. Field biologists in particular seem always to be searching for mystical truth and beauty in nature, and frequently at some unperceived level, for that happiness promised by the Indian seers."

As a graduate student, I embraced Savage's words. My search for the golden frog became fieldwork in Latin America, a path that has been richly rewarding. Frogs symbolize happiness for me, perhaps because I am happiest when I am in the field, studying frogs from their vantage point—the

8.1 The Panamanian and Costa Rican legend of the golden frog (*Atelopus zeteki*) promises that anyone who can hold on to this beautiful, miraculous frog will find happiness.

challenges of attracting mates, caring for young, surviving unpredictable environments, securing territories, and avoiding predation.

Thus far we have focused on how amphibians and reptiles are portrayed in folktales. In this chapter we'll look at folk beliefs concerning frogs ("tailless wonders"), caecilians ("naked serpents"), and salamanders ("fire lizards"). Folk beliefs provide yet another lens into how we view these animals in both positive and negative ways, and they suggest that amphibians have the power to affect our lives. Some beliefs offer hope for better times; others advise that we should respect the animals, for they can upset Earth's balance—and spin us out of control as well.

Frogs

Frogs symbolize good luck and prosperity for people of many cultures. Ancient Romans believed that frogs brought good luck to a home, and people worldwide still place frog figurines in their gardens and homes to attract good fortune and prosperity. Many Asian cultures believe that the frog represents the *yin* side of nature (dark side of the symbol)—slow, soft, cold, wet, and passive—associated with water, earth, moon, nighttime, femininity, and good fortune. Frogs symbolize good luck in the an-

cient Chinese principle of feng shui, which balances the forces of nature to influence human fate and prosperity. The money frog—based on the legend of a three-legged frog (toad) named Ch'an Chu (chapter 5)—represents wealth, abundance, and good luck. Carved from quartz, malachite, agate, jade, or other materials, money frogs carry a golden coin in their mouths or sit on a mound of coins. Feng shui experts generally advise that the frog be placed near the front entrance of a home, office, or business, facing the door.

Humans likely have always wanted to have some control over their lives, and so we invoke the supernatural. Worldwide, people carry small objects on their bodies to control their destinies—bodyguards such as amulets, charms, and talismans that protect against injury, disease, aging, and death, and that attract good fortune and health. Amazons—those legendary large women warriors of the Amazon forest who lived in all-women societies—are said to have given frog-shaped talismans carved from jade to their lovers as tokens of their encounters. From time to time, one of these jade frog-shaped stones, called *takua*, shows up in the Amazon Basin, giving a material presence to the many stories told by indigenous peoples, handed down from their ancestors, and to the tales shared in writings authored by early European explorers.

Some Japanese keep small gold frog charms in their wallets in the belief that the frogs, in contact with money, will increase wealth. Japanese also consider frogs to be good luck because they are frequently found in and near flooded rice paddies. The Japanese word for frog, *kaeru*, also means "to return." In this sense, frogs symbolize hope, especially after a natural disaster; the frog returns life to normalcy. Japanese often carry a small frog amulet when they travel, to ensure their safe return home. Years ago my Japanese graduate student, Kazuo, gave me one of these. I have faithfully carried it in my purse ever since, and I've always returned home safely.

My little gold Japanese amulet isn't the only frog I carry with me. While working in Costa Rica years ago, I purchased reproductions of pre-Columbian gold frogs—pendants, earrings, bracelets, even a ring. If I was going to let the frog symbolize happiness for me, the more the merrier. I sometimes wear my favorite gold Costa Rican frog pendant when I give lectures or seminars in hopes that it will ensure a satisfactory presentation. Once when I forgot to wear it, the projector burned a hole in the only copy of my favorite slide of a gladiator frog. I have never had a slide ruined while wearing the pendant.

Many European superstitions carried to North America associate frogs with good luck. The ideal time to make a wish is when you hear the first frog's croak in the spring. Walk backward into your house and whirl around three times while you make that wish. If newlyweds see a toad on the road, they will have a happy marriage. To attract good luck, carry the dried jawbone or breastbone of a tree frog in your pocket. Spit on the first toad you see in the spring to bring good luck. If you come across a frog on your way to a card game, you will win big-time.

Frogs are associated with love. Pliny the Elder attributed to the frog "the power of keeping affections true and constant, and of promoting harmonious relations between lovers." He also writes: "They say that if frogs are pierced with a reed from the genitals through the mouth, and if the husband plants a shoot in his wife's menstrual discharge, she conceives an aversion to adulterous lovers." Reflecting Pliny's teachings, Romans wore frog amulets to protect them from fading love. An old English love charm to avoid a breakup consisted of sticking nine pins into a live frog, immersing the frog in oil of vitriol, and burying it. In Denmark, a toad heart dipped in jam was eaten to cure a broken heart. In the United States, it was believed that if a young woman put a live frog under her pillow and slept on it, the first fellow to walk into her house the following day would be her future husband. If a girl saw a toad hopping across the road in front of her, she would see her beau that day. Lovesick young men were told to enclose a toad in a box bored with holes. Place the box near an anthill and leave it until the toad dies and ants clean the bones. Remove a hook-shaped bone and fasten it in the sleeve of the intended lover to make her fall in love. Toads are used in love magic: if a man places the tongue from a live toad over his wife's heart while she sleeps, the tongue will act as a truth drug, the wife will tell all, and the husband will learn if his wife is faithful.

Because many frogs are highly fecund, they and their tadpoles symbolize fertility. American bullfrogs (*Lithobates catesbianus*) lay up to 20,000 eggs in one clutch; a cane toad (*Rhinella marina*), 30,000 eggs. Ancient Egyptians closely associated frogs and human fertility. The frog goddess Heket was goddess of childbirth and fecundity,

and the tadpole symbolized the fetus. Men and women wore gold frog amulets to protect against loss of virility and against infertility. Frogs also symbolized fertility for the ancient Greeks, who linked frogs to Aphrodite, goddess of love. Greeks wore her symbol, the frog, to ensure their own fertility. The frog was also sacred for Venus, Roman goddess of love and fertility. Venus's yoni (female genitals) sometimes was depicted as a fleur-de-lis consisting of three frogs. The original version of the French coat of arms consisted of a fleur-de-lis in the shape of three frogs, and garment closures shaped like fleur-de-lis are still used and are called "frogs." In ancient Rome, tailors' folklore instructed that garments should be closed with nine frogs. Scholars have suggested that this belief stems from an ancient Babylonian cylinder seal used as a fertility charm that showed nine frogs, representing the nine months of human gestation. Ancient Europeans associated the toad with the womb; women left small toad figurines at holy sites in hopes of getting pregnant.

In the New World, the Aztec Earth Mother Goddess, Tlaltecuhtli, was often depicted as part toad, part feline, poised in a squatting position as though giving birth. The Mayan word for toad, *mut* or *much*, also refers to female genitalia. Tadpoles symbolize fertility for many Native Americans, who work the tadpole motif into weavings, pottery, and jewelry. The Mataco of northern Argentina associate frogs and human fertility through tales of the character Tokwah, who made human procreation possible by giving men their "milk." Tokwah inserted a thorn into a toad's anus, causing the toad to exude mucus all over its body, and then wiped the secretion on men's genitals to create semen.

Frogs and newborn children go hand in hand for some cultures. During the Middle Ages, the Wends, a western Slavic tribe, had a legend in which frogs—not storks—deliver children to their parents. People from the German province of Brandenburg believed that if a woman dug up a toad, she would soon bear a child. The Sea Dayak from Borneo believed that the goddess Salampandai took the form of a frog. This goddess was

8.3 Frogs are commonly represented in symbolic artwork in British Columbian Haida culture, who view frogs as a source of wisdom and knowledge. According to legend, two frogs guard the entrance to the mythical Thunderbird's realm, prepared to warn of intruders by vocalizing. The western toad (*Anaxyrus boreas*) occurs where the Haida live, and, as with most toads, when a western toad is handled, it gives a chirping release call. Perhaps the toads' behavior explains the origin of the Haida legend.

believed to be the creator of babies, which she formed from clay. When a baby was born, a frog would be seen near the home.

Medieval Europeans valued the toad for a precious stone or gem believed to be concealed in its head. Belief in this stone, called a toadstone (also bufonite or batrachite) goes back at least to the first century CE, reported by Pliny the Elder in *Historia Naturalis*. The stone was considered valuable because it served as an antidote for poison. It also protected its wearer by warning of the presence of poison by heating up or changing color. Worn in a ring or necklace, toadstone was valued for its magical healing powers to treat abdominal pain, epilepsy, and kidney and bladder stones. Various natural objects were identified as toadstones, including the peg-like fossilized teeth of an extinct genus of fish. An extensive lore developed around the toadstone, including use of the toad as a metaphor meaning that virtue is often concealed beneath an uncouth exterior.

Some folk beliefs protect frogs because they warn of the consequences of harming or killing these animals. In parts of the United States, people believe that if you

8.4 "Sweet are the uses of adversity, / Which, like the toad, ugly and venomous, / Wears yet a precious jewel in his head." –Shakespeare, *As You Like It*

kill a frog or toad, your house will catch on fire, you will soon lose your best friend, or your cows will give bloody milk. If you step on a toad, your grandmother will die. A Navajo taboo forbids killing a frog; to do so will cause heavy rains that will ruin crops. The Shona of Zimbabwe and Mozambique believe just the opposite: if one kills a frog, the heavens will prevent rain from falling and the wells will dry. In Romania, if one kills a frog or toad, the killer will also murder his mother. Europeans warned against killing frogs because they housed the souls of dead children. An old Persian belief said that if a person killed a frog, his hand would become "saltless," meaning from that time forward, no person would be grateful for any good the frog-killer performed.

Many other beliefs about frogs reflect and reinforce the idea that they possess supernatural powers. People have long believed that frogs and toads can survive for centuries underground or entombed in stone. The idea has even infiltrated popular culture, as with Michigan J. Frog, star of the Looney Tunes cartoon "One Froggy Evening," who is discovered in the cornerstone of an 1892 building being demolished. Of course no frog can live in solid rock, concrete, or brick, but the assumed phenomenon gives frogs an aura of mystery. Reports still surface of live, entombed frogs. These are either fabrications or misinterpretations. Some frogs estivate underground for months or even a few years, and some of these form cocoons of shed skin around themselves—but no frog can remain entombed for centuries.

Imagine how frightening an eclipse of the sun or moon or an earthquake must be to people with no understanding of the phenomena. To explain the occurrence, people make up stories. Frogs often feature in these stories because their seemingly magical metamorphosis suggests they are endowed with supernatural powers. According to both Old and New World legends, lunar eclipses occur when a great frog swallows the moon. In Siberia, India, and China, legends claim that the world rests on the back of a frog. Whenever the frog moves, earthquakes shake the world.

Interpretations of dreams about frogs run the gamut from negative to positive and depend on the dream itself. Just seeing a frog in a dream might portend a change in some aspect of life. A frog croaking signifies success—but first the dreamer must stop complaining and get to work. To kill a toad in a dream indicates that the dreamer will be criticized for some decision made. Alternatively, he or she will overcome an enemy. A woman's dream of tadpoles signifies fertility and her desire to become pregnant.

Some of the ancients claimed that frogs arise from putrefaction. People who bought into these beliefs must have viewed frogs as filthy, disgusting creatures. Aristotle noted that some animals generated spontaneously from putrefaction, an idea that likely arose because insects and some other animals appear seemingly out of nowhere around dead organic matter. Since antiquity, people of many cultures have believed that frogs were one of these animals. Frogs are often found near rotting matter—not because they were "born" there, but because they eat insects feeding on decomposing plants and animals. Sir Thomas Browne (1605–1682)—an English

writer who covered religion, medicine, and science—claimed that those frogs that arise from putrefaction, called *temporariae*, live shorter life spans than frogs produced in the "usual" way. Some people believed that frogs disintegrated into slime in the winter and recovered their form in the summer, a misconception that arose because many frogs remain dormant in winter and reappear when temperatures warm up.

Some people believed that frogs were born from corruption inside the human body and that they escaped through a person's mouth or from a vagina during child-birth. Reflecting this belief, the Dutch painter Hieronymus Bosch (ca. 1450–1516) painted a frog jumping from the central character's mouth in *The Conjurer*. Folktales tell of toads jumping from the mouths of corrupt, immoral, or otherwise misbehaving people. In the Brothers Grimm's tale "The Three Little Men in the Wood," a toad jumps out of the naughty little girl's mouth every time she speaks.

Toads often symbolize ugliness and evil in Western literature and folktales. In *Richard III*, Shakespeare refers to the king as "a poisonous hunch-back'd toad," and in another scene Lady Anne says to Gloucester: "Never hung poison on a fouler toad." In Hans Christian Andersen's "The Toad," the young green frogs refer to Mother Toad as thick and fat and ugly. In his epic poem *Paradise Lost*, John Milton describes Satan as "squat like a toad" as he whispers in Eve's ear to tempt her.

Many folk beliefs associate frogs with filth and evil. During early Christianity, frogs symbolized uncleanliness because they live in mud. In medieval Europe, perhaps because of their toxic skin secretions, toads were considered to be malevolent spirits, symbols of the sins of debauchery and sexuality. For medieval Europeans, frogs also symbolized the Devil, reflecting the Catholic Church's association of frogs and toads as ingredients of witches' brews. Witches turned themselves into toads, and toads accompanied witches as "familiars," helping them carry out evil deeds. Some people still believe that frogs and toads are witches and should be killed. A belief carried from England to New England (United States) claimed that a toad's breath caused convulsions in children. The Cuna from Panama and Colombia believe that contact of their babies with the cane toad (*Rhinella marina*) causes teething problems.

Toads get a bad rap because of their defensive behavior. When threatened, toads often inflate their bodies, making themselves appear more formidable, larger, and harder for a predator to eat, behavior that suggests aggression. In many places in the world, toads are thought to have a lethal bite. Some Malaysians believe that toad urine squirted into a person's eyes causes blindness. In Singapore, the Asian common toad (*Duttaphrynus melanostictus*) is said to blow poisonous gas at people. In England, people claimed that the European common toad (*Bufo bufo*) spits on people. Resem-bling a frog version of Jabba the Hutt from *Return of the Jedi*, Argentine horned frogs (*Ceratophrys ornata*) are pugnacious little guys with huge, wide mouths; they inflate their bodies, lunge at approaching predators, and sink their sharp teeth into flesh if the opportunity arises. A widespread Argentine belief warns that if one of these frogs bites the lips of a grazing horse or steer, the victim will die. This is no laughing matter

in a country where a gaucho's most valued possession is his horse and until recently Argentines boasted the highest beef consumption rate in the world (Uruguay now has a slight lead).

One of the plagues described in the Bible denigrates frogs. Moses and Aaron went to the Pharaoh of Egypt and delivered God's command: "Let my people go!" God demanded that the Israelite slaves be allowed to leave Egypt so that they could freely worship God instead of the many Egyptian gods. Pharaoh refused, so God sent a series of ten plagues. The second was a plague of frogs. God warned, "I will plague all your country with frogs; the Nile shall swarm with frogs which shall come up into your house, and into your bedchamber and on your bed, and into the houses of your servants and of your people, and into your ovens and your kneading bowls; the frogs shall come up on you and on your people and on all your servants."

Aaron stretched his hand over the waters of Egypt, and, sure enough, millions of frogs overran the country. Pharaoh asked Moses and Aaron to beg God to remove the frogs. If he would, Pharaoh would let the Israelites go. To prove that the plague was really caused by God, Moses let Pharaoh choose when the plague would end. Pharaoh chose the next day, and on schedule all the frogs died. People gathered the dead frogs in piles, and the land stank. When Pharaoh did not keep his promise, God sent the third plague: gnats. Then a fourth, on up to ten plagues, before Pharaoh finally freed the Israelites. Some scholars interpret this story as God showing Pharaoh his power over the Egyptian frog goddess Heket. By ending the plague and killing the frogs, God showed Pharaoh that Heket had no power.

During the Middle Ages, Christian preachers described infernal visions to persuade people to mend their ways so they could avoid Hell, a place of fire, serpents, and toads (chapter 3). One story tells of the widow of an oppressive bailiff who opened her husband's tomb and found a toad in his mouth. Another story describes what could happen as punishment for selfish behavior in this life. A young man convinced his father to turn over all his wealth so that the son could enter into a good marriage, after which he chased his father out of the house. One day, as the son was about to eat dinner, his father knocked on the door. The son hid the food. After the father left, the son went to get his plate, but instead of his meal he found a toad on the plate. The toad jumped onto his face. For the rest of his life, the son wandered about with the toad clinging to his face like a loathsome tumor.

Worldwide, people claim that frogs can harm a person, including the common belief that touching a toad causes warts. The skin of many toads is covered with clusters of granular glands that contain poison; these gland clusters resemble warts, providing a basis for the myth. Touching a toad will not cause warts, however—viruses cause warts. Another common toad misconception is that if a toad gets into water, it will poison it. Not so, though it might muddy the water a bit. A traditional Navajo belief warns that one should not watch a frog while it is eating. To do so causes throat problems and trouble swallowing.

8.5 The skin of many toads, such as this Japanese common toad (*Bufo japonicus*), are covered with clusters of warty-looking granular glands that contain poison.

8.6 The strawberry poison frog (*Oophaga pumilio*) is one frog you would not want to eat! These frogs sequester toxins from the prey they eat—ants and mites. Remarkably, females provide their tadpoles with toxin-laced unfertilized eggs, giving their tadpoles a head start on toxicity.

Some of our common expressions malign frogs and toads. Sri Lankans have a saying that "if one dies craving wealth, he will be reborn as a frog." In Malaysia, people call a politician who changes parties a "political frog." Also from Malaysia, "to die from the nip of a frog" refers to the humiliation of a vain person put into his/her place by someone relatively insignificant. In Western societies, "If you eat a toad first thing in the morning, nothing worse will happen to you all day long." Other Western expressions include "You have to kiss a lot of frogs before you find your handsome prince" and "looking like a stuffed toad." The simile "like a frog in boiling water" refers to a person unable or unwilling to react to significant changes that are occurring gradually. My favorite is Mark Twain's commentary on procrastination: "If it's your job to eat a frog, it's best to do it first thing in the morning. And if it's your job to eat two frogs, it's best to eat the biggest one first."

Caecilians

Caecilians—3-inch (7.6 cm) to 4-foot (1.2 m) earthworm-like amphibians that live only in the world's tropical and subtropical regions—belong to the order Gymnophiona, from the Greek words meaning "naked serpent." Most of these legless amphibians live underground, though some live on the ground and others are aquatic. These "naked snakes" are secretive and rarely seen by people, except for those of us searching for them. For this reason, people rarely interact with these amphibians, and caecilian folklore is scant.

One folk belief warns that caecilians are dangerous, perhaps reflecting their superficial similarity to snakes. Some people in Kerala, India, believe that the three-color caecilian (*Ichthyophis tricolor*) is more venomous than a king cobra (*Ophiophagus hannah*). There's a local saying: "God has not given eyes to caecilians and horns to horses for the deadly poison and the extreme muscle power can be used disastrously by the two animals."

Most South Americans have never seen or heard of a caecilian, but many of those who have seen them imagine these snake-like amphibians to be nasty and dangerous. A mythical creature called the *minhocão*—a giant wormlike animal that lives and burrows underground—reflects this perception. *Minhocão* is black, grows to 75 feet (22.9 m), and has a pair of tentacles sprouting from its head—the spitting image of a giant caecilian. *Minhocão* is a much-feared beast because it gouges out deep trenches as it tunnels, causing houses and roads to collapse into the bowels of Earth. The mythical *minhocão* reminds me of the giant sandworms in Frank Herbert's 1965 science fiction novel, *Dune*. Perhaps caecilians provided the inspiration for those creatures that plague the novel's barren desert planet setting.

Another bit of caecilian folklore involves a magical transformation. At Hacienda La Condesa, Colombia, locals believe that if a strand of a woman's hair is placed in a bottle and the bottle is submerged underwater, the following day the bottle will con-

8.7 Both caecilians pictured here are featured in folklore. *Left:* Río Cauca caecilian (*Typhlonectes natans*), an aquatic species believed to be a transformation of a woman's hair strand; *right:* Mexican burrowing caecilian (*Dermophis mexicanus*), a terrestrial species locally known as *tapalcua*, or "anus-plugger."

tain a caecilian—the locally common Río Cauca caecilian (*Typhlonectes natans*). Many locals don't realize this 20-inch-long (50.8 cm) aquatic animal is an amphibian, but instead assume it to be an eel.

And then there are other beliefs about caecilians. Jon Campbell writes in *Amphibians and Reptiles of Northern Guatemala, the Yucatán, and Belize:*

> Particularly vulgar traits are attributed to the secretive caecilians, possibly owing to their body shape and coloration. Their vernacular name *tapalcua* is a polite rendition of *tapalculo*, which in turn is derived from a Spanish phrase that describes certain almost unspeakable acts thought to be performed by these animals. Briefly, there is a widely held belief that caecilians will spring out of the ground and enter the lower body orifices of unsuspecting people who are answering the call of nature. The fact that caecilians may be found in mounds of rotting vegetation probably does not help.

Herpetologists often enlist help from locals to collect amphibians and reptiles. So when my herpetologist friend Joe Mendelson failed to find caecilians on a coffee finca in Guatemala, he consulted the local residents. Because these amphibians are rarely seen, many Guatemalans have no idea that such animals live beneath their feet. The word "caecilian" would never be understood, so Joe used the vernacular, *tapalcua*, hoping to elicit recognition. In halting Spanish, Joe began, "Hi, friends! How are you today? Say, do you know where a guy can find a butt plug around here?" Incredulous laughter erupted. Joe pleaded, "I just need one butt plug. Would that be possible?" More laughter. Joe sputtered, "Seriously, if I offered money, could someone bring me a butt plug sometime this week?" As the locals howled and slapped each other on the shoulders, Joe realized he was on his own to find these elusive amphibians.

In Mexico, the "anus-plugger" curse is worse. Amerindians of Tenejapa, in the state of Chiapas, believe that the local caecilian, the Mexican burrowing caecilian (*Dermophis mexicanus*), enters a person's anus while he or she is answering the call of nature. Not only does the creature plug up the orifice, but it also devours the host while inside the victim's body. Populations of this species are declining, and it could well be that people kill these caecilians when they encounter them because of this myth—or just because they resemble snakes.

Salamanders

Salamanders have long been associated with fire, and in fact the word "salamander" comes from Greek words meaning "fire lizard." Ancient European legend claimed that salamanders were created from fire and could withstand any amount of heat. The belief likely arose from the behavior of European fire salamanders (*Salamandra salamandra*), which seek shelter inside damp logs. When people brought logs indoors and threw them onto their fires, salamanders sometimes crawled out, giving the illusion that they arose from the flames. Many salamanders secrete mucus from their skin glands when frightened or disturbed. This mucus might protect the animal from heat for just a moment as it flees the fire. According to Aristotle, salamanders could also extinguish fires. Pliny the Elder, in *Historia Naturalis*, followed Aristotle's lead and wrote that salamanders are so cold that they can put out fire by contact, just as ice does. The Talmud taught that salamanders were the product of fire. As such, a person smeared with salamander blood became immune to burns caused by fire. In addition to having artistic talent, Leonardo da Vinci (1452–1519) was widely recognized in his time as a scientist. He claimed that the salamander has no digestive organs and that its only food is fire, from which it renews its "scaly" skin to obtain virtue.

8.8 Many salamanders, including European fire salamanders (*Salamandra salamandra*), seek shelter inside damp logs. When people brought logs indoors and threw them onto their fires, salamanders sometimes emerged—perhaps leading to the belief that salamanders were created from fire.

Long ago, people believed that salamanders lived inside volcanoes. As long as the salamander slept, the volcano remained dormant. When people incurred the salamander's wrath, the volcano erupted and the salamander's fiery, lava tongue licked everything in its path.

The belief that a salamander could pass through fire unscathed led to the idea that the animal passed through "without stain." Thus, the salamander came to symbolize enduring faith, courage, chastity, purity, virginity, and self-restraint. Salamanders became associated with the voice of God. During the eighteenth century, the word "salamander" referred to a woman who lived chastely despite being surrounded by temptations.

Because of their perceived bravery, salamanders depicted in flames are heraldry symbols. The salamander amid flames was the crest of the Douglas (Duglas) family, once the most powerful family in Scotland. King Francis I (1494–1547) of France chose the salamander in flames as his emblem, with the Latin motto (English translation): "I eat it and I put it out." Another interpretation of the king's motto was "I nourish the good and extinguish the bad."

A salamander surrounded by flames was a traditional emblem of the blacksmith trade. The town of Dudley, in West Midlands County, England, has such a salamander depicted on its present-day coat of arms. The town dates back to Anglo-Saxon times and was long an industrial hub for the working of iron. Many of the old furnaces remain, explaining the salamander on the town's coat of arms. My mother's maiden name was Dudley and her ancestors were from England, so I am most pleased to be associated (indirectly) with the "fire lizard"!

For the ancient alchemists, the salamander symbolized fire, one of the four elements (the others being earth, water, and air). Alchemists viewed salamanders as fire-eaters and the spirit of fire because the animals could walk unharmed through fire. The salamander also symbolized the human soul, attracted to and exposed to the sun's fire.

Asbestos has long been known to be incombustible. Mined and used for thousands of years, asbestos provides a superb insulating material resistant to heat. Not surprisingly, asbestos and salamanders are interconnected. When the Italian merchant-explorer Marco Polo visited China in the thirteenth century, he was shown cloth and garments made from fireproof "salamander wool," woven from the "hair" of salamanders. Polo wasn't fooled. He poked around and discovered that the fireproof cloth was woven from asbestos, mined in nearby mountains. In 1884 the first union of insulation workers in the United States took the salamander as its logo. Today the National Association of Heat, Frost and General Insulators and Asbestos Workers of America still has a salamander as its emblem—a salamander wrapped around a pipe over an open flame.

Salamanders symbolize fire in other ways as well. In South America, I have been warmed by many a *salamandra* (wood stove). Heaters, broilers, grills, and ovens are

often called salamanders. Some companies include the word "salamander" in their names, such as Salamander Stoves, based in Devon, England. In the eighteenth century, people used an invention called a salamander to brown the top of food—such as the cheese topping on Welsh rarebit. The heated salamander, consisting of a thick plate of iron attached to a long handle, was propped over the food to be browned. Today we use the equivalent of this cooking appliance, called a salamander broiler, to create perfectly melted cheddar cheese on a hamburger or to brown the cheese topping on French onion soup. Chefs in professional kitchens often use an appliance called a salamander—an electric or gas culinary broiler that has very high temperature overhead from infrared heating elements and that is based on the same idea as the eighteenth-century salamander.

Because of their supposed ability to withstand fire, salamanders were believed to have supernatural and extraordinary powers. One North American folk belief was that if you kill a salamander that lives at a spring, the water will dry up. A traditional Navajo taboo warned against killing salamanders, out of fear of becoming crippled, paralyzed, or contracting disease. In Germany, salamanders were thought to be weather prophets and house-protector spirits. Salamanders are also used in folk medicine and witchcraft because of their presumed healing and supernatural powers (chapters 11 and 12).

Salamanders are associated with transformation from death to rebirth—renewal and regeneration—for three obvious reasons. First, many salamanders pass through an aquatic larval stage before becoming terrestrial adults. The difference between

8.9 Salamanders are associated with rebirth in part because many can autotomize their tails when grabbed by predators and in time grow new ones. Pictured here is an Oregon slender salamander (*Batrachoseps wrighti*) with a regenerated tail tip.

8.10 Some salamanders protect themselves with toxic secretions. *Top left:* some salamanders, such as this spotted salamander (*Ambystoma maculatum*), have secretions concentrated in glands on the head that are released when they head-butt a predator; *top right:* some salamanders with caudal toxin glands lash their tails at predators, as shown by this Yunnan newt (*Tylototriton shanjing*) with secretion oozing from its tail; *bottom left:* fire salamanders (*Salamandra salamandra*) spray their potent secretions and can direct these toward a predator; *bottom right:* the aposematic underside of the warty newt (*Paramesotriton*) warns of its toxicity.

larval and adult salamander is not as dramatic as the difference between tadpole and adult frog, but the metamorphosis still reminds one of rebirth. Second, like frogs, salamanders shed their skin. Third, when grabbed by predators, some salamanders drop parts of their tails (tail autotomy). The tail wiggles for a while after it breaks off. If the salamander is lucky, the predator will focus on the wiggling tail while the salamander escapes. In time, the salamander will regenerate a new tail. This ability to grow a new tail can remind us of our own ability to recover after devastating events in our lives.

Many salamanders—especially newts (Salamandridae), lungless salamanders (Plethodontidae), and mole salamanders (Ambystomatidae)—have toxic secretions concentrated in skin glands. The poison of certain salamanders can be lethal to humans. If you eat a rough-skinned newt (*Taricha granulosa*), you just might die—as has happened to more than one inebriated person who swallowed a newt on a dare. These newts contain tetrodotoxin (TTX), one of the most potent toxins known. One rough-skinned newt has enough TTX in its skin to kill an estimated 25,000 white mice.

The "Parable of the Coffeepot Incident" explains how Dr. Edmund D. (Butch) Brodie Jr., who studies toxicity in these rough-skinned newts, began his research. As an undergraduate in Oregon in the early 1960s, Butch wandered into his biology professor's office, looking for research ideas. Dr. Kenneth Walker told Butch about a local legend he'd heard while growing up on the Oregon coast. Three hunters had been found dead at their campsite. Nothing seemed amiss—there was no sign of a struggle and no one was injured. Oddly, however, their coffeepot held a boiled newt. Dr. Walker suggested, "Why don't you try to find out whether or not those newts are poisonous." Within a few days, Butch was grinding newt skin, mixing it with water, and injecting his concoction into wild-caught field mice. Tiny amounts of the mixture killed the mice within a few minutes. The rest is history. Butch has been studying the newts and their TTX defense for over 50 years. A legend turned out to be a powerful motivator for scientific research.

If the European ancients had known the "Parable of the Coffeepot Incident," they would have had good reason to believe some of the salamander lore prevalent during their time. Salamanders were said to be so toxic that one animal entwined around a tree could poison the fruit and kill anyone who ate the fruit. A salamander that fell into a well would kill all who drank the water. A salamander's saliva was so toxic that if any fell on a person's body, his/her hair would fall out. Some people are still under the false impression that all salamanders are toxic. In general, salamanders' toxicity has long been exaggerated—except for a few species, including Butch's newts.

The belief that salamanders were outrageously toxic lead to widespread warnings that the animals were diabolical. During the Middle Ages, witches in eastern Europe purportedly made brandy from salamanders to summon demons. Shakespeare portrayed newts as evil in his play *Macbeth* by including eye of newt as an ingredient in the witches' magic potion. During the Middle Ages, people were awarded gold coins for killing salamanders. Brightly colored poisonous salamanders were

8.11 Although rough-skinned newts are exceedingly toxic, some garter snakes can eat them with impunity. *Top:* rough-skinned newt (*Taricha granulosa*) in a defensive posture; *bottom:* common garter snake (*Thamnophis sirtalis*) eating a rough-skinned newt.

linked with evil spirits. Although much folklore advised people to avoid these evil animals, some Europeans believed that if a person had the courage to lick the underside of a salamander three times from head to tail, that person would be protected from fire for life and could cure other people's burns. (Given the toxicity of newts, this is not something I would recommend!)

Because salamanders were considered evil, they were bad news inside the human body. In the 1800s, U.S. folk belief claimed that one could harm a person by conjuring salamanders into the victim's stomach. Ground salamander powder put into someone's nostrils would cause the victim to fill with salamanders and writhe in discomfort. Folk beliefs warned of salamanders entering the human body on their own. Some Irish believed that if a person slept outside with his or her mouth open, newts would enter the body and cause sickness. A Navajo friend tells me that mothers and grandmothers in the Navajo Nation in Arizona still warn young girls never to wade into ponds because the tiger salamander larvae might crawl into their private parts.

Let's focus on a few salamanders in greater detail, starting with these western tiger salamanders (*Ambystoma mavortium*), the world's largest terrestrial salamanders (up to 14 inches; 35.6 cm). The plains of western Texas are a good place to hear folk beliefs about these salamanders. There, terrestrial adults spend much of the year underground in burrows. After spring rains, the adults emerge and migrate to shallow lakes, where they lay eggs. The aquatic larvae, often called "water dogs," have plump bodies, large broad heads, feathery external gills, and voracious appetites, altogether a rather menacing appearance. People who know that the aquatic "water dog" stage and the terrestrial adult stage are the same animal, but do not understand amphibian metamorphosis, consider tiger salamanders to be offspring of the Devil, poisonous, and able to change from fish to lizard and back again.

The axolotl (*Ambystoma mexicanum*) in a sense never grows up. Instead of metamorphosing from an aquatic larva to a terrestrial adult, axolotls retain their larval features, including feathery external gills, and remain in the water. Xólotl, the twin of Quetzalcoatl (the Mesoamerican feathered-serpent deity), was the dog-headed Aztec god of fire, lightning, death, and bad luck. He was the evil twin who worked witchcraft against humans and the other gods. Legend has it that Xólotl threw himself into Lake Xochimilco, in the current location of Mexico City, to escape being sacrificed. There he transformed into the salamander that we now call the axolotl. The Aztecs believed that these salamanders were incarnations of Xólotl, and they attributed healing powers to them. Axolotls were used medicinally, stirred into a syrup as a folk remedy for respiratory ailments such as bronchitis. Because these salamanders breed while seemingly juvenile, the axolotl symbolizes eternal youthfulness.

Axolotls are native only to two lakes in central Mexico: Lake Xochimilco and Lake Chalco. The latter has been drained to avoid periodic flooding, so the salamanders now occur only in Lake Xochimilco, a mere shadow of its former self. Once an exten-

8.12 Axolotls (*Ambystoma mexicanum*), with their feathery external gills, give the impression that they never grow up and thus symbolize eternal youthfulness.

sive lake and series of canals that connected most of the Aztec settlements of the Valley of Mexico, it is now a polluted canal system damaged by introduced plants and animals. Axolotls, sometimes considered a metaphor for the soul of Mexico, are critically endangered. In an ironic twist, perhaps "forever young" isn't Utopia after all.

Axolotls will never disappear, however, as they are commonly bred in captivity all over the world for use in medical and scientific research. They are used as model organisms for regeneration studies because of their amazing abilities to regenerate limbs, tail, skin, spinal cord, and jaws. A limb can be amputated 100 times, and each time it regenerates in perfect form, leaving no scar tissue. Organs transplanted into axolotls from other individuals are accepted without rejection. Axolotls are over 1,000 times more resistant to cancer than are mammals. Perhaps someday this salamander will help people suffering from severe burns, loss of limbs, organ rejection, and cancer.

Siberian newts (*Salamandrella keyserlingii*) are fairly normal-looking terrestrial brown salamanders that reach about 6 inches (15.2 cm) in length. Behaviorally, these salamanders are unusual, however, in that they can survive freezing down to –40° C, and they can remain frozen in permafrost for years. Once the ice melts and they defrost, they stretch their legs and wander off. The Itelmen, aboriginal people of the Kamchatka Peninsula of eastern Siberia, held a folk belief that was even more bizarre than the natural history of these salamanders. They considered Siberian newts to be spies sent by Gaech, Lord of the Underground, to capture the Itelmen and deliver them to their master.

Hellbenders (*Cryptobranchus alleganiensis*), aquatic salamanders that can reach over 2 feet (0.61 m) in length, live in fast-flowing streams and rivers in the eastern United States. Black slaves from western Virginia purportedly coined the name "hellbender," referring to the salamanders' slow, twisted swimming movement—comparable to "tortuous pangs of the damned in hell." These salamanders have flat bodies and heads, beady eyes, extra folds of skin along the sides of their bodies, slimy skin, and large mouths. Most people consider them downright ugly, even repulsive,

reflected in their colloquial names of mud-devil, devil dog, and snot otter. Many people believe that hellbenders can inflict a poisonous bite (not true), and in fact fishermen often cut the line and throw these salamanders back into the water rather than handle them. Others kill them. Folk belief has it that hellbenders drive away game fish. Not true. These salamanders eat primarily crayfish, and they avoid large predatory fish that might eat them! Unfortunately, these unfounded beliefs have led fishermen to resent and thus persecute hellbenders.

The Japanese giant salamander (*Andrias japonicus*), the world's second largest salamander, measures nearly 5 feet (1.5 m), just a tad smaller than Chinese giant salamanders (*Andrias davidianus*). These brown, heavy-bodied salamanders—with their wrinkled skin covered with folds and tubercles, tiny eyes, and broad, flat heads—make hellbenders, their close relatives, appear almost attractive! Japanese giant salamanders live in cold streams and rivers with abundant oxygen. They often wait in ambush and slurp unsuspecting fish. When disturbed, giant salamanders secrete pungent-smelling mucus resembling the smell of *sansho*, a tangy spice made from pricklyash tree berries. Thus, the Japanese call their endemic salamander *sansho-uo*. Another local name for the salamander is *hanzaki*, literally meaning "cut in half," referring to the (incorrect) belief that the salamander can regenerate when bisected.

Japanese folklore and popular culture tell of "water demons" called *kappas*, which many scholars suggest are based on the giant salamanders. *Kappas* are often portrayed as tricksters who perform relatively benign pranks, such as loudly passing gas and looking up women's kimonos. But they also come onto land to carry out criminal acts, including kidnapping (and eating) children and raping women. Because they are believed to lure people into the water to drown them and pluck out their livers through their anuses, signs around bodies of water in rural areas warn of the resident *kappas*. People use *kappas* as a warning to children to stay away from water unattended. *Kappas* are especially fond of cucumbers, thus some Japanese believe that eating cucumbers before swimming will protect them. Others write their names and ages on cucumbers and toss them into the water for the *kappas* to eat while the humans swim or bathe. *Kappas* aren't all bad, though. Once befriended, if motivated, *kappas* help irrigate the rice paddies and offer fresh fish to their human friends.

Typical *kappa* tales tell of the creature molesting horses or cows, such as in the legend "The *Kappa* of Fukiura." A long time ago, in the village of Fukiura, a *kappa* crawled out of the water and headed toward a cow tied to a tree. The *kappa* inserted his hand into the cow's anus to draw out the cow's tongue. Startled, the cow ran circles around the tree, and the *kappa*'s arm became entangled in the rope. When he saw a farmer approaching, the *kappa* tried to yank his arm free, but it separated from his shoulder and fell to the ground. The farmer retrieved the arm and took it home. That night the *kappa* appeared at the farmer's house and begged for his arm, saying that if he didn't get it back within three days it would not reattach to his shoulder. The farmer refused. The *kappa* begged again the second night, but still the farmer refused.

On the third night, the farmer felt sorry for the *kappa* and agreed to return the *kappa*'s arm if he would promise never to harm anyone in the village until the buttocks of a nearby Jizo (Buddhist stone statue) rotted away. The *kappa* agreed and got his arm back. Every night, the *kappa* examined the buttocks of the stone Jizo. He sprinkled excrement on the Jizo, hoping to speed the process, but still the stone buttocks failed to rot. The *kappa* finally gave up hoping he could continue his mischief, and the villagers were safe from their resident *kappa*.

The giant salamander is of great cultural importance to the Japanese, and a seventeenth-century tale explains why. A 10-foot (3 m) giant salamander marauded across the countryside eating horses and cows until a local hero named Mitsui Hikoshiro, a samurai, allowed himself to be swallowed whole by the salamander. Once engulfed, Mitsui slew the creature with his sword and crawled back out through the stomach. The villagers realized their folly when their crops began to fail and people—including Mitsui—began dying mysteriously. The salamander's spirit was wreaking havoc. To placate the spirit, the people of Maniwa city (in Okayama prefecture, in the mountains hundreds of kilometers west of Tokyo) built a wooden shrine to honor the *hanzaki*. This shrine is still standing. Every eighth of August, residents of Maniwa celebrate the *hanzaki*. Decked out in costume, people parade in the streets doing the *hanzaki* dance while pulling two floats, each with a 30-foot (9 m) replica of a Japanese giant salamander. One float has a male salamander, the other a female. The salamanders are kept separate all year and only brought together for this one occasion. Folk belief in the power of the giant salamander to affect human lives still influences these people. Fear has led to respect.

A highlight for me of a recent trip to Japan was visiting the Hanzaki Institute, located near Hyogo on Honshu Island. I had never seen a large adult Japanese giant salamander up close and personal. As I watched the 4-foot (1.2 m) giant crawling on the concrete next to my foot, I recalled the huge fossil replicas I have seen of late Carboniferous salamander-like amphibians from 300 million years ago. I felt transported back in time, long before dinosaurs roamed Earth.

The Hanzaki Institute combines ecological research, conservation, and education. Dr. Takeyoshi Tochimoto, who has studied Japanese giant salamanders for nearly 40 years, runs the institute. As one project, Dr. Tochimoto collects eggs from nests in the nearby river, raises the hatchlings until they are a year old, and then releases them back into the river. His helpers are local schoolchildren. He gives each child a yearling salamander to name and draw, after which they troop to the river with Dr. Tochimoto and release their charges. I can't think of a better way to instill respect for these salamanders! Conservation begins with children.

Japanese giant salamanders have gone from being revered, to exploited, to protected in less than a century. They were exploited after World War II when they be-

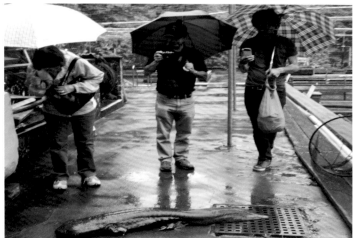

川オオサンショウウオの会

matsude

ぎふ郡上

自然がくれた宝物

オオサンショウウオが棲む、建屋川
建屋・三谷地域づくり研究会

came a much-needed source of protein for people. The salamanders are no longer eaten, at least not legally. Since 1952, they have been fully protected in Japan and are currently protected by international laws. The Japanese consider their salamanders a national treasure. Likenesses of the salamander appear on items from T-shirts to sake cups. Schoolchildren learn about the natural history of their unique animals and begin to respect them. Efforts to protect Japanese giant salamanders provide a highly successful model to encourage conservation for other threatened wildlife in Japan as well. Considering the appearance of the Japanese giant salamander—not large-eyed, cute, fluffy, or beautiful—it is remarkable that the animal has such a revered status in Japan.

8.13 The Hanzaki Institute, on Honshu Island, Japan, combines ecological research, conservation, and education focused on Japanese giant salamanders (*Andrias japonicus*). *Top left:* figurine depicting the samurai Mitsui, who slew the legendary giant *hanzaki* that marauded across the countryside; *top right:* line-up of Japanese giant salamanders at the institute; *center left:* the author and her friends watch a giant up close and personal; *center right:* cartoon image of a male Japanese giant salamander guarding his eggs; *bottom left:* "going fishing" conservation poster, intended to encourage people to share the fish in rivers with the salamanders; *bottom right:* poster of children's drawings of "their" yearling salamanders to be released into the river.

9

Marshmallow-Eaters, Methuselahs, Spiny-Backs, Were-Lizards, and Protectors

Perception of Reptiles through Folk Beliefs

The prevailing opinion of the student body was that alligators loved marshmallows, and marshmallow toting gator watchers were usually in evidence on the lake's banks. While wieners were doubtless preferred by the reptiles, these sank upon splashing, denying their tossers the opportunity to witness the action. Marshmallows, on the other hand, float and are prominently white, insuring that perpetrators can incite a toothy and electrifying lunge, always the outcome desired by those who feed or harass alligators. And alligators do, in fact, ingest marshmallows with considerable enthusiasm, so it is possible to buy a lot of excitement for the price of a bag of marshmallows.
—DON GOODMAN, *Summer of the Dragon*

In the mid-1960s, when Don Goodman moved to Gainesville, Lake Alice on the University of Florida campus was a superb place to watch alligators. When I moved to Gainesville in 1976, students still wiled away hours tossing marshmallows into gators' toothy gapes. Periodically, the newspaper reported that a gator had feasted on a small dog that had ventured too close. Finally, the powers that be proclaimed that the gators had become so accustomed to being fed by people that inevitably one would snatch a child from the bank. All resident gators were relocated.

What inspires us to feed dangerous wildlife? For some, it's the adrenaline-fueled thrill of danger. For others, it's an attempt to connect with fearsome animals, hoping that if we get close to them, we will understand them better and relinquish our fear. In Florida, it is now illegal

to feed alligators. The animals benefit, though the impetus for the law was human safety.

Thus far, we've looked at how humans perceive reptiles through mythology and other tales. In this chapter, we'll focus on perceptions of reptiles through folk beliefs. As with the folk beliefs of amphibians described in the last chapter, these beliefs about crocodilians, turtles, tuatara, lizards, and snakes can provide a lens into how we view the animals in both positive and negative ways.

Crocodilians

Folk beliefs about crocodilians range from the mundane to the outrageous, and they encompass the good, the bad, and the ugly. Regardless of the perspective, most folk beliefs reflect these animals' predatory nature. For example, some Papuan tribes believe that people who have been devoured by crocodiles can be seen in crocodiles' eyes at night, explaining why pairs of eerie red lights shine back from their flashlights.

9.1 Crocodilians represent power. This ceremonial caiman dance costume hails from the highlands of Mexico. From the collection of Butch and Judy Brodie, 6 feet (186 cm) long.

(The real reason for the eye shine is a layer of tissue made of guanine crystals within crocodilians' retinas that reflect light. This layer, called the tapetum lucidum, contributes to the superb night vision of these nocturnal animals.)

Ancient Egyptians wove the crocodile into their solar symbolism. Just as the sun sank below the darkness at night and rose from the darkness every morning, the crocodile walked the land by day and disappeared into the water at night. The crocodile god, Sobek, wore a solar disk on his head and in his beneficent aspect was associated with Ra, the main solar deity. But the crocodile encompassed a negative aspect as well—greed.

Herodotus, the ancient Greek historian (ca. 484–425 BCE), wrote of the conflicting views concerning crocodiles in ancient Egypt. In some areas, crocodiles were considered sacred and viewed as a symbol of reason. An animal that can see clearly through eyes covered by a protective veil surely must be thoughtful and reasonable. (The "veil" is the nictitating membrane, housed in the lower corner of the eye nearest the nostrils. This membrane, which sweeps across the eye as it is opened, cleans and lubricates with fluid secreted by the tear duct.)

Elsewhere in ancient Egypt, people killed crocodiles, viewed as "noxious beasts." This perception might have been reinforced by negative associations of crocodiles with Osiris, god of the dead and afterlife. Osiris's wicked younger brother, Seth, aspired to Osiris's throne as king of Egypt. Seth killed his brother, cut Osiris's body into fourteen pieces, and scattered the body parts. Osiris's wife, Isis, found all the pieces except for the penis, which according to some stories was swallowed by a Nile crocodile. Isis resurrected her husband through her magical powers. Although she purportedly made her husband a wooden prosthetic phallus, crocodiles got a bum rap for this inappropriate deed. As we've already seen from folktales, this double attitude toward crocodiles—positive and negative—is evident throughout ancient and modern Egyptian culture and religion.

Conflicting views about crocodilians are still expressed by residents of Madagascar. Some people view crocodiles so favorably that they believe if you kill a crocodile, you will soon die. Malagasy sorcerers make talismans from crocodile teeth that purportedly bring success and love. Some Malagasy clans claim to be descended from crocodiles. In one crocodile clan, when a person dies, a long nail is driven into the deceased's forehead so that the corpse cannot move. When the body is placed in the family grave a few days later, the nail is removed. Clan members believe that once the grave is closed, a tail forms, the hands and feet grow claws, and the skin hardens and becomes scaly. Once the corpse transforms into a crocodile, it joins its ancestors in the river. Malagasy crocodiles must be watchful, however. Madagascar doesn't have any large terrestrial carnivores, and the Nile crocodile (*Crocodylus niloticus*) is the only animal that threatens people. Every culture seems to fear and therefore kill some threatening animal. The crocodile has the dubious honor of being that animal for those Malagasy who do not consider crocodiles their ancestors.

Many Africans credit crocodiles with great powers. Some believe that crocodiles house the souls of murder victims seeking revenge, and that an attack on a human by a crocodile happens because the person inside the crocodile's body is exacting vengeance for some prior deed. Bantu shun anyone even splashed by a crocodile, due to the animal's power. Some Africans believe that crocodiles grab people's shadows and pull them underwater. Many feel that crocodiles should be respected because they carry the souls of humans' deceased relatives, including revered grandparents. In Ghana, the crocodile symbolizes protection. Shamans in West Africa use crocodile livers and intestines to cast evil spells. The Konde, from the East African Rift region, used to bewitch crocodiles to kill their enemies. This was considered an especially heinous crime. If caught, the offender was locked in a fish trap and left in the water until a crocodile ate him.

Likewise, Australians hold conflicting folk beliefs about crocodiles. Some Aboriginals associate crocodiles with wisdom. Especially along the coast, some consider the

9.2 Although most species of crocodilians are not aggressive enough or large enough to threaten humans, some are potentially dangerous. *Left:* Danté Fenolio holding the skull of a black caiman (*Melanosuchus niger*), a species that occasionally attacks humans. *Right:* Imagine bumping into what appears to be a log, but in reality is one of the world's largest reptiles and an aggressive predator—a saltwater crocodile (*Crocodylus porosus*).

saltwater crocodile (*Crocodylus porosus*), the world's largest crocodilian (giants grow up to 24 feet; 7.3 m), their totem and therefore sacred. They don't kill salties, despite their aggressive and potentially dangerous nature. In other parts of Australia, Aboriginals hunt them for dinner.

Borneans used to protect crocodiles because they believed the reptiles drove away ever-present evil spirits. Habitat destruction now has reduced crocodiles' natural food supply in some areas, and hungry reptiles aren't above eating domesticated animals or children playing in the water. Thus, attitudes toward crocodiles are becoming increasingly negative, an attitude change mirrored in much of the world as we encroach on crocodilians' living space.

People probably have always held a morbid fascination for crocodilians because we fear that they might eat us. Imagine being confronted by a prehistoric-looking creature with a mouth full of sharp teeth suddenly lunging toward you from murky water. Snap! Lunch! Realistically, however, most species are not aggressive enough or large enough to tackle us. Nile and saltwater crocodiles are exceptions, and a few others such as the American alligator are potentially dangerous to people.

In south and southeast Asia, an extensive lore has developed concerning the benefit of being eaten by a crocodile, though not always to the victim. In Bago, Burma (Myanmar), it was believed that anyone unfortunate enough to be devoured by a crocodile went to a place of perpetual happiness. Filipinos felt it was an honor to be eaten by a crocodile. In some areas of India and Pakistan, people thought they could gain favor with crocodiles by throwing their newborn females into the Ganges River as sacrificial offerings—until British colonists outlawed the practice in the early nineteenth century.

Alligators in the southeastern United States also have a mixed reputation. A Muskogean tribe of Louisiana, the Bayogola, held the alligator as their totem. At the other extreme, a Cajun belief warned that if an alligator gets under your home, a resident would die.

For some people, crocodilians symbolize deceit. Those who have dared to approach crocodilians while they are eating have noticed that the animals appear to be crying. This observation inspired the expression "to cry crocodile tears," implying an insincere display of emotion. The expression "crocodile tears" reportedly comes from a medieval legend that crocodiles wept for the people they attacked and ate—but not from remorse. They shed tears of frustration because humans have so little flesh on their heads! (Crocodiles have lacrimal glands and form tears, but they don't "cry." Rather than expressing emotion, the tears merely clean the eyes. Crocodilians might shed tears when they eat because the pressure of biting hard on the prey squeezes tears from their lacrimal glands, or because their huffing and hissing while eating forces air through their sinuses and stimulates their lacrimal glands to shed tears.)

People who interpret dreams involving animals rely, to a large extent, on folk beliefs. Dreams about crocodilians are interpreted in various ways depending on what

9.3 The urban legend of alligators roaming New York City sewers originated in 1935, when a *New York Times* article reported that an 8-foot (2.4 m) alligator had been found in a manhole in East Harlem. With no explanation of how it got there, people invented one—the gator was flushed down the toilet—a story told ever since.

happens in the dream. Because these reptiles are large, powerful, and attack prey with lightning-fast speed, some interpreters say that in frightening dreams the reptiles represent the dreamer's subconscious fear of enemies, impending doom, or a hidden problem. In contrast, a pleasant dream featuring crocodilians reflects a person's comfort in his or her own skin.

The urban legend of alligators roaming New York City sewers hasn't helped the alligator's reputation. One popular version is that (the imaginary) sewer-living alligators are descendants of children's pets brought back from Florida vacations. Once the baby alligators outgrew their cuteness (and their enclosures), the kids' parents flushed the gators down toilets. The gators survived in the sewer system by eating rats, and they reproduced. Some embellished versions claim that over time the alligators have become albino in the absence of sunlight.

In *Introduction to Mythology*, Eva Thury and Margaret Devinney suggest that this alligator urban legend can teach us a lot about ourselves and our culture. The tale suggests that in our society "there is something unclean and scary hidden underneath the pleasant surface of civilized life." Underneath the pavement lies a mysterious infrastructure of tunnels, subways, and sewer systems. "The alligators, then, are an expression of the fears we have of all the unknown parts of living in a city, all the natural or instinctual parts of ourselves that, as civilized people, we are not completely

comfortable or completely familiar with." The legend also reflects the fears we have of each other in high-density living conditions. One person's careless flushing of baby alligators down the toilet affects many innocent people. I would add that one reason the urban legend is so widespread and popular is the target animal: a large, powerful reptile perceived as fierce and prehistoric. I doubt the legend would have such a devoted following if it concerned spotted salamanders swimming in the sewers.

Turtles

We see turtles as hardy survivors: they watched the dinosaurs go extinct, but they continued living. They live a long time, so we consider them wise. They plod through life, so we see them as patient, introspective, and thoughtful. Not everyone loves a turtle, however. Because they retreat into their shells when frightened, some people view turtles as weak, cowardly, and slow-witted. Turtle lore embraces all these traits and more.

Turtles, especially tortoises, are the vertebrate Methuselahs. The longevity record for a captive tortoise is 188 years, an honor bestowed to a radiated tortoise named

9.4 Turtles make perfect symbols for road signs signaling drivers to "Slow Down!"

Tu'i Malila from Madagascar. In the 1770s, Captain James Cook presented Tu'i Malila to the royal family of Tonga. Tu'i Malila lived until 1965. The common box turtle may live a century, and sea turtles may live over 80 years. Thus, turtles symbolize long life and immortality. In ancient China, some burial mounds were turtle-shaped, turtles were embroidered on burial clothes, and pins with turtle likenesses were placed in deceased women's hair. Huge carved stone turtles supported memorial tablets marking the graves of Chinese emperors and other nobles. Visitors still flock to the Turtle Temple in Bangkok, Thailand, to pray for long lives as they feed turtles living in the pond. Taiwanese offer red turtle-shaped cakes—combined symbols of longevity (turtle) and good fortune (red)—during wedding celebrations and funeral gatherings. The tortoise motif is popular in traditional Japanese wedding ceremonies where the

9.5 Turtles symbolize longevity, wisdom, and stability.

9.6 Turtles, symbols of strength and endurance, often show up as supports. *Top:* carved stones in the shape of turtles provide a foot bridge in Kyoto, Japan; *bottom:* statue of a sea turtle transporting a boy, Amami Island, Ryukyus, Japan.

bride might wear a kimono with tortoise images and guests might be served tortoise-shaped *wagashi* (Japanese cakes), symbolizing hope for a long marriage. Longevity implies endurance, and so the turtle also represents strength and indestructibility, explaining why turtle figures rest at building foundations and serve as weight-bearing bases for columns.

The ancient Chinese considered tortoises to be extremely wise. Secure between the plastron (bottom shell) and the carapace (upper shell), the tortoise was seen as a mediator between Heaven and Earth, possessing great knowledge and an ability to foresee the future. During the Shang Dynasty (1766–1122 BCE), the Chinese frequently used tortoise plastrons in their art of divination. A tortoise was killed and its plastron cleaned and polished. A question was posed, for which the diviner sought a yes or no answer, and the plastron was heated with red-hot metal bars or held over a flame. The diviner interpreted the shape, sound, or speed with which stress cracks appeared in the shell. Tortoise plastrons were believed to predict agricultural success or failure, weather, and possible disasters, and they were used for interpreting dreams. Generally, only one question was posed per plastron. Confucius (551–479 BCE) eventually condemned the practice, because so many tortoises were slaughtered.

The steady, deliberate movements of turtles suggest persistence. In Celtic symbolism, the turtle teaches us to be grounded, in tune with Earth—to "go with the flow." The fact that the turtle is self-contained, living within its home, suggests focus and self-reliance. In Hinduism, a turtle's ability to pull its head into its shell suggests an advanced spiritual state, or a conscious turning inward, as if the turtle were meditating.

Turtles symbolize good fortune and protective power. Worldwide, people have long used turtle amulets, charms, and talismans worn as jewelry or carried in a pocket to bring good luck, protect, ward off evil spirits, or promote good health and longevity. One can buy turtle-shaped bodyguards carved from tiger's-eye, agate, jade, amethyst, malachite, rose quartz, onyx, hematite, soapstone, and other stones—take your pick.

Tortoises represent stability and are used as guardians in the ancient Chinese art of feng shui decoration, which balances the energies in a home, office, or garden to ensure good health and fortune. The tortoise—one of four Celestial Animals in feng shui (the others are the dragon, phoenix, and tiger)—is used in various ways. A tortoise figurine at the back door or in the back of a garden provides protection and strengthens energy, while a tortoise in the bedroom ensures good sleep and prevents unpleasant dreams.

In some Native American cultures of North America, a newborn baby's umbilical cord is placed in an amulet bag attached to the baby's cradleboard or worn by the mother. The Lakota place their daughters' umbilical cords in turtle-shaped bags, representing safety because of the animal's protective shell. In contrast, they put their sons' cords into lizard-shaped bags. They believe that lizards are especially able

9.7 Surrounded by water and marine wildlife, many native Hawaiians have a deep respect for sea turtles. The green turtle (*Chelonia mydas*), *honu* in the native Hawaiian language, represents the islands, and the turtle symbolizes good luck and peace. Legend has it that long ago, sea turtles guided the Polynesians to the Hawaiian Islands.

to care for themselves, because when attacked they can shed part of their tails and grow new ones. Some Lakota keep their cord amulets their entire lives and are buried with them.

Turtles have been and still are perceived in negative ways as well. Ancient Egyptians associated turtles with the Underworld. Turtles symbolized darkness and evil and were enemies of Ra, the Sun God. Legend has it that as Ra traveled through the Underworld, dangerous creatures—including turtles—tried to attack the god. The turtle was synonymous with drought, and drought was an enemy of Ra. Because Ra was worshipped as a good god, the turtle was seen in a negative light. People would chant, "May Ra live and may the turtle die." The Muscogee (Creek) from North America believed that box turtles caused droughts and floods, and they killed all they encountered. For the Aztecs, turtles symbolized cowardice and boastfulness because although turtles are hard on the outside, they are soft inside. In parts of the Amazon Basin, people believe that turtles are evil and associated with human sin. Caribs from South America did not eat tortoise meat because doing so would make them "heavy and stupid like tortoises themselves." In West Africa, Fon men in the prime of their lives avoid eating tortoise meat for fear of losing their vigor and agility.

We use the turtle metaphor for the human condition of being afraid to face responsibility or reality. With disdain, we refer to "withdrawing into one's shell." To encourage someone to interact with others or to face up to reality, we say, "Come out of your shell." During World War II, in February 1942, President Franklin D. Roosevelt used the turtle metaphor during a radio Fireside Chat to fight feelings of defeatism: "Those Americans who believed that we could live under the illusion of isolationism wanted the American eagle to imitate the tactics of the ostrich. Now, many of these same people, afraid that we may be sticking our necks out, want our national bird to be turned into a turtle. . . . I know I speak for the mass of the American people when I say that we reject the turtle policy."

Cultures worldwide use turtle proverbs that reflect their slow pace, silent nature, and ability to hide in their shell. A turtle travels only when it sticks its neck out (Korea). The turtle underestimates the value of fast feet (Japan). The turtle lays thousands of eggs without anyone knowing, but when the hen lays an egg, the whole country is informed (Malaysia). It is the fear of what tomorrow may bring that makes the tortoise carry his house with him wherever he goes (Nigeria). Sleepy turtles never catch up with the sunrise (Jamaica).

Turtles featured in omens and superstitions reflect both positive and negative attitudes. In the United States, if you dream of a turtle, either you will have a long and successful life or you are afraid of facing responsibility. Other U.S. folk beliefs include the following: Keep a turtle in your garden or a turtle's bone in your pocket for good luck. If you kill a turtle, thunder and lightning will soon happen. Elsewhere in the world, set a turtle free, and you will be relieved from sadness and upset (Thailand). If you see a turtle cross the street, your plans will be delayed (Vietnam). Pat the shell of a turtle, and good luck will come to you (China). Don't keep a turtle as a pet; if you do, it will slow down your business (China). To ward off evil, put a tortoise shell underneath your door (Angola).

Tuatara

Many people have never heard of tuatara. There is only one species (*Sphenodon punctatus*), and they now live only on small islands off the coast of New Zealand. Tuatara superficially resemble lizards, but their closest relatives are a group of extinct reptiles that roamed Earth with the dinosaurs. The name "tuatara" comes from the Maori words *tua* meaning "back" and *tara* meaning "spiny," referring to the crest of spines that runs down the center of the animal's back.

Because many Maori feared tuatara, some of their folk beliefs reflect negative attitudes toward them. Some believed that tuatara were messengers of Whiro, god of darkness and evil who controlled disasters and death. As such, tuatara signified death and warned of impending calamity. For some, they housed spirits, were evil omens, and conveyed bad luck. Figures of the reptiles were used to indicate boundaries be-

9.8 Henry, a tuatara (*Sphenodon punctatus*) living in the Southland Museum at Invercargill, New Zealand, served as the model for the tuatara featured on the country's 5-cent coin.

yond which one could not cross without repercussions. As an extreme example of such use, women tattooed reptile figures, presumably including tuatara, near their genitals. Another negative attitude reflected the fact that tuatara lack copulatory organs: people viewed them as having been sent to Earth in an unfinished, inferior condition.

Some folk beliefs reflect positive attitudes and respect for tuatara. Those Maori who viewed tuatara as divine guardians would release the reptiles near burial caves to protect the dead. Some believed that tuatara were keepers of knowledge. This belief may stem from the tuatara's "third eye" (pineal gland) located on the top of the head, suggesting that they can see in another dimension. Tuatara live a long time (70 years or more), thus they are believed to accumulate considerable knowledge. These "living fossils" also feature in some Maori creation stories.

Lizards

We both love and hate lizards—they heal or kill, ensure tranquility or cause disruption, and bring good or bad luck. On the plus side, lizards represent divine wisdom and guardian spirits, and they serve as messengers to the gods. For the ancient Romans, lizards symbolized resurrection—they slept through the winter and awoke in the spring. In ancient Greece and Egypt, lizards symbolized good fortune, perhaps because lizards shed their tails to protect themselves and then grow new ones. Residents of New Caledonia in the South Pacific revere lizards because they believe these animals harbor their ancestors' souls. On the negative side, lizards represent

ill fortune and death. In Gambia, chameleons are considered to be messengers of evil spirits. New Zealand folk beliefs tell of "were-lizards" and of evil spirits housed in lizards, spirits that cause misfortune, calamity, and death. Iranians often kill lizards because they believe they house the Devil's soul. Thai don't want geckos in their homes because the lizards bring bad luck. We'll take a closer look at folk beliefs surrounding four groups of lizards: monitors, chameleons, horned lizards, and Gila monsters and beaded lizards.

Monitor lizards (called goannas in Australia) belong to the family Varanidae, genus *Varanus*. Europeans who colonized Australia confused these lizards with the large iguanas of the Americas, and the word "iguana" eventually became "goanna." The approximately 40 species of monitors are found on three continents: Australia, Africa, and Asia. About two-thirds of all monitor species occur in Australia. Their body sizes range from 9 inches (23 cm) to the largest living lizard, the Komodo dragon, at nearly 10 feet (3 m).

Monitors feature prominently in folklore throughout their native range because they are aggressive, powerful, and intelligent. Many are lizard giants. They command respect. No wonder, then, that people from many cultures believe that monitors can dictate the course of their lives in both good and evil ways. Most superstitions about monitors have no basis of fact and likely originated through fear. In Pakistan, people kept their mouths tightly closed in a monitor's presence. If the lizard saw your teeth, its spirit could infect your soul. In Kazakhstan, if a monitor ran between your legs, your chance of having children was reduced to nil. Some Thai won't utter the word "monitor" for fear of attracting bad luck. In Sri Lanka, it is said that if you walk on monitors' feces, your feet will erupt with sores. People believe that desert monitors (*Varanus griseus*) will jump to bite a person's face, and that a monitor's tail lashing against a person results in sterility.

Walter Auffenberg, a world authority on monitor lizards, writes: "Probably no creature has such a split personality in tribal cultures as the water monitor (*Varanus salvator*). It is both good and evil, cherished and feared, used or shunned, depending on the people relating to it." At a maximum body length of nearly 10 feet (3 m), water monitors are the second largest and the most widespread of all monitors. Carved wooden effigies of monitors are placed among crops to protect against disease and insect and rodent damage. People eat monitor flesh for the "strength" the lizards possess, rub balms made from monitor fat onto their bodies to ease arthritis and rheumatism pain, and drink rejuvenating tonics made from baby monitors drowned in herbs, spices, and alcohol.

Others believe water monitors bring misfortune. According to Bornean Kalabit, if a monitor is seen at a wedding, the marriage is doomed. Some Borneans depict water monitors on their shields, to send hardship and suffering to their opponents. In parts of Thailand, if a water monitor enters a house, it brings bad luck that can only be exorcised by a Buddhist monk. One myth claims that when the moon is full,

9.9 The water monitor (*Varanus salvator*), second largest of all monitors, is considered both good and evil, cherished and feared, depending on the culture.

certain people break out in scales, develop long forked tongues, and turn into "were-monitors" that seek warm human flesh.

Water monitors eat carrion, including human remains, a behavior viewed as positive or negative depending on the culture. People who disapprove of such habits cover grave sites with heavy rocks, build exclusion fences, or place their dead in monitor-proof receptacles to keep water monitors from desecrating their loved ones' bodies. In contrast, in days past on Bali, Indonesia, members of some cultures covered a corpse with a wicker basket with holes large enough that juvenile water monitors could pass through but small enough that monkeys or dogs could not reach the body. A family member sat near the basket, keeping watch for a foraging water monitor. When one arrived and began to eat the corpse, the relative relayed the joyous news to the village that the person's spirit had been carried to the land of the dead. People in the Mergui Archipelago in far southern Burma (Myanmar) left corpses on exposed platforms in the forest to allow monitors easy access to their relatives, thus eliminating the need to bury or burn the bodies.

9.10 An African myth says that the Devil made chameleons from spare parts. He gave the creature "the tail of a monkey, the skin of a crocodile, the tongue of a toad, the horns of a rhinoceros, and the eyes of who-knows-what." Pictured here is a Werner's chameleon (*Trioceros werneri*).

People have long believed that water monitors' saliva is toxic, or that the animals are venomous, because their bites often cause severe infections. In Sarawak, Borneo, people eat water monitors, but they cook them with ginger as a precaution: if the flesh is poisonous, the meat will turn black and serve as a warning. Many Sri Lankans insist that not only is water monitor flesh poisonous, but also that the monitor's breath causes serious illness. The Karen from Burma ate monitors but discarded the heads, believing them to be poisonous.

What does the scientific evidence say? Komodo dragon saliva houses 54 potentially deadly kinds of bacteria. After a Komodo dragon bites its prey, bacteria from the saliva infect the wound and later kill the victim. The folk belief about toxic saliva turned out to be true in a sense—for Komodo dragons. Scientists have long thought that the only venomous lizards were Gila monsters and beaded lizards. Then in 2006 Bryan Fry and his coauthors reported the presence of venom glands located in the lower jaws of certain monitors. (Monitors are fairly close relatives of Gila monsters and beaded lizards.) Further work is needed to determine if the venoms are actually toxic to the lizards' prey and to their predators, but in time folklore claiming that monitors are venomous might be vindicated.

Most of the 130 species of chameleons (family Chamaeleonidae) live in Africa and on neighboring islands—in wet jungles, savannas, and deserts. And what bizarre-looking lizards they are! The word "chameleon" comes from the Greek words *chamae* meaning "small, crawling," and *leon*, meaning "lion."

9.11 The Marka from northwest Mali circumcise boys as adolescents. Perhaps the chameleon featured on this Marka circumcision mask used during the circumcision ceremony symbolizes the change from adolescence to manhood. From the collection of Butch and Judy Brodie, 15 inches (39 cm) long.

Chameleons have spawned considerable folklore. For example, chameleons can survive for weeks without eating, leading to the belief that they digest air. In *Hamlet*, Shakespeare refers to air as "the chameleon's dish." Later, perpetuating the belief, the English romantic poet Percy Bysshe Shelley wrote that "chameleons feed on light and air." Chameleons are loved, tolerated, or hated depending on the culture and the person within that culture. In some places, people believe that the lizards house spirits of dead ancestors and thus should not be killed. Some people admire chameleons for their beauty and wouldn't dream of harming them. Elsewhere, people fear and kill chameleons, believing they are poisonous.

Fady, or taboos dictated by the dead, rule the people of Madagascar. Although everywhere on the island it is *fady* to kill a chameleon, the specific taboos vary from tribe to tribe, town to town, family to family, and person to person. People vary greatly in how they view chameleons, from admiration to tolerance to fear. One of the most spectacular of all chameleons, the panther chameleon (*Furcifer pardalis*), is protected on Madagascar thanks to *fady*. It is forbidden to eat these large, gaudily colored lizards, and women never touch them. If a man touches one, his wife will not allow him to touch her for three days. People are careful not to kill these chameleons because they are so powerful. Drivers who don't think twice about hitting a chicken or a dog will swerve to miss a panther chameleon crossing the road.

Just because many Africans won't kill chameleons doesn't mean they like them, however. Superstitions abound. Women are advised not to look directly at chameleons lest bad luck follow them. A girl who has had a chameleon look her in the eyes will not marry. If a chameleon sees a pregnant woman, she will have a difficult birth. To have a chameleon cross your path has the same outcome as the European superstition of a black cat crossing your path. If a chameleon walks over food, it should not be eaten because the food now is poisoned. If hunters see a

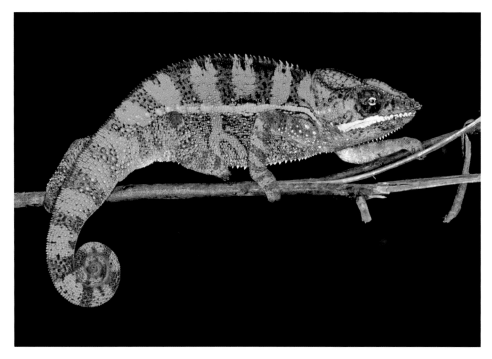

9.12 The panther chameleon (*Fucifer pardalis*) is protected on Madagascar, thanks to a taboo against killing them.

chameleon early in their hunt, they should return home because the hunt is cursed. To calm evil spirits housed in chameleons, Gambian women expose their breasts, and if lactating, they spray the lizards with milk.

In contrast, people of some African cultures admire chameleons. The Dogon of Mali in western Africa appreciate the lizards' color changes—just like the rainbow that joins Earth with sky. In the Republic of Benin in western Africa, chameleons are considered sacred; a myth tells how chameleon brought fire from the sun to people. The San of southern Africa prayed to the chameleon for its perceived ability to deliver rain. Some Tunisians respect chameleons, claiming that the lizards kill snakes by crawling along tree branches above sleeping snakes and discharging glutinous threads of saliva onto the snakes' heads. This belief likely originated because of chameleons' long, lightning-fast tongues.

People of some cultures use chameleons as remedies, amulets, and charms because of their perceived powers. The Mensa from northern Ethiopia let a chameleon amble on a person's head to resolve a headache. As the lizard changes color, the pain will ease. When the chameleon is removed, the headache disappears. In North Africa, women who fear that their husbands are straying conceal chameleon meat or bones in their partner's food; eating chameleon restores men's fidelity. In Tunisia, people kill and bury chameleons in the foundations of new buildings because the lizards protect against the evil eye and bad luck. To bring much-needed rain, people burn a

chameleon's head, throat, and liver with hard wood. Women ingest chameleon ashes to guarantee fertility. For good luck, people wear charms with chameleon figures or pieces of chameleon skin around their necks. To protect against thieves, people are advised to place a chameleon's foreleg in a hyena skin and wear it on the left arm.

Much African chameleon folk belief focuses on the lizards' swiveling eyes and slow, deliberate walk. One explanation for the chameleon's slow gait is that way back in time, the chameleon had to tread carefully to avoid sliding into the primeval mud. Not changing its ways, the chameleon still walks deliberately, one step at a time. In Madagascar, people profess, "Walk like a chameleon—look forward, but watch your back" and "Like a chameleon, have one eye on the future, one eye on the past." In Ghana, people say, "The chameleon may be slow, but it always reaches its target." An Arabic proverb advises: "A chameleon does not leave one tree until it is sure of another."

We've long incorporated the chameleon's ability to change appearance rapidly into our speech. For practitioners of the Sufi Islamic tradition, a chameleon symbolized an inconsistent person who changed his tune depending on the circumstances. Early Christians used the chameleon to symbolize Satan, who assumed different appearances to deceive people. Anyone who flip-flops in how they look, think, or talk is considered a chameleon, such as a politician who advocates policy shifts. During the campaign for the 1932 U.S. presidential election, Herbert Hoover famously referred to Franklin D. Roosevelt as a "chameleon on plaid." The American celebrity lawyer Marvin Mitchelson is reported to have said, "A divorce lawyer is a chameleon with a law book." And then there's the expression "to be more confused than a chameleon in a bag of Skittles." Chameleons have also infiltrated gemology. Alexandrite, a rare and costly gem discovered in the Ural Mountains, is called the "chameleon stone." The magical changing of its color depends on the amount and type of light. In daylight, a high-quality alexandrite is emerald green or vivid bluish green. In incandescent light, the gem turns a soft shade of red or purplish red.

On the other side of the world, imagine the following peering up at you from the desert sand: a 4-inch (10.2 cm) lizard resembling a miniature flattened dinosaur sporting a crown of wicked-looking horns and sides fringed with large spiny scales. This odd-looking creature is a horned lizard, family Phrynosomatidae, from the Greek words *phrynos* meaning "toad" and *soma* meaning "body." Except for having a tail, horned lizards superficially resemble squashed toads, explaining why many people call them "horny toads." As a group, the 14 species of horned lizards range from southern Canada through Mexico, with one species as far south as Guatemala.

One vernacular name for these lizards is "little gnomes of the sand." Mexicans call them *camaleón* (chameleon), because their colors change with body temperature. Another Mexican epithet is *torrito de la Virgen* (Virgin's little bull). Like bulls, horned lizards have horns on their heads, and some horned lizards squirt blood from their eyes as a defense behavior, their "tears of blood" forging a connection with Christ.

9.13 Among herpetologists, horned lizards, such as this desert horned lizard (*Phrynosoma platyrhinos*), are the "darlings" of the lizard world, displaying a gentle disposition despite their prickly exterior.

Horned lizards play a central role in traditional beliefs and sacred stories of Native Americans from the southwestern United States. Long ago, various peoples painted images of the lizards on their pottery, carved horned lizard fetishes from stone, etched petroglyphs in the rocks around their homes, and sang and told stories about the lizards. Still today, many believe that horned lizards have the power to bestow good health and happiness.

Wade Sherbrooke described how the Piman from southern Arizona appeal to horned lizards for cures of "staying sicknesses." Piman believe that staying sicknesses, which affect only them, are caused by the "ways" or "strengths" of objects they have offended. Most of these objects are desert animals, including horned lizards. Piman feel that each animal is endowed with a dignity that must be respected. For this reason, a person's health is interwoven with his or her interactions with nature. If a Piman even unknowingly kills or injures a horned lizard, or walks on its tracks, horned lizard strength is offended and enters that person's body, causing foot sores, pain and swelling, and perhaps death. The staying sickness can be cured by a shaman, who appeals to horned lizard strength, but only after the lizard has been shown due respect by a ritual curer who sings horned lizard songs at the person's side.

The Navajo believe that the horned lizard—a symbol of power, strength, and wisdom—is their maternal grandfather. Traditionally, a person would hold a horned lizard against his or her chest and stroke it four times while praying for protection.

Children of the Navajo Nation in Arizona and New Mexico still hold horned lizards to their hearts and murmur, "*Yáat' ééh shi che*" ("Hello my grandfather"). As thanks for this respectful greeting, the lizards give the children strength. With its power and wisdom, the horned lizard is a sacred animal for the Navajo. They used horned lizards in ceremonies held for their warriors in the belief that the lizards protected the men from their inner selves. Perhaps because of the special strength of horned lizards, traditional Navajo still have a taboo against weaving horned lizard designs into their rugs.

Others look kindly upon these lizards as well. Indigenous Mexicans respect horned lizards and attribute the following words to them: "Don't tread on me! I am the color of the earth and I hold the world; therefore walk carefully, that you do not tread on me." Horned lizards are considered good omens. Along the Texas-Mexico border, some people believe that the lizards bring much-needed rain. In Texas, some people look to horned lizards for advice. They say that if you are lost and come across a horned lizard, notice which direction it is facing. That is the direction you want to go.

Some people consider horned lizards so powerful that they can harm humans. A popular belief in the Brazos Valley, Texas, warns that if a horned lizard "spits" blood from its eyes and then bites you, you will die. Elsewhere people believe that horned lizards are venomous and can kill by jabbing their spines into your flesh. One belief says that if you step on a horned lizard, it will give you a sore that will not heal, and eventually your foot will rot away. A traditional Navajo taboo advises that because horned lizards are grandfathers, killing one will give you a stomachache, swelling, or a heart attack. Respect or pay the consequences.

9.14 The "studded skin" of beaded lizards (*Heloderma horridum*; *left*) and Gila monsters (*Heloderma suspectum*; *right*) may have provided inspiration for many a beaded moccasin, belt, pouch, and necklace crafted by Native Americans of North America.

Gila monsters (*Heloderma suspectum*), found in the southwestern United States to northern Sinaloa, Mexico, and beaded lizards (*Heloderma horridum*), from Mexico and Guatemala, belong to the family Helodermatidae. The family name comes from the Greek words *helos* meaning "the head of a nail or stud," and *derma*, meaning "skin."

Both the Gila monster and beaded lizard have long been surrounded by folk beliefs. When the Spanish first saw beaded lizards in about 1577, they believed the lizards had deadly breath. Gila monsters were assumed to spit or belch toxins and kill vegetation with a single drop of their deadly saliva. These beliefs might reflect the fact that when angered, Gila monsters frequently hiss and sometimes saliva droplets are carried in the blasts of expelled air. Another misconception was that Gila monsters have no opening through which waste matter leaves the body, and therefore their venom comes from food decomposing in their intestines. Gila monsters do have an opening, but their scales obscure it. Now we know that both lizards have venom housed in glands located in the lower jaw. Other widespread beliefs included the erroneous ideas that Gila monsters sting with their forked tongues and that beaded lizards sting with their tails.

Gila monsters and beaded lizards are believed to have curative powers. The Navajo view the Gila monster as the first medicine man, able to diagnose the nature of illness and protect against it. With their mystical power, the lizards see and know everything. When Gila monsters walk, their forelimbs tremble when they raise them from the ground. Through this trembling, Gila monsters determine a person's illness and how it should be treated. When a Navajo medicine man begins a curing ceremony, he sprinkles sacred corn pollen in the four directions and chants special prayers to the Gila monster spirits, asking for help to diagnose the illness and methods for curing it. To extract poison from an infected wound and enhance healing, a traditional Yaqui healer from Sonora, Mexico, places Gila monster skin over the wound. The Seri Indians of the Sonoran coast of Mexico heat Gila monster skin and place it on their heads to relieve headache. Mexicans believed that preparations from beaded lizards were the best way to awaken sexual appetite. Homeopathic preparations from *Heloderma* venom treat manic depression, aggression, hypertension, and multiple sclerosis. Even Western medicine recognizes the curative powers of Gila monsters. A synthetic version of a component of Gila monster saliva is currently used to treat type-2 diabetes (chapter 13).

In contrast, some native peoples believed that Gila monsters and beaded lizards caused human illness. The Tohono O'odham, who live in the Sonoran Desert of southeastern Arizona and northwestern Mexico, thought that an encounter with a Gila monster could cause a lactating mother's milk to dry up or a person to break out in sores. Remedies to reverse these ailments ranged from a shaman singing a Gila monster song to tying a red cloth around either the offending lizard or a fetish carved from a saguaro cactus. Either way, whether Gila monsters are believed capable of healing or of causing sickness, they are viewed as powerful.

Snakes

Folk beliefs tell of snakes' unusual powers. Snakes can restore life, but they also kill—even by staring. They spit fire, shoot their toxic saliva into human food, suck milk from cows, and jam their tails up cows' nostrils to kill them. In India, it was believed that the inability to conceive meant that the man or woman must have killed a snake in a former life. The snake's spirit was haunting the woman and making her barren. To expel the spirit, a snake's image was burned and funeral rites performed.

Ancient Greeks harbored unusual folk beliefs about snakes that surfaced in their mythology. For example, it was bad luck to see serpents engaged in sex. Tiresias, a seer, paid a dear price for witnessing the act. When the copulating serpents struck at him, Tiresias killed the female with his staff. According to ancient Greek belief, if a man killed a female snake, he would either become homosexual or transform into a woman. In the seer's case, Hera, Queen of the Gods, transformed him into a female prostitute for seven years. Different versions explain how he regained his manhood. One was that after seven years he again found copulating snakes but left them alone. Another version says that Tiresias returned to where he had seen the copulating snakes and killed the male.

During the Middle Ages, illustrated compendia called Bestiaries described "strange creatures," including vipers. Viper sex was said to be a cruel affair that ended in death for both partners. One belief was that at the moment of ejaculation, the female viper takes her mate's head in her mouth and bites off his head in ecstasy, killing him. In another version, the male inserts his head into the female's mouth to deliver the semen, and driven mad by lust she bites off his head. In both versions, the young gnaw through their mother to enter the world. The *Aberdeen Bestiary*, from the twelfth century, added a twist to the viper story for a sermon on "conjugal rights." When the male viper desires intercourse, he seeks out a lamprey, which happily obliges. The message in the sermon is that women should tolerate their men's deceitful, uncouth, and unreliable behavior. If the lamprey can embrace the "slimy snake" with affection, women should acquiesce to their men's sexual desires.

Many folk beliefs associate snakes with the dead and the afterlife, likely for several reasons. First, venomous snakes kill people. Second, people often see snakes emerge from underground crevices and then "mysteriously" disappear underground. Third, snakes symbolize evil. Recall the descriptions of snakes terrorizing the damned in the Christian version of Hell and in the Norse version of Nastrand. Worldwide, people believe that snakes guard the souls of the dead and thus are themselves embodiments of those souls. Ancient Romans, medieval Germans, Celts, and Finnish tribes identified the snake as the seat of a person's soul. If a person killed a snake, the person associated with that snake would die. Zulu consider snakes to be spirits of the deceased. Some Dayak of Borneo, Indonesians, and Japanese believe that a "soul-substance" gives life to the dead and causes them to return in the form of snakes. In South Africa, pythons are believed to be incarnations of dead chieftains.

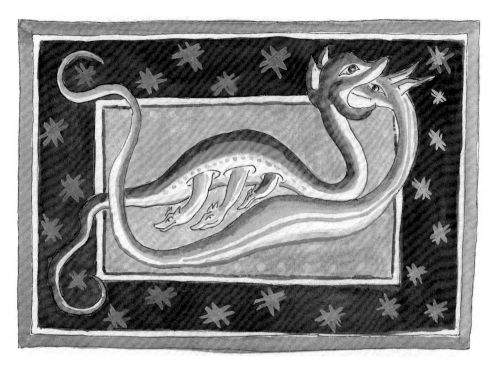

9.15 Bestiaries from the Middle Ages described viper sex as a cruel affair that ended in death for both male and female. The female bites off the male's head, and the young eat their way out of their mother's body.

Folk beliefs worldwide tell of snakes having power to harm humans in unusual ways. Kwakiutl Indians from British Columbia believe that if a person skins a female snake bearing young, the babies will crawl into the person's body and cause sickness. The snake is one of the traditional Navajo's most taboo animals: if one touches a snake, an evil spirit will enter the person's body at some future time and cause sickness. This belief has led to other traditional taboos such as "Do not call a person a snake, or a snake will bite you." "Do not step on a snake, or your legs will swell or become crooked." "Do not laugh at a snake, or it will bite you."

Bull snakes normally do not enter homes, but if one does, the Hopi believe it is a sorcerer and should be killed. They also warn that if you encounter the tracks of a bull snake, you should drag your feet across them. If instead you step over the tracks, your legs will ache and your waist will become skinny. Folk beliefs from various cultures warn that the sight of a snake causes face swelling, handling a snake makes skin peel, and working on land where snakes live causes leg pain. Snakes are thought to cause diseases, and if someone does something evil, he or she might become a snake. In England, an adder on one's doorstep forewarns that someone in the household will soon die.

Cultures everywhere have devised folk methods for protecting against snakebite. Snakes are appeased with gifts or driven away by spells, amulets, and curses. Many Native Americans wear a turquoise bead to protect against snakebite. When sleeping

outside, some people encircle themselves with hemp or horsehair ropes, onions, or garlic as a barrier against snakes; others carry a vulture's heart or use their own spit as repellents. The Atsugewi from northeastern California put angelica root on their legs, and women tied the herb turtlehead to their skirts. The Miskito Indians from Central America chewed leaves of *guaco*, a vine-like climbing plant, believing it would make the person's perspiration so foul that snakes would refuse to bite. In southern South America, men tie rhea feathers around their ankles in the belief that a venomous snake will strike the feathers instead of flesh. The British held that "snakestones" protected against snakebite. In some areas, these objects were glass beads found in the countryside, likely spindle-whorls used by people in former days. Fossil ammonites have long been called "snakestones" in British folklore.

Folk beliefs also sing praises to snakes. Snake amulets and charms repel danger and improve one's well-being. Medieval European peasants rubbed snake fat on their cows' udders to protect from witches' spells. Snake fangs, skin, rattles, bones, blood, venom, and fat are used to cure all manner of ailments. The physician Arnaldus de Villa Nova (ca. 1235–1311) claimed that the ashes of a snake burned when the moon is full and entering Aries, held under a person's tongue, imparted wisdom and eloquence. If placed under the soles of feet, the ashes increased the person's social advancement.

9.16 Brazilian musicians place rattlesnakes' rattles inside the sound holes of their guitars to improve the instruments' tone and the singers' voices. In Kentucky (United States), fiddlers kept rattlesnake rattles inside their violins to bring good luck. Pictured here is a western diamond-backed rattlesnake (*Crotalus atrox*) rattle.

Ukrainians use the snake symbol as a talisman for protection against evil spirits and disaster on their Easter eggs (called *pysanky*), which are decorated with traditional folk designs written with beeswax. The serpent is drawn as an "S," spiral, or wave. *Pysanky* with snakes represented by the spiral motif are considered the most powerful talismans because demons entering a house are drawn to spirals and become trapped therein. Snakes are associated with these Ukrainian eggs in another way. The Hutsul from western Ukraine believe that *pysanky* control the world's fate. As long as Ukrainians keep making *pysanky*, the world will exist as is. If the custom ever dies out, however, evil in the shape of a terrible serpent will overrun the world. According to legend, each year the serpent's followers count how many *pysanky* have been made. If the number is low, the serpent is unchained from his rock cliff. He roams the world and causes destruction. If the number is high, the serpent remains chained and good triumphs over evil for the coming year.

Rattlesnakes feature in many folk beliefs and perceptions, both positive and negative. In North America, most Native Americans respected rattlesnakes because of their perceived power. Rattlesnakes have long been associated with rain and Earth's fertility, and they are used in traditional medicines for their curative powers. For the Kickapoo from Michigan and Wisconsin, rattlesnakes were sacred because of their control over rain. In the southwest deserts, the Sia begged rattlesnakes to communicate with the cloud rulers to water the earth. The Yurok from northern California believed that a solar eclipse is caused when a rattlesnake swallows the sun. Some Native Americans claimed that rattlesnakes transmit disease through staring. Warriors froze in their tracks when rattlesnakes crossed their paths, and they offered the snakes whatever gifts they were carrying to bribe them from causing harm.

For the Cherokee, snakes were the most powerful animals of the Underworld, and Rattlesnake was leader of the snakes. The Cherokee revered rattlesnakes, but they also feared them for their ability to kill. People performed the Eagle Dance only in late autumn and winter when the snakes were hibernating. To do so during summer months would have made the snakes angry and vengeful. Some Cherokee believed that just seeing a rattlesnake could cause a person's eyes to become intolerably sensitive to the bright light from flames or the sun's rays. People avoided killing rattlesnakes except when absolutely necessary. After killing a rattlesnake, the person recited prayers to obtain pardon. If this was not done, the dead snake's relatives would seek revenge. Hunters chanted prayers and waved their leggings and moccasins over fires to discourage snakes. Victims of rattlesnake bite often attributed their lacerations to toads and other "weak" creatures or to briars to avoid offending the real culprit.

Snakes were also powerful animals for the Osage from North America. These first peoples distinguished between true stories and made-up tales. They told made-up stories only during wintertime, when snakes hibernate underground. The Osage regarded snakes as guardians of the truth. An untrue story would anger snakes, a consequence to be avoided.

During the American Revolutionary War (1775–83), an American general named Christopher Gadsden designed a flag with a coiled rattlesnake and the motto "Don't Tread on Me." The rattlesnake on the Gadsden flag, as it came to be known, was unique to the New World and symbolized vigilance, deadly power, and ethics. Rattlesnakes warn before striking. They don't start fights, but once engaged they don't back down. Likewise, the thirteen colonies had no intention of surrendering their independence to Great Britain.

Many U.S. snake-related omens concern luck—good or bad. For good luck, kill the first snake you see in the spring. To see a resting snake is lucky; to see a crawling snake is unlucky. If a snake enters your home, an enemy is trying to harm you. Do not pick up a shed snake's skin in the early spring, or trouble will ensue. Two snakes coiled together foretell an impending wedding. If a snake frightens a pregnant woman, her baby will have a snake-shaped birthmark or be deformed.

Worldwide, people attach symbolic or prophetic meaning to dreams about snakes. Freudians interpret snake dreams as repressed sexuality. Beyond that, the interpretation of a dream about snakes, whether positive or negative, often depends on what happens in the dream. If you see a snake and kill it, you will have good luck; if the snake escapes, you will have bad luck. If you kill a sleeping rattlesnake before it wakes up, you will conquer an enemy; if the rattlesnake awakes before you can kill it, you will never conquer the enemy. The Cherokee viewed snake dreams as harbingers of sickness, but the Pomo believed that dreaming of a bull snake or rattlesnake brought good luck. For the Maya, a dream about snakes foreshadowed a quarrel with one's spouse. The Chinese attach much significance to snake dreams: If a pregnant woman dreams of a black snake, she will give birth to a son; if she dreams of a white or gray snake, a daughter. A dream of a snake coiling around one's legs or body foretells a coming change. If a snake bites you, you will soon become wealthy. If a man dreams of one snake, he will soon acquire a new lady friend; a dream of many snakes means he could soon be tricked or betrayed. A snake crawling into your arms means you will be blessed with a gifted child.

Snakes have long been associated with milk, in both positive and negative ways. In the United States, milk snakes (*Lampropeltis triangulum*) acquired their common name from the belief that these snakes sneak into barns and suck milk from cows. Some people even believe that cows get sore teats from milk snakes. Coachwhips (*Coluber flagellum*) were thought to suck the breasts of nursing women and poison their nipples. In India, milk was offered to Nagas to obtain better crops. In much of the world, for hundreds of years people have left out milk for snakes in return for their protection. The truth is that no snake drinks milk, and they most certainly do not suckle cows' teats! No doubt the association between snakes and milk reflects snakes' common presence around barns, where they are attracted to rodents.

Kiyoshi Sasaki and his colleagues offer a good example of the power of folk beliefs to influence perceptions of reptiles, and thus affect their conservation. The authors write that Japanese respect awe-inspiring aspects of the natural world and of the deceased. These entities are referred to as *kami*, loosely translated as god or spirit. In the Shinto religion, most *kami* are nature spirits of this world who often visit or live in natural areas. Disturbance to these areas can result in retribution from the *kami*, whereas respectful behavior by humans can bring protection and blessing. Because of the strong traditional beliefs concerning *kami*, many natural areas in Japan, as well as small forest "islands" in urbanized areas, have remained undisturbed for hundreds of years despite easy accessibility or exploitability.

Japanese have traditionally revered snakes as *kami*, both as gods and as messengers of the gods. As reincarnations of the deceased, snakes watch over families. Shrines dedicated to snakes dot the landscape, in honor of their association with health, prosperity, and protection. To harm or kill a snake brings misfortune or death to individuals, families, or entire villages. Thus, Japanese traditionally refrained from harming snakes, and they avoided disturbing natural areas where snakes live. In general, the taboo against killing was stronger regarding harmless snakes, but even venomous snakes were protected.

Times have changed, however, and *kami* beliefs concerning snakes and nature in general have declined throughout Japan. Many Japanese now share the aversion to snakes exhibited by people in many other parts of the world and attempt to kill every snake they encounter, especially venomous species. Can anything be done to turn the situation around? Sasaki and colleagues posit that because traditional folk beliefs discouraged Japanese from killing snakes and destroying natural areas where snakes live, preservation and revival of such beliefs might improve snakes' future. The authors suggest the following, among other measures: (1) archive traditional beliefs and mores concerning snakes and natural areas; (2) implement educational programs to revive traditional beliefs and reinforce mores; and (3) encourage the government to recognize traditional taboos as formal practices. They conclude, "Most traditional beliefs have persisted only through oral traditions and are not in written format. In a highly modernized and industrialized society, these traditional beliefs and cultures that have lasted for centuries or millennia are at risk of being lost forever without this effort."

This association among Japanese folk beliefs, perception of animals, and the consequences to the animals' conservation could serve as a model for comparable conservation programs elsewhere in the world where traditional beliefs have eroded and led to a decreased appreciation of nature. Taboos, for example, play an increasingly less relevant role in the lives of people of many cultures. Whereas once a taboo might have protected an endangered species from being eaten or otherwise persecuted, now people are bombarded with ethical and legal reasons to protect the species. Will fear of the law prove to be as powerful a deterrent to exploitation as traditional taboo? I don't believe so.

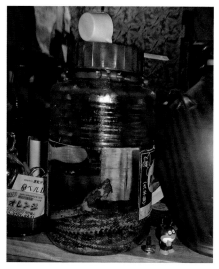

10.1 I drank my first *habushu*, pit viper wine, in Okinawa, Japan. *Top:* jar of wine, with a habu (*Protobothrops flavoviridis*); *center:* the server about to ladle the wine; *bottom:* my first sip.

10

Move Aside, Viagra

Reptile Sexual Power

Snakes are sinuous, supple eroticism exaggerated by paired, intricately ornamented sex organs.

—HARRY GREENE, *Snakes*

A large pit viper, mouth open and fangs exposed, sat coiled in a gallon jar of *awamori* (rice wine). I was in Okinawa, Japan, about to sip some of that wine—my first *habushu*, Okinawan snake wine made with habu (*Protobothrops flavoviridis*). The *awamori* is mixed with herbs and honey, and a viper is stuffed into the jar of flavored alcohol. Sometimes a live habu is left to drown in the *awamori*. Other times, a snake is gutted, stitched back together, and planted in the jar. Intestine-free snakes are said to impart a better flavor. Both times I drank *habushu*, it was delicious—smooth and slightly sweet and spicy (surely the intestine-free variety). Because the habu is feared as a powerful, venomous snake that can retain strength and vigor for over a year without eating, *habushu* is believed to impart energy. And, because habu copulate for hours, *habushu* purportedly mitigates male sexual dysfunction.

Thus far, we have explored our entangled perceptions of amphibians and reptiles through folklore, which reflects the affect dimension of how we perceive the animals—how we feel about them emotionally (chapter 1). The next four chapters will focus on the utility dimension—how we view the animals based on their usefulness to us. In this chapter, we will see

that throughout history and around the world, human cultures have viewed snakes, crocodilians, and turtles as sexually potent—admired as phallic symbols and consumed in hopes of increasing one's own sexual prowess and gratification. We can't ignore folklore, however, as our beliefs of reptile sexual potency derive from long-held traditions.

Snake Phallic (and Female Sexual) Power

One day the Great Spirit was annoyed because his penis kept getting in his way as he hunted. He twisted off the offending member and flung it into the bushes, whereupon the penis transformed into a snake (North American Algonquin myth).

While copulating with the moon, a man's penis grew so long that he had to stuff it in a basket to carry it home. Every night thereafter when the man went out, his penis crawled out of the basket, wandered off, and copulated with every woman it encountered. This state of affairs greatly angered the villagers, especially one man whose daughter had been violated. When the father saw the penis crawl into his hut in search of his daughter again, he cut off the end. The man with the long penis died, but the cut portion became a snake (Bolivian myth).

There's not much doubt from these Algonquin and Bolivian tales that snakes symbolize the human penis. Such symbolism goes back to earliest human history and continues to this day for an obvious reason: a snake's body shape resembles a phallus. This symbolism should not be interpreted in any obscene sense, though the message varies. In some contexts, the association between the human penis and snakes is positive: fertility on the human side, and rebirth and everlasting life on the snake side. In other contexts, the association is negative: seduction and rape on the human side, and the ability to kill on the snake side. Sherman and Madge Minton, in *Venomous Reptiles*, write: "Throughout India a symbolic equation of snake and phallus is specific and ubiquitous. The rearing stance and spread hood of an alert cobra, suggesting phallic tumescence, make this snake a natural symbol for human virility." Many of us associate the phallic symbolism of snakes with Sigmund Freud, founder of psychoanalysis. Freud believed that dreams expressed the unconscious through imagery and symbolism. He saw the snake as a phallic symbol—a super-penis—and argued that a dream of snakes indicated repressed sexual desire and inner conflict about one's sexuality.

In some eastern philosophies, one's life force, or spiritual energy, is imagined as Kundalini, a snake that lies coiled at the base of the spine until awakened through mystical or physical practices such as meditation and yoga. "Kundalini" is an ancient Sanskrit word meaning "she who is coiled." The goal of Kundalini yoga is to have the snake ascend through the vertebral column to the top of the head. As Kundalini rises, she awakens and develops the energies of seven main nerve centers known as chakras. Once Kundalini reaches the crown of one's head, that person will achieve

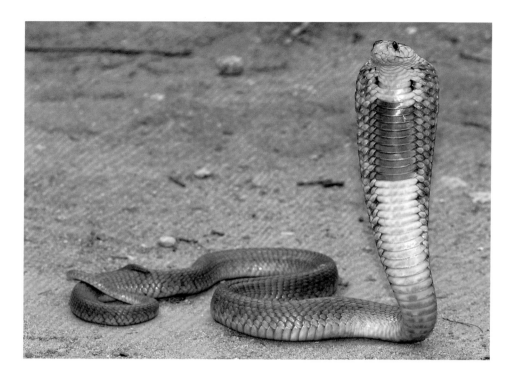

10.2 The rearing stance and spread hood of this snouted cobra (*Naja annulifera*) suggests phallic tumescence.

the highest level of consciousness. Some followers of Kundalini yoga associate the uncoiling of Kundalini with erection of the penis and thus a phallic symbol representing sexual energy.

Although we generally associate snakes with the phallus, they also are associated with female sexuality. Coiled snakes represent the feminine cycle of life—earth, moon, egg, and infinity. Wadjet, the ancient Egyptian goddess of childbirth, was depicted as a cobra-headed woman. The Egyptian harvest goddess Renenutet, and a nursing goddess who presided over a baby's suckling and symbolized nourishment, was depicted as a snake-headed woman or as a *uraeus* (stylized cobra in rearing stance) with two long plumes. In many traditions, the snake symbolizes the vagina. Numerous cultures share the folk belief that women menstruate because of snakebite that caused a magic wound that periodically bleeds but does not heal. (See chapter 6 for folktales featuring snakes and menstruating women.)

We've just seen that snakes are associated with both male and female sexuality. Another set of opposing views concerns snakes associated with fertility, on the one hand, vs. abortion and miscarriage, on the other. We'll explore fertility first.

The basis for association between snakes and human fertility is likely three-fold. First, the snake's shape resembles the human penis. Second, females of many snake species are highly fecund. Third, male snakes have two hemipenes, suggesting to some that snakes are endowed with double the power. Adding to the mystique, snakes' hemipenes are often ornamented with spines and ridges and look quite formidable when everted.

Snake-fertility associations play major roles in creation myths. For example, the Ashanti from Ghana, West Africa, tell how Python unraveled for man and woman the mystery of procreation. In the beginning, a man and a woman came down from Heaven. Another man and woman came up from underground. Neither couple had children, nor did they desire each other. Python offered to spice up their lives. He had the couples stand facing each other, then he sprayed river water on their bellies and told them to go home and lie together. They did, and the women conceived and bore children. These children took the spirit of the Python's river as their clan spirit. Members of this Ashanti clan still have a taboo against killing pythons because of the snakes' honored status. Anyone who finds a dead python covers the body with white clay and buries it.

Even Hippocrates, the "Father of Medicine," apparently believed in an association between snakes and human fertility. In a book on sterility, he recommended a vaginal suppository to aid conception: Mix together bulls' bile, verdigris (a green pigment made from copper acetate), and serpent fat. The mixture should be soaked in wool, and then wrapped in byssus cloth (made from the silky filaments produced by certain bivalve mollusks) and covered with honey. The olive-size suppository should be introduced into the vagina at night, and the woman should sleep on her back. This snake-based preparation purportedly dissolved a thwarting membrane.

Ceremonies involving snakes to increase women's fertility were carried out in various parts of the world during the vernal equinox or near summer's end. Some of these rituals have persisted in India. In *Venomous Reptiles*, the Mintons write:

> During the yearly festival of the snakes women encouraged living cobras to penetrate their vaginas in a graphic simulation of the fertility god Siva's union with the mother goddess Shakti. In the 1880s a visitor to Nagpur said: "Rough pictures of snakes in all sorts of shapes and positions are sold and distributed, something after the manner of valentines. In the ones I have seen in days gone by, the position of the women with the snakes were of a most indecent description and left no doubt that, so far as the idea in the sketches was concerned, the cobra was regarded as a phallus."

Most snake fertility deities are female. Demeter, Greek goddess of agriculture, sometimes was depicted holding snakes. During festivals to honor Demeter, participants carried both living snakes and images of snakes and penises. The Hindu goddesses Mudamma and Manasa, both of whom resided over human fertility, were represented as cobras. Corchen, an ancient Celtic goddess, likely represented fertility, as she was depicted naked with a snake at each side.

Although less common, some snake fertility deities are male. Some mythographers suggest that in Greek mythology Hermes was originally a phallic god associated with fertility, depicted as a snake. Later, he was depicted as a bearded man with

an erect penis. Eventually, he morphed into messenger of the gods. In this role, he traveled to relay messages from the gods to humans and was viewed as the god of travel, commerce, hospitality, and sexual intercourse. As messenger, Hermes was depicted as holding a winged staff with two intertwined snakes. Quetzalcoatl, the Aztec patron of human reproduction, was depicted as a feathered serpent. Kukulkan, the Maya's feathered serpent, likewise was associated with fertility and abundance. The El Castillo pyramid, a temple dedicated to Kukulkan, dominated the center of the Mayan city of Chichén Itzá in northern Yucatán. At the spring and fall equinoxes, the setting sun slants its rays across the northwest corner of the pyramid. Shadows from the play of fading light resemble an undulating snake crawling down the pyramid steps.

10.3 Quetzalcoatl, the Aztec god depicted as a feathered serpent, was associated with human fertility.

In sharp contrast to its fertility-promoting role, the snake is blamed for miscarriages and abortions. The prophet Muhammad advised his followers to kill snakes with two white lines on their backs because these snakes blinded people and caused abortions. European and Thai superstitions warn that merely seeing a snake will cause a pregnant woman to miscarry. According to rural U.S. superstition, if a snake enters a pregnant woman's home, she will lose her child.

Because snakes represent sexual power, people worldwide consume snake-based remedies believed to enhance sexual performance. Drake Stutesman, in her book *Snake*, describes various Chinese snake liquors touted as virility enhancers. Five Penis Wine is made with penises of snake, dog, sheep, deer, and bull. Another drink, consumed on the spot, is made from the blood of a freshly killed cobra dripped into rice wine. A greenish wine called *viperine*—commonly sold in markets, bars, and restaurants, and considered good for libido—is made from a live snake submerged in concentrated alcohol with herbs. Three days later, the snake is removed, decapitated, drained of blood, and its insides gutted. The snake's body is placed in 40-proof liquor and left to age for at least 100 days. *Viperine* made from a venomous snake reportedly gives more bang for the buck.

My husband, Al, recently visited Vietnam with several Japanese colleagues. One evening their Vietnamese host took them to one of the many snake restaurants in Hanoi where snake drinks and snake meat are consumed for their aphrodisiacal properties and as a general tonic. The Vietnamese host was led to an enclosure in the lobby where he chose two Chinese rat snakes, each about 6.5 feet (2 m) long. The snakes' gallbladders were removed while the snakes were still alive, and bile was dripped into a beer mug to be mixed with distilled spirits. Next, the snakes' jugulars were cut and blood dripped into a second mug to be mixed with spirits. The resulting green and red

10.4 Chinese snake wine, touted as a virility enhancer, from Guangxi, China.

10.5 Vietnamese consume snake blood, bile, and meat for their aphrodisiacal properties and as a general tonic. *Top left:* snake restaurant in Hanoi; *top right:* cobra wine; *center left:* Chinese rat snake (*Ptyas korros*); *center right:* employee dripping cobra blood into a mug to be mixed with distilled spirits; *bottom left:* rat snake soup and distilled spirit-based drinks with rat snake blood and bile; *bottom right:* crispy snakeskin in foreground, delicacy of ground snake bone behind.

drinks were divvied up among the seven adults in the group. In time, servers brought a multi-course meal that included soup, crispy fried skin, ground-up bone, and other snake dishes—boiled, baked, and fried. All quite good, I understand.

People in the New World also consume snake to improve their sex lives. Some first peoples drank rattlesnake venom as an aphrodisiac and to increase potency. Mexicans still swallow pills made from powdered rattlesnakes to cure sexual impotence. Some Brazilians drink tea steeped with either crushed rattlesnake bone or anaconda (*Eunectes murinus*) fat as a cure for impotence, and they steep venomous snakes in *cachaça* (an alcoholic beverage made from distilled sugarcane) to make "Pinga de Cobra," used as an aphrodisiac and cure for impotence. Some people in the United States make snake wine by immersing baby rattlesnakes in vodka. And the list goes on. Move aside, Viagra!

Crocodilian Phallic Power

Ernest Jones writes in a 1914 essay about the opposing beliefs regarding the sexual prowess of crocodilians. On the one hand, some cultures viewed these animals as impotent. He notes that according to Pliny, the crocodile was "the only land animal which lacks the use of its tongue." Because of this, it was assumed that the animal was "dumb," and dumb implied impotence. The truth is that although crocodilians can't stick out their tongues, they do use them. Their tongues house taste buds and salt glands. For crocodiles and gharials, these glands excrete excess salt, though they are non-functional in alligators and caimans. Absence of visible genital organs in crocodilians no doubt reinforced the impotence myth. How did people think crocodiles reproduced if the beasts were impotent? One theory held that female crocodiles conceived through their ears.

In contrast, other cultures viewed the crocodile as the glorification of phallic power, and some ascribed supernatural sexual power to these beasts. Jones writes:

> The phallic significance of the crocodile may be suspected from the circumstance alone that it is closely associated with the ideas of wisdom, the sun, and the snake, but grosser facts than these can be cited. In the [ancient Egyptian] text of the Unas, written during the Sixth Dynasty, are passages expressing the desire that a deceased person may attain in the next world to the virility of the crocodile and so become "all-powerful with women." At the present day in the Egyptian Soudan the belief is acted on that the penis of the crocodile eaten with spices is the most potent means of increasing sexual vigour in the male. Both in Ancient Egypt and in the modern Soudan the belief has prevailed that the crocodile has the habit of carrying off women for sexual purposes. Two physiological facts concerning the animal probably contribute to these ideas: the copulatory act is unusually ardent and lasts a long time; and the male organ, though never visible in the ordinary way being concealed within the cloaca, is unusually large.

I have no proof that eating spiced crocodile penis won't increase sexual vigor, nor that crocodiles don't occasionally carry off women for sexual gratification. But I do have it on good authority, from my friend and crocodilian expert Lou Guillette, that a crocodile's penis length isn't unusual for its body size. A 4.5-foot-long (1.4 m) caiman has a penis just shy of 3 inches (7.6 cm). A 16-foot (4.9 m) adult Nile crocodile has an 8-inch (20.3 cm) penis. A crocodilian's penis length is just right—neither too small like the gorilla's 1.5-inch (3.8 cm) erect teeny weenie, nor outlandishly huge like the 16-inch (40.6 cm) Argentine lake duck's extended 17-inch (43.2 cm) whopper (the longest penis proportionate to body size of all vertebrates). Jones also exaggerated a bit on the copulatory act lasting "a long time." Crocodilian copulation can last 10 to 15 minutes, but that's nothing compared to lovebugs, which often stay coupled for

several days, even in flight, or Indian walking sticks, which sometimes stay coupled for 11 weeks. No doubt crocodile phallic power myths arose because crocodilians are large, aggressive predators, and it follows that such macho animals should boast extravagant organs and sexual stamina!

Sobek (Sebek), an ancient Egyptian deity associated with fertility, was depicted either as a Nile crocodile or, more often, as human with a crocodile head. In some accounts, he was a violent, aggressive, hypersexed god. Some scholars have suggested that the origin of his name, from *Sbk*, is a form of the verb meaning "to impregnate." Because of his strength and power, Egyptians revered him as a protector from real human-eating crocodiles and from dangers associated with the Nile River, but they also feared his aggressive nature.

People have long used crocodilians for their own sexual benefit. Ancient Egyptians tied crocodile teeth to their right arms to incite lust. Today the Chinese make capsules from crocodile penises, touted as 100 percent natural and with no associated side effects. According to various websites, these capsules alleviate impotence, heighten libido, improve sperm quality, and provide effective male enhancement. The Chinese also eat Chinese alligator flesh as an aphrodisiac. Concoctions from male gharials are used as aphrodisiacs, and Brazilians make preparations from caimans to treat sexual impotence.

All is not well in the world of crocodilian penises, however. The enemy is chemical contamination, and the issue is diminishing dicks. In the 1990s, Lou Guillette and his colleagues studied possible causes for reproductive failure of alligators from contaminated Lake Apopka in central Florida. There, the alligators are exposed to the pesticide dicofol and to DDT and its metabolites, which originated from a spill at a nearby pesticide plant. Egg viability was 20 percent at Lake Apopka as compared to

10.6 On the India subcontinent, people harvest adult male gharials (*Gavialis gangeticus*) for their "ghara" (bulbous boss at the tip of the snout), used in concocting aphrodisiacs.

80 percent at a Florida wildlife refuge control site. Juvenile male alligators from Lake Apopka had only one-fourth the concentration of plasma testosterone as animals from the control site. And, their penises were abnormally small. Lake Apopka is not the only chemically contaminated site in the country, and alligators may not be the only animals suffering from chemical-related phallic reduction.

David Rovics, folksinger and writer of songs of social significance, has incorporated Guillette's research on gator penises and reached out to humanity in "The Alligator Song."

First verse:

> Everybody's getting cancer
> At a geometrical rate
> Maybe it's something you drank or breathed
> Maybe it's something you ate
> Perhaps this doesn't concern you
> Hey, we've all gotta go sometime
> But maybe I can tell you something
> To make you change your mind

Refrain:

> The alligator dicks are shriveling up
> Soon they'll all be through
> Yeah, the alligator dicks are shrinking fast
> And it will happen to you
> It will happen to you, boys
> It will happen to you.
> The alligator dicks are shriveling up
> And it will happen to you.

Last verse:

> PCBs in the water
> Pesticides in the ground
> Radiation in the wind
> There's poison all around
> So if you care about your love life
> And that good old whoop-de-doo
> You've gotta stop pollution, boys
> That's what I'm telling you.

Turtle Phallic Power

Mark Twain writes about turtle sex in *Letters from the Earth*: "The Bible doesn't allow adultery at all, whether a person can help it or not. It allows no distinction between goat and tortoise—the excitable goat, the emotional goat, that has some adultery every day or fade and die; and the tortoise, that calm cold puritan, that takes a treat only once in two years and then goes to sleep in the midst of it and doesn't wake up for sixty days."

Twain was mistaken when it comes to turtle sex. Turtle mating can be a lively affair, and male turtles can be ruthless in their quest for sex. Males sometimes crash into females and snap at their legs to thwart escape. Tortoises are normally mute, but during sexual climax males sometimes squeal with delight. Galápagos tortoises roar. Male turtles come naturally well endowed. As a tortoise's penis enlarges with fluid, its length increases nearly 50 percent, and its width increases about 75 percent. The erect penises of some tortoises are nearly half the length of their plastrons (bottom shell). When not in use, the penis rests inside the cloaca. A male turtle may have a penis unusually long for his body length, but he can't use it unless his intended mate cooperates. Mud turtles and stinkpots immobilize their mates and bite their heads, shells, or legs. Red-eared turtles lavish attention on indifferent females by quivering and drumming their claws against the females' eyes.

Turtles have long been associated with human sexuality. In Greek mythology, the tortoise was sacred both to Aphrodite, goddess of love and procreation, and to Her-

10.7 This male leopard tortoise (*Stigmochelys pardalis*) just might be in the throes of sexual climax, squealing with delight.

MOVE ASIDE, VIAGRA 193

mes, who among other designations was god of sexual intercourse. This association between turtles and human sexuality is based on two chelonian characteristics. First, a turtle's head and neck resemble the human penis. Second, a turtle's head slowly emerges from its shell as in an erection.

An ancient Chinese myth tells of Dragon, who had nine sons, each endowed with a unique gift. One, Baxia, was a good swimmer and capable of bearing heavy weights. He represented resilience, longevity, and good fortune. Many centuries ago, artists depicted Baxia as a gigantic turtle rather than a dragon. Over time, Baxia developed a bad reputation: The Chinese associated this Dragon son with the human penis because of the physical resemblance; an insult of the worst kind in those days was to call someone a "turtle head." (Curiously, in English we use the term "dickhead.") Eventually, artists depicted Baxia more like a dragon, a more respectable figure. (As an aside, the fact that Dragon had nine sons is significant. For the Chinese, the number 9 is the emperor's number. It is a magical number: if you multiply 9 by any of the numbers from 1 to 9 and then add the numbers of the result, you always end up with 9!)

10.8 Baxia, one of the nine sons of Dragon, was a good swimmer. Although he was originally depicted as a turtle, in time he was depicted as a turtle-dragon, a more respectable figure. Touching this statue, photographed in Guangxi, China, brings good luck.

Other Chinese myths and songs reflect the resemblance between a turtle's head and a penis. In many Asian countries, the human penis is still referred to as "the turtle's head." A culture-specific medical syndrome from Southeast Asia alludes to the ability of a turtle's head to slide in and out of its shell. *Koro*, meaning "head of the turtle" in Malay, refers to a human psychological disorder characterized by delusions of one's penis shrinking and retracting into the body. The sufferer experiences extreme anxiety that may include fear of impotence. Causes of this syndrome are thought to stem from psychosexual conflict. Traditional treatment includes drinking a potion of herbs, animal penises, and other ingredients. Medical exams of people diagnosed with *koro* have revealed no shrinkage or retraction. Unlike many turtles that can retract their heads completely, the human penis cannot be sequestered.

Sea turtle eggs are soft, leathery, and protein-rich. Depending on the species, they range in size from Ping-Pong to tennis balls. Ancient Maya believed sea turtle eggs to be an aphrodisiac. Throughout much of Mesoamerica, people wanting a sexual jump-start still eat sea turtle eggs. The eggs are served as snacks in bars and brothels, where people eat them raw—sometimes au naturel, sometimes mixed with salsa and lemon, often chased with beer. Although there is no scientific basis for sea turtle eggs having aphrodisiacal properties, it seems reasonable that people who live on the world's coasts believe in the association because of having seen sea turtles mate for up to eight continuous hours. Some people believe that male sea turtles get their stamina by eating eggs of their own species. What's good for a male turtle must be good for a human male! In *So Excellent a Fishe*, Archie Carr writes:

> Mexicans have immense reverence for turtle eggs as an aphrodisiac. They are, in fact, more religious in their faith in this alleged property of turtle eggs than any people I know anywhere, unless it be the Colombians. The people of the Tuxtlas have multiplied lately, and tourists come down from the plateau in growing numbers, hungry for *mariscos* and avid after aphrodisiacs. The visitors and the local folk all eat turtle eggs, and in due course new hosts of Mexicans are born, and they eat eggs too, and in their turn are stirred to procreation.

And in another chapter, he explains:

> The eggs of sea turtles are in most places wanted for one or both of two reasons: as a source of protein, and as an aphrodisiac. The former is a valid motivation. You can't blame any poor man for digging turtle eggs if his family is hungry, as usually it is. The aphrodisiac idea is, of course, a baseless folk belief. It is a deeply rooted one, nevertheless. In some places it will probably turn out to be a greater obstacle to enforcement than the demand for the eggs as food. Tampering with a man's sex life will make a poacher of an upright citizen.

10.9 Green turtle eggs are irresistibly delicious and believed by many to be potent aphrodisiacs. Pictured here is a green turtle laying eggs on Tortuguero beach, Costa Rica.

Sea turtle eggs are highly prized as aphrodisiacs, but what could be a more powerful sex booster than the turtle penis itself? In Jamaica, one can buy sea turtle penis by the inch, to be mixed with rum, wine, roots, oysters, or conch. In the British Virgin Islands, one can drink sea turtle penis steeped in rum. In the Dominican Republic, one can buy bottles of rum containing fragments of fish, leaves, and bark, to which dried sea turtle penis can be added for extra punch.

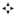

Sex. We want more, and we want better. And so we turn to reptiles. If one believes the folklore, reptiles heighten libido, reverse impotence, and enhance penis size. We've been parasitizing reptile phallic power for millennia, and it's hard to imagine that the exploitation will stop anytime soon. Have our beliefs in the sexual power of reptiles affected the animals' population status and conservation? Most crocodilians, turtles, and snakes used for traditional medicines are caught from the wild—not raised in captivity. Ironically, many of these species already are on endangered species lists and therefore are legally protected. Illegal poaching and black market sales are rampant, however, and harvest of some species has led to further population declines.

Although overharvesting for traditional medicines—including cures for sexual dysfunction—is responsible for some population declines, the other side of the coin is that some protection might occur precisely because local people believe in the medicinal value of reptiles. In some cultures, the animals are harvested wisely so as not to exterminate the population. Wipe out the population, and you've lost the cure for what ails you. Conservation and removing animals from the wild may seem mutually exclusive, but they are not. The goals and approaches of conservation have long been closely tied to the value and use of resources. The problem arises when we take too many animals in an unsustainable way. Sustainable harvesting means removing individuals from a population in such a way that the population will continue into the future indefinitely. Can we sustainably harvest wild reptiles for their presumed sexual power? For therapies that require killing adult animals, the answer is likely "no" for many species. Eggs are another matter.

Instead of demanding that sea turtle eggs never be collected, conservationists have developed sustainable harvesting programs. In some places in Latin America—including Mexico, Nicaragua, and Costa Rica—programs allow for organized and re-

stricted collecting of sea turtle eggs. The rationale behind legalizing egg collection is that flooding the market with a legal supply of inexpensive eggs will reduce illegal and unrestricted activity.

One example involves olive ridley turtles (*Lepidochelys olivacea*). In 1983 the Ostional Wildlife Refuge, extending 9.5 miles (15 km) along the shoreline on the Pacific side of Costa Rica, was established to protect nesting beaches of olive ridleys. There, some populations gather by the thousands over a series of days to lay their eggs—an event called an *arribada*, from the Spanish word meaning "arrival." In the Ostional Wildlife Refuge, *arribadas* can involve 20,000 to 130,000 or more females per event. During an *arribada*, females haul their heavy bodies out from the ocean and drag themselves along the beach. Each female digs a nest into which she deposits her 80 to 100 white soft-shelled eggs. After covering her treasure, she returns to the ocean. A musical-chairs situation occurs during these large *arribadas*. With insufficient space on the nesting beach for all the females, later arrivals digging nests destroy nests made on the first few nights of the *arribada*. Hundreds of thousands of olive ridley eggs are obliterated.

Since 1985 the Costa Rican government has allowed Ostional community members to harvest olive ridley eggs deposited during the first 36 hours of an *arribada* within the refuge. Villagers package the eggs stamped with the Ostional insignia. The eggs are transported throughout Costa Rica, mainly to bars, where they are served

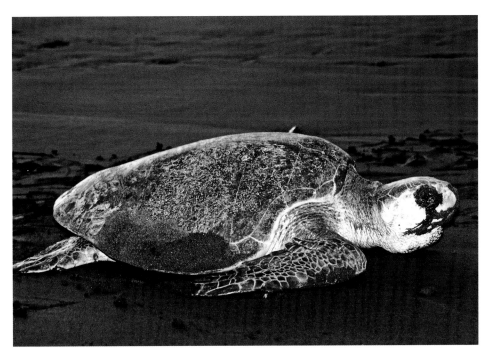

10.10 Female olive ridley turtles (*Lepidochelys olivacea*) nest in such high numbers in the Ostional Wildlife Refuge in Costa Rica that they inadvertently destroy each others' eggs.

raw in spicy red salsa as an appetizer—for their aphrodisiac qualities and just because people crave sea turtle eggs chased with beer. By saturating the market with low-priced eggs, the program discourages poachers from illegally collecting eggs elsewhere. Villagers gain economically, but many also have developed an appreciation for the turtles and fight for their protection by patrolling the beach for poachers. Profits have supported structural improvements for the local school, road repairs, construction of a community center and basketball and volleyball court, and electricity for the community.

<div style="text-align: right">

11

</div>

Pick Your Poison—
Blood, Venom, Skin, or Bones

Folk Medicines

Folk medicine has one advantage: it has no doubt; it believes. Scientific medicine moves from truth to error to truth—it must search and re-search.

—BRUNO GEBHARD, "The Interrelationship of Scientific and Folk Medicine in the United States of America Since 1850"

Allow me to start with a disclaimer in this chapter, which addresses another aspect of utility—amphibians and reptiles as cures for what ail us. When I write something to the effect of "To stop nosebleed, stuff the nostrils with ash of tadpoles," I am not advocating the remedy, nor do I mean to imply that it has been clinically tested and its effectiveness proven. I am simply sparing the reader from reading the phrase "is believed to be" a hundred times in this chapter. Consider the "is believed to be" implied when the phrase is noticeably absent!

Since our beginnings, humans have suffered from health problems. Before the advent of modern medicine, people probably dealt with health issues in much the same way people do today who have no access to conventional medicine. For those who believe that sickness is caused by evil spirits or by angry gods, the spirits must be driven out of the body or the gods appeased. For those who believe that illness is caused when the body's system becomes unbalanced, natural remedies made from plants, animals, and

minerals restore harmony and balance. These remedies are often discovered by trial and error, with the subsequent knowledge passed down through generations. Healing abilities of these folk medicines (= traditional medicines) often are considered more effective when administered by a medicine man or shaman intimate with the associated rituals, incantations, and taboos. The patient believes.

Perhaps that explains why various folk remedies I've tried in Central and South America worked with minimal success. I didn't believe. In Ecuador, I placed live tadpoles over my eyelids to relieve eyestrain but felt no relief. In Brazil, I smeared snake fat onto an infected tick bite. That definitely didn't work. In Costa Rica, I squeezed lime juice onto a snail shell and covered a scar with the resulting paste to reduce the blemish. The scar eventually disappeared, but I don't know what the outcome would have been had I done nothing. In Chile, I clotted blood from a cut with a gob of spiderweb. That worked, though I think a tissue would have accomplished the job just as effectively.

Folklorist Don Yoder writes that there are two kinds of folk medicine: natural folk medicine and magico-religious folk medicine. Natural folk medicine "represents one of man's earliest reactions to his natural environment, and involves the seeking of cures for his ills in the herbs, plants, minerals, and animal substances of nature." In contrast, magico-religious folk medicine "attempts to use charms, holy words, and holy actions to cure disease. This type commonly involves a complicated, prescientific world view." Natural folk medicine assumes a direct cause and effect between application of some substance and a somatic problem. In contrast, magico-religious folk medicine attempts to manipulate a situation through influencing some agent other than the patient—for example, communing with divinities or healing saints. We'll focus on natural folk medicine in this chapter. In the following chapter, we'll explore magico-religious folk medicine.

As you read this chapter, you might wonder how people could have believed in many of these remedies. Curing asthma by blowing into a frog's mouth? Resolving a headache by eating crushed sea turtle carapace mixed with honey? Removing a hangnail by applying the uterus of a dog boiled in oil? Did people keep believing if, after trying these remedies, they got no relief?

In *Honey, Mud, Maggots, and Other Medical Marvels*, Robert and Michele Root-Bernstein point out that positive correlations of events impress us more than do negative ones. We remember the rare times our Chinese fortune cookies accurately foretell some future event, but we forget the countless times when they get it wrong. If we perceive that a given remedy worked once, even though the association between remedy and recovery was spurious, we trust that it will work again. Clearly, "cure" is a big black box, and the most recent treatment is not necessarily responsible for a patient's recovery. Many illnesses and diseases have a limited course, recovery can

be spontaneous in the absence of treatment, remissions occur unexpectedly during treatment, and previous treatments sometimes kick in belatedly.

Archie Carr's ruminations after being bitten by a fer-de-lance (*terciopelo*; *Bothrops asper*) in Tortuguero, Costa Rica, suggest how folk remedies might get entrenched in a culture. After Archie got bitten on his right calf, he limped home, the small puncture wounds dripping blood along the way. A few hours later, the skin around the bite had turned blue-green, but Archie experienced no swelling, breathing difficulty, or nausea. Perhaps it had been a dry bite. Unable to get airlifted out until the following morning, and having decided not to risk using the antivenin in his snakebite kit, Archie suffered through his neighbors' "bush medicine." A *curandera* (curer) scolded Archie for not having caught the snake that bit him. He could have split open the snake's head, mashed the brain, and smeared the mush on the bite. To avoid vomiting blood, Archie drank coffee the consistency of melted roofing compound. He chewed on a tar-black rope of locally grown tobacco, but declined to drink "two fingers" of kerosene.

Archie survived what turned out to be a dry bite. The more Archie thought about his experience, the more he realized that folk belief is often more rational than it seems. In a difficult situation such as a bite from a venomous snake, the victim needs to be reassured. If the person believes that a simple, quick intervention close at hand will resolve the situation, that reassurance can't hurt. In *Ants, Indians, and Little Dinosaurs*, he writes:

Two factors make it turn out that way, I think. One is the desperation of having no other recourse than your own experience and imagination, and those of your fore-bears and neighbors. The other is the apparently high frequency of false bites that terciopelos deliver. In fact, an important basis for all bush cures for snakebite—a factor that keeps intelligent people believing in them—may be the frequency of cases in which no venom or small quantities of venom are injected when the bite glances or hits a bone or otherwise misfires, and patients get well in spite of the treatment. The disaster of a full terciopelo bite in [a] country without medical help would lead anyone to grasp at straws, to accept a neighbor's treatment without de-manding to know how it works, simply because it is all there is. And if the incidence of aborted bites is high enough, the cure would be bound to take hold as part of the folk medicine of the country. If generations keep getting 40 percent recovery from snake brains, kerosene, and chewing tobacco, they have to be unnaturally skeptical not to stick to these as treatment. Modern medicine has few specifics that cure at such a rate.

Just as the Costa Rican *curandera* recommended smearing mashed snake brain on Archie's wound, so, too, have people worldwide advocated the offending snake it-self as the best medicine for venomous snakebite. In medieval times, gypsies treated venomous snakebite by frying the offending snake's fat and rubbing it on the wound. Not long ago in Oklahoma and Arkansas (United States), people believed that if warm flesh of the freshly killed snake that had bitten the person were placed on the bite, the snake's body would reclaim the venom.

Uses of animals in traditional medicines generally reflect their natural attributes—appearance and behavior—and the ways we perceive these animals. In some cases, the animal takes something from us. Put a live frog on a gouty toe, and the frog absorbs the pain. Slit open a live frog and lay it across a venomous snakebite; the frog's blood will draw out the venom. Place a cold frog on your forehead, and it will suck out your fever. For goiter, wrap a snake around your neck. When it slithers away, it will take your goiter with it.

In contrast, other remedies work because some aspect passes from amphibian or reptile to human. Toxic secretions of some salamanders protect them from their predators, so if we ingest those secretions we can cure ourselves of disease, even cancer. Blood and medicines made from large, powerful animals—such as pythons, crocodilians, and monitor lizards—convey strength or protection. Turtles live a long time; eat their flesh, lengthen your life. Because various illnesses and diseases have the same symptoms, the same folk medicine may serve many purposes. At the same time, one illness or disease might respond to many different folk medicines.

Amphibians and reptiles feature prominently in folk medicine worldwide. As a group, they are associated with healing and rebirth because they periodically slough their skin, regenerate body parts, appear and disappear seemingly by magic due to

their cycles of hibernation and activity, and, for amphibians, metamorphose from one form to another. We use entire bodies or parts—blood, venom, secretions, flesh, fat, excrement, gallbladders, ovaries, phalli, heads, shells, skin, bones, and eggs—of at least 331 species (284 reptiles and 47 amphibians) to improve our sex lives, reduce pain, enhance memory, invigorate our bodies and strengthen our immune systems, ease stress, treat illnesses, and cure diseases. Let's visit two continents—Asia and Europe—and take a brief look through time at some ways that people have valued amphibians and reptiles as natural medicines.

Asia

Traditional Chinese Medicine (TCM) goes back about 5,000 years and is based on a different way of viewing the human body than envisioned by current Western medicine. TCM sees the body as interconnected with nature and subject to its forces. One aspect of TCM is the concept of *yin* and *yang*, two opposing yet complementary forces. The condition of the human body (health vs. illness) results from the balance of *yin* (inner and negative aspects) and *yang* (outer and positive aspects). We become sick when the two aspects fall out of whack. TCM attempts to correct the balance, in part with herbs and animal products. Many remedies that were employed thousands of years ago are still in use today.

The Chinese have long considered frogs valuable in traditional medicine, in the belief that they detoxify the body and reduce excess internal heat. Consider *hasma*—ovaries of the snow frog (also called Chinese forest frog; *Rana chensinensis*). In northeast China, workers string live female snow frogs on wire and leave them to dry in the sun. They remove the ovaries, along with adhering fat. *Hasma*, rich in nutrients, is often added to soups. Purported health benefits of *hasma* include strengthening the immune system, replenishing the vital essence of the lungs and kidneys, enhancing memory, reducing insomnia, treating nervous exhaustion, improving skin condition, and reducing coughing and night sweats associated with tuberculosis.

The toad, considered one of the five poisons of *yin* (the others are centipede, scorpion, snake, and lizard), is a favored TCM animal. Many toads (Bufonidae) have parotoid glands located behind their eyes. When disturbed, toads often defend themselves by oozing white secretion from these and other granular glands. Depending on the species, this secretion is distasteful, irritating, or deadly. For over 3,000 years, the Chinese have made a powder called *chan su* from the parotoid secretions of Asiatic toads (*Bufo gargarizans*) and Asian common toads (*Duttaphrynus melanostictus*). *Chan su*, mixed with flour and other ingredients and formed into cakes, was and still is used to treat heart ailments, dry boils and abscesses, and heal ulcers. *Chan su* is also sipped in herbal tea. In small doses, *chan su* stimulates myocardial contraction, due to the bufadienolides it contains. One of these bufadienolides, bufalin, blocks vasodilation and increases vasoconstriction, vascular resistance, and blood pressure. *Chan*

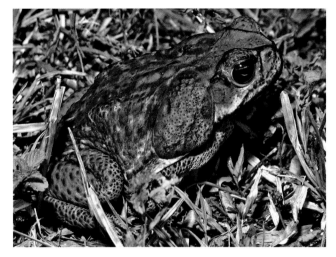

su reached Europe in the seventeenth century, and physicians there used it as a heart drug for at least 200 years.

More recently, *chan su* has been touted as an aphrodisiac. Marketed as "Love Stone" and "Hard Rock," this form of *chan su* is a topical application designed for men. Potential consumers beware. In the 1990s, four men in New York City died after ingesting *chan su* meant as a topical application.

Huachansu, an injectable form of *chan su*, is used in China and other Asiatic countries to treat liver, lung, colon, and pancreatic cancers. The preparation is a sterilized hot-water extract of dried Asiatic toad or Asian common toad skin. In addition to its cardiotonic effects, bufalin induces apoptosis (programmed cell death) in human tumor cells. *Huachansu*, officially approved in 1991 as a cancer treatment in China, produces few side effects.

The two toads used to make *chan su* also are used by themselves to treat many ailments in Asia. In China, flesh of the Asiatic toad is used to detoxify the body, reduce swelling, and control coughs; the toad's skin is applied to reduce fever. The Asian common toad is used in China as a cardiotonic and diuretic and to treat sore throat, toothache, and pain. In Thailand, the toad's flesh treats alcoholism; in Vietnam, rickets and delayed growth in children; and in India, gonorrhea, tuberculosis, and leprosy.

Salamanders have long been used in TCM to cure human ailments. Chinese giant salamanders (*Andrias davidianus*), the world's largest salamander, can reach 5 feet (1.5 m) and nearly 90 pounds (40.8 kg). When disturbed, these giants ooze a milky-white, foul-smelling secretion from their skin glands. The secretions have been used in TCMs for at least the past 2,300 years to treat malaria, anemia, and more recently heavy-metal poisoning, Alzheimer's disease, and cancer. The salamander's flesh is eaten as an appetite stimulant, and its pancreatic juice reduces body heat and improves eyesight. Ironically, these rather unattractive amphibian giants also provide ingredients for health and beauty products. In northwestern China, people dried and ground Central Asian salamanders (*Ranodon sibiricus*) into powder, steeped as tea and consumed to treat bone fractures and malaria. Dried Yunnan newts (*Tylototriton shanjing*) are used for TCMs, and in China one can buy their dried bodies on sticks

11.2 Toads (Bufonidae) have toxic secretions stored in parotoid glands behind the head. *Top:* note the huge parotoid glands in the cane toad (*Rhinella marina*); *bottom:* Asian common toad (*Duttaphrynus melanostictus*), whose parotoid secretions are used to make *chan su*.

as street fare. Reportedly, they are "spicy," no doubt reflecting their poisonous skin secretions. Raw flesh of the Oriental fire-bellied newt (*Cynops orientalis*) cures itchy and burning skin. Eviscerated bodies of paddletail newts (*Paramesotriton labiatus*) are sun-dried and ground into powder; the powder, mixed with wine or warm water, cures stomach ailments.

India's only salamander, the Himalayan newt (*Tylototriton verrucosus*), is dried as a cure for gastric ailments. This salamander has large parotoid glands and warty skin. Some of its chemical secretions exhibit a wide spectrum of antimicrobial properties, others are associated with proteolytic activity (breakdown of proteins), and still others exhibit trypsin-inhibiting activity (chemicals that reduce availability of the enzyme trypsin, which affects absorption). The properties of these secretions no doubt explain the efficacy of Himalayan newt folk medicines.

Newts rule in some cultures (at least where it most matters to men). One of the animals used in medieval medicine in what is now Israel and parts of present-day Syria, Lebanon, and Jordan was the banded newt, called "triton" (*Ommatotriton vittatus*). The newt was made into a concoction to enhance libido and treat erectile dysfunction. Like other newts in the family Salamandridae, the banded newt's skin contains tetrodotoxin (TTX), a potent neurotoxin with no known antidote. Concoctions made from tritons must have contained low doses of TTX.

As I read about tritons and tetrodotoxin, I wondered about the scientific basis for the medieval concoction. I found that researchers have recently discovered that low doses of TTX administered to abstinent heroin addicts reduce craving and anxiety. Perhaps the medieval concoction reduced anxiety enough that the partaker could fo-

11.3 The banded newt (*Ommatotriton vittatus*), a salamander that contains the potent neurotoxin tetrodotoxin, has been used to make a concoction to enhance libido.

cus on sex—thus the enhanced libido? Vasodilators (drugs that dilate blood vessels) are used today to treat erectile dysfunction. It turns out that TTX in low doses causes vasodilation, so perhaps the newt concoction has a sound pharmaceutical basis. One tetrodotoxin expert I consulted (who will remain unnamed to protect his reputation) told me: "I can imagine in very small doses it could have a positive effect on potency—not that I would be willing to try it."

Snakes are central to Chinese, Tibetan, and Indian (Ayurvedic) traditional medicine. Subhuti Dharmananda, director of the Institute for Traditional Medicine in Portland, Oregon, suggests that traditional healers value snakes for three reasons. First is snakes' unusual physique and locomotion. Their cylindrical, limbless bodies are amazingly flexible, suggesting they can reverse body stiffness. Extracts made from snakes soaked in alcohol, as well as snake oil, are rubbed onto stiff joints caused by bursitis, arthritis, and rheumatism. Because snakes move quickly, medicines made from them might travel quickly through the patient's body. Snakes are used for treating "wind" syndromes—contagious diseases such as measles, influenza, and SARS that often peak in the windy season of spring and spread quickly, like the wind.

Second, because snakes shed their skin, they are considered valuable in treating human skin conditions. One of the earliest records of snakes used in Chinese

11.4 Shed snakeskin is considered useful in treating human skin problems, from acne to psoriasis.

medicine is found in the *Shen Nong Ben Cao Jing* around 100 CE. Sloughed snakeskin was used to treat skin eruptions, eye infections, sore throat, and hemorrhoids. Tied around a woman's belly, shed snakeskin reduced pain and eased and sped delivery during childbirth. People have long observed that a snake's eyes become opaque and milky and its skin becomes dull before shedding. After shedding, its eyes are clear and its skin is rejuvenated. Snakes are still used to treat skin problems such as acne, carbuncles, mammary abscesses, rashes, boils, and psoriasis. The shed skin typically is roasted and then ingested or applied topically.

Third, traditional healers value venomous snakes. The observation that some snakes' venom causes paralysis in attacked prey has led to venom-based traditional medicines administered orally to treat convulsions. The venom stops convulsions by inhibiting intense muscle contractions. Some forms of paralysis are caused by over-contraction of muscles. Venom from the sharp-nosed viper (*Deinagkistrodon acutus*) is used to overcome paralysis in these cases and to treat epilepsy. Curiously, the same venom is used to treat leukemia.

TCM incorporates snakes in other ways as well. Snake bile treats whooping cough, fever, hemorrhoids, bleeding gums, and skin infections. Fresh snake blood, rich in iron, relieves fatigue and increases libido. Snake gallbladder in wine provides an invigorating tonic, as the person assumes the snake's strength. The medicinal drink *Wu Shiu Jiu* (five-snake wine), made by soaking the bodies of five kinds of venomous snakes in a large jar of distilled rice wine, strengthens the body and relieves joint ailments.

Because turtles are associated with hardiness and longevity, TCM uses turtle meat to strengthen the body, increase life expectancy, and cure problems with joints, spleen, and kidney. Some East Asian athletes drink turtle blood to enhance their performance. The practice has become common even outside of Asia since 1993, when long-distance runner Wang Junxia cut 42 seconds off the 10,000-meter world record. As part of her training program, she had consumed a stress-relieving tonic composed of turtle blood and caterpillar fungus (*Ophiocordyceps sinensis*) on her coach's advice.

Use of turtle shells in TCM is a 4,000-year-old tradition. Shell, believed to nourish *yin*, is currently an ingredient in over 100 preparations. Turtle jelly—eaten to treat kidney problems, boost circulation, and improve complexion—is a black, gooey substance traditionally made from the critically endangered golden coin turtle (*Cuora trifasciata*). The plastron is boiled with medicinal herbs, including honeysuckle and chrysanthemum flowers. Now, turtle jelly typically is made from non-endangered turtles, such as the Chinese softshell turtle (*Pelodiscus sinensis*). *Bie jia*, made from dried and ground carapace of Chinese softshell turtles, invigorates the blood, cools night sweats, and promotes menses. Pills known as *gui ban*—taken to stop uterine bleeding, nourish the blood, strengthen bones, reduce anxiety, and end sleeplessness—are made from dried and ground plastrons of Reeve's turtles (*Mauremys reevesii*).

Perhaps because geckos are unusual—most are active at night, they walk on ceil-

11.5 In much of Asia, tokay geckos (*Gekko gecko*; *left*) are tied to sticks (often in pairs, male and female; *right*) and dried in the sun. Their ground bodies are believed to cure asthma, impotence, premature ejaculation, tuberculosis, diabetes, and AIDS. The pair of geckos on the stick pictured here was sold at a market in Guangxi, China.

ings, and many chirp to each other—many people view these lizards as mysterious and endowed with special powers. Geckos are blamed for the spread of leprosy and other skin conditions in parts of the Arab world through to India; but in East and Southeast Asia, geckos typically are associated with good luck and fertility. Not surprisingly, use of geckos in folk medicine mirrors local perceptions. Where geckos are considered harmful or dangerous, they are used to treat the conditions they are believed to cause, such as skin disorders. For example, the Shoka tribes of the Kumaon Himalayas of Uttaranchal, India, use house geckos (*Hemidactylus*) to relieve eczema, blamed on the geckos. The entire gecko, boiled in oil, is applied to the sufferer's rash. Where geckos are appreciated, as in China, they are eviscerated, dried, and ground into powder to treat ailments for which they are not to blame—kidney stones, fractures, epilepsy, and cancer.

While reading about TCMs, I kept wondering about their efficacy. I chose geckos, searched for studies that address their medicinal effectiveness, and quickly found papers on the subject. For example, a 2008 paper published in the *World Journal of Gastroenterology* examined the effectiveness of Gecko ("Tian Long, Shou Gong," made from Japanese geckos, *Gekko japonicus*) as an anti-cancer drug. The study—conducted by researchers from the Medical College and the Medical Department of the First Affiliated Hospital, both at Henan University of Science and Technology in Luoyang, China—addressed the anti-tumor effect and mechanism of Gecko on human esophageal carcinoma cell lines (*in vitro*) and xenografted sarcoma 180 in mice.

Results of the study indicated that cell growth treated with Gecko was significantly inhibited, and tumors treated with the TCM shrank significantly, as compared to the control group. Gecko induced tumor cell apoptosis—programmed cell death. The TCM also decreased protein expression of VEGF (vascular endothelin growth factor) and bFGF (basic fibroblast growth factor) in tumor tissues. VEGF normally functions in creating new blood vessels. When over-expressed, cancerous tumors

can grow and metastasize. Medical researchers have hypothesized that during tumor development, bFGF is activated and new blood vessels are formed. In addition, this growth factor stimulates proliferation of a wide variety of cells. Programmed cell death combined with down-regulation of protein expression of the growth factors suggests that Gecko has promise as an anti-cancer drug.

I wonder: Is there something special about Japanese geckos that makes them effective as anti-cancer drugs? Might other geckos be as effective? Maybe any lizard? Lizards would leap higher on the utility dimension of human perception if that were the case!

Europe

Snakes and medicine have long been intertwined in the Western world, with roots in Greco-Roman civilization. Ancient Greeks and Romans worshipped snakes. Both Asclepius, the Greek god of healing, and Aesculapius, the corresponding Roman god of healing, were depicted with a snake entwined around their staffs. In time, the Western medical profession adopted the symbol of the single-snake staff—the rod of Asclepius. Various characteristics of snakes explain why these gods were associated with snakes. First, to the ancients, a snake's ability to shed its skin represented rejuvenation and renewed health. Second, the early Greeks recognized the medicinal properties of snake venom. Third, snakes likely represented the inevitable dual nature of the physician, one who works with life and death, sickness and health.

(The symbol of the Western medical profession is sometimes incorrectly referred to as a *caduceus*. The Greeks depicted Hermes, messenger between the gods and humans, holding a winged staff with two intertwined snakes. The Greeks called the staff *kerykeion*, from the Greek word for messenger. Mercury, the Roman equivalent of Hermes, also had a winged staff with two snakes. The Latin word for this staff is *caduceus*, and it symbolizes commerce and negotiation. In 1902 the medical branch of the U.S. Army adopted its version of Hermes' two-snaked *caduceus* as its insignia, which explains why people confuse the *caduceus* and the rod of Asclepius as the symbol for the Western medical profession. Various U.S. health-care organizations have adopted the *caduceus* as their symbol, further confusing the issue.)

11.6 Snakes have long been associated with health. *Left:* Rod of Asclepius, symbol for the Western medical profession; *right:* caduceus, symbol for commerce and negotiation, but also adopted by the medical branch of the U.S. Army and some other U.S. health care organizations as their insignia.

Early Greeks and Romans used magic and witchcraft to treat illness and disease. Later, Hippocrates (ca 460–380 BCE), the "Father of Medicine," taught that illness had natural causes. His medicine revolved around the concept of four humors that fill the human body: black bile, yellow bile, phlegm, and blood. When the four humors were in balance, a person was healthy. An excess or deficiency of any of these substances caused illness and disease. Herbs and other medicines treated unbalanced humors and restored their balance, an idea that dominated Western philosophy of medicine and disease for over 2,000 years, until the late 1800s.

A little more than four centuries after Hippocrates, the Roman writer Pliny the Elder (23–79 CE) wrote his 37-volume work *Historia Naturalis*. This opus, which purportedly summed up all knowledge of the time, included a compilation of medicinal uses of plants and animals. Amphibians and reptiles figure prominently. Romans, and subsequently people during the Middle Ages and even more recently, relied heavily on Pliny's medical guidance.

Because frogs are associated with water, and water is associated with cleansing, people have long admired frogs for their healing powers. Included in Pliny's frog-based remedies: Eat the flesh of river frogs to counteract snake and scorpion venom. Hair lost by mange can be restored by covering the area with ash of three frogs mixed with honey. To cure a cough, spit into the mouth of a tree frog. To stop nosebleed, stuff the nostrils with ash of tadpoles. Frog fat placed into sore ears eases pain. Toothache can be eliminated by rinsing one's teeth in a juice made of frog boiled in vinegar, by placing a mixture of boiled frog liver and honey onto the tooth, or by tying a whole frog onto the jaw. Live frogs applied to diseased joints soothe pain. Fever can be lowered by rubbing the body with frog fat boiled in oil at a place where three roads meet. Frog ash or dried blood stops bleeding, and frog flesh heals bruises.

Pliny advocated reptiles for diverse remedies. A snake's tooth, worn as an amulet, relieves toothache. Even better, rinse your teeth with tortoise blood three times a year, and you'll never develop a toothache. To cure a headache, sprinkle on the head wine in which a chameleon has been soaked. Eat hard-boiled tortoise eggs to reduce stomach pain. Carry stones extracted from a crocodile's belly as charms against aching joints. To cure a wart, place sloughed snakeskin over the wart or apply a lizard's head or blood to the growth. Python fat, dried in the sun, heals fresh wounds, and viper fat heals burns. Apply the ash of a green lizard or fresh tortoise gall to diminish scars. The right eye removed from a living lizard and tied to the human body reduces fever. Apply pebbles from a crocodile's belly or crocodile fat to a feverish body. For cataract, anoint the eyes with crocodile gall and honey or with a mixture of sea turtle gall, river turtle blood, and milk. Tortoise gall or crocodile blood dripped into eyes improves eyesight. Crocodile dung in a lint tampon provides an effective contraceptive.

Theriac, a viper-wine formulated by the Greeks in the first century CE, was originally intended as an antidote for venomous snakebite. (The word "theriac" hails from

11.7 Because of their close affinity to water, frogs are associated with cleansing and healing. Pictured here is a Kajika frog (*Buergeria buergeri*) from Japan.

the ancient Greek word *theriakos*, meaning "concerning wild beasts or venomous reptiles.") Pliny was skeptical of theriac because it contained up to 60 ingredients in what he found to be absurd proportions. Herbs, minerals, opium, and animals' blood were added to wine, but the most important ingredient was snake flesh. Whole bodies or body parts of vipers (generally the Palestine saw-scaled viper, *Echis coloratus*) were boiled or soaked in wine. Each ingredient was thought to correspond to a particular part and function of the human body; as such, theriac mirrored human physiology. Despite Pliny's skepticism, theriac became popular throughout the ancient world. From the Middle Ages to the eighteenth century, theriac was thought to invigorate one's health—a panacea for all ailments, including plague. Perhaps not coincidentally, saw-scaled viper venom is highly anti-coagulant in nature, and during the Middle Ages bloodletting was a standard medical approach to cure nearly everything from acne to tuberculosis.

Pliny wasn't the only medical force during the late Middle Ages. Nicholas of Poland, a Dominican friar who lived ca. 1235–1316, urged people to use natural healing methods. He advocated eating scorpions, toads, lizards, and snakes as cures for all ailments because of these animals' extraordinary virtues. The friar also claimed that his concoctions were far more powerful than physician-recommended drugs. Nicholas argued that the more filthy and abominable the creature, the greater the medicinal value. (Think about the parallel in modern medicine. As a kid, you knew that the stronger the medicine, the worse the taste.)

Many European amphibian- and reptile-based folk remedies popular in the past two millennia can be traced back to Roman medicine, which was strongly influenced by Pliny. Consider frogs and the British Isles. Just as Pliny recommended spitting into a tree frog's mouth to cure a cough, people in rural England believed that if a child coughed into a frog's mouth, the frog would assume the cough. If an asthmatic person blew or spit into a frog's mouth, the asthma would pass to the frog. An English cure for whooping cough consisted of placing a small frog in a box, tied around the sufferer's neck. As the frog weakened from starvation, the cough subsided until the frog died and the cough disappeared. Soup made from nine frogs provided a Yorkshire, England, cure for whooping cough. Pliny's recommendation that frogs can stop bleeding was followed in England, where frogs or their eggs were applied to wounds. Toads were used to treat premature and copious menstruation. In medieval England, dried toads soaked in vinegar were laid on the forehead or hung around the neck to stop nosebleed. Pliny recommended frogs as a remedy for toothache, but a folk belief from County Cork, Ireland, advocated that if you bite into a live frog, you'll never get a toothache. Many of these European folk remedies traveled to the New World with European immigrants, and some are still used.

11.8 Nicholas of Poland urged people to eat toads. As "filthy" animals, toads were capable of healing all manner of ailments. Among other remedies, Nicholas recommended that one should drink his mixture of snake and toad powder in wine twice daily to break a bladder stone. He offered powdered toad pills to cure weak hearts, sore eyes, and insomnia.

Many European amphibian- and reptile-based folk remedies were presumed to work based on transference. The pain, swelling, fever, or other ailment passes from the afflicted person to the animal. For example, Pliny recommended laying slit-open frogs on the big toe as a cure for podagra (gout in the big toe). The idea of transference continued with frog-based remedies in the United States where people bound live toads on sore joints to cure rheumatism. A non-venomous snake wrapped around a goiter would assume the growth.

In some areas of the world, use of amphibian- and reptile-based remedies is declining. In other places, however, people still use these remedies either because they convey real pharmacological benefits, or because they offer psychological reassurance. We believe because they make us feel better. And they make us feel better because we believe. Thus is the power of the placebo effect. Bring on the dried frog ovaries, *Wu Shiu Jiu*, and stewed frog fat!

About 80 percent of the world's human population uses traditional medicines as their primary source of healing remedies. An estimated one-third of the world's population have no access to Western drugs and depend exclusively on folk remedies. Many other people have access to conventional medicines but prefer folk remedies either because they cannot afford Western drugs or because they believe folk medicines are superior. Furthermore, people in developed countries are increasingly interested in alternative medicine. The U.S. National Institutes of Health (NIH) estimates that nearly 40 percent of Americans use health-care approaches developed outside of mainstream Western medicine. To address the growing use of alternative remedies, in 1998 the NIH established the National Center for Complementary and Alternative Medicine (NCCAM) to investigate the usefulness and safety of complementary and alternative medicines and to evaluate their roles in health care. Each year increasing pressure is placed on wild populations of animals used in folk medicines.

What does our use of amphibians and reptiles in traditional medicines mean for their future? Rômulo Alves and his colleagues recently examined global use of these animals in folk medicine and reported that of the 284 species of reptiles used, 182 (64 percent) are included on the IUCN Red List of Threatened Species. Of the 47 species of amphibians used, 42 (89 percent) are on the IUCN Red List. (The International Union for Conservation of Nature, IUCN, evaluates the extinction risk of species and maintains an inventory of the conservation status of species worldwide. Threatened species are included on what is called the "Red List" and are designated as extinct, extinct in the wild, critically endangered, endangered, or vulnerable.) It is often difficult to separate the negative effects of exploitation of a given species for food vs. for folk medicine, as people often make dietary choices based on the animal's perceived medicinal value. Nonetheless, some species' declines have been linked directly to their exploitation for folk medicines.

One example is rattlesnakes in Mexico, where capsules containing powdered rattlesnake skin, flesh, and bone are used to treat multiple ailments, including cancer, heart disease, kidney disease, diabetes, rheumatism, skin rashes, and impotence. Demand for rattlesnakes to prepare these folk medicines has led to significant population declines in some areas, such as Plateros in the state of Zacatecas. The same is true for some snakes in Brazil and for various turtles in Southeast Asia. In Guangxi, in southern China along the border with Vietnam, hundreds of thousands of locally collected tokay geckos were purchased every year until the supply was depleted. Now populations of these geckos are declining in other Asian countries because of the large numbers collected and exported to China for use in TCMs.

The impact on individual species through exploitation for folk medicine depends on many factors, including the nature and quantity of body parts used. Harvesting of whole bodies, organs, and tissues obviously affects a population more than does collection of the animals' secretions, although the latter stresses the animals. Other relevant factors include life history attributes such as timing of maturation, longevity, reproductive phenology, and clutch or brood size. Whereas small individuals are often favored for the pet trade, larger individuals are preferred for folk medicines. For long-lived, slow-maturing species that have low reproductive potential, removal of adults from wild populations can have disastrous consequences for long-term population survival. Whether the targeted population is increasing, remaining stable, or decreasing at the time of harvest likewise affects impact.

Following are three suggestions that have been offered to protect animals from over-exploitation. Each one has associated problems. I'll use turtles as examples.

One way to protect animals is through national and international laws that restrict trade. Passing legislation isn't enough, however. Regulations must be enforced. Better training and identification guides need to be provided to customs and wildlife personnel, who often are more concerned and knowledgeable about birds and mammals. Without effective enforcement, smuggling becomes profitable. Consider, for example, that one golden coin turtle can fetch $2,000 on the black market. This plus the belief that a preparation made from the turtle's plastron cures cancer provide strong incentives for illegal activity. Of course, playing Devil's advocate, one can argue that stringent laws and effective enforcement of those laws make it even more profitable for those willing to take the risk, because of reduced competition from less-daring unscrupulous people.

Captive breeding represents a second way to reduce pressure on wild populations. Farming of the Chinese softshell turtle for food and folk medicine has been exceedingly successful in Asia, with 1,499 registered turtle farms in China alone in 2007. Every year, farms sell an estimated 300 million captive-raised turtles, worth about $750 million.

Although farming is meant to relieve pressure on wild populations, this is not the case for the Chinese turtle farms. Shi Haitao and his colleagues have argued that

the lucrative Chinese turtle farms represent a major threat because they are the main purchasers of wild-caught turtles. The turtle farming operations are unsustainable. Because successive generations of farm-raised turtles show decreased reproductive performance, farmers constantly seek wild breeders to infuse vigor into their stock.

Several other problems are associated with turtle farming. First, for some TCM preparations, clients prefer wild-caught turtles because their medicinal value is considered superior to that of captive-bred individuals. Second, wild-caught animals fetch higher prices, so some suppliers prefer to deal in wild turtles. Third, people launder illegally collected turtles as captive-raised merchandise. Fourth, the fact that many turtle farms are located in areas where the farmed species do not occur naturally leads to potential ecological problems. When turtles escape, they can become major predators or competitors in that foreign ecosystem, and/or they might transmit diseases to which the native turtles have never been exposed and carry no resistance.

A third way to reduce pressure on wild populations is to substitute herbs or products from domesticated animals for endangered animals. A 2000 article in *Pro Wildlife* quotes the president of the Association of Chinese Medicine and Philosophy, Lo Yan-Wo, as saying, "The herbs used in the [turtle] jelly are the most important ingredients, not turtles. Herbs are very cheap, but by adding turtle, they can charge much more." Theoretically, substitution might work in some cases, but there are many concerns. One is that consumers might prefer the real deal. If for hundreds of years your culture has believed that sea turtle penis is the ultimate sex stimulant, would you accept bull pizzle? Unlikely. Pulverized and boiled woody wine? Probably not.

A basic problem with recommending substitutions is that we know very little about the chemical makeup of animals or animal parts used in folk medicines. For example, why do Brazilians use the fat of Geoffroy's side-necked turtle (*Phrynops geoffroanus*)—rather than the fat of some other turtle, lizard, or snake—to heal the umbilical cord of newborn babies? Presumably there is something special—real or imagined—about the fat of this particular turtle. Without knowing the chemical makeup and pharmacological functioning of the ingredients, the choice of a substitution would be a best guess or even a random alternative.

Another issue with substitution is that some protection of endangered species used for folk preparations might occur precisely *because* of their perceived medicinal value. As mentioned in the last chapter, to avoid wiping out a critical population, local residents might harvest animals in a sustainable manner and protect the habitat. If cow liver is used instead of the endangered turtle's liver, with no incentive to protect the habitat, the turtle population might be headed for certain extirpation.

Fifteen years ago, two ecologists from South Africa, T. S. Simelane and G. I. H. Kerley, proposed that if Western scientists would only leave their "cultural comfort-zone" and work closely with local people and traditional healers, they might use such interactions to implement conservation strategies. Because people generally respect animals perceived as having medicinal value, biologists should be able to gain support

from local people to establish and maintain reserves to manage these species. Furthermore, because traditional healers command respect associated with their knowledge and power to heal, if they understand the importance of sustainable harvesting, they are in a good position to educate their community. We would do well to accept this challenge from South Africa.

Ultimately, the combined goals of health-care practitioners and conservation biologists should be to support folk medicine that is critical to 80 percent of the world's people and at the same time avoid exterminating wildlife. These goals raise ethical concerns, however. What if there is no evidence that certain remedies are effective? From a Western medical perspective, we should not support ineffective folk medicines; we should provide proven treatments. On the other hand, from the perspective of people using those remedies, perhaps the placebo effect affords some degree of relief. Is it ethical for outsiders to interfere with another culture's traditional beliefs?

Do biologists outside the culture have an ethical right to demand that people give up traditional medicines (whether effective or ineffective) made from threatened species? These might be the only remedies available, affordable, or acceptable. People who depend on traditional healing believe they have every right to use the remedies taught to them by their ancestors, incorporating animals that share the land with them. Rather than demand that exploitation stop entirely, might sustainable harvesting provide a solution? Unfortunately, in many cases the populations of threatened species used for folk medicines are so tenuous that sustainable harvesting cannot be accomplished. What then? Who makes the decision regarding use of threatened species?

Clearly, compromises must be made and there is no one correct answer for all situations.

12

Like a Hell-Broth, Boil and Bubble

Witchcraft and Magic

"They sure *fixed* Adele," she said. "She was walkin' down the street and somethin' got in both her eyes. It hurt so bad she fell down and screamed. They took her to the hospital but she was blind. You know what they does. They kills a snake, lets him rot in the sun and then takes and throws the dust in a person's eyes. You see all kinds of little snakes grow in the person's eyes, and they can't see nothin'."

—ROBERT TALLANT, *Voodoo in New Orleans*

Did you ever sprinkle powdered lizard on your husband to cool his sexual appetite? Wear an amulet necklace containing bits of caiman skin to protect against the "evil eye"? I learned about these products and more as a young graduate student in Belém, Brazil, in 1969–70, where the Ver-o-Peso market introduced me to the exotic world of witchcraft and folk magic to control events or influence other people's behavior or emotions. Amidst the pervasive smell of decay, grizzled women taught me about powdered and liquid concoctions guaranteed to bring love, financial success, happiness, good health, and sexual satisfaction. Shriveled Amazon River dolphin eyes, armadillo tails, crusty bird skins, and water buffalo teeth promised relief and cures, but I was intrigued by the prominent status of amphibians and reptiles offered as folk magic. One toothless woman with a wide smile gifted me a small vial containing smidgens of boa constrictor in rosewater. I shook the vial and it became an eerie snow globe of dancing organic mat-

12.1 Powdered and liquid concoctions from the Ver-o-Peso market in Belém, Brazil, promise to bring love, financial success, happiness, good health, and sexual satisfaction. Boas feature prominently in much of this folk magic.

ter. The vendor instructed me to pour the contents into bathwater for guaranteed happiness.

Why did amphibians and reptiles feature so prominently at Ver-o-Peso both as occult objects for casting evil spells and as enhancements for enriching our lives? I concluded that the opposing applications reflect our dual perceptions of the animals—we love and hate them, admire and despise them. But why are they used at all? In this chapter, I will explore some of the roles that amphibians and reptiles play in folk magic, both "black" and "white."

Ah, the color of magic: black vs. white. The terms are used in various ways, but a commonly used distinction, and the one I will use here, is that magic can either help or harm. Generally, white magic is performed with good intentions, and its effects are constructive and positive. The methods used to bring about the magic cause no harm to others and generally are legal and ethical. In contrast, black magic is carried out with evil intention to harm others, and its effects are destructive and negative. Black magic methods are often illegal and unethical. The objects and substances used to work magic are neither good nor evil in themselves; it depends on how they are used. Thus, a given animal might be used for white or black magic.

Folk magic generally works on the premise that disease is demonic, sent by evil forces into a victim. As such, a person possessing supernatural power—a sorcerer, witch doctor, shaman, or conjurer—must treat the disease by counter-spell. In the case of Adele, as reported by Tallant, an enemy worked evil by dusting her eyes with

powdered snake. Later a sorcerer placed fifteen drops of her special mixture in each of Adele's eyes, a mixture made from cooking mustard greens with "juice" from a dog's tail. Within thirty minutes, the snakes poured out of her eyes and she could see again.

Whereas I might attribute my falling down the stairs to carelessness or clumsiness, believers in folk magic would ask why I—rather than someone else—should have missed the step I had always found in the past. The logical answer is that something or someone caused the fall. Events can be influenced for good or for evil. If someone has created evil, someone else can elicit a good event or at least undo the evil. By intervening with spirits or divinities, a sorcerer or shaman can manipulate situations to remedy ill fates. Beyond manipulation, humans desire to control their own destinies, life and death. We try to do this in many ways, from making offerings, praying, and visiting the doctor, to evoking folk magic.

Have you ever wondered how people can believe in folk magic after a spell or curse is cast and the intended result fizzles? Bruce Jackson, in a chapter in *American Folk Medicine*, suggests: "What if we assume that events in this world are *causally* rather than *randomly* linked? What if we assume the world has a sense to it greater than accident and less than total divine plan? Then the only real problem is to find out how to influence the various operations. The *donnée* [set of assumptions] would be that the world *can* be influenced for good or ill, that both events and persons can be directed in significant ways." Thus, failure of folk magic could be blamed either on a practitioner's incompetence or on someone else working stronger magic. And, of course, the client could be faulted for not really believing or for having followed instructions incorrectly. Negative results themselves do not invalidate the magic.

West African-Influenced Magic in the New World

Often when people think of folk magic, "voodoo" springs to mind and with it visions of wax dolls sprouting pins, and animal sacrifices. The word "voodoo" by itself doesn't mean much, however. Non-devotees often use "voodoo" indiscriminately to refer to West African Vodun, Haitian Vodou, and Louisiana (United States) Voodoo. West African Vodun, a religion, is the main origin for the other two. Haitian Vodou and Louisiana Voodoo both incorporate practices, folk magic, and beliefs of African culture, but they differ from each other. Haitian Vodou is an established religion with a supreme being and lesser spirits. Louisiana Voodoo blends West African animism, Catholicism, and Native American use of sacred and medicinal plants, while it emphasizes folk magic and occult paraphernalia to conjure and cast spells, protect and heal.

In Louisiana Voodoo, conjurers claim to possess magical power to perform witchcraft: for example, to cause illness and bad luck, drive a person insane, or kill. To deal with the threat and to counteract evil caused by conjurers, one can enlist the help of three kinds of practitioners, who sometimes overlap in their modi operandi. Some use herbs and other non-prescription remedies. Other practitioners are spiritual or

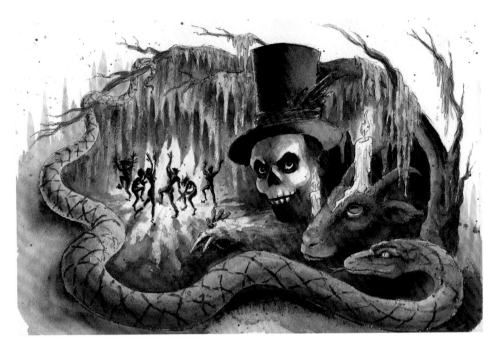

12.2 Voodoo conjures up visions of dancing with snakes around blazing bonfires, amid savage rhythms; communion with spirits; curses, hexes, and murder; cauldrons bubbling with snakes and frogs; sexual orgies; sacrificed roosters, goats, black cats, and dogs; and blood consumption.

faith healers who believe they have God-given powers to heal through prayers, without medicines. The third group offers magic—powders, potions, charms, amulets, and *gris-gris* ("hoodoo bags") that can be concealed on one's body.

Good *gris-gris*, designed to enact white magic, smells good. For example, a love *gris-gris* might be scented with talcum powder. Evil *gris-gris* for black magic predictably smells raunchy, and that's where amphibians and reptiles come into play. Black magic *gris-gris* contains evil-emanating substances, such as graveyard dust, rusty nails, dog feces, snake fangs, alligator teeth, fingernail scrapings, vulture bones, dead flies, rats' tails, and dried toad, lizard, and snake skin and bones. There's not much doubt how practitioners of Louisiana Voodoo view amphibians and reptiles!

Alligators and snakes are considered evil, but beyond that they are frightening and powerful. Imagine working on a sugarcane plantation in southern Louisiana 160 years ago—long hours of forced labor in the heat and humidity, exhaustion, and the thought of the same for the next day. Adjacent swamps and bayous—a mysterious world of towering live oaks and gnarled cypress draped with Spanish moss—bid possible escape and freedom. But they are forbidding territory, crawling with venomous cottonmouth snakes and alligators. These beasts don't stay in their foreboding landscape, however. They wander into the cane fields, where you must be ever vigilant, for they can kill you. If fear of these reptiles permeates your existence, imagine their power in *gris-gris*.

12.3 Evil *gris-gris* often incorporates bits and pieces of amphibians and reptiles: snake skin and fangs, toad bones, and crocodilian teeth.

Snakes participate in Louisiana Voodoo in ways other than as ghosts and skeletons in *gris-gris*. They are revered as keepers of intuitive knowledge, a belief likely rooted in African python worship. Marie Laveau, a well-known Louisiana Voodoo priestess in the mid-1800s, embraced snake power. The Catholic daughter of a white planter and Creole mother, Marie had a snake named Zombi, likely a large boa constrictor. Her followers believed that Zombi could cause sickness or health, good or bad luck, life or death. Marie hosted weekly gatherings to affirm her occult powers. During these Friday-night meetings, participants danced naked, intoxicated with rum. Marie's snake crawled over the dancers' legs, and Marie danced with Zombi wrapped around her shoulders. The wild dancing culminated in a sexual orgy.

Louisiana Voodoo uses amphibians and reptiles in another major way: practitioners cause snakes, lizards, and frogs to enter victims' bodies. Tallant offers firsthand reports. A woman named Corinne believed that her mother died when snakes inside her body grew large enough that they needed to exit. Corinne felt nothing supernatural about it—simply that an evil Voodoo doctor had put snake eggs in her mother's food. And then there's unfortunate Aunt Laura, who "had snakes under the

skin of her foot. You could see 'em crawlin'. Some hoodoo had boiled a lot of snakes and put the powder on Aunt Laura's foot when she was sleepin'. Sometimes they would crawl up her leg to her stomach and then she would vomit snails. It was awful. You know when she died—and this is the truth—you could hear a frog croakin' in her belly!"

Another Voodoo practice of killing with snakes involved hanging a dead rattle-snake in the sun to dry. The name of the intended victim was written on a scrap of paper and stuffed into the snake's mouth. As the snake shriveled, so would the person. The power of this physical contact parallels the belief of transference in traditional healing (chapter 11).

Another magico-religious belief system, one that still flourishes in Latin America, is Santería, whose roots lie in Nigeria. Over four hundred years ago, slave traders brought many Yoruba from Nigeria to the New World. The Yoruba brought with them their vibrant mythology and religious practices. Santería combines the magic rites of Yoruba religion with traditions of the Catholic Church, including veneration of saints. A *santero* (practitioner of Santería) uses magical powers to help clients remove negative influences, cure illnesses, attract lovers, control wandering spouses or paramours, secure employment, increase wealth, and subdue and even destroy rivals and enemies. A *santero* has a fix for everyone's problems. Generally, he/she does not think of magic as good or evil, but simply the ability to accomplish the requested task—to better situations or to solve problems unsolvable by other means.

In *Santería: African Magic in Latin America*, Migene González-Wippler offers a cross section of traditional and reputedly effective magic spells of Santería employing "spiritually noxious" animals as vehicles for casting hexes, jinxes, and curses. Such animals include "all manner of reptiles and venomous insects, such as scorpions and centipedes, some varieties of frogs, all birds of prey, the rat, the crocodile, the lizard, and the spider." One Santería spell uses snakes to overcome an enemy: write the person's name on a piece of parchment paper and dip it in snake oil. Sew the paper to a piece of snakeskin that you have previously cut to fit the inside of your shoe. Place the snakeskin inside your shoe so that you will always step on your enemy's name. Just as a snake crawls on the ground, your former enemy will crawl at your feet—impotent and humiliated.

More Body Intrusions

Intrusion of live animals into a victim's body is associated with many types of black magic in addition to Voodoo. This form of witchcraft reputedly still occurs in many places in the world, where snakes, lizards, and frogs play prominent roles. In the United States, belief in conjuring may be a holdover from the rich body of folk magic carried to the New World through the African slave trade. Africa has a diverse herpe-

tofauna, thus it is not surprising that these animals feature prominently in the folk beliefs of African Americans. From the United States south to Chile, sorcerers and witches are still believed to insinuate frogs and toads into human bodies. The animals are blamed for many lumps, including cancerous tumors.

The idea of frogs, salamanders, snakes, and lizards writhing inside a person isn't as far-fetched as it might seem, and may have been inspired by the harmful internal parasites we harbor. For example, beef tapeworm larvae are acquired from eating undercooked hamburger or steak. The tapeworms grow to 20 feet (6.1 m) inside the human intestine. Their long and thin body physique isn't that different superficially from that of snakes. Each day an adult beef tapeworm releases hundreds of thousands of eggs in segments that pass with feces. These defecated segments resemble maggots, a yuck factor for most people.

I can personally vouch for the horror of watching a parasite inside your body. In my case, which happened in Costa Rica, the head of a white maggot bobbed up and down through an opening in my wrist. The yuck factor kicked in, and I recognized my companion as a botfly larva. The botfly life cycle begins when a fertilized female botfly—stout, black, and hairy—catches a mosquito and attaches her eggs to the mosquito's abdomen. When the mosquito lands on bare human (or other animal) skin, the warmth induces the eggs to hatch into tiny larvae that burrow into the host. The larvae feed on tissues and fluids, and they construct breathing holes through which they extend their snorkel-like spiracles. After fifty to sixty days, the larvae mature, exit the host, fall to the ground, and pupate.

One should not yank out a botfly larva with tweezers, for it will dig its tiny hooks into the sides of its breathing hole. If the body snaps and part is left inside, infection is likely. I wrapped masking tape around my wrist to cut off the larva's air supply. A few hours later, the masking tape came off and *voilà*! The 1-inch (2.5 cm) larva, protruding from my wrist, gasped for air and immediately found itself in a small vial of alcohol. If invertebrates can enter and exit our bodies, why not amphibians and reptiles?

How do conjurers introduce animals into victims? One way is magically "shooting" them into people. Some claim that a lizard can be introduced by placing it in a bottle left on the road; the lizard will hop inside anyone who steps over the bottle. In the late 1800s, in the eastern United States, one method for introducing salamanders into a person's stomach was to put some "ground puppies" (likely mole salamanders, Ambystomatidae) in a bottle buried beneath the enemy's doorstep. Eventually, the ground puppies burst forth and entered the stomach of the targeted person. The victim died. Reportedly, conjurers worldwide dry animals, grind them, and slip the powder into a person's food, drink, or shoes, or throw powdered animal dust directly onto a victim. The animal gets reconstituted once inside the person's moist body.

Amphibians and reptiles also are believed to intrude into the human body on their own volition. People in many countries, including Japan, Ireland, England, Spain, Hungary, and the United States, believed that the animals enter the mouths of people sleeping on the ground, particularly near wells and springs. If a person saw a snake, lizard, frog, or salamander near the water and later acquired a waterborne illness, then of course the animal must have entered his/her body. Drinking spring water was deemed risky, as it likely harbored amphibian and reptile eggs.

The widespread belief that amphibians and reptiles inside our bodies cause physical discomfort reflects our aversion to them. People explained intestinal pain and hunger pangs as gnawing of internal reptiles. In medieval Europe, people guzzled milk and devoured garlic to ease the pain caused by their internal snakes. (Garlic has proven to be one of the world's most effective natural antibiotics, killing bacteria, worms, and other intestinal parasites.) Folklore has it that a child from the southern United States afflicted with internal reptiles had to eat constantly to keep the animals from devouring his vital organs, and in Scotland a child died because his internal snake lodged its fangs in the child's heart and sucked him to death.

How did one expel internal amphibians and reptiles? Some people resorted to herb-based emetics. People from various Native American tribes and early settlers to the U.S. East Coast who experienced intestinal ailments lay beside a spring or brook in the belief that their internal lizards would crawl out to drink. Some ate salty food before doing this—to increase their lizards' thirst.

Giraldus Cambrensis, a Welsh clergyman and chronicler in the twelfth century, offers an unusual antidote, based on his travels in Ireland. He claims that when venomous reptiles are brought to Ireland, they die because of the "kindly influence" of the air or some "occult property" of the soil. He writes, "Indeed the soil of Ireland is so hostile to poison, that, if gardens or any other spots in foreign countries are sprinkled with its dust, all venomous reptiles are immediately driven far away." Cambrensis recommended drinking the "salubrious" water of Ireland to cast out an internal snake:

> It happened also, within my time, on the northern borders of England, that a snake crept into the mouth of a boy while he was asleep, and passed through his gullet into his belly. The reptile, making a very ill return to his host for the lodgings with which it had been unconsciously supplied, began to gnaw and tear the lad's intestines, and threw him into such agonies that he would have preferred death at once to such a dying life. After satisfying his hunger, however, the snake allowed him some respite from his sufferings, but before that none at all. After the boy had resorted to the shrines of the saints of God throughout England for a long time, but all in vain, at length, better advised, he crossed over to Ireland, where, as soon as he had drank of the salubrious waters of that country and partaken of its food, his deadly enemy expired, and was voided through his intestines. Then rejoicing in renovated health, he returned to his own country.

More Black Magic

Sorcerers use reptiles for black magic in other ways as well. In the United States, some people believed that the dust of dried and ground lizard heads sprinkled on a victim's head induced headache. For a more evil curse, the same lizard dust sprinkled on a person's body withered the victim. Ingested lizard blood mixed with snake blood purportedly made the victim fall to the ground speechless within two minutes. Powdered snake dust placed near the steps of an enemy induced madness. In areas of southern and western Asia where geckos are feared and considered evil, black magic practitioners still use these lizards in potions. In the Punjab region of northwest India, northwestern Pakistan, and Afghanistan, magicians prepare potions from gecko tail, skin, and blood to weaken enemies. Cooked gecko mixed with an enemy's food purportedly causes the person to weaken and his skin to peel. In Malawi, toxins derived from the blue-headed agama lizard (*Acanthocercus atricollis*), head of the boomslang (*Dispholidus typus*) or puff adder (*Bitis arietans*), or gall of crocodile are powdered and slipped into an intended victim's drink or food. Reportedly, death comes swiftly.

12.4 Crocodile objects used for magic in Zaire, Africa. *Top:* After blood and other "nasty" substances are sprinkled on top of this two-headed crocodile, the fetish is used either to send curses or to protect from curses, depending on the intended magic; from the Bakongo people in Zaire; 20 inches (51 cm) long. *Bottom:* Crocodile divinatory instrument from the Bakuba tribe in Zaire used to mediate between a diviner and nature spirits to detect the cause of illness or to expose dishonesty; 13 inches (33 cm) long. Both from the collection of Butch and Judy Brodie.

In talking with Sri Lankans, Walter Auffenberg learned of the belief that water monitor lizards (*Varanus salvator*) can be used to murder human enemies. One recipe: Prick a human finger and collect some blood. Mix the blood, plus human hair, with oil and flesh from a water monitor. Boil ingredients. Slip one drop of the concoction into the enemy's food or drink; the person will die immediately. A second, more ghoulish, recipe instructs one to hang a dead monitor by a hind leg for several days. In a bowl underneath the body, collect the juices and decomposing flesh. Mix a drop of the putrid fluid into the victim's food. He or she will experience a terrifying and lingering death.

Another form of witchcraft, performed in southern China for thousands of years and still practiced to a much lesser extent, incorporates a poison called *gu*. Traditionally, the poison was made by housing numerous venomous animals—typically centipedes, snakes, and scorpions—together in a sealed vessel. The animals were left until they ate one another and only one survived. Toxin was then extracted from the survivor, super-venomous because it contained the toxins of all the consumed creatures. The poison, *gu*, was used to effect black magic. Women were accused of using it to incite lust in men and lure them into debauchery. *Gu* magic reportedly led to hallucinations, insanity, painful diseases, and even slow, painful death. People assumed to have been poisoned with *gu* often reported emaciation, lethargy, chronic diarrhea, and abdominal bloating.

Entire regions of southern China became commercial centers for *gu* manufacture. Of course, with the prevalence of *gu*, society needed anti-*gu*. Similar to homeopathic reasoning, the ground-up *gu* animal itself was believed to be an effective antidote. *Gu* and anti-*gu* hysteria eventually led to an imperial decree in 598 CE forbidding manufacture of *gu*, but that didn't stop people determined to produce the magic—or the antidote.

What really caused the symptoms of supposed *gu* poisoning? More than 2,000 years ago, the oldest known Chinese dictionary defined *gu* syndrome as a state of "abdominal worm infestation." Heiner Fruehauf, a prominent scholar and researcher of Chinese medicine, offers a vivid description of the cultural context of *gu*: "Gu, in short, is the ancient Chinese symbol for extreme pathological yin—the dark side of life, the worst nightmare of any human being. It represents darkness, rottenness, slithering vermin, poisonous snakes, betrayal, black magic, backstabbing murder and in medical terms, progressive organ decay accompanied by torturous pain and insanity." Fruehauf suggests that in ancient China the most common causes of what is called *gu* syndrome were likely schistosomiasis (caused by parasitic flatworms, *Schistosoma*) and chronic entamoeba (amoebae living inside the human body) infections. In immune-compromised people today, the most likely causes are afflictions caused by helminths (internal parasitic worms), protozoans, fungi, spirochete bacteria, or viruses.

The Evil Toad

Amphibians and reptiles are strongly associated with European witchcraft, a relationship reinforced by William Shakespeare in his play *Macbeth*. In the early 1600s when Shakespeare wrote *Macbeth*, many English, including James I, king of England, believed in witches. Shakespeare created a macabre scene with three witches huddled around their bubbling caldron containing eyes, toes, tongues, and legs of amphibians and reptiles. The fact that Shakespeare included these animals as ingredients reflects his contemporaries' perceptions of them as "evil."

Europeans believed that witches were in league with the Devil. Having formed such a pact, witches received direct assistance through the Devil to harm people and property, turn food inedible or poisonous, cast fatal spells and curses, sicken livestock, render other women's husbands impotent, and dry up neighbors' cows. Many beliefs about witches and their powers were brought to the New World, as evidenced by witch-hunts, including the infamous witch trial held in Salem Village in the Massachusetts Bay Colony. Witches were blamed for illness, crop failures, infant deaths, and anything else that went wrong. They even had sex with the Devil.

Witches were believed to have familiars, personal demons that protected their practitioners and assisted in carrying out magic and dirty deeds. European witches were partial to toads as familiars, and, in fact, the word "toading," derived from an old Fen word *tudding*, was synonymous with casting spells or performing witchcraft. Toad familiars accompanied witches to Sabbat, the witches' midnight meeting during which they carried out satanic rituals. Witches were thought to have breast-like structures from which their toad familiars drank blood. Toads were also favorite animals for European witches to turn into, perhaps because unlike many animals, toads are tailless and many people believed that during the transformation, the witch's body turned into another animal form, member for member.

Toads have long been associated with poisonous mushrooms (the ones they sat on were called toadstools), filth, disease, and pestilence. How did they garner such a bad reputation? Toads often live in muddy habitats, but part of the negative perception of them stems from

12.5 "Eye of newt and toe of frog, / Wool of bat and tongue of dog, / Adder's fork and blind-worm's sting, / Lizard's leg and owlet's wing, / For a charm of powerful trouble, / Like a hell-broth, boil and bubble." –William Shakespeare, *Macbeth*

their warty skin and the poisons within those warts. When a toad is disturbed, its parotoid glands (located on a toad's head, posterior to the eyes) and sometimes the warts covering the body ooze milky droplets of poison—an effective anti-predator defense. Depending on the species, these toxins taste foul and can sicken or kill an attacking predator.

Humans have long recognized both the therapeutic nature and the toxic properties of toad skin. Folk beliefs claimed that toads were ingredients in flying ointments, which, when rubbed onto broomsticks, allowed witches to fly. Witches supposedly used toads in their magic potions—live, freshly killed, dried carcasses, feces, and/or blood. Purportedly, they also added blood of murdered children and bats, fat of various animals (including children), bones of exhumed corpses, menstrual blood, and the poisonous, hallucinogenic plants henbane, mandrake, hellebore, and belladonna. With the combination of toad toxin and hallucinogenic plants, it's no wonder witches experienced wild rides and frenzied dancing—or at least thought they did. The tight association between witches and toads exaggerated people's negative perceptions of the animals, as witches frequently blamed their toad familiars for any evil deed: "Not my fault, the toad did it."

12.6 When a toad is disturbed, milky droplets of toxin ooze from its parotoid glands, as with this cane toad (*Rhinella marina*). The toxin provides an anti-predator defense for the toad. Humans have figured out how to use the toads' secretions for folk magic and witchcraft.

From European witchcraft during the early modern period (ca. 1500–1800 CE) to current Brazilian black magic brought to the New World from Africa, toads have long been considered capable of effecting great evil. In *Drum and Candle*, David St. Clair writes that Brazilian practitioners make toad preparations by drying parotoid secretion, sometimes mixing it with black chalk, to kill an enemy. If one wants only to curse, not kill: Sew a black toad's mouth shut with black thread. Tie long pieces of black thread to each toe. Hang the toad upside down, as though it were an inverted parachute, over a thick-smoking fire. At midnight, call on the evil spirits and spin the toad as you say, "Filthy toad, by the power of the devil, to whom I have sold my body but not my soul, I beg you not to let [name of your enemy] enjoy one more hour of happiness on earth. Let his health be trapped inside the mouth of this toad. Let him wither away and die. Make this happen to [name your enemy] as soon as I finish saying the name of the devil three times. Satan! Satan! Satan!" The next morning, put the toad into a clay jar and seal the lid with candle wax.

Toads have other uses in Brazilian magic. For example, St. Clair writes that Brazilian magic can reveal the truth if one suspects a wife of being unfaithful. Dry the heart of a pigeon and the head of a toad. After crushing them into a fine powder, add a few drops of rosewater and place the paste in a small velvet bag. Lie beside your wife, and after she has fallen asleep, slip the velvet bag under her pillow. Fifteen minutes later she will begin to talk about her love life and reveal her secrets. When she stops talking, remove the bag. If the bag stays under her pillow too long, it can cause brain fever or even death. On the other hand, if overly distressed by her secrets, leave the bag! (Perhaps not coincidentally, in the United States a toad's tongue placed over a wife's heart while she slept would also cause her to divulge extramarital exploits—see chapter 8.)

As one final example of toad magic in the New World, we'll visit Haiti. In the spring of 1962, a man named Clairvius Narcisse walked into the Hôpital Albert Schweitzer in Port-au-Prince. He felt achy, feverish, and disoriented. Two days after he slipped into a coma, attending physicians pronounced him dead. The following day, Clairvius's family buried him. Eighteen years later, a vacant-eyed man shuffled up to his sister in a busy market and identified himself as Clairvius. The sister and many villagers recognized him immediately. He told them that he had been dug up from the grave, beaten, and hauled away to work as a slave on a distant sugarcane plantation. Clairvius had been the victim of Vodou magic and turned into a zombie. Two years later, the plantation's zombie master was killed. Clairvius and the other zombie slaves dispersed. Clairvius spent the next sixteen years wandering.

Enter Wade Davis, an ethnobotany graduate student at Harvard University. Davis traveled to Haiti in 1982 to obtain a sample of zombie powder for analysis. After lengthy negotiations, a sorcerer named Marcel Pierre agreed to prepare zombie powder for Davis, in exchange for a large sum of money. The fascinating story of what happened is brilliantly told by Davis in *The Serpent and the Rainbow*.

Preparation began in a cemetery, where Pierre and several others dug up a wooden coffin housing the body of a recently deceased baby girl—the first ingredient. Three days later, the Haitians charred the child's cranial bone fragments on a grill, along with remains of two iridescent blue lizards and the dried and flattened carcass of a large toad (presumably a cane toad, *Rhinella marina*). The toad had been placed in a sealed container overnight with a polychaete worm before being killed. Pierre's assistant explained to Davis that imprisonment with the worm had enraged the toad, making it secrete copious skin toxin. Next came leaves of two plants and finally a puffer fish. By the time the charred ingredients were ready to be crushed in the mortar, corrosive yellow smoke rose from the vessel.

Back at Harvard, technicians shaved the backs of laboratory rats and sprinkled the powder onto their naked skin. The rats became comatose. After six hours, the rats appeared dead, although EKGs revealed faint heartbeats and EEGs revealed brain waves. As expected, the primary active ingredient in the powder was tetrodotoxin (TTX), the powerful nerve poison of puffer fish, but the dried toad skin may have enhanced the effect of the TTX. Two of the active ingredients in toad skin, bufotenine and bufotoxin, increase contractive powers of heart muscle.

In Haiti, zombie creation used to be part of the traditional justice system to punish people for violating community rules. After Clairvius cheated family members out of land, his brother contracted out for his zombification. A *bokor* (sorcerer) gave Clairvius zombie powder and allowed him to go home. Clairvius soon sickened, went to the hospital, "died," and was buried. The *bokor* dug up his body and gave Clairvius a paste made from Jimsonweed (*Datura stramonium*), a powerful hallucinogen that also causes memory loss. Clairvius was aware of what was happening but couldn't react. The *bokor* took Clairvius to a sugarcane plantation, where he joined other zombies in forced labor. Throughout his two years on the plantation, Clairvius was given regular doses of Jimsonweed paste, which kept him in an obedient, zombie-like state. After the plantation master died and Clairvius no longer had his regular fix of Jimsonweed, he regained sanity and in time became the first well-documented zombie. Zombification is now illegal in Haiti, considered to be attempted murder.

Amphibians and Reptiles in White–and Dual–Magic

Most of this discussion has focused on amphibians and reptiles used to enact black magic, but these animals also are used to bring about positive changes. To examine some white magic, let's return to Brazil, where at least 20 reptile species are used for magic/religious purposes and certain qualities of the reptiles are believed to be transferred to the human users. Products made from docile brown tree-climber lizards (*Uranoscodon superciliosus*), yellow-footed tortoises (*Chelonoidis denticulatus*), and red-footed tortoises (*Chelonoidis carbonarius*) calm an aggressive person or ease the anger of someone betrayed by a spouse. The skin, head, eyes, teeth, tail, cloaca,

12.7 In Africa, a python's head is used to protect against witches. In Brazil, a boa constrictor's head serves the same purpose, no doubt reflecting folk magic carried to the New World from Africa through the slave trade. Both are seen as powerful. *Top:* Angolan python (*Python anchietae*) with eggs; *bottom:* boa constrictor (*Boa constrictor*).

feces, and fat of large, powerful boa constrictors (*Boa constrictor*) are worn around the neck to execute white magic spells, attract sexual partners, and protect against the "evil eye." Skin, tail, cloaca, rattle, and fat of South American rattlesnakes (*Crotalus durissus*) are used for the same purpose. Meant to attract love, good luck, and financial success, talismans containing bits of reptile body parts come in baby carrot–size glass vials or as pieces of cloth or leather onto which reptile bits have been glued. These reptile products and preparations are commonly sold in outdoor markets, such as Ver-o-Peso in Belém, and in stores that sell religious articles.

Given that many people perceive toads as ugly, and that toads are widely used in black magic, it might seem surprising that they are used in white magic to secure love. *Curanderos* (curers) in Veracruz, Mexico, prepare love magic pills from toad parotoid secretions. The toads are harassed, and the secretions are collected in a small bowl and heated over fire to remove or reduce harmful effects. The dried substance is hardened and molded into pills.

In many Asian cultures, frogs and toads are associated with the *yin* side of nature. As such, they bring happiness, good health, good luck, and prosperity, a belief also held by many non-Asians. People worldwide wear or carry frog or toad charms, plant frog or toad statues in their gardens, and display figurines of frogs and toads in their homes in hopes of attracting positive happenings. Surely my happiness and comfort stem from the more than 200 frog and toad figurines that collect dust in my home.

Some amphibians and reptiles are used to execute both white and black magic by the same practitioners, reflecting perceived versatility in the animals' powers. For example, Brazilian *santeros* rely on transference in positive and negative spells incorporating frogs. If the frog is to be used to kill an enemy, paper with the victim's name is placed in a frog's mouth, and the mouth is sprinkled with salt. Next, one of the victim's handkerchiefs is sewn to the frog's mouth, and the frog is placed inside a large-necked bottle. The frog is left in a cemetery to die. At the same time the frog dies inside its bottle, so does the victim. *Santeros* also use frogs to acquire a husband or wife for a client. In this form of Santería spell, a red and a black ribbon are used to tie a personal article of the desired person around a frog's belly. The frog is placed inside a cardboard box punched with holes. The person's guardian angel is invoked and a prompt marriage is requested. The target of the spell will become obsessed with marrying the person who has bewitched him or her.

Another example comes from Dahomeans of West Africa, who long ago used frogs both to cure smallpox and to infect an enemy with the disease. To cure smallpox, a needle and a stick were put into the mouth of a small dried frog, and the frog was carried in a sock. When needed, the stick was removed and placed in cold water. If the smallpox victim was then washed with the cold water, a cure resulted. If the goal was black magic, the dried frog, again with a needle and stick in its mouth, was bathed in pox fluid from a smallpox victim. If one jabbed the frog with the needle and said the name of a person four times, that person contracted smallpox.

Our perceptions of amphibians and reptiles are not black and white, but black, white, gray, and all shades in between. Any given animal may generate positive, negative, and neutral feelings. Recall creation stories, in which amphibians and reptiles play both constructive and destructive roles. Frogs and snakes represent rebirth, a second chance, yet many of our transformation stories feature the animals as filthy and evil. So, too, we respect amphibians and reptiles for their ability to bring love, happiness,

12.8 Along with bats and spiders, amphibians and reptiles are viewed as "nasty" animals, valued for casting evil spells and other forms of black magic. *Top left:* Jamaican fruit bat (*Artibeus jamaicensis*): *top right:* wolf spider (*Lycosidae*) with young; *center left:* cane toad (*Rhinella marina*); *center right:* brown water snake (*Nerodia taxispilota*); *bottom left:* mugger crocodile (*Crocodylus palustris*); *bottom right:* blue-headed agama (*Acanthocercus atricollis*).

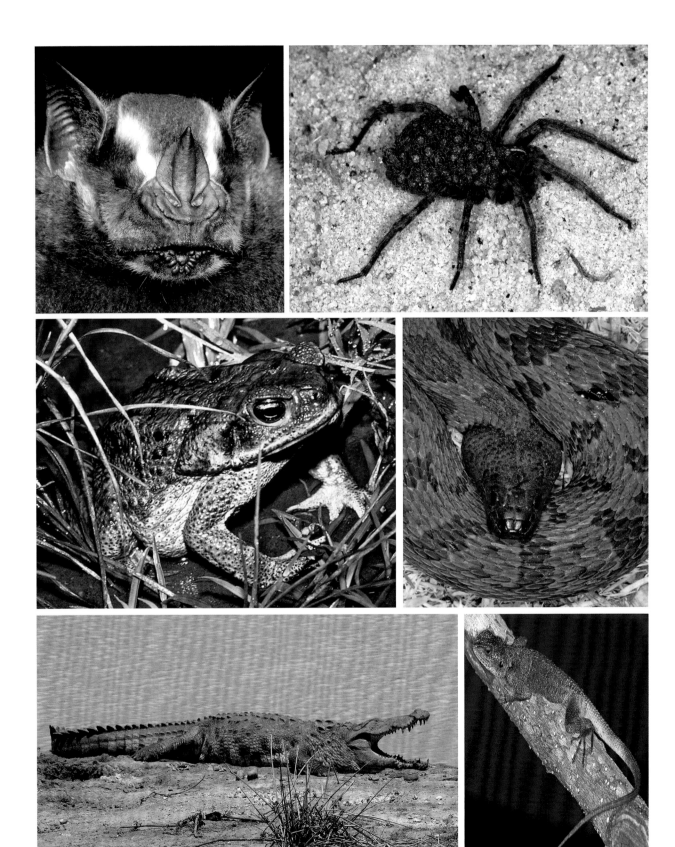

or good fortune through white magic, but we also value them as instruments for casting evil spells and effecting other forms of black magic.

In an article entitled "The Compelling Frog," William Emboden notes that the one element uniting stories of toads in folklore is their power. They are capable of "divination, malefaction, and a portent of good." Emboden argues that this combination of positive and negative is not contradictory in a shamanic sense. The toad simply reflects the essential state of all things: a combination of good and bad. In the shamanic way of viewing the world, there are opposing facets to every being: positive vs. negative energy, giving vs. receiving, creation vs. destruction. A shaman strives to balance opposing facets. Emboden's comments are specifically about toads, but if we interpret human perceptions of amphibians and reptiles on a larger scale in a shamanic way, the apparent contradictions disappear. We perceive these animals as simultaneously good and evil because, as in the shamanic understanding (and in many other spiritual and philosophical belief systems), we view all animals—including ourselves—as having desirable and undesirable aspects.

Recall the question from my days spent wandering through Ver-o-Peso: Why did amphibians and reptiles feature so prominently both as occult objects for casting evil spells and as enhancements for enriching our lives? I still believe the opposing roles reflect our dual perceptions of the animals as good and evil. But in addition, I suggest that their widespread use is not because of their goodness or evilness per se, but because of their perceived power. Through folk magic we try to capture that power and use it to extend our normal abilities to control others, punish, seek vengeance, cure, secure happiness and fortune, and manipulate our surroundings and destinies for our own benefit.

13

"How 'bout Them Toad Suckers"
Other Ways We Use Amphibians and Reptiles

How 'bout them toad suckers, ain't they clods?
Sittin' there suckin' them green toady-frogs.
—MASON WILLIAMS, "Them Toad Suckers"

In the early 1970s, Mason Williams's song "Them Toad Suckers" danced through my head as I walked the muddy trails of Amazonian Ecuador in search of frogs: "suckin' them chunkers, suckin' them leapy-types, suckin' them plunkers." The image of sucking toads, downright weird and ludicrous, made me smile. I naively assumed that was the point. I had no idea then that the words referred to counterculture drug-seekers who lick toads to get high. Now I wonder if there is more to the princess kissing a toad than appears at face value . . .

The past three chapters have touched on our perceptions of amphibians and reptiles on the utility dimension through their application in sexual enhancements, folk medicine, and witchcraft. We use them in many other ways as well, more ways than I have space to cover here. In this chapter, I'll focus on their role in literature, art, music, and dance; in philosophy, spirituality, and religion; in modern medicine; as food; and as pets. First, however, I'll describe some esoteric ways we exploit these animals.

Imagine this chapter as a crazy quilt, a patchwork of fabrics representing ways in which we incorporate amphibians and reptiles into our lives.

13.1 "How 'bout them toad suckers?"

13.2 Objects made from reptile skins and shells and whole toads, sold in Naha City, Okinawa. *Top left:* combs made from "tortoiseshell" (scutes of hawksbill sea turtles); *top right:* lacquered sea turtle shells; *bottom left:* shamisens (3-stringed musical instruments) with snakeskin fronts; *bottom right:* purses made from dried toads.

The colors, shapes, and textures of the fabrics offer a visual feast reflecting our perceptions. A red corduroy octagonal patch represents rattlesnake venom used to poison arrowheads and reveals our admiration for the snakes' powers. A pale blue oval patch of velvet represents orchestral instruments mimicking frog calls and expresses our bond with these minstrels of the night. Use your imagination to piece together the rest of this crazy quilt.

The Esoteric

Toads as Hallucinogens

"How 'bout them toad suckers?" The Colorado River toad (*Incilius alvarius*) occurs in the southwestern United States and northern Mexico. Secretions from the parotoid glands of this 7.5-inch (19 cm) toad contain many pharmacologically active compounds. One of these is the psychoactive drug 5-MeO-DMT, one of the most powerful naturally occurring hallucinogens. Drug-crazed folks figured out that licking these toads produces vivid hallucinations. The practice is dangerous, however, because the toads' secretions also contain a powerful toxin, bufotenine. Too many licks can cause heart palpitations, brain damage, and even death. Toad-licking currently is illegal both in the United States and Australia. The word now: Don't lick toads; smoke them. The new and improved method of getting a toad high calls for heating and drying the secretions, as heat appears to break down the toxins but preserves the psychedelic

13.3 Secretion from the Colorado River toad (*Incilius alvarius*) contains the psychoactive drug 5-MeO-DMT. Drug-crazed folks used to lick these toads to get high, but the word now is that it's better to heat and dry the secretion and then smoke it; the new method reduces risk of brain damage.

compounds. The Colorado River toad is the only toad known with the psychoactive compound. People have licked another large toad, the cane toad (*Rhinella marina*), which does not contain 5-MeO-DMT—and died.

Counterculture drug-seekers may not be alone in appreciating toad secretions. Anthropologists and ethnopharmacologists have speculated that ancient Mesoamerican cultures used toad secretions as an intoxicant and hallucinogen during their religious ceremonies. Toad skins, toad-shaped bowls, and other artifacts depicting toads with prominent parotoid glands have been found at ceremonial sites in Mexico and Central America dating back over 1,000 years. The toad used by these pre-Columbian peoples may have been the Colorado River toad. Although the species occurs only as far south as northwest Sinaloa, Mexico, extensive trade routes connected Mexico with much of Mesoamerica. Traders may have trafficked in dried toad secretions or in whole toads.

Frogs and Snakes as Weapon Enhancers

Dr. Charles W. (Chuck) Myers, from the American Museum of Natural History, has long studied poison frogs (Dendrobatidae) and the toxins contained in their skin glands. Several decades ago, Chuck told me that his quick-and-dirty field method of guesstimating qualitative differences in skin toxin among species was to let a frog

13.4 One golden poison frog (*Phyllobates terribilis*) has enough toxin to kill at least 10 people. The Chocó Indians from western Colombia use secretion from this species to poison their blowgun darts for hunting game.

walk on his tongue for a few seconds. The strength of the ensuing tongue-tingling sensation roughly corresponded to the strength of the frog's poison. Once after the exercise, Chuck's mouth numbed completely. The numbness continued for several hours, during which Chuck wondered if his mouth would ever recover. Fortunately, Chuck ended these field assays several years before he and his colleagues discovered, in western Colombia, the most toxic of all frogs—the golden poison frog. In 1978 they named this frog *Phyllobates terribilis*: a bright golden yellow, orange, or pale metallic green frog so poisonous that a small amount of toxin from one frog would kill a person if it entered the bloodstream, for example, through an open wound. One *P. terribilis* has enough toxin to kill an estimated 20,000 mice, or at least 10 humans.

The Chocó Indians from western Colombia use three species of dendrobatids to poison their blowgun darts for hunting game, including deer, bear, and jaguar. The two smaller species, *Phyllobates bicolor* and *Phyllobates aurotaenia*, are less than 1.6 inches (40 mm) in body length; *Phyllobates terribilis* can reach 1.9 inches (47 mm)— 15 percent larger than the other two. These frogs contain strong steroidal alkaloids that prevent nerves from transmitting impulses and can lead to heart failure in a predator that eats them or to an unfortunate victim struck by a poisoned dart.

When using either of the two smaller species, the dart-preparer impales a frog on a stick. Sometimes he holds the frog-on-a-spit near a fire to hasten release of poison from the skin glands. Dart tips are rolled across the frog's skin. In contrast, a person preparing darts with *P. terribilis* poison catches a frog between two plantain leaves (to protect his hands), restrains the frog with a stick, and simply rubs the dart tip along the frog's back. *Phyllobates terribilis* does not need to be tortured to secrete poison. It is at least 20 times more toxic than the other two *Phyllobates* used for poisoning darts. After poisoning several darts, the person releases the frog.

During the sixteenth century, the now-extinct Patángoro Indians of western Colombia produced a different type of poison for their arrows. According to Paul Kirchhoff, as described in *Handbook of South American Indians*, old women who were tired of living prepared the poison and purportedly often died from the fumes. They threw snakes, red ants, scorpions, and spiders into a large pot, along with menstrual blood and men's testicles when available. The women beat captive frogs with sticks to make them exude toxic secretions, which they added to the pot.

In Greek mythology, after slaying the serpent-like Lernaean Hydra, Heracles dipped his arrows in the beast's poisonous blood and killed the centaur with them. In real life, spears and arrows dipped in snake venom have provided feared biological weapons. In 326 BCE, Alexander the Great lost many men during his conquest of India from enemy arrows poisoned by Russell's viper (*Daboia russelii*) venom. Members of Hill Tribes in India are thought to have poisoned spears and arrows with cobra venom, and Tatars are believed to have done the same with viper venom. During the fifth century, Scythian archers in western Asia poisoned their arrows with a putrefied mixture of human blood, viper venom, and animal dung.

Many first peoples of North America poisoned their warfare arrowheads with rattlesnake venom. Some, such as the Shoshone and Nez Perce, applied the venom directly to the arrowheads. Others, such as the Atsugewi and Klamath, concocted a more complex poison. A deer was killed, its liver removed, and then one or more rattlesnakes were induced to bite the liver. Once injected with venom, the liver was buried and allowed to rot. Hundreds of poison arrows could be made with one deer's liver. Pathogenic bacteria no doubt increased the virulence of the poison by causing septicemia in the human victims.

Snakes as Weapons

I saw my first snake when I was four years old while playing in the Adirondack woods with the neighborhood bully, Butch, two years older than I. He grabbed my arm and spun me around to face him. "Ahhhhh," he yelled as he thrust a little striped snake into my face. He meant to use the snake as a torture weapon—little boy impresses littler girl and scares the crap out of her. It didn't work. I was fascinated by this legless creature that flicked its forked tongue at me. Butch and I became buddies, and I have liked snakes ever since.

Butch's use of the snake as a weapon wasn't original. Through the ages, snakes have been instruments of torture, murder, suicide, and execution. In ancient Egypt, death by snakebite was offered to political prisoners as an alternative to other forms of torture. Parricide, the killing of one's parents, has always been considered a heinous crime. The ancient Romans wrongly believed that young vipers killed their mother at birth. Thus, figuring tit for tat, Romans punished parent-killers by tying the accused in a bag with live vipers and drowning murderer and vipers together. The Incas reportedly tormented their captives with rattlesnakes. During the summers of 1964 and 1965, civil rights workers in Mississippi (United States) found cottonmouths in their cars, a warning that the workers were not welcome.

Perhaps the most famous story of a snake weapon is the suicide of Cleopatra VII. After he lost a battle to Octavian's forces, Mark Antony killed himself, thinking that his lover, Cleopatra, was dead. Distraught and imprisoned, Cleopatra followed suit. A popular version of her suicide is that on August 12, 30 BCE, Cleopatra persuaded an asp—probably an Egyptian cobra (*Naja haje*) or perhaps a horned viper (*Cerastes*) but not any of the European asps or adders (*Vipera*)—to bite her body. Some say it was her arm; others claim it was her breast. Supposedly she lapsed into a coma and died peacefully. (An alternative hypothesis is that Cleopatra died from drinking a mixture of hemlock, opium, and wolfsbane.)

Venomous snakes used as military weapons were hurled at the enemy by slingshot or released into the enemy's camp. Hannibal, one of the greatest military commanders in history, used venomous snakes to win a battle he never could have won by usual military tactics. In 190 BCE, Hannibal attacked Eumenes, king of Pergamum.

Knowing he was greatly outnumbered in ships, Hannibal ordered venomous snakes to be collected and secured in earthenware jars. He and his men catapulted the snake-filled jars onto the king's ship. At first the enemy laughed at the crude earthenware "weapons." Once they realized their ship was filled with venomous snakes, they retreated in panic and terror. More recently, venomous snakes were used as living booby traps, placed in underground bunkers or along trails during the Vietnam War in the 1960s.

In places as disparate as New Delhi, India, and Camden, New Jersey, people have been robbed at snake-point. It appears that a snake thrust in an intended victim's face can be a very effective weapon! Butch just didn't choose his weapon wisely. Garter snakes aren't very frightening—at least not to one four-year-old.

Snakes as Security Systems

Just as snakes guard treasure in folktales, they protect property in real life. One of my graduate students at the University of Florida kept a large sign on his front door: BEWARE OF PYTHON. He never had his home in the student ghetto broken into, although his neighbors did. At the other end of the legality spectrum, ingenious drug smugglers place waterproofed packages of drugs in the cages of rattlesnakes, Asian pit vipers, and other snakes in hopes of frightening drug enforcement officers. It hasn't always worked. In June 1993, a snake-savvy customs official at Miami International Airport noticed an unnatural bulge in a live boa constrictor and had the snake X-rayed. After the bulge turned out to be condoms filled with cocaine, drug enforcement agents examined the rest of the snake shipment and found 36 kilos of cocaine inside condoms stuffed into 312 live boas.

Tapirage

For centuries, various South American indigenous peoples altered the colors of parrot feathers through a process called *tapirage*. Yellow, orange, and red feathers were especially valued for feather artwork. People plucked the large green wing and tail feathers from tame parrots and filled the tiny wounds with plant dyes, turtle fat, or the blood or skin secretions of frogs, especially dendrobatid poison frogs. Afterward, they coated these areas with wax. The feathers grew back an intense yellow, orange, or red color.

From 1848–50, Alfred Russel Wallace traveled and explored the Amazon Basin along with his friend and fellow naturalist Henry Walter Bates. On one expedition, the naturalists and two Indian companions paddled up the Río Uaupés (Vaupés). They spent a week at Jauarité, where they watched a traditional dance performed by men wearing their highly valued headdresses (*acangatára*) made from macaw feathers. In

A Narrative of Travels on the Amazon and Rio Negro, Wallace describes the headdress and the Indians' method of *tapirage*:

> [The headdress] consists of a coronet of red and yellow feathers disposed in regular rows, and firmly attached to a strong woven or plaited band. The feathers are entirely from the shoulders of the great red macaw, but they are not those that the bird naturally possesses, for these Indians have a curious art by which they change the colours of the feathers of many birds.
>
> They pluck out those they wish to paint, and in the fresh wound inoculate with the milky secretion from the skin of a small frog or toad. When the feathers grow again they are of a brilliant yellow or orange colour, without any mixture of blue or green, as in the natural state of the bird; and on the new plumage being again plucked out, it is said always to come of the same colour without any fresh opera-tion. The feathers are renewed but slowly, and it requires a great number of them to make a coronet, so we see the reason why the owner esteems it so highly, and only in the greatest necessity will part with it.

Frog Juice

The latest scandal to threaten the multibillion-dollar U.S. horse racing industry in-volves frog secretions. Suspicions arose when less-than-speedy horses began to win races. In the spring of 2012, a laboratory cracked the code for what was assumed to be a new performance-enhancing drug. Dermorphin, made from waxy monkey frog

13.5 Secretion from the waxy monkey frog (*Phyllomedusa sauvagii*) is used to make Dermorphin, a drug illegally injected into racehorses.

(*Phyllomedusa sauvagii*) skin secretion, was detected in more than 30 horses. A handful of trainers had intravenously injected horses with Dermorphin, "frog juice" in the popular lingo. Frog juice, up to 100 times more powerful than morphine, presumably allows the horses to continue running at top speed even when badly injured. Dermorphin joins cobra venom, Viagra, and other banned substances found in racehorses.

Fear arose in the spring of 2013 that Dermorphin might be present in horsemeat shipped from the United States into Europe. Over 100,000 horses are slaughtered in the United States each year and sold to the European market. The United States does not require veterinary records when horses are slaughtered, but the European Union bans medicines in animals destined for human consumption. Therein lies a regulatory problem, compounded by consumer issues. Although many Italians, Swiss, French, and other Europeans love horsemeat, they prefer it without frog juice, thank you very much, and are now fearful of consuming the delicacy. Other Europeans prefer not to eat horsemeat at all, and certainly not meat laced with frog juice. When equine DNA was discovered in samples of burgers, meatballs, and frozen lasagna labeled as beef, the alarm bell was rung and products pulled from grocery shelves.

Snake Charming

The Psylli, a North African snake clan, were the world's most famous snake charmers, trading in venom and antidotes as early as 1500 BCE. They were renowned for their natural immunity, probably induced by allowing venomous snakes to bite them often. By the twelfth century CE, the Psylli danced with snakes draped around their bodies. Reportedly, they foamed at the mouth and ripped the snakes apart with their teeth. Onlookers touched the dancers in hopes of receiving some of the charmed strength. This tradition continued well into the eighteenth century.

In traditional snake charming—practiced especially in India, Egypt, and Pakistan—a person removes the lid of a reed basket or clay pot containing a snake and plays music on a wooden flute or a flute-like instrument made from a gourd. The snake slowly emerges from the basket or pot and sways along with the person as if hypnotized. Unable to hear the music, the snake merely follows the person's movements, which it perceives as a threat.

Snake charmers generally use cobras because they are large, dangerous, and command respect in their rearing stance with spread hood. The dramatically patterned spectacled Indian cobra (*Naja naja*) is frequently the cobra of choice. Cobras respond to visual cues more so than do most other venomous snakes, and they sway the entire front halves of their bodies in response to the charmers. Because cobras strike relatively slowly, charmers can usually evade strikes.

In parts of Burma, young women charm freshly captured king cobras (*Ophiophagus hannah*), the world's largest venomous snake; some of the snakes charmed measure 10 feet (3 m). The snake-charming ceremony combines entertainment and

religious ritual. For a climax, a second woman might approach the cobra from behind and kiss it three times atop its head as the snake rears poised to strike the snake charmer facing it. Although the effect is dramatic, the women should be safe, as the kisses mimic cobra behavior. Male king cobras try to touch each other on the head to establish dominance. When one succeeds, the other drops down and retreats. When kissed on the head, the cobra should accept the touch as an act of dominance.

Literature, Art, Music, and Dance

Amphibians and reptiles play a prominent role in human expression of creative activity. Following are several aspects, with a few examples.

Eighteenth-century naturalists offered vivid descriptions of amphibians and reptiles, conveying the animals' essences in a very few words. In 1789 Gilbert White writes of his pet tortoise: "When one reflects on the state of this strange being, it is a matter of wonder to find that Providence should bestow such a profusion of days, such a seeming waste of longevity, on a reptile that appears to relish it so little as to squander more than two-thirds of its existence in a joyless stupor, and be lost to all sensation for months together in the profoundest of slumbers." In 1791 William Bartram said of the American alligator: "His enormous body swells. His plaited tail brandished high, floats upon the lake. The waters like a cataract descend from his opening jaws. Clouds of smoke issue from his dilated nostrils. The earth trembles with his thunder."

The written word provides an ideal vehicle for championing causes, and Archie Carr made good use of the written word to inspire people to care about sea turtles. I suspect it all began one day when, as a young boy, Archie lay dozing on a warm dock, waiting for a fish to jiggle his line. A huge loggerhead turtle swam next to his face, thrust his head from the water, opened his mouth, and sighed loudly. Archie awoke, and for one magical moment lay gazing into the reptile's eyes—a moment that may have triggered an awakening in Archie's heart and soul, initiating his lifelong concern for the future of turtles and his desire to share his appreciation for turtles with others.

Some of Archie's most beautiful writing is found in the introduction to his *Handbook of Turtles*, in which he describes the evolution of turtles.

> The Permian ended, and the turtles watched as the main reptile stock found its evolutionary stride and through a hundred million years staged the most dramatic show the world has ever seen—the rise and spread and the incomprehensible decline of the incredible archosaurs. The turtles remained conservative through it all and though some of them took to the sea—sacrificing parts of the beloved shell for greater buoyancy . . .—they always clung to their basic structural plan, as other lines tested and exploited and abandoned a thousand specious schemes.

The Cenozoic came, and with it progressive drought, and the turtles joined the great hegira of swamp and forest animals to steppe and prairie, and watched again as the mammals rose to heights of evolutionary frenzy reminiscent of the dinosaurs in their day, and swept across the grasslands in an endless cavalcade of restless, warm-blooded types. Turtles went with them, as tortoises now, with high shells and columnar, elephantine feet, but always making as few compromises as possible with the new environment, for by now their architecture and their philosophy had been proved by the eons; and there is no wonder that they just kept on watching as *Eohippus* begat Man o' War and a mob of irresponsible and shifty-eyed little shrews swarmed down out of the trees to chip at stones, and fidget around fires, and build atom bombs.

Amphibians and reptiles frequently appear in fiction. They play major roles in some of the best-loved children's books. There's *The Tale of Mr. Jeremy Fisher*; *Frog and Toad Are Friends*; *The Wind in the Willows*; *Tadpole Rex*; *Yertle the Turtle*; *Minn of the Mississippi*; *The Enormous Crocodile*; *The Mixed-Up Chameleon*; *Hieronymus*; *The Crafty Chameleon*; *The Day Jimmy's Boa Ate the Wash*; *Verdi*. What a great way to get children thinking positively about amphibians and reptiles! In contrast, these animals often play negative roles in short stories and novels, such as *The Adventure of the Speckled Band*, *Green Mansions*, *The Poisonwood Bible*, and many others.

Artists have long depicted amphibians and reptiles in sketches, woodcuts, lithographs, and paintings. Consider a few examples of herpetological art from Europe. In the twelfth century, illustrated manuscripts called bestiaries were produced in England. The entries included real animals as well as mythical creatures such as dragons. Each beast was accompanied by a short description or story. The stories often were allegories, meant to instruct, such as the phoenix rising from its ashes, having burned itself to be reborn. Bestiaries were not meant to be scientific texts, and the real animals were not illustrated accurately. For example, in the *Aberdeen Bestiary*, the salamander was depicted as a serpent-like animal. Its description included the widespread beliefs that the beast could survive and extinguish fire, and that it could poison fruit and water. Bestiaries reflected commonly held myths and no doubt reinforced negative perceptions of some animals.

A major turning point in the way Europeans illustrated amphibians and reptiles came with Swiss naturalist Conrad Gesner (1516–1565), who published the first animal encyclopedia with illustrations (woodcuts) drawn from life, a five-volume opus entitled *Historia animalium* consisting of more than 4,500 pages. The illustrations generally were accurate depictions because the work was meant to catalog nature. In fact, the goal was to describe every animal known at the time—both real and mythical. Many drawings are in such intricate detail that the animals can be identified to species. Accompanying his drawing of the fire salamander, Gesner reported his own experimental evidence that salamanders cannot survive fire.

13.6 Art from early illustrated natural history books: *Top:* woodcut from botanist Pietro Andrea Mattioli's herbal *Commentarii in Libros sex Pedacii Dioscoridis* (1565). *Center:* woodcut from Edward Topsell's *History of Four-Footed Beasts and Serpents* (1658). *Bottom:* copper engraving from Christophorus Gottwald's *Museum Gottwaldianum* (1714).

By the 1600s and 1700s, European naturalists were exploring the New World and illustrating many animals unknown back home. German-born artist and natural historian Maria Sibylla Merian (1647–1717) worked on *Metamorphosis* for two years in Dutch Surinam. Included in that work, published in 1705, are her watercolors of the life cycle of a frog and of a female Surinam toad (*Pipa pipa*) carrying eggs embedded in her back. She was one of the early artist-naturalists to draw her subjects in nature within a context of plants and other animals, rather than as specimens on an otherwise blank page. Merian portrayed the animals exhibiting natural behaviors, including reproduction and their roles as both predator and prey.

The English naturalist Mark Catesby (1683–1749) explored what was then known as Carolina, Florida, and the Bahamas islands (parts of the eastern United States and the West Indies). His two-volume *Natural History*, eighteen years in the making, was the first published account of the flora and fauna of that part of the world. In it, he featured 4 species of frogs and 23 reptiles.

13.7 *Left:* Green tree frog (*Hyla cinerea*) and skunk weed, by Mark Catesby in *Natural History of Carolina, Florida and the Bahama Islands* (1731-43). *Right:* Mockingbirds being attacked by a rattlesnake, by John James Audubon, in *The Birds of America* (1827-38).

TAB. CX.

ADMIRANDA
LEVIVM SPECTACVLA
RERVM

TERRAPENE CLAUSA.

Many other Europeans illustrated animals for the purpose of cataloging nature, but let's move on to a rather esoteric form of art—that of the Dutch graphic artist and printmaker Maurits C. Escher (1898–1972). Escher included herpetological themes combined with visual paradoxes in some of his mathematically inspired woodcuts and lithographs. *Stars* features two chameleons in a polyhedral cage floating through space. Snakes wind through a pattern of interlocking circles in *Snakes*. In *Reptiles* alligator-like animals crawl across a desk, and in *Gravitation* the heads and legs of multicolored turtles protrude from a stellated dodecahedron. Images of Escher's drawings are now found on everyday objects from aprons to T-shirts. When I worked in Ecuador in the early 1970s, I purchased weavings depicting the Escher design of interlocking birds woven by Otavalo Indians who had been introduced to the design by a Peace Corps volunteer in the 1960s.

Amphibians and reptiles are featured in many other art forms. Their likenesses frequently appear as carved objects and figurines, and on pottery, clothes, jewelry, magnets, and more. Charles Dickens kept a neatly arranged collection of bronze toads on his desk. Gary Larson featured amphibians and reptiles in many *The Far Side* single-panel cartoons: smoking dinosaurs, alligators bobbing for poodles, human warts on frogs, a frog's tongue stuck to fly paper, and a snake with tire tracks crossing its body. My favorite is a woman sitting on a sofa, surrounded by bowls of tadpoles, talking on the phone and saying, "Well, that's how it happened, Sylvia . . . I kissed this frog, he turns into a prince, we get married and wham! . . . I'm stuck at home with a bunch of pollywogs."

People everywhere who live alongside frogs are aware of their songs. Frogs' some-times melodious, sometimes raucous mating calls are either music to our ears or dis-turbance to our sleep. In Sarawak, Malaysia, certain shrub frogs (Rhacophoridae) are thought to be agents of evil spirits, capable of bringing death, because their calls resemble the sound of nailing a coffin shut. In contrast, in Japan the flutelike chirps, birdlike trills, and warbles of the Kajika frog (*Buergeria buergeri*) have long been cel-ebrated in Japanese poetry. The Aztecs likened the noise made by one of their earth goddesses to the trill of the cane toad (*Rhinella marina*). Indians of the Río Içana in northwestern Brazil say that ghostly frog people paddle up the river in their canoes

13.8 *Top left:* For decades, Albertus Seba, a pharmacist by trade, collected anything and everything plant and animal. He commissioned illustrations of his entire collection and published the art in *Cabinet of Natural Curiosities* (1734-65); pictured here are dissections showing the internal anatomy of a crocodile's mouth, a lizard, and a tadpole. *Top right:* August Johann Rösel von Rosenhof's hand-colored copper engraving of frogs, a fire salamander, and a sand lizard at a pond provided the frontispiece for his *Historia Naturalis Ranarum* (1758). The Latin-inscribed stone reads: "The nat-ural history of our country's frogs." *Bottom left:* Artist Edward Lear (1812-1888) produced this hand-colored lithograph of a North American box turtle (*Terrapene carolina*, formerly *Terrapene clausa*), after an original drawing by James de Carle Sowerby, from Thomas Bell's *Monograph of the Testudinata* (1836-42). *Bottom right:* This hand-painted color plate of a Madagascar warty chameleon (*Furcifer verrucosus*) appears in the *Erpétologie générale* by André-Marie-Constant Duméril and Gabriel Bibron (1834-54); the goal of the 9-volume set was to provide the first comprehensive scientific account of the amphibians and reptiles of the world.

13.9 Amphibians and reptiles play a prominent role in our everyday lives, from decorative objects to fashion to utilitarian articles.

13.10 *Left:* devil mask from Cobán, Guatemala; presumably the snakes are meant to frighten; 11 inches (28 cm) long. *Right:* various reptiles were incorporated into this 1970s competition mask from the highlands of Mexico; 28 inches (70 cm) long. Both from the collection of Butch and Judy Brodie.

13.11 Amphibians and reptiles commonly pop up in statues and other forms of art. *Top left:* Fionna on a Komodo dragon at the Phoenix Zoo (Arizona, United States); *top right:* Gila monster mosaic, located at the entrance to the Chiricahua Desert Museum in Rodeo, New Mexico (United States); *center left:* lizard gargoyles on the Basílica del Voto Nacional, in Quito, Ecuador; *center right:* cobra statue in Phù Yên, Son La province, Vietnam; *bottom left:* lizard on building in Naha City, Okinawa, Japan; *bottom right:* Maureen Donnelly and bronze frog in Boston, Massachusetts (United States).

13.12 Countries worldwide celebrate their amphibian and reptile fauna by showcasing them on colorful postage stamps.

at night. A frog locally named "paddle frog" imitates the sound of their paddles as it calls. Indigenous people of Hispaniola liken a frog call, "*toa toa*," to infants asking for their mother's breast. During their rain dance, the Pima of Arizona (United States) shake rattles that imitate a frog call.

We have incorporated frog calls into our classical music. Joseph Haydn's Quartet No. 41 in D Major is often called "The Frog" quartet because of the croaking sound made by the first violinist playing the same notes alternately on two neighboring strings. Likewise, frogs croak in Georg Philipp Telemann's Violin Concerto in A Major, affectionately called "The Frogs." In Sally Beamish's piece "Voices in Silence," each movement builds a soliloquy on a single theme in a postwar world. In one movement, the devastated landscape is punctuated by frog calls emanating from bomb craters.

We sing songs about amphibians and reptiles: "I'm in Love with a Big Blue Frog," "Froggie Went A-Courtin'," "Freckles and Pollywog Days," "Ode to a Toad," "Chameleon Eyes," "If You Wanna Be an Iguana," "Who Put the Turtle in Myrtle's Girdle," "Crocodile Rock," "The Lady and the Crocodile," "Rattlesnake Bit the Baby," "Snake Mistakes," and "I'm Being Swallowed by a Boa Constrictor."

North American first peoples have long used parts of reptiles' bodies as percussion instruments. The buzzing of a rattlesnake's rattles creates a sound similar to that produced by a castanet, and in fact the rattlesnake's generic name *Crotalus* comes from the Greek word *krotalon*, meaning "rattle" or "castanet." Cherokee shook gourds filled with rattlesnake rattles while dancing. Delaware made rattles from turtle shells filled with corn, and Seminole and Creek women positioned themselves behind male dancers and provided rhythm accompaniment from leg rattles made from turtle shells filled with gravel.

Various cultures have incorporated amphibians and reptiles into their dances. In ancient Greece and Rome, people danced with snakes coiled around their bodies during fertility celebrations, and Africans performed fertility dances with live snakes draped over their bodies. Members of snake-handling Pentecostal sects in the United States dance with snakes, as do belly dancers and Voodoo queens. One of the best-known dances with snakes from North America is the Hopi Snake Dance, during which snake-priests dance with live snakes in their mouths (chapter 4). Cherokee warriors who performed the War Dance prior to leaving on war expeditions wore wooden masks with coiled rattlesnakes carved on the foreheads to convey the warriors' fearlessness and defiance of their enemies. The Cherokee also danced the Knee-Deep, or Spring Frog Dance, associated with the spring peeper (*Pseudacris crucifer*). This short dance, often done for relaxation and social interaction, was enjoyed in March and April, a time of renewal.

Philosophy, Spirituality, and Religion

Snakes play a major role in human spirituality, as discussed in chapter 3, but other reptiles and frogs also are central to some cultures' philosophies and spiritual beliefs. For example, Heket, depicted as a frog or frog-headed being, was the ancient Egyptian goddess of childbirth, fecundity, and resurrection. Egyptian women who wished to get pregnant wore gold frog-shaped amulets. Heket gave all creatures the breath of life before they were placed in their mothers' wombs. Egyptian women often wore Heket amulets during childbirth, because the goddess protected them as they gave birth.

In Taoist (Daoist) philosophy, the turtle symbolizes the universe. As one of the four spiritually endowed animals, the sacred tortoise represents immortality. Its domed carapace represents Heaven (spirit or essence), the flat plastron represents Earth (substance), and the body between the shells represents "Man" (the synthesis of Heaven and Earth). "Man" is the Taoist Sage or "Confucian Perfect Man," an idealized person who achieves the greatest potential of human nature.

In 1893 W. Crooke wrote that the tortoise was sacred to people of northern India, a perception reflected in many ways. Recall that Lord Vishnu assumed the body form of the giant tortoise Kurma to serve as a base and pivot for the churning of the Milky Ocean to recover the Elixir of Immortality (chapter 3). The Ganrar, Ben-

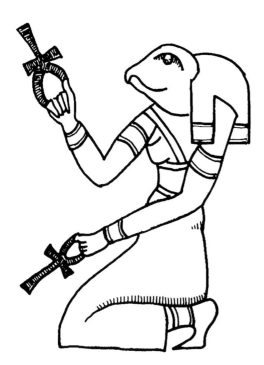

13.13 Heket, depicted as a frog or frog-headed being, was the ancient Egyptian goddess of childbirth, fecundity, and resurrection.

gal fishermen, killed and offered sacred river turtles to their goddess Kolokumari to avert sickness. Other Indians worshipped clay images of tortoises, because the tortoise had conveyed their first ancestor across a river during a flood. The Gond revered the tortoise, because it had saved one of their ancestors from a crocodile attack.

In addition to scarab beetles, snakes, ibis, and hawks, ancient Egyptians worshipped crocodiles. They believed that Sobek, their crocodile god of protection, power, and fertility, created the Nile River. Egyptians worshipped Sobek to appease him and to ensure fertility of their crops. Crocodiles were Sobek's representatives on Earth, and to kill these venerated animals was punishable by death. A person eaten by a crocodile was considered fortunate. In the reptiles' honor, Egyptians built a city on the west bank of the Nile named Sobek. Greeks later renamed the city Crocodilopolis (Crocodile City).

Residents of Crocodilopolis worshipped a live crocodile named Petsuchos, decorated with golden rings in his ears and bracelets on his forelegs. They believed that the incarnated soul of Sobek resided inside the sacred crocodile. Petsuchos lived in a lake near the city's great temple, where he was hand-fed wine, cake, honey, and milk. When a Petsuchos died, another Petsuchos was captured and housed in the temple lake in its place. Each deceased Petsuchos was mummified and elaborately buried in a tomb. (There's a parallel here to how we treat some sports teams' mascots, as in the nine deceased bulldogs all named Uga, former mascots of the University of Georgia, who are interred in a mausoleum near the main entrance of Sanford Stadium.)

Animals sacred to the ancient Egyptians were so valued that they were given funerals and buried. Crocodiles were mummified and buried with their eggs and newly hatched young in reptile cemeteries. Many have been found in human graves. A few years ago, I viewed a display labeled "Gifts for the Gods" in the Ancient Egypt exhibit in the Smithsonian's National Museum of Natural History. Associated information told that ancient Egyptians used animal mummies like we use votive candles today. Pilgrims bought animal mummies at the temples and offered them to the gods, along with their prayers for blessings and requests for help, and then left the mummies in the sanctuary for priests to bury in nearby catacombs. Presence of the animal mummies would forever remind the gods of the pilgrims' requests. Most of these animal offerings were mummified just like humans were preserved in preparation for the afterlife. Their internal organs were removed, the bodies dried, and the remains wrapped in strips of linen. The exhibit's little mummies, including hatchling crocodiles, are from 332–30 BCE.

In parts of Madagascar, people worship crocodiles, considered to have supernatural powers. After chiefs die, their spirits are believed to pass into crocodiles. Cultures that consider crocodiles to be sacred have a taboo (*fady*) against touching crocodiles, even their eggs. In some places it is taboo to throw grass or mud in the water; to do so insults the crocodiles. In years past, the Sakalava, an ethnic group from western Madagascar, extracted teeth from live Nile crocodiles and passed these highly valued treasures from one king to the next. Subjects honored crocodiles of Lake Komakoma by feeding them intestines of deceased Sakalava kings.

For centuries, people of various religions have worshipped the mugger crocodile (*Crocodylus palustris*). Hindus worshipped muggers as animals dedicated to Vishnu, ruler of the water, among other titles. Sufi Islamic devotees and followers from other faiths still visit the Manghopir Shrine in Karachi, Pakistan, to heal themselves in the sulfur hot springs and to pay their respects to the thirteenth-century Sufi saint, Baba Farid Shakar Ganj, believed to be buried there. Legend tells of Manghopir, a Hindu thief who attempted to rob the shrine. Realizing his sin, he converted to Islam and was rewarded by Ganj, who rid him of head lice. When Manghopir bathed in the hot spring, he shook his head. As the lice fell into the sulfur water, they transformed into crocodiles. Reportedly, crocodiles have lived in a lagoon near the shrine for at least seven centuries. In the belief that the crocodiles guard the shrine and are sacred, devotees and tourists alike feed the animals red meat or chicken in hopes of having their wishes fulfilled. Currently about 150 crocodiles live in the lagoon. Archaeological evidence suggests that residents of a nearby Bronze Age (2200–1200 BCE) settlement also held crocodiles sacred.

New World inhabitants venerated crocodilians as well. Presence of a 600-foot (182.9 m) alligator-shaped shell mound suggests that the Atakapa in present-day Cameron Parish, Louisiana, revered alligators around 1000 CE. Many Central and South Americans have worshipped crocodilian gods over the centuries. In many cases, the gods were associated with death or fertility. The Aztecs worshipped a crocodilian fertility god, Cipactli, who protected their crops. The Maya's caiman god, Itzam Cab, was associated with creation, fertility, earth, water, and the cycle of life—birth, growth, and death.

"Modern" Medicine

Many substances from amphibians and reptiles have been used directly or synthesized to make medicines to address human ailments. Following are a few examples.

Tetrodotoxin (TTX), the poison that makes puffer fish so deadly, also occurs in the skin of *Taricha* newts and in some species of *Atelopus* frogs. TTX blocks nerve impulses and can cause respiratory paralysis and death in a predator that eats the endowed newt or frog. Weight for weight, TTX is 160,000 times stronger than pure cocaine and 3,000 times more potent than morphine. Because of its extreme potency,

medical researchers use TTX as a model to study nervous system transmission and excitation. Since the 1930s, physicians in Japan have used TTX as a local anesthetic, painkiller, and muscle relaxant for patients suffering from cancer, heroin withdrawal, and migraines. TTX is currently in clinical trials in Canada and the United States for use as a potential analgesic compound. Someday more physicians might alleviate pain with TTX, a non-addictive alternative to opioids.

Because they live in moist environments, frogs are frequently exposed to pathogenic fungi and bacteria. More than 20 years ago, Dr. Michael Zasloff wondered why an injured African clawed frog (*Xenopus laevis*, the original pregnancy test frog) swimming in bacteria-infested water doesn't acquire infection. He found that glands in the frogs' skin produce microbe-killing peptides he named magainins. After injury, an African clawed frog releases mucus from its skin glands. The mucus containing magainins covers the wound, and the peptides kill bacteria and fungi, allowing the skin to heal.

Zasloff and others have synthesized analogues that are virtually indistinguishable from natural magainins. These synthetic magainins are active against a broad range of bacteria, fungi, and protozoa, which suggested their use as human medicines. Considerable effort and money have been spent developing magainin-based drugs designed as anti-infectives—for example, to treat impetigo, periodontal disease, gastrointestinal infection, and conjunctivitis.

One of these drugs was an antibiotic cream, Pexiganan, made from synthetic magainin to treat diabetics' foot ulcers. In randomized double-blind trials carried out with diabetic patients with infected foot ulcers, application of Pexiganan achieved clinical cure or improvement in about 90 percent of patients and was well tolerated. The U.S. Food and Drug Administration (FDA) did not approve marketing of the cream—not because it was unsafe or ineffective, but because it was no more effective than other antibiotics used to treat ulcers. After the cream failed this hurdle, many pharmaceutical researchers lost interest in frog antimicrobial peptides. One day when bacterial resistance to current antibiotics becomes an even bigger public health threat than it is now, the African clawed frog just might resurface in drugs made from synthetic magainins.

If a venomous snake bites you, your best chance of survival may be an injection of antivenin (antivenom), which counteracts the effects of that particular species' venom. Antivenin is made in stages. Venom is extracted from venomous snakes, and a small amount is injected into a horse or sheep. The immune systems of these large animals produce antibodies that destroy the venom. Blood is then drawn from the animal, and the serum containing the antibodies is purified. When this purified serum is injected into a snakebite patient, he or she has a much better chance of survival, thanks to the antibodies produced by the horse or sheep.

The same venom that kills can save people's lives. Medical researchers are studying how components of snake venom might be used to develop new medicines to

13.14 A king cobra (*Ophiophagus hannah*) is being "milked" of venom to produce antivenin.

fight human diseases. Some are still in the experimental stage. For example, researchers are experimenting to see if enzymes from cobra venoms might be useful in treating certain brain injuries, strokes, and neurological diseases such as Alzheimer's and Parkinson's diseases. Venoms of snakes belonging to the families Elapidae and Viperidae contain analgesic substances. As long ago as the 1930s, minute amounts of cobra venom—stronger than morphine—were used as a painkiller for cancer patients. Painkillers made from snake venom may someday be valuable in reducing arthritic pain. A blood-clotting protein found in venom of the coastal taipan (*Oxyuranus scutellatus*) from Australia may be useful in stopping excessive bleeding during surgery.

Some drugs have already survived the testing process. Captopril, the first ACE (angiotensin-converting enzyme) inhibitor developed, is made from a synthetic version of an enzyme isolated from venom of the *jararaca* (*Bothrops jararaca*), a Brazilian pit viper. Approved in 1979 to treat high blood pressure and heart disease, the drug was developed because it was noticed that some people bitten by the *jararaca* suddenly collapse due to a dramatic drop in blood pressure. Scientists isolated the component of the venom that caused blood pressure to drop and developed a synthetic version; eventually Captopril became available to treat people with hypertension. Lisinopril,

the third ACE inhibitor developed, also is made of a synthetic analogue of a peptide derived from *jararaca* venom. Used to treat hypertension and heart disease, Lisinopril is one of the 20 best-selling drugs in the world!

It has long been known that some people bitten by African saw-scaled vipers (*Echis carinatus*) bleed to death. It turns out that this snake's venom contains anti-clotting proteins. Scientists isolated the protein and developed a synthetic molecule to mimic the anti-clotting effect of the snake's venom. The result was Aggrastat, a drug introduced in 1998 that prevents blood clots from enlarging and causing heart attacks in humans.

My final example of reptiles used in modern medicine features the role that Gila monsters (*Heloderma suspectum*) played during the 1990s in development of a drug to treat Type 2 diabetes. Gila monsters eat mainly bird and reptile eggs and nestling mammals and birds. Because the lizards spend about 95 percent of the year underground or in shelters, they often fast for months at a time. They are able to fast so long because they have low metabolic rates—less than 50 percent of that expected for a similar-size lizard. They also store fat in their sausage-shaped tails and in their abdomens. When Gila monsters eat, they can consume more than one-third of their body mass—enough energy to last them four months. That would be comparable to a 140-pound (63.5 kg) person eating 30 large pizzas at one sitting! How do binge-feeding Gila monsters deal with this much food all at once?

Scientists discovered that a hormone in Gila monster saliva—exendin-4—is released when the lizard bites into its long-awaited meal. At this point the concentration of this hormone in the bloodstream surges thirtyfold. The hormone apparently primes the gastrointestinal tract, getting it ready for a meal following its energy-conserving fasting state.

To get from monster saliva to human medicine, we need to examine diabetes. Insulin, a hormone that regulates carbohydrate and fat metabolism in the body, is produced in the pancreas. Insulin is critical because it regulates the body's use of sugar and other food. Without the correct amount of insulin (Type 1 diabetes) or proper utilization of insulin in the setting of insulin deficiency (Type 2 diabetes), glucose builds up in the blood. Based on experiments carried out in the 1960s, physiologists hypothesized that some signal must trigger the release of insulin. These hypothesized signaling molecules were named incretins. Later researchers discovered several small molecules that turned out to be the hypothesized incretins.

Once this connection was made, studies focused on the functions of incretins. One incretin, a hormone called GLP-1, is secreted from gut cells when we eat. It stimulates insulin release from the pancreas, slows gut motility, and stimulates receptors in the brain that decrease appetite. The obvious next question was "Are diabetics either deficient in incretins, or do they exhibit a resistance to the actions of incretins?" Either situation would lead to lower insulin levels and higher blood glucose levels. Researchers asked: "If you gave diabetic patients GLP-1, would it lower their blood

glucose levels?" Yes, but there's a problem: GLP-1 lasts only a few minutes in the body because an enzyme breaks it down. It can't be taken orally, so a diabetic would need a continuous IV infusion—neither practical nor desirable.

Next came a "Eureka moment." Medical researchers learned about the hormone exendin-4 that is released from Gila monsters' salivary glands when they bite into their long-awaited meals. It turns out that exendin-4 is an analogue of GLP-1! Exendin-4 has properties similar to the hormone GLP-1 in the human gut that stimulates secretion of insulin from the pancreas—but only when blood sugar is high. The good news is that exendin-4 is extremely resistant to being broken down by the enzyme that breaks down GLP-1 in humans.

So, could we give Gila monster saliva to people with diabetes? That would be impractical, but what about a synthetic form of exendin-4? The two lines of investigation came together with eventual synthesis of a drug named Exenatide (marketed as Byetta), approved by the FDA in 2005 and now used to treat Type 2 diabetes. The drug is a synthetic version of a protein known only in Gila monster saliva.

Food

No discussion of the uses of amphibians and reptiles would be complete without at least a nod to the culinary aspect. For some people, amphibian and reptile flesh serves as a much-needed source of protein. For others, the meat is simply an esoteric main ingredient in a gourmet dish: fried amphiuma in beer batter, axolotl tamale, giant bullfrog chop suey, frog legs teriyaki, stir-fried frog legs smothered with oyster sauce, spicy rattlesnake pasta, stuffed alligator steaks, poached alligator tail, turtle étouffée, turtle vindaloo, fricassee of iguana, and ajiaco of iguana.

Many people consider frog legs a delicacy. An added plus is that the meat is both high in protein and rich in omega-3 fatty acids. Conservative estimates of human consumption of frogs range up to 3.2 billion frogs per year, one-third of which may be harvested from the wild. The French consume 3,000–4,000 tons of frogs each year; people in the United States eat 2,000 tons annually. Indonesia currently is the world's largest exporter of frog legs, followed by China, Taiwan, and Vietnam. Up to 140 million frogs (14 native species) are exported annually from Indonesia, but an estimated seven times as many frogs are consumed within the country each year. Indonesia's native frog populations are declining. If frogs disappear, insect pests might increase dramatically in agricultural areas, as happened in India when huge numbers of frog legs were exported. India responded. Since 1987 India has banned exportation of frog legs, though Indians still catch frogs for their own tables.

Tadpoles are fair game also. How would you like your tadpoles—coated with cayenne pepper breadcrumbs and deep-fried? Wrapped in banana leaves and steamed? Stir-fried with veggies? In India and Nepal, tadpoles are smoked over the fire, eaten fresh, or dried and salted. The Kalabit of northern Sarawak, Borneo, offer tadpole

13.15 Vietnam is one of the world's largest exporters of frogs as food. The country also keeps a good supply for its citizens, who eat more than the legs.

porridge as a dietary supplement to nursing mothers. In Papua New Guinea, tadpoles are cooked in a stew, and in Thailand they appear in soup. Tadpoles of all sizes are consumed, from small treefrogs to the 4-inch (102 mm) tadpoles of the water frog *Telmatobius mayoloi* found in the Peruvian Andes. Purportedly tadpoles are great for those on diets—nutritional but essentially fat-free. Just be careful which ones you eat, as some are poisonous.

Turtles serve as food for people worldwide because they taste good, are fairly easy to capture, and provide a good source of protein. Sea turtles, freshwater turtles, and tortoises—all are eaten. Some people eat turtle for its perceived medicinal, health, or spiritual benefits, or as the pièce de résistance in celebrations. Before Aldabra giant tortoises (*Aldabrachelys gigantea*) were protected, people on the Seychelles Archipelago gave each baby girl at birth a young Aldabra tortoise. The tortoise was raised until the young woman's wedding day, at which point it was slaughtered and served at the wedding feast.

Galápagos tortoises have seriously declined over the past few centuries in part due to over-exploitation beginning in the 1500s by whalers, buccaneers, and explorers who visited the Galápagos Islands. Sailors commonly loaded their ships with up to 400 tortoises at a time. Live tortoises could be kept on board for months, providing the sailors with fresh meat. Charles Darwin ate many tortoises during his stay on the islands, but it seems he was not too fond of them. In *Voyage of the Beagle* he writes: "The breastplate roasted (as the Gauchos do *carne con cuero*), with the flesh attached to it, is very good; and the young tortoises make excellent soup; but otherwise the meat to my taste is very indifferent."

Southeast Asia is the world's largest consumer of freshwater turtles and tortoises, and over half of the area's freshwater turtles are heavily hunted and endangered. Because the Chinese have eaten so many of their own turtles, they have long imported turtles from Bangladesh, Pakistan, India, and Nepal to satisfy their craving. If the gluttony for turtles continues, many species from Southeast Asia may disappear forever. Asian markets have increasingly imported turtles from North America. Licensed collectors took more than half a million wild freshwater turtles from Arkansas alone between 2004 and 2006. Experts estimate that the total trade in U.S. turtles is likely thousands of tons per year. Because turtles grow and reproduce slowly, these harvests are unlikely to be sustainable.

13.16 Sea snake is commonly eaten in Okinawa, Japan. *Top: irabu-jira*, sea snake soup; *bottom:* dried and shredded sea snake.

Sea snakes are eaten in much of Southeast Asia, especially in Japan and the Philippines. During a recent visit to Okinawa, Japan, I had to try sea snake since the locally eaten species—the sea krait (*Laticauda semifasciata*)—is abundant off Okinawa and is not endangered. Okinawans eat the snake not only because it tastes good, but because of its purported health and energy-boosting benefits. My first taste was as *irabu-jira* (sea snake soup), consumed on Kudaka Island with my husband and Japanese colleagues. The chunk of sea snake (skin still intact), stewed with pork and kelp, was exceedingly chewy, though not objectionable in flavor. The following day, we visited the sea snake meat facility. After the sea snakes are smoked, they are shredded and cooked. We taste-tested meat from two batches, each cooked with a different combination of herbs. Both were delicious—less chewy than the meat in the *irabu-jira* and more flavorful. The owner told us that last year he smoked 1,300 sea snakes. He hoped that

his largest smoked snake would fetch 12,000 yen ($120). His smoked sea snake meat is eaten by people on Kudaka and sold to tourists as curiosities.

Pets

Let's look at one last patch on our crazy quilt—the controversial use of amphibians and reptiles kept as pets. One extreme attitude is represented by the Smithsonian Institution, which since the early 1970s has advocated a "no herp-as-pet" position. From concern for the conservation and health of wild populations to poor maintenance of amphibians and reptiles in pet stores, the Smithsonian recommends keeping neither local nor exotic species as pets.

At the other extreme, some people argue that keeping amphibians and reptiles as pets leads to greater appreciation for the animals. A child watching a chameleon's eyes swivel develops a more positive attitude about lizards than one who never sees such a creature up close and personal. Many herpetologists credit their passion for the science to childhood pets. As is true with any pets we take on, however, amphibians and reptiles require responsible ownership. Sadly, this often does not happen.

In 2014 pets outnumbered children in U.S. households four to one. Although our most popular pets are cats and dogs, we keep millions of amphibians and reptiles. Reptiles are especially popular. A 2013–14 Pet Owners Survey reports that 5.6 million U.S. households keep at least one pet reptile, and in total these households keep 11.5 million pet reptiles. We admire our exotic pets, but their possession comes at a high price. Many of the millions of amphibians and reptiles caught in the wild die before they reach pet stores. Many of those that reach homes die within a few months because of poor care. All too often the survivors outgrow their cages, require higher maintenance costs than we bargained for, or fail to keep our interest. Out they go—released into neighborhood lakes, streams, woods, or fields.

And therein lies the next problem: introduced alien species often wreak havoc in non-native ecosystems. They eat native species, compete with native wildlife for food and space, transmit parasites, spread diseases for which native species lack resistance, and often multiply quickly because they have no predators.

This scenario happened in the Florida Everglades with Burmese pythons (*Python molurus bivittatus*, native to Southeast Asia) that have been released into the swamp over the past several decades. Baby Burmese pythons are beautiful and docile, but they grow into giant constrictors—one of the world's largest snakes at 12 feet (3.7 m) or more. The first Everglades Burmese python was reported in 1979. Estimates of

13.17 Popular amphibians and reptiles kept as pets. *Top left:* Chuxiong fire belly newt (*Cynops cyanurus*); *top right:* green poison frog (*Dendrobates auratus*); *center left:* red-eared sliders (*Trachemys scripta*); *center right:* veiled chameleon (*Chamaeleo calyptratus*); *bottom left:* tomato frog (*Dyscophus antongilii*); *bottom right:* western emerald tree boa (*Corallus batesii*).

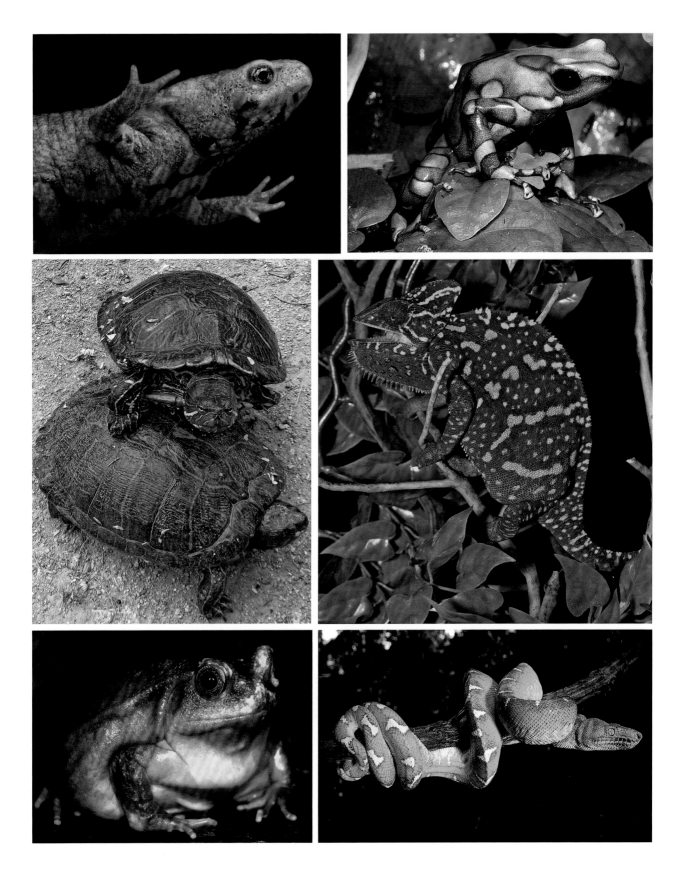

13.18 Introduced Burmese pythons (*Python molurus bivittatus*) have become a problem in the Everglades and other places in southern Florida. *Left:* a young python—beautiful and docile; *right:* a large adult captured in southern Florida.

the number of Burmese pythons currently living in the Everglades range from 10,000 to more than 100,000, indicating that we don't yet know the scope of the problem. But we do know that the pythons have been eating so many native reptiles, birds, and mammals that populations of some prey species, such as raccoons, are declining. Since 2002, over 1,800 Burmese pythons have been removed from the Everglades and surrounding areas. Public attitudes regarding this exotic species range from awe and admiration (*How cool to have giant snakes in our backyards! Leave them in peace!*) to hatred (*They're eating all the bunnies. They don't belong here. Kill them!*)

A January 13, 2013, article in my Logan, Utah, newspaper, the *Herald Journal*, began: "An armed mob set out into the Florida Everglades on Saturday to flush out a scaly invader." That Saturday began a month-long "Python Challenge" run by the Florida Fish and Wildlife Conservation Commission to rid the Everglades of Burmese pythons. Nearly 1,600 people—representing 38 states, Washington, D.C., and Canada—signed up, planning to have an adventure and hoping to win a prize. In addition to killing the invasives, the program raised public awareness of the pythons' threat to the Everglades ecosystem and of the importance of responsible pet ownership. The program also offered the public an opportunity to interact with scientists and learn about the snakes' biology.

Ruben Ramirez, a Miami resident, and his team of python hunters were the big-time winners: $1,500 for the most pythons killed (18) and $1,000 for the longest python (nearly 10 feet 7 inches; 3.2 m). They donated their winnings to a little girl battling cancer. Sixty-eight snakes were harvested during the month, a mere drop in the bucket, but that's 68 fewer Burmese pythons eating rabbits, raccoons, bobcat, wading birds, alligators, and other native wildlife in the Everglades. Perhaps more importantly, thousands of people have been educated about not releasing non-native species into the wild.

14

Singing Tuatara from Their Holes

The real reason for saving tuataras is so people can continue to sing them out of their holes.

—ARCHIE CARR, as quoted in *Biological Conservation* (Ehrenfeld, 1970)

Grandma, what happens to Darwin's frogs when they go away? Will they come back? Or will they live with Sharptooth [= *Tyrannosaurus rex*] and unicorns?"

I had just read my book *The Mystery of Darwin's Frog* to Fionna. She was fascinated by the papa frog brooding tadpoles in his vocal sac, but she was particularly curious—and concerned—about the frogs disappearing from Chile. How does one explain to a three-year-old that extinction is forever? A three-year-old who firmly believes that *T. rex* still lives somewhere, and that unicorns really exist, just not in her world.

I began, "We have to protect the forests where Darwin's frogs live. If all the Darwin's frogs die, they will be gone forever. There's no way to get them back."

"Oh," she mumbled.

"Remember when Moonlight [pet moth] died? We buried her, and I told you she would never come back. Now, imagine if all the Moonlights in the world died. There would never, ever be any more Moonlights."

"Not even one?"

14.1 This male Darwin's frog (*Rhinoderma darwinii*) is brooding tadpoles in his vocal sac. How tragic it would be to lose these unique frogs.

"Not even one. That's what extinction means. Someday, I will take you to Chile to see Darwin's frogs," I promised.

Fionna grinned. "Grandma, I hope the frogs will still be there when we go."

(Less than a year later, Fionna includes "extinction" in her vocabulary. My daughter interrupted Fionna's invented game of "unicorns, ponies, and lizards" and told her it was time to practice for her Suzuki lesson. Fionna responded, "I don't want to practice now! I wish violins went extinct. A hundred bazillion years ago. Until tomorrow. I'll practice tomorrow.")

Why Conservation?

Nearly 50 years ago, Archie Carr emphasized the importance of knowing *why* we believe preservation and conservation are needed. In his view, the real worth of wilderness and wildlife is in our wonder of them. In *Ulendo*, he writes that depending on what we do today, our descendants will either enjoy preserved landscapes and wildlife, or they will question what kind of people we were. Along the same lines, I presume that when Archie said we should save tuatara so people can continue to sing them out of their holes, he meant that conservation is crucial not only to protect species, but also to allow future generations to appreciate nature and to enjoy the cultural significance of the wildlife and landscapes that their ancestors experienced.

Archie's comment about tuatara wasn't just a figure of speech. Tuatara emerge from their burrows in response to unusual sounds, human voices, and music. In *The Animals of New Zealand* (1909), Captain F. W. Hutton and James Drummond quoted a 1903 newspaper article reporting that tuatara "seem to be susceptible to music. They will come out of their holes in the rocks to hear a song, when nothing else will induce them to appear. They prefer a good rousing chorus rather than a solo."

The idea of thinking ahead to future generations, of course, goes way back. Many of us have a romanticized view of North America's first peoples as having unconditional respect and reverence for all of nature. In reality, however, by the time Europeans came to the New World, game animals had already been over-exploited, landscapes deforested, and soil fertility depleted. But there was also thought about the future and the need to keep people rooted to their ancestral lands. Over 500 years ago, the Great Law of the Iroquois Confederacy incorporated the need to consider the impact of current actions on the next seven generations. The concept is one to which we can relate, as some of us knew our great-grandparents and will know our great-grandchildren—seven generations. Applying the seven-generation concept to conservation, we need to think about how our actions will affect the landscape, plants, and animals for our descendants seven generations from now.

In *Ignoring Nature No More*, Marc Bekoff writes: "We're all over the place, big-brained, big-footed, arrogant, invasive, menacing, and marauding mammals. No need to look for mythical Bigfoot: we're here! We leave huge footprints all over the place and have been rather unsuccessful at solving urgent problems."

We're not doing a very good job as stewards of our environment. We abuse our surroundings and pay the consequences with decreased quality of life and physical and psychological health issues. In addition to hurting ourselves, we destroy and pollute habitat for wildlife and threaten their future through human-induced climate change. Seven generations from now, our descendants may read about staghorn coral, leatherback sea turtles, emperor penguins, and polar bears, but never see them alive.

We are losing biodiversity at such an alarming rate that conservation biologists are warning that we are in the early phase of Earth's sixth major extinction episode. This one stands out from those of the past in two major ways. First, the rate of extinctions is much faster than in the past. The current rate of extinctions has been estimated to be 1,000 to 10,000 times higher than the normal background extinction rate (the number that would happen without human effects). Second, the activity of one species—*Homo sapiens*—causes most current extinctions. At the moment on January 18, 2014, when I logged in to the World Population Clock website (http://www.worldometers.info/world-population/), the world's human population was 7,207,275,164. When I logged on again exactly one year later, it was 7,288,958,611—a net gain of more than 81 million people. Check out this site and watch the numbers increase each fraction of a second. Human population growth is most rapid in the Earth's "hotspot" areas of biodiversity and in the tropics. Combine this with the fact

that more than 80 percent of all species of amphibians and reptiles occur in tropical areas, and it is clear that the rapid human population growth will severely affect these animals.

14.2 Children often show no dislike or fear toward amphibians and reptiles and find them fascinating. *Top left:* Art Freed's son, Joe, with his pet ball python (*Python regius*); *Top right:* Danté Fenolio's daughter, Sierra, pokes a tomato frog (*Dyscophus antongilii*); *Bottom left:* Jeff Lemm's daughter, Sydney, shows off an Ensatina salamander (*Ensatina eschscholtzii*); *Bottom right:* my daughter, Karen, with an amplectant pair of Argentine rococo toads (*Rhinella schneideri*).

Conservation biologists predict that by the end of this century, as many as two-thirds of all plants and animals could be headed for extinction. And yet a 2010 Gallup poll revealed that only 31 percent of over 1,000 U.S. adults questioned were concerned about extinction. Why? Perhaps the staggering figures lead to feelings of helplessness. Perhaps we deny or ignore loss of biodiversity because we just can't be bothered as we rush to meet deadlines and fulfill obligations. Perhaps we simply don't care because we lack a strong bond with our surroundings. Many of us don't live in our ancestral homelands, and we are not exposed to our ancestral folklore. Recall from chapter 1 that cognitive scientists have documented humans as being hard-wired to learn through stories. We learn to love our surroundings both from experiencing nature and from stories about nature.

Abundant evidence suggests that in much of the world children are becoming less engaged with nature. Instead of interacting with their surroundings out-of-doors, they watch television or play on their iPods or computers. In a 2012 paper, Peter Kareiva and Michelle Marvier cite studies revealing that kids recognize hundreds of corporate logos but fewer than ten native species of plants. Examination of the 8,036 images in 286 Caldecott Prize–winning medal and honor children's books since the award's beginning in 1938 revealed a steady decline in the frequency of images of natural environments and wild animals.

A critical starting point to getting people to care about loss of biodiversity is educating our children. Studies have shown that if we experience the joy of nature as kids, we are more likely to appreciate nature as adults. The best way to strengthen the connection between young people and their natural surroundings is by example. When we share our passion for nature with children, they feel a strong connection to the outdoors. Interactions with "a grown-up" during the exploration validate the experience, be it rolling logs to find salamanders, photographing flowers, canoeing, hiking, or fishing. We can't care about protecting what we don't know, and we can't know what we haven't experienced. In *Beyond Ecophobia*, David Sobel writes: "What's important is that children have an opportunity to bond with the natural world, to learn to love it and feel comfortable in it, before being asked to heal its wounds." All of us, children and adults alike, need to appreciate nature before we can understand the urgency of conservation. Thinking about our great-grandchildren continuing to sing tuatara out from their holes or to witness "birth" in Darwin's frogs gives us reason to care.

Who Gets Saved, Who Gets Ignored, and Why?

The 2014 IUCN Red List of Threatened Species reports that an estimated 31 percent of the world's amphibian species and 21 percent of reptile species are threatened with extinction. For comparison, the Red List indicates that an estimated 22 percent of mammals and 13 percent of birds are threatened with extinction.

In 2012 more than 8,000 scientists from the IUCN Species Survival Commission identified 100 of the most threatened fungi, plants, and animals on Earth. Of these 100 organisms from 48 countries, 16 percent are amphibians and reptiles (1 salamander; 8 frogs; 1 snake; 2 lizards; 4 turtles). Humans have caused the declines of most of these 100 species, identified as "the first in line to disappear completely if nothing is done to protect them." The authors of the report suggest that if the recommended conservation efforts are enacted, most of these 100 species can be saved. Suggested efforts for the 16 amphibians and reptiles include habitat protection and restoration, stopping illegal collection and commerce for the pet trade, and head-starting programs to boost populations. But will we allocate the necessary time, energy, and financial resources?

14.3 The emperor spotted newt (*Neurergus kaiseri*) has been identified as one of the 100 most threatened species on Earth.

Many of the biologists worry that we might not be able to save these 100 species because most of them provide little or no obvious benefit to people. Declining species often are prioritized for conservation efforts according to the services they provide directly to us and to the ecosystem. But we also need to consider the moral and ethical question: "Do all species, regardless of their worth to humans, have a right to survive?" Asked another way: "Do we have a right to drive species to extinction?" The authors of the report argue that in order to save many of these species, both conservationists and society as a whole must support the moral and ethical position that all species have an inherent right to exist. (This notion of inherent rights, although widely assumed by many environmentalists, is problematic on multiple grounds. For example, how many people really believe that a malaria-carrying mosquito has the same right to live as a Siberian tiger? And where does one draw the line regarding the impact of a species on humans? Does a species have a right to exist if it just sickens us but does not kill us? On another level, does one particular religious faith have a right to dictate species rights?)

Beyond these 100 species, even if we agree that all animals have a right to survive (at least all those that do not threaten human health and well-being), we must make priority decisions because we lack the financial resources, personnel, and time to save all the world's declining species. How will we make these choices? Public support plays a major role in species preservation. Thus, we need to understand (and in many cases change) how the public views species in need of protection—both how people think and how they feel about the animal, for these two perceptions might lead to very different outcomes. From a cognitive standpoint, many people recognize the ecological value of protecting bats, spiders, and snakes, but from an emotional aspect, they rank the animals low because they view them as ugly or fearsome—not characteristics they admire, such as soft, fluffy, and cuddly, intelligent, or having good memory or the ability to express emotion. This mind-set leaves amphibians, reptiles, and many other animals vulnerable.

How Do We Perceive Amphibians and Reptiles?

The contrasts, contradictions, and paradoxes of our interactions with amphibians and reptiles reveal that our perceptions of these animals vary all over the map—literally and figuratively. No simple statement can describe how people view these animals, for perception varies with historical time, context, the animal itself, the culture, and the individual person. Folktales and folk beliefs reflect our wide range of perceptions based on affect—how we feel about the animals emotionally. The positive side of the utility dimension—how we view the animals in terms of what they can do for us— reveals that amphibians and reptiles enhance our lives in numerous ways, but the animals may or may not be valued. People also place amphibians and reptiles on the

14.4 Many people reach out and protect amphibians and reptiles in human-altered landscapes. For example, signs warn drivers of the animals crossing roads, especially during times of migration.

negative side of this utility dimension, perceiving them as detrimental to our well-being.

Affect

Herpetologists, many other biologists, and some others find amphibians and reptiles fascinating and would rank them high on the affect dimension. They are some people's favorite animals, a paradox to others who cringe when encountering one of these so-called slimy, ugly, dirty, scaly, or creepy animals. Most people simply don't think much about amphibians and reptiles one way or the other (except for venomous snakes, which are generally feared). In contrast, in cultures where traditional beliefs influence daily life and structure societal values, people hold strong opinions concerning the "good" or "evil" nature of amphibians and reptiles—beliefs that correspond to the animals' roles in local folklore.

All groups of amphibians and reptiles inspire conflicting feelings. Frogs symbolize happiness, fertility, and good luck—also ugliness, filth, and evil. The axolotl symbolizes eternal youthfulness, but the hellbender represents evil. We admire turtles for their wisdom and longevity, yet ridicule them for their sluggish and cowardly behavior. Crocodilians are considered sacred, or feared and killed. Tuatara are viewed as divine guardians that protect the dead, or as messengers of the god of evil and conveyors of bad luck. People believe that lizards can cure or kill, and bring good fortune or bad luck. Lizards represent guardian spirits or the Devil himself. We despise, fear, and malign snakes for their ability to kill us, but we also respect their ability to restore life and to ward off illness and evil forces. We revere frogs and snakes because they bring much-needed rain, but we also fear their power to cause floods, droughts, and other natural disasters.

Attitudes about animals can change rapidly through time. Consider our perceptions of amphibians, especially frogs, over the past few decades. Scientists and journalists have effectively communicated to the general public that amphibians are declining worldwide. The public has responded by empathizing with am-

14.5 Whereas several decades ago few non-herpetologists were familiar with Neotropical poison frogs, images of these colorful animals now frequently appear on T-shirts, coffee mugs, and solicitations from conservation organizations. Perhaps the greater visibility of these attractive species, such as this *Ranitomeya*, will raise the status of all frogs.

phibians, perhaps because we cheer for the underdog. Some of the most colorful and appealing species have become "poster children" for conservation efforts, not only for amphibians, but also for all wildlife. Images of red-eyed tree frogs and gaudily decorated poison frogs leap from glossy magazine covers and peer out from solicitations sent by conservation organizations. The pervasive presence of these poster beauties (curiously, many with large eyes) has raised the status of all frogs. And then of course there's the great ambassador Kermit the Frog, that lovable star of *Sesame Street* and the Muppet movies who has warmed the hearts of children the world over.

Utility

How much utility affects our perception of amphibians and reptiles strongly depends on the culture and individual person. Those who use these animals in folk medicines and witchcraft for their perceived power to cure, improve lives, or inflict evil on others value them. Non-partakers do not value the animals for these attributes. Many of us acknowledge that amphibians and reptiles are beneficial to us because they eat pest insects and rodents and serve as critical components of the food chain in both aquatic and terrestrial ecosystems. Not everyone understands ecosystem function.

And so it goes for other aspects of utility. Biomedical researchers value snakes for their venom, and frogs and salamanders for their secretions, but much of the

general public is unaware that amphibians and reptiles are used in modern medicines. People who keep these animals as pets consider them useful, but they represent a minority. Individuals who depend on amphibians and reptiles for protein value the animals more than those who occasionally eat turtle soup or iguana stew as a delicacy. People who worship the animals, consider them messengers to the gods, or who in other ways associate amphibians and reptiles with religion or spirituality, value the sacredness of the animals. Others do not feel a spiritual reverence for amphibians and reptiles.

Our perceptions on the negative half of the utility spectrum—animals viewed as detrimental to our interests—range from dislike because we see the animals as annoyances, to hatred because we fear them. My neighbors in Gainesville, Florida (United States), disliked the tree frogs that crawled on their picture windows at night, leaving smeary trails of mucus, and they complained that they couldn't sleep at night through the raucous breeding choruses. Some people dislike geckos that enter their homes and leave droppings on the counters and floors. At the far end of the negative utility spectrum, many people fear certain reptiles. In some cases, these fears are justified (e.g., dangerous crocodilians and venomous snakes in environments shared by people). In other cases, these fears are imagined (e.g., the many folk beliefs claiming that monitor lizards bring misfortune and are venomous).

Across cultures and throughout time, we both love and hate amphibians and reptiles, which, in shamanic philosophy makes perfect sense. Like all animals, including ourselves, they possess both desirable and undesirable traits. Perhaps the most all-encompassing descriptor for how we perceive these animals is *powerful*. The fact that human nature makes us both love and despise power helps to explain our complex and sometimes ambivalent perspectives concerning amphibians and reptiles.

Our Perceptions Influence Conservation

In the English language most herpetological expressions used in everyday conversation convey negative attitudes. Consider common metaphors. We refer to someone disparagingly as a snake in the grass or a cunning serpent. A potentially explosive situation is a nest of angry snakes. Calling a politician a snake implies that he or she is guilty of duplicity—saying one thing to appease a constituent, but supporting something else (reflecting the snake as a symbol of duality, with forked tongue, hemipenes, and ecdysis). A deceitful person is a weeping crocodile. A delayed resolution is a poky turtle. An unattractive person is an ugly, loathsome, or hateful toad. We say, "Eat a toad first thing in the morning, and nothing worse will happen to you all day." The expression "to swallow the toad" refers to putting up with something negative. We do have neutral expressions, such as to have a frog in one's throat or to be a big frog in a small puddle, but the only really positive amphibian or reptile metaphors I can summon are some attributes that these animals symbolize, such as frogs and

happiness, frogs and snakes and rebirth, and turtles and longevity. Amphibians and reptiles aren't soft or cuddly, and we don't view them as busy, eager, happy, or playful.

Aristotle wrote of the power and pleasure of metaphors, and writers still draw upon the energy of metaphorical language. We speak and write in metaphors because they offer unique perspectives through comparisons with familiar objects or concepts. Robert Frost's phrase "a road not taken" refers to a forsaken opportunity during one's life journey. "Melting pot" refers to a mixture of cultures and ethnic backgrounds. "Being engulfed in a sea of grief" is to be consumed with a deep sadness. These metaphors are seductive and compelling, but metaphors can be dangerous.

In 2011 Paul Thibodeau and Lera Boroditsky from Stanford University reported on their survey of participants' responses to specific questions in experiments using contrasting metaphors—crime

14.6 The expression "ugly as a toad" reinforces a negative attitude about these animals.

as a virus infecting a city, and crime as a beast preying on the city. When crime was framed as a virus, participants were more likely to recommend reform as a crime-reducing solution. When crime was described metaphorically as a beast, participants were more likely to recommend jail time. Curiously, participants did not recognize the influence that the metaphors exerted on their reasoning or decisions. The investigators concluded that even fleeting and seemingly unnoticed metaphors have immense power to influence people's reasoning.

If the terms "virus" vs. "beast" used metaphorically for crime have such a powerful impact on people's reasoning, might the same be happening with negative herpetological expressions we use in everyday speech, such as "ugly toad" or "cunning snake"? Perhaps these expressions unconsciously reinforce our own negative feelings and influence how our listeners feel about the animals. Extending this line of reasoning, might these negative expressions affect how we prioritize species for conservation efforts? Is a lavishly colored poison frog more worthy of protection than an ugly, warty toad?

Let's switch the proverbial gears now and focus on several real-life examples of how folk beliefs can influence the well-being of animals. I witnessed such power of folk belief while I was part of a research team surveying plants and animals in southeastern Amazonian Ecuador, in an area designated to become Yasuni National Park.

The year was 1977. Our group consisted of four U.S. biologists, two Peace Corps volunteers, two Ecuadorian forestry specialists and an Ecuadorian biologist from

Quito, and two cooks and a boatman from Amazonian Ecuador. The Ecuadorian government informed us that we were the first non-indigenous people in the region since rubber tree tappers exploited the area 80 years earlier. No one had dared enter the area for fear of hostile Huaorani. Until contacted by missionaries in the 1950s, the nomadic Huaorani were almost completed isolated. They lived in small clans and killed all intruders—including other Huaorani. By 1977 most of the existing 1,200 to 1,500 Huaorani were less hostile toward outsiders. Two never-contacted splinter groups, however, still roamed this unexplored stretch of the Amazon Basin that we intended to survey. Ecuadorian government officials didn't think the splinter groups were in our immediate area, but they really didn't know for sure. "Be watchful," they advised.

Whereas we six *gringos* were concerned about running into one of the splinter groups, our cooks and boatman were more spooked by the forest at night. They urged me not to survey after dark because the forest was alive with evil spirits. And snakes. As children, they had been warned to stay away from the dark forest, and that every snake should be killed, as it had the power to kill. I explained that I worked at night because many amphibians and reptiles are nocturnal and that I've always loved nighttime fieldwork. Perhaps my mind is over-stimulated in daylight, the lushness of a tropical rain forest in all 360 degrees too much to absorb. In contrast, at night everything is off-limits except for the centerpiece of my headlamp beam. Pink, white, and yellow orchids cling to moss-covered branches; an emerald-green dwarf iguana impersonates a sleeping dragon; a white-lined leaf frog watches me from its high perch. The guys stared at me throughout my monologue as though I were an evil spirit. I suspect they also pegged me as a witch because I handled frogs, toads, lizards, and snakes.

Later, as I lay in my damp sleeping bag, I thought about our contrasting fears. The three Ecuadorians *knew* the nighttime forest harbored evil spirits and snakes bent on killing; the threat of Huaorani was less certain. For these men who had grown up in the rain forest of eastern Ecuador, the forest at night was a dense, dark, mysterious world punctuated with unidentified sounds. Dangerous animals that could kill you. Tangled masses of roots and vines that could trip you. Evil spirits that could punish you. I *knew* there were no evil spirits in the forest, my headlamp would protect me from subversive vines and roots, and that snakes are more afraid of me than I am of them. The threat of Huaorani was real. I had read the accounts of missionaries speared by Huaorani and knew that raids still occurred.

Just as traditional folk beliefs led my Ecuadorian companions to kill every snake they encountered, so, too, the folklore of many other cultures influences whether or not animals are persecuted or protected. Consider the role of folklore in conservation of the rain forest in Edo State, western Nigeria.

The way in which the Edo treat their local plants and animals is determined by how they perceive the organisms through folklore, which holds that each organism is either holy or unholy. Holy resources, considered sacred, are used to cure, protect against negative spirits, and correct social ills through traditional rites. Two holy

14.7 One night during the Yasuni survey, I returned to camp clasping a large two-striped forest pit viper (*Bothrops bilineata*). The Ecuadorian cooks and boatman, who typically killed every snake they encountered, declared: *"No es una mujer! Tiene cojones!"* ("She's not a woman! She has balls!") I suspect they also pegged me as a witch because I roamed the forest at night and handled snakes.

reptiles include the Nile crocodile (*Crocodylus niloticus*) and the African rock python (*Python sebae*). Unholy plants and animals—including the common agama (*Agama agama*), puff adder (*Bitis arietans*), and ball python (*Python regius*)—are believed to be negative spirits capable of harming people. The Edo routinely kill many unholy animals. Some Edo communities consider tortoises holy; others consider the same tortoise species unholy. Local people's attitudes heavily impact resource management and conservation in the area. Thus far, folklore has ensured long-term preservation of pockets of rain forest and of selected species. Changing religious beliefs have disintegrated many traditions on which the folklore is based, however, and the impact of folklore on conservation for the Edo is less now than in the past. (Recall a parallel situation in Japan regarding an erosion of traditional *kami* beliefs and how snakes are no longer as valued and protected as they once were.)

Taboos, as social norms that regulate human behavior, can strongly impact management of natural resources. Whether a culture views a given animal as evil or sacred, a taboo that prohibits killing that animal will protect it. No doubt many species threatened with extinction are still with us because local human groups have taboos against killing them.

Some taboos are associated with positive attributes of the animals. An Ashanti clan has a taboo against killing pythons because they are honored for teaching hu-

mans about procreation. The Pedi from South Africa don't eat frogs for fear of stifling the rains. Traditional taboo prohibits Navajo and Cherokee from killing rattlesnakes because of their power to control rain. Navajo do not kill horned lizards, respected for their wisdom and viewed as grandfathers. Some Malagasy cultures consider crocodiles so sacred that one must not even touch a crocodile's egg. Malagasy won't kill or even touch panther chameleons because of the power they wield. The indigenous Antandroy and Mahafaly of Madagascar regard the radiated tortoise as sacred and refrain from eating it because of traditional taboo.

Other taboos are associated with abhorrence. In some places in Brazil, matamata turtles (*Chelus fimbriatus*) are taboo as food because of their "ugly, horrible, and disgusting" appearance. In Swaziland, eating frogs is taboo because people believe all frogs are poisonous. People who live on Búzios Island off the coast of the state of São Paulo, Brazil, consider tegus (*Tupinambis teguixin*) to be so nasty and dirty that they typically spit on the ground when they see one of these 2- to 3-foot (60–90 cm) lizards. Although these large lizards would provide a major source of protein, the tegu is the strongest of all animal food avoidances for Búzios islanders. Yet they use tegu fat to treat venomous snakebite and rheumatism and consider the lizard their most important medicinal animal. The strong taboo against eating these "disgusting" lizards keeps tegus around for medicinal use. Many fewer tegus are killed for their medicinal use than would be killed for human consumption, so the food taboo benefits the lizards.

Totemism—the belief in a supernatural connection between a group of people and an object (the totem), such as a particular animal or landscape—also protects individual species and environments. When animals, streams, and forests are viewed as totems, they are revered and respected. For example, people from the Useifrun and Ujevwu communities of Delta State, Nigeria, regard the python as a totem. Legend has it that during an intertribal war, the python followed the people and erased their footprints so enemies could not follow their paths. Today pythons are not killed or eaten, but revered and allowed to wander free in the communities, where they are fed and protected.

In the absence of taboo and totemic beliefs, people of many cultures kill amphibians and reptiles they consider to be dangerous—such as snakes, monitor lizards, Gila monsters, and snapping turtles—and they fail to think twice about destroying these animals' habitats. Many people kill amphibians and reptiles they view as ugly, despicable, or evil, a good example being fishermen killing hellbenders. Uncaring vehicle drivers swerve to smash salamanders and frogs migrating across roads to breeding ponds and snakes sunbathing on roads. Some run over turtles to hear the pops. The attitudes behind these behaviors are obvious: amphibians and reptiles should be eliminated, or, at best, they don't matter. Fortunately, these people are few in number.

The abundant examples I've shared in this book illustrate that folk beliefs and human behaviors can influence conservation in both positive and negative ways. For

this reason, biologists need to focus not only on the animals they wish to protect, but also on local people's perceptions of the threatened animals. Consider the following example.

In 2004 Kristina Ramstad and her co-investigators interviewed Maori elders and found that their traditional knowledge of the cultural significance of tuatara is more widespread and detailed than their traditional ecological knowledge. Overall, many elders feel a strong personal connection with tuatara. They are aware of the threats to the remaining populations, and they express a strong desire to conserve the animals. Many elders interviewed felt that it was not necessary for them to understand tuatara from a scientific perspective to be willing to protect the species. They felt that understanding tuatara from a cultural perspective—from their traditional folklore— engenders the same positive conservation ethic. We would do well to take a lesson from the Maori. Let's not lose sight of what the animals mean to the local people.

What Can We Do? What Should We Do?

People from all cultures denigrate other cultures. Those that castigate others for not living in harmony with nature are generally just as guilty, though perhaps in different ways. Although most cultures use petroleum, wood, and mineral products at least to some extent, and most use barbaric methods to raise, hunt, and kill animals for food, we blame each other for excess and abuse. Most cultures exploit wildlife and other natural resources to excess, instead of harvesting those resources sustainably.

Ethical relativism—the theory that morality is relative to the norms of one's culture—has been debated for thousands of years, ever since the ancient Greeks and Indians argued about what was right and wrong. We are still debating the concept and arguing about where to draw the line in interfering in others' beliefs, such as abortion, female mutilation, and gender inequality. Conservation biologists argue against the wanton killing of sea turtles, golden eagles, and polar bears. But do we have a right to do so?

An attorney friend pointed out to me that when you mediate, you address the facts—not values. Facts remain the same regardless of who presents the information. In contrast, values represent cherished core beliefs and therefore vary depending on the situation, the person, and the culture. Attorneys run into problems because value judgments are subjective, and therefore even despicable actions can be morally justified under some moral codes. I see a parallel dilemma for conservation biologists, who frequently face conflicts between facts and values when trying to convince local people to protect wildlife.

I return to the question I posed in the introduction: Is it ethical for conservationists to attempt to change beliefs held by people from other cultures? Some Gambians kill chameleons because they consider them to be messengers of evil spirits, some Iranians kill lizards because they house the Devil's soul, and some Hopi kill bull snakes

that enter their homes because they believe them to be sorcerers. Do others have a right to tell these people they are wrong?

Opinions vary. At one extreme, some people take the *Star Trek* "Prime Directive" approach and argue that we have no right to interfere with another culture's beliefs. At the other extreme, some argue that it is unethical to allow the beliefs of a subgroup of one species (*Homo sapiens*) to cause the decline and possible extinction of other species; therefore we not only have a right to interfere, but an obligation. Many take a middle ground and argue that it is our duty, as stewards of nature, to educate with understanding and respect. Then, if education doesn't work, back off so as not to trample on another culture's beliefs.

If we believe we have a right, even an obligation, to meddle in another culture's societal values and beliefs to save species from extinction, how can this be done most ethically and effectively? Change in fundamental beliefs will only happen from within the culture, by working with highly respected and revered leaders. Even then, changing attitudes will be a slow, arduous process. Conservation biologists often feel they are treading new waters when approaching these issues. We need to focus more attention to the questions of where the line of human ethical behavior should be drawn — and who gets to draw that line.

Our ethical behavior also applies to species that cannot speak for themselves. Should our code of conduct vary with phylogenetic position of the affected species, say slug vs. panda? We don't tolerate killing tigers for traditional medicine or elephants for their ivory, yet we treat amphibians and reptiles with less concern. Does our response depend on the target species' geographic distribution? Are rainforest species any more or less "valuable" than desert scrub species?

What Are We Doing?

Now, more than ever before, scientists are sharing their stories. We are doing this through magazine articles and memoirs, radio and television interviews, public lectures, and social media such as blogs and Facebook. Why? Because passion and enthusiasm are contagious. Sharing the excitement of discovery with the general public will go a long way toward improving support for conservation.

Involving "citizen scientists" in discovery and in the process of science, such as collecting data for inventory and monitoring studies, provides another ideal way to gain public support. One such public outreach project is being spearheaded by Steve Ressel at College of the Atlantic in Bar Harbor, Maine. The project, carried out in Acadia National Park, involves monitoring population dynamics of red-backed salamanders (*Plethodon cinereus*). In addition to gathering valid scientific data, Steve and his colleagues hope to enhance scientific understanding and appreciation for conservation efforts of this salamander. From 2008 to 2014 (and ongoing), trained volunteers, ranging from children through college undergraduates and adult island

residents, have checked weekly or monthly for the presence of salamanders under artificial wooden coverboards placed on the ground. Each observer records the presence of a salamander, measures its body length, notes its color phase (red-striped vs. gray), and records whether the tail is intact or regenerating. The project is a resounding success, with citizen scientists enjoying the fieldwork and taking ownership of their data. Many have become fond of salamanders. One child was heard proudly telling her parents, "We did science today!"

Although governments spend only a fraction of the resources needed for conservation, all over the world many thousands of enthusiastic laypersons and scientists are carrying out conservation projects focusing on amphibians and reptiles. Many are working anonymously, with meager financial support. They are passionate about saving Japanese giant salamanders, Taiwanese brown frogs, California desert tortoises, Texas horned lizards, Malagasy Tarzan chameleons, and the species' habitats.

14.8 Involving children in the process of science increases their enjoyment and appreciation of nature. *Top:* red-backed salamander (*Plethodon cinereus*); *bottom:* children monitoring a red-backed salamander population in Acadia National Park, Maine.

14.9 Brady Barr, host of National Geographic's *Dangerous Encounters* television show, holds an adult Japanese giant salamander (*Andrias japonicus*). Nature shows bring to life animals that many of us would never see otherwise. Japanese giant salamanders, fully protected by national and international laws, are the focus of intensive grassroots conservation efforts.

Many current conservation projects have strong educational components that are improving people's perceptions of animals. One such program involves geckos in Portugal. In North America geckos may be viewed as cute and harmless thanks to the Geico Gecko, but Luis Miguel Pires Ceríaco and his colleagues have documented that people in southern Portugal often fear and hate the two geckos (the Mediterranean house gecko, *Hemidactylus turcicus*, and the common wall gecko, *Tarentola mauritanica*) often encountered in and around homes where the lizards congregate to eat insects attracted to lights.

Ceríaco and his colleagues interviewed 865 people from the area and recorded their beliefs about the geckos. Ten percent of people interviewed believed geckos to be venomous or poisonous. Ten percent believed that if a gecko touches your skin, you could get *cobro*, a skin disease that presents with rash, blistering skin, inflammation, pain, and fever. Some believed that if a gecko falls on your head, your hair will fall out. Fifty percent of people viewed geckos as ugly. Although 55 percent considered geckos to be useful because they eat mosquitoes and other insects, 71 percent did not feel that geckos enriched their lives. Forty-eight percent claimed to ignore geckos when encountered; another 22 percent kill them, 20 percent shoo them away, 13 percent flee in fear, and 8 percent ask another person to kill the geckos. Most people (71 percent) did not agree that geckos should be legally protected. Although the geckos are protected by law, 96 percent of people interviewed were unaware of the law.

Since 2010, Ceríaco and others have carried out a project called *Salvem as Osgas!* (Save the Geckos!) in southern Portugal to improve perceptions of the lizards, including informing the public that the geckos are not poisonous or venomous, and there is no evidence that they are vectors for transmission of any kind of bacteria, fungus, or virus that might cause skin diseases. In 2011–12 visits were made to kindergarten and primary school classes, involving 114 children, to present a children's story about a little boy and a gecko. The story integrates basic biology and ecology about the local geckos and debunks folklore-driven beliefs. Children's attitudes about geckos were compared pre- and post-visitation.

In the story, a little boy finds a gecko in his room. At first he is frightened, because he has heard that these geckos are poisonous and carry *cobro*. The two become friends when the gecko promises to keep the boy safe from mosquitoes. All is well, until the little boy's mother finds the gecko in her son's room. She tries to kill the gecko, but it escapes and tells the other geckos what happened. To show people how life would be without geckos, they stop eating mosquitoes. Several days later, the townspeople are so covered with bites that they call a town hall meeting to deal with the mosquito plague. The little boy introduces his gecko friend and explains that the geckos in town protect him against mosquitoes and are not dangerous. From then on, the townspeople respect the geckos for their help, and they stop killing them.

The story changed the kids' attitudes dramatically. During the project the chil-

Adjective	Number of uses before session	Number of uses after session
Venomous	86	0
Dangerous	90	0
Ugly	77	20
Friendly	0	90
Cute	1	70
Useful	0	80

dren used 15 adjectives to describe local geckos. Above are six of these adjectives used by the children before and after hearing the story.

How sad that children this young had already absorbed the misguided beliefs handed down orally through folklore told by their parents and grandparents. The success of this study documents the value of environmental education to combat misconceptions. Knowledge trumps fear. Not only that, but it reinforces the importance of understanding local folklore before engaging in conservation efforts.

The Motagua Valley of Guatemala is the only home of the declining Guatemalan beaded lizard (*Heloderma horridum charlesbogerti*). This lizard is one of the rarest in the world, with an estimated 200 remaining. Much of the Motagua Valley has been cleared for agriculture, and trees have been harvested for firewood. In addition to destroyed habitat, another major cause of the lizards' decline is direct killing by local people because of myths and superstitions regarding the lizards' deadliness. The lizard's vernacular name *escorpión* (scorpion) reflects the belief that it stings with its tail. Local residents have long believed that the lizard's venom is so powerful that it can kill by passing through people's shadows, and that its breath can render a person dizzy and disoriented. A tale that likely originated with the Mayan civilization from this valley tells how these beaded lizards attract electricity from the sky, and that lightning strikes where the lizards lay hiding underground.

To protect this critically endangered but excessively feared lizard, conservation biologists began with an environmental education program to debunk the myths and convince locals to view their lizards as a national treasure. An ongoing research project encourages villagers to work as field assistants, a hands-on experience that heightens their understanding of and appreciation for the animals. Already, over 25,000 people in the Motagua Valley have been exposed to the conservation project. People rarely kill the lizards now, and the Guatemalan beaded lizard has a chance for recovery. Again, knowledge trumps fear.

In 2008 ecologist Dr. Kerry Kriger founded Save the Frogs!, an international nonprofit organization composed of scientists, educators, policy makers, and naturalists, with the stated mission: "to protect amphibian populations and to promote a society that respects and appreciates nature and wildlife." In addition to activities such as re-

storing habitat critical for amphibians, developing educational materials, working to keep frog dissections out of the classroom and frog legs out of restaurants, scientists and other volunteers representing Save the Frogs! have held over 1,300 educational events in 59 countries. These events educate people about amphibian population declines and empower by teaching ways to protect the amphibians in their own communities. Save the Frogs! is more than an organization. It is a movement. To find out more about the organization, log on to their website: www.savethefrogs.com.

My final example of programs designed to improve public perception of amphibians and reptiles highlights PARC, Partners in Amphibian and Reptile Conservation. This organization, established in 1999, includes members from diverse backgrounds, including nature centers, the pet trade industry, state and federal agencies, academic research institutions, museums, forestry industries, environmental consulting firms, and more. The network provides an open forum for addressing conservation issues, and it values all perspectives. One effective program has been raising public awareness of conservation issues surrounding specific taxonomic groups. The year 2011 was designated "Year of the Turtle." Through press releases, newsletters, interviews, photo contests, and other events and educational material, PARC highlighted turtles and work being done to identify and mitigate threats to their survival. The project has empowered individuals to work together to improve the long-term survival prospects for turtles. Similar activities were developed for 2012, designated "Year of the Lizard"; 2013, "Year of the Snake"; and 2014, "Year of the Salamander." To learn more about PARC, log on to their website: www.parcplace.org.

14.10 Since 2011, Partners in Amphibian and Reptile Conservation (PARC) has highlighted one group of amphibians or reptiles each year to raise public awareness of conservation issues for that group.

Last, but certainly not least, people worldwide are working to improve attitudes concerning amphibians and reptiles by sharing their knowledge and positive feelings for the animals. They are talking to groups of schoolchildren, leading field trips, offering hands-on programs at nature centers; writing blogs, websites, magazine articles, and books; creating and sharing art and photography. All are showing by example. You can also.

Gather around the fire with me while I share two last stories.

A long time ago, before Europeans arrived in what would become the United States of America, two hunters paddled east in a canoe to find richer hunting grounds. Far off, they found two small serpents, one silver and the other gold. The serpents glowed and turned

14.11 According to Mohawk legend, two hunters in search of richer hunting grounds found two small serpents, one silver and the other gold. Snakes, in their infinite power, provide commanding metaphors in this story.

the sky into a magnificent display of colors. The men scooped the serpents into their canoe to protect them from harm. They also imagined the glory they would receive from people in their village when they revealed their catch.

Sure enough, everyone crowded around the returning hunters and admired the serpents and the beautiful light they emitted. The people kept the serpents in a canoe and fed them daily, first mosquitoes and flies and later rabbits, raccoons, and muskrats. When the serpents outgrew the canoe, the people built a pen for them and fed them deer and finally moose. One day the serpents escaped. They attacked and swallowed children. The people unsuccessfully fought back with clubs, spears, and arrows. While the people argued about the best way to stop the beasts, the serpents disappeared in the forest. The silver serpent headed north, and the gold one headed south. As they traveled they tunneled through mountains, blocked rivers, killed game animals and forests, poisoned waters, and left filth.

Three hundred years later, a hunter from the same village saw the gold serpent, now the size of a mountain, heading back toward Mohawk country. The silver serpent, also now huge, had turned and was heading south. The people knew the legend of the serpents devouring many of their ancestors' children. They argued about how to kill the serpents. Finally, unable to agree, they fled to the mountains. There, the Creator told the people that one day a small boy would make a bow from a willow and string it from hair of the clan mothers. He would make an arrow and tip it with white flint from the village. This small boy would show the people how, with this weapon, to protect themselves from the two serpents of the United States and Canada. ("The Prophecy of the Two Serpents," a Mohawk tale)

This Mohawk tale encourages people to stand together as one to overcome injustice, empowers future generations to provide leadership, and emphasizes the need to protect nature. Thus is the power of story. I hope that science will never eliminate folklore from the toolbox of explaining the world around us—from creation of the universe to why we die. There is room for both, and we need both. Science is a way of knowing that involves testing alternative hypotheses to explain observations. Folklore is fantasy and magic. Both science and folklore strengthen our bond with the world. They simply accomplish this goal in different ways. Scientists can learn much by paying attention to folklore, especially in understanding the prejudices associated with some animals.

Archie Carr was right. We must preserve nature so that people can continue to sing tuatara from their holes. So that future generations can be inspired by wilderness teeming with biodiversity and experience the cultural significance of the animals and landscapes of their ancestors. This personal connection to the wonder and beauty of nature will in turn support conservation.

My final story links Fionna and Archie, frogs and tuatara. Three days after Fionna's mother, Karen, was born, Archie knocked on my door. He handed me a small

mayonnaise jar with sprigs of vegetation and 19 newly metamorphosed spadefoot toads. With his characteristic shy grin, he explained, "Spadefoots used to be common in this mesic hammock where you live. They're gone now, and I thought that if you release these lil' fellers, one day Karen might enjoy spadefoots singing in her backyard." People singing for tuatara, spadefoots singing for mates—Archie, always thinking about preserving nature for future generations, including, indirectly, Fionna.

Acknowledgments

I am indebted to my editor, Christie Henry, for, once again, her friendship, insight, guidance, and support through my years of work on the book. Thanks to Amy Krynak, editorial associate, who patiently answered my many questions. Once again, it was a pleasure to work with Erin DeWitt, copy editor extraordinaire.

This book is based on the stories, real and imagined, of many creative minds throughout the centuries. To all these people from all walks of life, throughout the world, and throughout time, I give my heartfelt thanks.

A picture is indeed worth a thousand words. I am grateful to the friends, colleagues, family members, and complete strangers (whom I now consider friends) who generously contributed their photographs and original art so that the reader might visualize the magnificent animals and their stories. For their original art, I thank Alan Crump, Irma Crump, Helena Guindon, Bronwyn McIvor, and Sheri Sanders. For photographs, I thank Achmad Arifiandy, Brady Barr, Butch Brodie Jr., René Clark (Dancing Snake Nature Photography), Polly Conrad, Alan Crump, Irma Crump, Lexi Dick, Andrew Durso, Matt Edwards, Lilly Euvathingal, Danté B. Fenolio, Art Freed, Paul Freed, Janet Headland, Debbie Hutchinson, Bill Lamar, Jeff Lemm, Bill Love, Karen McCree, Joe Mitchell, Akira Mori, the National Park Service, Alexa Nelson, Harvey Pough, Rookery Bay National Estuarine Research Reserve, Al Savitzky, and Sea Turtle Conservancy. I thank Andrew Durso

for helping me create the affect/utility graph. Special thanks to Danté B. Fenolio for his heroic work in producing the plates in this book, and to Al Savitzky for teaching me about Photoshop and for guiding my work with the images in so many ways.

Photographs and original art are reproduced in color thanks to the generous donations from organizations, herpetological societies, and private individuals. The Ecology Center, Utah State University, provided major funding. Additional funding was provided by Partners in Amphibian and Reptile Conservation (PARC), Amphibian and Reptile Conservancy (ARC), Museum of Comparative Zoology (MCZ; Harvard University), Southern Nevada Herpetological Society, Evelyn Savitzky, Save the Frogs!, Chicago Herpetological Society, East Texas Herpetological Society, Tucson Herpetological Society, Nancy Huntly, Tom Lovejoy, Al Savitzky, an anonymous donor, and the North Carolina Herpetological Society. I thank each and every one for believing in my book.

Many friends and colleagues read parts or the entirety of the manuscript and offered constructive feedback. Members of the USU Herp Group and Department of Biology who read and commented on all or parts of the manuscript include Butch Brodie Jr., Judy Brodie, Andrew Durso, Susannah French, Gareth Hopkins, Shab Mohammadi, Lori Neuman-Lee, Al Savitzky, Geoff Smith, Austin Spence, and Amber Stokes. Geoff Smith read all 14 chapters, and Al Savitzky read every chapter twice. Zach Gompert, Nancy Huntly, Lauren Lucas, and Kendalynn Morris, members of the USU Department of Biology, offered feedback on several chapters. Brock Dethier, Keith Grant-Davie, Benjamin Gunsberg, Keri Holt, Christine Cooper Rompato, and Rebecca Walton, from the USU English Department writing group, gave me feedback on several chapters. I also thank my writing buddy Nancy Bo Flood, who offered feedback on many chapters from a non-herpetological perspective. I thank Danté B. Fenolio, Gareth Hopkins, Bill Lamar, Al Savitzky, John Simmons, and Jim Stout for funneling obscure stories my way.

Finally, I thank my husband, Al Savitzky, who has supported me in every way possible for the first three years of our married life while I have been obsessed with writing this book. Thank you for always being there for me, for believing in me, and, like Fionna's caterpillars turning into unicorns, for bringing magic into my life.

References

Adler, K. "Amphibians and Humans." In *Grzimek's Animal Life Encyclopedia*, 2nd ed. Vol. 6, *Amphibians*, ed. M. Hutchins, W. E. Duellman, and N. Schlager, 51–55. Farmington Hills, MI: Gale Group, 2003.

Aftandilian, D. "Frogs, Snakes, and Agricultural Fertility: Interpreting Illinois Mississippian Representations." In *What Are the Animals to Us?: Approaches from Science, Religion, Folklore, Literature, and Art.*, ed. D. Aftandilian, 53–86. Knoxville: University of Tennessee Press, 2007.

Altherr, S., and D. Freyer. "The Decline of Asian Turtles." *Pro Wildlife*, March 2000, www.prowildlife.de/sites/default/files/Turtle%20report.pdf.

Altherr, S., A. Goyenechea, and D. Schubert. "Canapés to Extinction—the International Trade in Frog's Legs and Its Ecological Impact." A report by Pro Wildlife, Defenders of Wildlife and Animal Welfare Institute (eds.). Munich, Germany, and Washington, DC, 2011.

Alves, R. R. N., N. A. Léo Neto, G. G. Santana, W. L. S. Vieira, and W. O. Almeida. "Reptiles Used for Medicinal and Magic Religious Purposes in Brazil." *Applied Herpetology* 6 (2009): 257–74.

Alves, R. R. N., W. L. S. Vieira, and G. G. Santana. "Reptiles Used in Traditional Folk Medicine: Conservation Implications." *Biodiversity and Conservation* 17 (2008): 2037–49.

Alves, R. R. N., W. L. S. Vieira, G. G. Santana, K. S. Vieira, and P. F. G. P. Montenegro. "Herpetofauna Used in Traditional Folk Medicine: Conservation Implications." In *Animals in Traditional Folk Medicine: Implications for Conservation*, ed. R. R N. Alves and I. L. Rosa, 109–33. New York: Springer-Verlag, 2013.

Ames, D. *Egyptian Mythology*. London: Paul Hamlyn, 1965.

Anderson, J. *When Frog Stole the Waters*. Kootenai, ID: American Designs, 1996.

Auffenberg, W. "Catch a Lizard, Use a Lizard." *International Wildlife* 10 (November–December 1982): 16–19.

Aymar, B. *Treasury of Snake Lore: From the Garden of Eden to Snakes of Today in Mythology, Fable, Stories, Essays, Poetry, Drama, Religion, and Personal Adventures*. New York: Greenberg, 1956.

Bailey, F. A., ed. *The Osage and the Invisible World: From the Works of Francis La Flesche*. Norman: University of Oklahoma Press, 1995.

Ballouard, J.-M., G. Provost, D. Barré, and X. Bonnet. "Influence of a Field Trip on the Attitude of Schoolchildren toward Unpopular Organisms: An Experience with Snakes." *Journal of Herpetology* 46 (2012): 423–28.

Barlow, G. *Latin American Tales: From the Pampas to the Pyramids of Mexico*. New York: Rand McNally, 1966.

Bartram. *Travels*, 1791. Portion reprinted in *The World of Animals: An Anthology of Lore, Legend, and Literature*, ed. J. W. Krutch. New York: Simon and Shuster, 1961.

Bauchot, R., ed. *Snakes: A Natural History*. New York: Sterling, 1994.

Bauer, A. "Geckos in Traditional Medicine: Forensic Implications." *Applied Herpetology* 6 (2009): 81–96.

Beaubien, J. "Rumor Patrol: No, a Snake in a Bag Did Not Cause Ebola." NPR, *All Things Considered*, July 22, 2014. http://www.npr.org/blogs/goatsandsoda/2014/07/22/334022357.

Beck, D. B. *Biology of Gila Monsters and Beaded Lizards*. Berkeley: University of California Press, 2005.

Beebe, W. *Edge of the Jungle*. Garden City, NY: Garden City Publishing, 1926.

Bekoff, M., ed. *Ignoring Nature No More: The Case for Compassionate Conservation*. Chicago: University of Chicago Press, 2013.

Bellman, L., B. Hoffman, N. Levick, and K. Winkel. "US Snakebite Mortality, 1979–2005." *Journal of Medical Toxicology* 4 (2008): 43.

Bennett, D. *Monitor Lizards: Natural History, Biology and Husbandry*, ed. T. Wilms and B. Bartholomew. Meckenheim, Germany: Frankfurt am Main, 1998.

Bergen, F. D. *Animal and Plant Lore*. New York: Kraus Reprint Co., 1969. First published 1899 by Houghton Mifflin.

Bierhorst, J. *The Mythology of South America*. New York: William Morrow, 1988.

Bierlein, J. F. *Parallel Myths*. New York: Ballantine, 1994.

Blacker, C. "The Snake Woman in Japanese Myth and Legend." In *Animals in Folklore*, ed. J. R. Porter and W. M. S. Russell, 113–25. Cambridge: D. S. Brewer, 1978.

Bogert, C. M., and R. Martín del Campo. "The Gila Monster and Its Allies: The Relationships, Habits, and Behavior of the Lizards of the Family Helodermatidae." *Bulletin of the American Museum of Natural History* 109 (1956): 1–238.

Böhm, M., B. Collen, J. E. M. Baillie, P. Bowles, J. Chanson, N. Cox, G. Hammerson, M. Hoffmann, et al. "The Conservation Status of the World's Reptiles." *Biological Conservation* 157 (2013): 372–85.

Boyle, J. A. "Historical Dragon-Slayers." In *Animals in Folklore*, ed. J. R. Porter and W. M. S. Russell, 23–32. Cambridge: D. S. Brewer, 1978.

Brandon, E. "Folk Medicine in French Louisiana." In *American Folk Medicine: A Symposium*, ed. W. D. Hand, 215–34. Berkeley: University of California Press, 1976.

Brodie, E. D., III. "Patterns, Process, and the Parable of the Coffeepot Incident: Arms Races Between Newts and Snakes from Landscapes to Molecules." In *In the Light of Evolution: Essays from the Laboratory and Field*, ed. J. B. Losos, 93–119. Greenwood Village, CO: Roberts and Co., 2011.

Brown, D. E., and N. B. Carmony. *Gila Monster: Facts and Folklore of America's Aztec Lizard*. Salt Lake City: University of Utah Press, 1999.

Burghardt, G. N., J. B. Murphy, D. Chiszar, and M. Hutchins. "Combating Ophidiophobia: Origins, Treatment, Education, and Conservation Tools." In *Snakes: Ecology and Conservation*, ed. S. J. Mullin and R. A. Seigel, 262–80. Ithaca, NY: Comstock, 2009.

Burton, T. *Serpent-Handling Believers*. Knoxville: University of Tennessee Press, 1993.

Campbell, J. *The Way of the Animal Powers: Historical Atlas of World Mythology*. Vol. 1. San Francisco: Harper and Row, 1983.

Campbell, J. A. *Amphibians and Reptiles of Northern Guatemala, the Yucatán, and Belize*. Norman: University of Oklahoma Press, 1998.

Campbell, L. "Understanding Human Use of Olive Ridleys: Implications for Conservation" In *Biology and Conservation of Ridley Sea Turtles*, ed. P. T. Plotkin, 23–43. Baltimore: John Hopkins University Press, 2007.

Carr, A. "Bitten by a Fer-de-Lance." In *Ants, Indians, and Little Dinosaurs*, ed. A. Ternes, 104–16. New York: Charles Scribner's Sons, 1975.

———. *Handbook of Turtles: The Turtles of the United States, Canada, and Baja California*. Ithaca: Cornell University Press, 1952.

———. *So Excellent a Fishe: A Natural History of Sea Turtles*. Garden City, NY: Natural History Press, 1967.

———. *Ulendo: Travels of a Naturalist in and out of Africa*. New York: Knopf, 1964.

———. *The Windward Road: Adventures of a Naturalist on Remote Caribbean Shores*. Tallahassee: University Presses of Florida, 1979. First published 1955 by Knopf.

Catesby, M. *The Natural History of Carolina, Florida and the Bahama Islands*. Vol. 2, 1743.

Centers for Disease Control. "Deaths Associated with a Purported Aphrodisiac: New York City—February 1993—May 1995." http://www.cdc.gov/mmwr/preview/mmwrhtml/00039633.htm.

Ceríaco, L. M. P., and M. P. Marques. "Deconstructing a Southern Portuguese Monster: The Effects of a Children's Story on Children's Perceptions of Geckos." *Herpetological Review* 44 (2013): 590–94.

Ceríaco, L. M. P., M. P. Marques, N. C. Madeira, C. M. Villa-Viçosa, and P. Mendes. "Folklore and Traditional Ecological Knowledge of Geckos in Southern Portugal: Implications for Conservation and Science." *Journal of Ethnobiology and Ethnomedicine* 7 (September 2011): 26. doi:10.1186/1746-4269-7-26.

Charlesworth, J. H. *The Good and Evil Serpent: How a Universal Symbol Became Christianized*. New Haven, CT: Yale University Press, 2010.

Cherry, J. *Loco for Lizards*. Flagstaff, AZ: Northland, 2000.

Cincotta, R. P., J. Wisnewski, and R. Engelman. "Human Populations in the Biodiversity Hotspots." *Nature* 404 (2000): 990–92.

Clark, K. *Animals and Men: Their Relationship as Reflected in Western Art from Prehistory to the Present Day*. New York: William Morrow, 1977.

Cochran, D. M. *Living Amphibians of the World*. Garden City, NY: Doubleday, 1961.

Colding, J., and C. Folke. "The Relations among Threatened Species, Their Protection, and Taboos." *Conservation Ecology* 1 (1997): 6. http://www.consecol.org/vol1/iss1/art6/.

Collins, J. P., and M. L. Crump. *Extinction in Our Times: Global Amphibian Decline*. New York: Oxford University Press, 2009.

Conlon, J. M., and A. Sonnevend. "Clinical Applications of Amphibian Antimicrobial Peptides." *Journal of Medical Sciences* 4 (2011): 62–72.

Convention on International Trade in Endangered Species of Wild Fauna and Flora. "Status of Hawksbill Turtle Trade: A Review of the Regional Wider Caribbean and Global Trade, Including Domestic and Non-shell Products." http://www.cites.org/eng/prog/hbt/bg/trade_status.shtml.

Conway, D. J. *Animal Magick: The Art of Recognizing and Working with Familiars*. St. Paul, MN: Llewellyn, 2002.

Cooper, J. C., and J. A. Fitzgerald, eds. *An Illustrated Introduction to Taoism: The Wisdom of the Sages*. Bloomington, IN: World Wisdom, 2010.

Costa-Neto, E. M. "Animal-Based Medicines: Biological Prospection and the Sustainable Use of Zootheraputic Resources." *Anais da Academia Brasileira de Ciencias* 77 (2005): 33–43.

Costa-Neto, E. M., and M. V. M. Oliveira. "Cockroach Is Good for Asthma: Zootherapeutic Practices in Northeastern Brazil." *Human Ecology Review* 7 (2000): 41–51.

Courlander, H. *A Treasury of Afro-American Folklore: The Oral Literature, Traditions, Recollections, Legends, Tales, Songs, Religious Beliefs, Customs, Sayings and Humor of Peoples of African American Descent in the Americas*. Cambridge, MA: Da Capo Press, 2002.

Covey, H. C. *African American Slave Medicine: Herbal and Non-Herbal Treatments*. New York: Lexington Books, 2007.

Crooke, W. *The Popular Religion and Folk-Lore of Northern India*. 1893. Vols. 1 and 2. Nai Sarak, Delhi, India: Munshiram Manoharlal, 1968.

Crump, M. *Amphibians and Reptiles: An Introduction to Their Natural History and Conservation*. Granville, OH: McDonald and Woodward, 2011.

———. *Headless Males Make Great Lovers and Other Unusual Natural Histories*. Chicago: University of Chicago Press, 2005.

———. *In Search of the Golden Frog*. Chicago: University of Chicago Press, 2000.

———. *The Mystery of Darwin's Frog*. Honesdale, PA: Boyds Mills Press, 2013.

Daly, J. W., J. Caceres, R. W. Moni, F. Gusovsky, M. Moos Jr., K. B. Seamon, K. Milton, and C. W. Myers. "Frog Secretions and Hunting Magic in the Upper Amazon: Identification of a Peptide that Interacts with an Adenosine Receptor." *Proceedings of the National Academy of Sciences, USA* 89 (1992): 10960–63.

Daniels, F. J. "Snake and Dragon Lore of Japan." *Folklore* 71 (1960): 145–64.

Darwin, C. *Voyage of the Beagle*. 1839. Edited by L. Engel. Garden City, NY: Doubleday, published in cooperation with the American Museum of Natural History, 1962.

Das, I. "Man Meets Frog: Perceptions, Use and Conservation of Amphibians by Indigenous People." In *Amphibian Biology*. Vol. 10, *Conservation and Decline of Amphibians: Ecological Aspects, Effects of Humans, and Management*, ed. H. Heatwole and J. W. Wilkinson, 3383–468. New South Wales, Australia: Surrey Beatty and Sons, 2010.

Davis, F. R. *The Man Who Saved Sea Turtles: Archie Carr and the Origins of Conservation Biology*. New York: Oxford University Press, 2007.

Davis, W. *The Serpent and the Rainbow*. New York: Simon and Schuster, 1985.

Davis, W., and A. T. Weil. "The Identity of a New World Psychoactive Toad." *Ancient Mesoamerica* 3 (1992): 51–59.

de Crevecoeur, M. *Letters from an American Farmer*, 1782. Portion reprinted in *The World of Animals: An Anthology of Lore, Legend, and Literature*, ed. J. W Krutch. New York: Simon and Shuster, 1961.

DeGraaff, R. M. *The Book of the Toad: A Natural and Magical History of Toad-Human Relations*. Rochester, VT: Park Street Press, 1991.

Dharmananda, S. "Endangered Species Issues Affecting Turtles and Tortoises Used in Chinese Medicine." 2007. http://www.itmonline.org/arts/turtles.htm.

———. "The Medicinal Use of Snakes in China." 2007. http://www.itmonline.org/arts/snakes.htm.

Donaldson, G. *Frogs*. New York: Van Nostrand Reinhold, 1980.

Dorcas, M. E., J. D. Willson, R. N. Reed, R. W. Snow, M. R. Rochford, M. A. Miller, W. E. Meshaka Jr., P. T. Andreadis, F. J. Mazzotti, C. M. Romagosa, and K. M. Hart. "Severe Mammal Declines Coincide with Proliferation of Invasive Burmese Pythons in Everglades National Park." *Proceedings of the National Academy of Sciences, USA* 109 (2012): 2418–22.

Dorson, R. M. *Folk Legends of Japan*. Rutland, VT: Charles E. Tuttle, 1962.

Eamon, W. "The Monk Who Loved to Eat Toads." 2011. http://williameamon.com/?author=2.

Ehrenfeld, D. W. *Biological Conservation*. Modern Biology Series. New York: Holt, Rinehart, and Winston, 1970.

Emboden, W. A. "The Compelling Frog." *Terra* 13 (1975): 27–32.

Erdoes, R., and A. Ortiz, eds. *American Indian Myths and Legends*. New York: Pantheon, 1984.

Etheridge, K. "Loathsome Beasts: Images of Reptiles and Amphibians in Art and Science." In *Origins of Scientific Learning: Essays on Culture and Knowledge in Early Modern Europe*, ed. S. L. French and K. Etheridge, 63–88. Lewiston, NY: Edwin Mellen Press, 2007.

Evans, B. *The Natural History of Nonsense*. New York: Knopf, 1968.

Fielde, A. M. *Chinese Fairy Tales*. Rosholt, WI: Rosholt House, 1998.

First People: The Legends. http://www.firstpeople.us/FP-Html-Legends/.

Fitzgerald, L. A. "*Tupinambus* Lizards and People: A Sustainable Use Approach to Conservation and Development." *Conservation Biology* 8 (1994): 12–15.

Fitzgerald, L. A., C. W. Painter, A. Reuter, and C. Hoover. "Collection, Trade, and Regulation of Reptiles and Amphibians of the Chihuahuan Desert Ecoregion." Washington, DC: TRAFFIC, 2004.

Fradkin, A. *Cherokee Folk Zoology: The Animal World of a Native American People, 1700–1838*. New York: Garland, 1990.

Frazer, Sir J. G. *The Golden Bough: A Study in Magic and Religion*. New York: Macmillan, 1951.

———. *The New Golden Bough*. Edited by T. H. Gaster. New York: Criterion Books, 1959.

Frembgen, J. "The Folklore of Geckos: Ethnographic Data from South and West Asia." *Asian Folklore Studies* 55 (1996): 135–43.

Fruehauf, H. "Driving Out Demons and Snakes. Gu Syndrome: A Forgotten Clinical Approach to Chronic Parasitism." *Journal of Chinese Medicine* 57 (1998): 10–17.

Furman, B. L. "The Development of Byetta (exenatide) from the Venom of the Gila Monster as an Anti-Diabetic Agent." *Toxicon* 59 (2012): 464–71.

Furst, P. T. *Hallucinogens and Culture*. San Francisco: Chandler and Sharp, 1976.

Gaster, T. H. *Myth, Legend, and Custom in the Old Testament: A Comparative Study with Chapters from Sir James G. Frazer's Folklore in the Old Testament*. New York: Harper and Row, 1969.

Gebhard, B. "The Interrelationship of Scientific and Folk Medicine in the United States of America since 1850." In *American Folk Medicine: A Symposium*, ed. W. D. Hand, 87–98. Berkeley: University of California Press, 1976.

Gloyd, H. K., and R. Conant. *Snakes of the Agkistrodon Complex: A Monographic Review*. Contributions to Herpetology, No. 6. Oxford, OH: Society for the Study of Amphibians and Reptiles, 1990.

Goldman, I. *The Cubeo Indians of the Northwest Amazon*. Champaign: University of Illinois Press, 1963.

González-Wippler, M. *Santería: African Magic in Latin America*. New York: Original Publications, 1987.

Goodman, D. *Summer of the Dragon*. Gainesville, FL: Gainesville Association for the Creative Arts, 2007.

Goris, R. C., and N. M. Maeda. *Guide to the Amphibians and Reptiles of Japan*. Malabar, FL: Krieger, 2004

Green, M. *Animals in Celtic Life and Myth*. London: Routledge, 1992.

Greene, H. W. *Snakes: The Evolution of Mystery in Nature*. Berkeley: University of California Press, 1997.

———. *Tracks and Shadows: Field Biology as Art*. Berkeley: University of California Press, 2013.

Grenard, S. *Medical Herpetology*. Pottsville, PA: Reptile and Amphibian Magazine, 1994.

Griffith, R. T. H., trans. *The Rig Veda*. 1896. http://www.sacred-text.com.

Guggisberg, C. A. W. *Crocodiles: Their Natural History, Folklore and Conservation*. Harrisburg, PA: Stackpole Books, 1972.

Guiley, R. E. *The Encyclopedia of Witches, Witchcraft and Wicca*. 3rd edition. New York: Infobase, 2008.

Guillette, L. J., Jr., D. B. Pickford, D. A. Crain, A. A. Rooney, and H. F. Percival. "Reduction in Penis Size and Plasma Testosterone Concentrations in Juvenile Alligators Living in a Contaminated Environment." *General and Comparative Endocrinology* 101 (1996): 32–42.

Guynup, S. "Turtle Triage." *Wildlife Conservation*. Wildlife Conservation Society, 2007. www.wildlifeconservation.org/wcm-home/wcm-article/7191105.

Haitao, S., J. F. Parham, M. Lau, and C.Tien-Hsi. "Farming Endangered Turtles to Extinction in China." *Conservation Biology* 21 (2007): 5–6.

Hand, W. D. *Magical Medicine: The Folkloric Component of Medicine in the Folk Belief, Custom, and Ritual of the Peoples of Europe and America*. Berkeley: University of California Press, 1980.

Hays, H. R. *In the Beginnings: Early Man and His Gods*. New York: G. P. Putnam's Sons, 1963.

Headland, T. N., and H. W. Greene. "Hunter-Gatherers and Other Primates as Prey, Predators, and Competitors of Snakes." *Proceedings of the National Academy of Sciences* 108 (2011): 20865–66.

Hemingway, E. *Green Hills of Africa*. New York: Charles Scribner's Sons, 1953.

Herzog, H. *Some We Love, Some We Hate, Some We Eat: Why It's So Hard to Think Straight about Animals*. New York: HarperCollins, 2010.

Himmelman, J. *Discovering Amphibians: Frogs and Salamanders of the Northeast*. Camden, ME: Down East Books, 2006.

Hofrichter, R., ed. *Amphibians: The World of Frogs, Toads, Salamanders and Newts*. Buffalo, NY: Firefly Books, 2000.

Hood, R. W., Jr., and W. P. Williamson. *Them That Believe: The Power and Meaning of the Christian Serpent-Handling Tradition*. Berkeley: University of California Press, 2008.

Horgan, J. "*Bufo* Abuse." *Scientific American* 263 (1990): 26–27.

Howey, M. O. *The Encircled Serpent: A Study of Serpent Symbolism in All Countries and Ages*. New York: Arthur Richmond, 1955.

Hunn, E. S. *Tzeltal Folk Zoology: The Classification of Discontinuities in Nature*. New York: Academic Press, 1977.

Hutton, F. W., and J. Drummond. *The Animals of New Zealand: An Account of the Dominion's Air-Breathing Vertebrates*. Christchurch, New Zealand: Whitcombe and Tombs, 1909.

Hyatt, H. M. *Folk-Lore from Adams Country Illinois*. Hannibal, MO: Western Printing and Lithographing, 1965.

———. *Hoodoo Conjuration Witchcraft Rootwork*. Vol. 1. *Memoirs of the Alma Egan Hyatt Foundation*. Hannibal, MO: Western, 1970.

Ingpen, R., and B. Hayes. *Folk Tales and Fables of Asia and Australia*. New York: Chelsea House, 1994.

Ions, V. *Indian Mythology*. New York: Paul Hamlyn, 1967.

IUCN. *Red List of Threatened Species, 2014.2* version. www.iucnredlist.org.

IUCN. "The 100 Most Threatened Species. Are They Priceless or Worthless?" 2012. http://www.iucn. org/?11022/The-100-most-threatened-species—Are-they-priceless-or-worthless.

Jackson, B. "The Other Kind of Doctor: Conjure and Magic in Black American Folk Medicine." In *American Folk Medicine: A Symposium*, ed. W. D. Hand, 259–72. Berkeley: University of California Press, 1976.

Jackson, C. G., Jr., and J. D. Davis. "A Quantitative Study of the Courtship Display of the Red-Eared Turtle, *Chrysemys scripta elegans* (Wied)." *Herpetologica* 28 (1972): 58–64.

Jacobson, S. K., M. D. McDuff, and M. C. Monroe. *Conservation Education and Outreach Techniques*. Oxford: Oxford University Press, 2006.

Jones, D. E. *Poison Arrows: North American Indian Hunting and Warfare*. Austin: University of Texas Press, 2007.

Jones, E. "The Madonna's Conception Through the Ear." 1914. In *Essays in Applied Psychoanalysis*. Vol. 2, *Essays in Folklore, Anthropology and Religion*, ed. E. Jones, 266–357. London: Hogarth Press Ltd. and the Institute of Psycho-Analysis, 1951.

Jones, J. P. G., M. M. Andriamarovololona, and N. Hockley. "The Importance of Taboos and Social Norms to Conservation in Madagascar." *Conservation Biology* 22 (2008): 976–86.

Kalof, L. *Looking at Animals in Human History*. London: Reaktion Books, 2007.

Kahn, P. H. "Developmental Psychology and the Biophilia Hypothesis: Children's Affiliation with Nature." *Developmental Review* 17 (1997): 1–61.

Kareiva, P., and M. Marvier. "What Is Conservation Biology?" *BioScience* 62 (2012): 962–69.

Kellert, S. R. "Social and Perceptual Factors in Endangered Species Management." *Journal of Wildlife Management* 49 (1985): 528–36.

Kelly, L. *Crocodile: Evolution's Greatest Survivor*. Crows Nest, NSW, Australia: Allen and Unwin, 2006.

Kennedy, A. B. "*Ecce Bufo*: The Toad in Nature and in Olmec Iconography." *Current Anthropology* 23 (1982): 273–90.

Kirchhoff, P. "Patangoro and Amani." In *Handbook of South American Indians*. Vol. 4, ed. J. H. Steward, 339–68. Smithsonian Institution Bureau of American Ethnology Prepared in Cooperation with the United States Department of State as a Project of the Interdepartmental Committee on Cultural and Scientific Cooperation. Washington, DC: U.S. Government Printing Office, 1946.

Klauber, L. M. *Rattlesnakes: Their Habits, Life Histories, and Influence on Mankind*. Berkeley: University of California Press, 1956.

Klemens, M. W., ed. *Turtle Conservation*. Washington, DC: Smithsonian Institution Press, 2000.

Knight, A. J. "'Bats, Snakes and Spiders, Oh My!': How Aesthetics and Negativistic Attitudes, and Other Concepts Predict Support for Species Protection." *Journal of Environmental Psychology* 28 (2008): 94–103.

Kolbert, E. *The Sixth Extinction: An Unnatural History*. New York: Henry Holt, 2014.

Krappe, A. H. *The Science of Folklore*. London: Methuen, 1930.

Krutch, J. W., ed. *The World of Animals: An Anthology of Lore, Legend, and Literature*. New York: Simon and Shuster, 1961.

La Barre, W. *The Human Animal*. Chicago: University of Chicago Press, 1954.

———. *They Shall Take Up Serpents: Psychology of the Southern Snake-Handling Cult*. Minneapolis: University of Minnesota Press, 1962.

La Flesche, F. *The Osage and the Invisible World: From the Works of Francis La Flesche*. Introduced and edited by G. A. Bailey. Norman: University of Oklahoma Press, 1995.

Leach, M., ed.; J. Fried, assoc. ed. *Funk and Wagnalls Standard Dictionary of Folklore, Mythology, and Legend*. New York: Funk and Wagnalls, 1972.

Lee, J. C. *The Amphibians and Reptiles of the Yucatán Peninsula*. Ithaca: Comstock, 1996.

Leeming, D. A., and M. A. Leeming. *A Dictionary of Creation Myths*. New York: Oxford University Press, 1994.

Lev, E. "Traditional Healing with Animals (Zootherapy): Medieval to Present-Day Levantine Practice." *Journal of Pharmacology* 85 (2003): 107–18.

Lewin, M. "The Killers Underfoot." *New York Times*, Sunday Review, 12 April 2014. http://nyti. ms/1g12194.

Li, Y. M., and D. S. Wilcove. "Threats to Vertebrate Species in China and the United States." *BioScience* 55 (2005): 147–53.

Linnaeus, C. *Systema Naturae*, Edition 10, Tom 1, Pt. 1, Uppsala, Sweden, 1758.

Liu, F., J.-G. Wang, S.-Y. Wang, Y. Li, Y.-P. Wu, and S.-M. Xi. "Antitumor Effect and Mechanism of *Gecko* on Human Esophageal Carcinoma Cell Lines *in vitro* and Xenografted Sarcoma 180 in Kunming Mice." *World Journal of Gastroenterology* 14 (2008): 3990–96.

Livo, N. J., and D. C. Livo. *Folk Stories of the Hmong: Peoples in Laos, Thailand, and Vietnam*. Englewood, CO: Libraries Unlimited, 1991.

Lynch, P. A. *Native American Mythology A to Z*. New York: Facts on File, 2004.

Lyttle, T., D. Goldstein, and J. Gartz. "*Bufo* Toads and Bufotenine: Fact and Fiction Surrounding an Alleged Psychedelic." *Journal of Psychoactive Drugs* 28 (1996): 267–90.

MacManus, S. *The Story of the Irish Race: A Popular History of Ireland*. New York: Devin-Adair, 1967.

Manly, D. "Regeneration: The Axolotl Story." Guest blog. *Scientific American*, April 13, 2011.

Mann, J. *Murder, Magic and Medicine*. 2nd edition. New York: Oxford University Press, 2000.

Marriott, A., and C. K. Rachlin. *American Indian Mythology*. New York: Thomas Y. Crowell, 1968.

Marshall, J. V. *Stories from the Billabong*. London: Frances Lincoln Children's Books, 2008.

Martin, J. *Masters of Disguise: A Natural History of Chameleons*. New York: Facts on File, 1992.

Martin, L. C. *Wildlife Folklore*. Old Saybrook, CT: Globe Pequot Press, 1994.

Matsuda, B. M., D. M. Green, and P. T. Gregory. *Amphibians and Reptiles of British Columbia*. Victoria, British Columbia, Canada: Royal BC Museum, 2006.

Mayor, V. *Greek Fire, Poison Arrow and Scorpion Bombs: Biological and Chemical Warfare in the Ancient World*. New York: Overlook Press, 2003.

McCleary, R. J. R., and R. M. Kini. "Non-Enzymatic Proteins from Snake Venoms: A Gold Mine of Pharmacological Tools and Drug Leads." *Toxicon* 62 (2013): 56–74.

McNamee, G. *The Serpent's Tale: Snakes in Folklore and Literature*. Athens: University of Georgia Press, 2000.

Ménez, A. *The Subtle Beast: Snakes, from Myth to Medicine*. New York: Taylor and Francis, 2003.

Métraux, A. "Ethnography of the Chaco." In *Handbook of South American Indians*, Vol. 1, ed. J. H. Steward, 197–380. Smithsonian Institution Bureau of American Ethnology prepared in cooperation with the United States Department of State as a project of the Interdepartmental Committee on Cultural and Scientific Cooperation. Washington, DC: U.S. Government Printing Office, 1946.

Milton, K. "No Pain, No Game." *Natural History* (1994): 44–51.

Mineka, S., R. Kier, and V. Price. "Fear of Snakes in Wild- and Laboratory-Reared Rhesus Monkeys (*Macaca mulatta*)." *Animal Learning and Behavior* 8 (1980): 653–63.

Minton, S. A., Jr., and M. R. Minton. *Venomous Reptiles*. New York: Charles Scribner's Sons, 1969.

Mohneke, M., A. B. Onadeko, and M.-O. Rödel. "Exploitation of Frogs—a Review with a Focus on West Africa." *Salamandra* 45 (2009): 193–202.

Morgan, D. *Snakes in Myth, Magic, and History: The Story of a Human Obsession*. Westport, CT: Praeger, 2008.

Morris, B. *The Power of Animals: An Ethnography*. New York: Berg, 1998.

Morris, D. *Body Guards: Protective Amulets and Charms*. Boston: Element, 1999.

Morris, R., and D. Morris. *Men and Snakes*. New York: McGraw-Hill, 1965.

Mullin, S. J., and R. A. Seigel, eds. *Snakes: Ecology and Conservation*. Ithaca, NY: Cornell University Press, 2009.

Mundkur, B. *The Cult of the Serpent: An Interdisciplinary Survey of Its Manifestations and Origins*. Albany: State University of New York Press, 1983.

Myers, C. W., J. W. Daly, and B. Malkin. "A Dangerously Toxic New Frog (*Phyllobates*) Used by Emberá Indians of Western Colombia, with Discussion of Blowgun Fabrication and Dart Poisoning." *Bulletin of the American Museum of Natural History* 161 (1978): 307–66.

Naish, Darren. "Terrifying Sex Organs of Male Turtles." *Scientific American*. June 8, 2012. http://blogs.scientificamerican.com/tetrapod-zoology/2012/06/08/terrifying-sex-organs-of-male-turtles/.

Nassen-Bayer and K. Stuart. "Mongol Creation Stories: Man, Mongol Tribes, the Natural World, and Mongol Deities." *Asian Folklore Studies* 51 (1992): 323–34.

Newcomb, F. J. *Navaho Folk Tales*. Albuquerque: University of New Mexico Press, 1967.

Newman, J. M. "Snow Frog: Trailing This Rare Delicacy." *Flavor and Fortune* 7 (2000): 11–12.

Nissenson, M., and S. Jonas. *Snake Charm*. New York: Harry N. Abrams, 1995.

Oakley, K. P. "Animal Fossils as Charms." In *Animals in Folklore*, ed. J. R. Porter and W. M. S. Russell, 208–40. Cambridge: D. S. Brewer, 1978.

Oliver, J. A. *Snakes in Fact and Fiction*. Garden City, NY: Doubleday, 1958.

Osemeobo, G. J. "The Role of Folklore in Environmental Conservation: Evidence from Edo State, Nigeria." *International Journal of Sustainable Development and World Ecology* 1 (1994): 48–55.

Parrinder, G. *African Mythology*. London: Hamlyn, 1967.

Partners in Amphibian and Reptile Conservation. http://www.parcplace.org.

Peterson, L. C., and G. H. Haug. "Climate and the Collapse of Maya Civilization." *American Scientist* 93 (2005): 322–29.

Pezzuti, J. C. B., J. P. Lima, D. F. da Silva, and A. Begossi. "Uses and Taboos of Turtles and Tortoises along the Rio Negro, Amazon Basin." *Journal of Ethnobiology* 30 (2010): 153–68.

Pinney, R. *The Snake Book*. Garden City, NY: Doubleday, 1981.

Piper, J. M. *Rice in South-East Asia: Cultures and Landscapes*. New York: Oxford University Press, 1993.

Plinius, S. C. (Pliny). *Historia Naturalis. Natural History*. Translated by H. Rackham. Vol. 3. Cambridge, MA: Harvard University Press, 1967.

———. *Historia Naturalis. Natural History*. Translated by W. H. S. Jones. Vol. 8. Cambridge, MA: Harvard University Press, 1963.

———. *Historia Naturalis. Natural History*. Translated by D. E. Eichholz. Vol. 10. Cambridge, MA: Harvard University Press, 1962.

Pooley, J. A., and M. O'Connor. "Environmental Education and Attitudes: Emotions and Beliefs Are What Is Needed." *Environment and Behavior* 32 (2000): 711–23.

Pough, F. H., R. M. Andrews, J. E. Cadle, M. L. Crump, A. H. Savitzky, and K. D. Wells. *Herpetology*. 3rd edition. Upper Saddle River, NJ: Prentice Hall, 2004.

Powell, P. H. *Frog Brings Rain*. Flagstaff, AZ: Salina Bookshelf, 2006.

Preece, R. *Animals and Nature: Cultural Myths, Cultural Realities*. Vancouver, British Columbia: UBC Press, 1999.

Radford, E., and M. A. Radford. *Encyclopedia of Superstitions*. New York: Philosophical Library, 1949.

Ramstad, K. M., N. J. Nelson, G. Paine, D. Beech, A. Paul, P. Paul, F. W. Allendorf, and C. H. Daugherty. "Species and Cultural Conservation in New Zealand: Maori Traditional Ecological Knowledge of Tuatara." *Conservation Biology* 21 (2007): 455–64.

Rawlings, M. K. "The Ancient Enmity." In *Treasury of Snake Lore*, ed. B. Aymar, 245–53. New York: Greenberg, 1956.

Read, K. A., and J. J. González. *Handbook of Mesoamerican Mythology*. Santa Barbara, CA: ABC-CLIO, 2000.

Rim-Rukeh, A., G. Irerhievwie, and I. E. Agbozu. "Traditional Beliefs and Conservation of Natural Resources: Evidences from Selected Communities in Delta State, Nigeria." *International Journal of Biodiversity and Conservation* 5 (2013): 426–32.

Root-Bernstein, R. and M. Root-Bernstein. *Honey, Mud, Maggots, and Other Medical Marvels: The Science behind Folk Remedies and Old Wives' Tales*. Boston: Houghton Mifflin, 1997.

Rowland, B. *Animals with Human Faces: A Guide to Animal Symbolism*. Knoxville: University of Tennessee Press, 1973.

Sasaki, K., Y. Sasaki, and S. F. Fox. "Endangered Traditional Beliefs in Japan: Influences on Snake Conservation." *Herpetological Conservation and Biology* 5 (2010): 474–85.

Saunders, N. J. *Animal Spirits*. Boston: Little, Brown, 1995.

Savage, J. M. "On the Trail of the Golden Frog: With Warszewicz and Gabb in Central America." *Proceedings of the California Academy of Sciences* 38 (1970): 273–87.

Sax, B. *The Frog King: On Legends, Fables, Fairy Tales and Anecdotes of Animals*. New York: Pace University Press, 1990.

Scheub, H. *A Dictionary of African Mythology: The Mythmaker as Storyteller*. New York: Oxford University Press, 2000.

Schlaepfer, M. A., C. Hoover, and C. K. Dodd Jr. "Challenges in Evaluating the Impact of the Trade in Amphibians and Reptiles on Wild Populations." *BioScience* 55 (2005): 256–64.

Scott, J. G. "The Wild Wa—a Head-Hunting Race." *Asiatic Quarterly Review* 1, 3rd series (1896): 138–52.

Serpell, J. A. "Factors Influencing Human Attitudes to Animals and Their Welfare." *Animal Welfare* 13 (2004): S145–51.

Service, E. R., and H. S. Service. *Tobatí. Paraguayan Town*. Chicago: University of Chicago Press, 1954.

Seyfarth, R. M., and D. L. Cheney. "The Ontogeny of Vervet Monkey Alarm-Calling Behavior: A Preliminary Report." *Zeitschrift fur Tierpsychologie* 54 (1980): 37–56.

Seyfarth, R. M., D. L. Cheney, and P. Marler. "Monkey Responses to Three Different Alarm Calls: Evidence for Predator Classification and Semantic Communication." *Science* 210 (1980): 801–3.

———. "Vervet Monkey Alarm Calls: Semantic Communication in a Free-Ranging Primate." *Animal Behaviour* 28 (1980): 1070–94.

Shakespeare, W. *Macbeth*. In *The Unabridged William Shakespeare*, ed. W. G. Clark and W. A. Wright, 979–1006. Philadelphia: Running Press, 1989.

Shepard, P. *The Others: How Animals Made Us Human*. Washington, DC: Island Press, 1996.

Sherbrooke, W. C. *Horned Lizards: Unique Reptiles of Western North America*. Globe, AZ: Southwest Parks and Monuments Association, 1981.

———. *Introduction to Horned Lizards of North America*. Berkeley: University of California Press, 2003.

Shi, J., T. T. Liu, X. Wang, D. H. Epstein, L. Y. Zhao, X. L. Zhang, and L. Lu. "Tetrodotoxin Reduces Cue-Induced Drug Craving and Anxiety in Abstinent Heroin Addicts." *Pharmacological and Biochemical Behavior* 92 (2009): 603–7.

Sibley, G. "Musicians of the Chac." *Terra* 13 (1975): 43–46.

Simelane, T. S., and G. I. H. Kerley. "Conservation Implications of the Use of Vertebrates by Xhosa Traditional Healers in South Africa." *South African Journal of Wildlife Research* 28 (1998): 121–26.

Simons, C. "Chinese Takeout." *Conservation* 14 (2013): 38–44.

Skutch, A. *A Naturalist on a Tropical Farm*. Berkeley: University of California Press, 1981.

Slater, C. *Entangled Edens: Visions of the Amazon*. Berkeley: University of California Press, 2002.

Smith, E. L., and N. R. Brown. *The Complete Idiot's Guide to World Mythology*. New York: Alpha Books, 2007.

Smithsonian, "Amphibians and Reptiles as Pets." *Smithsonian Simply Amazing*. http://www.si.edu/Encyclopedia_SI/nmnh/arpets.htm.

Sobel, D. *Beyond Ecophobia: Reclaiming the Heart in Nature Education*. Great Barrington, MA: Orion Society and the Myrin Institute, 1996.

Somaweera, R., and N. Somaweera. "Serpents in Jars: The Snake Wine Industry in Vietnam." *Journal of Threatened Taxa* 2 (2010): 1251–60.

Spence, L. *Ancient Egyptian Myths and Legends*. New York: Dover, 1990.

Spriggs, R., selector and ed. *The Fables of Aesop: 112 Moral Tales Retold*. New York: Rand McNally, 1975.

St. Clair, D. *Drum and Candle: First-Hand Experiences and Accounts of Brazilian Voodoo and Spiritism*. Garden City, NY: Doubleday, 1971.

Steiger, B. *Totems: The Transformative Power of Your Personal Animal Totem*. New York: HarperCollins, 1997.

Steward, J. H., ed. *Handbook of South American Indians*. Smithsonian Institution Bureau of American Ethnology prepared in cooperation with the United States Department of State as a project of the Interdepartmental Committee on Cultural and Scientific Cooperation. Washington, DC: United States Printing Office, 1946.

Stout, E. J. *Folklore from Iowa*. American Folk-Lore Society. New York: G. E. Stechert and Co., 1936.

Stutesman, D. *Snake*. London: Reaktion Books, 2005.

Swingland, I. R., and M. W. Klemens, eds. "The Conservation Biology of Tortoises." *Occasional Papers of the IUCN Species Survival Commission (SSC)*. No. 5. Gland, Switzerland: IUCN, 1989.

Tallant, R. *Voodoo in New Orleans*. Gretna, LA: Pelican, 2003. First published 1946 by Macmillan.

Tapley, B., and A. R. Acosta-Galvis. "Distribution of *Typhlonectes natans* in Colombia, Environmental Parameters, and Implications for Captive Husbandry." *Herpetological Bulletin*, no. 113 (2010): 23–29.

Thibodeau, P. H., and L. Boroditsky. "Metaphors We Think With: The Role of Metaphor in Reasoning." *PLoS ONE* 6 (2011): e16782. doi:10.1371/journal.pone.0016782.

Thomas, W. H. "One Last Chance: Tapping Indigenous Knowledge to Produce Sustainable Conservation Policies." *Futures* 35 (2003): 989–98.

Thorbjarnarson, J., C. J. Lagueux, D. Bolze, M. W. Klemens, and A. B. Meylan. "Human Use of Turtles: A Worldwide Perspective." In *Turtle Conservation*, ed. M. W. Klemens, 33–84. Washington, DC: Smithsonian Institution Press, 2000.

Thury, E. M., and M. K. Devinney. *Introduction to Mythology: Contemporary Approaches to Classical and World Myths*. New York: Oxford University Press, 2005.

Twain, M. *Letters from the Earth*. Edited by B. De Voto. New York: Harper & Row, 1938.

Tyler, R., ed. *Japanese Tales*. New York: Pantheon, 1987.

Wallace, A. R. *A Narrative of Travels on the Amazon and Rio Negro*. 2nd edition 1889. New York: Dover, 1972.

Waylen, K. A., A. Fischer, P. J. K. McGowan, S. J. Thirgood, and E. J. Milner-Gulland. "Effect of Local Cultural Context on the Success of Community-Based Conservation Interventions." *Conservation Biology* 24 (2010): 1119–29.

Whitaker, P. B., and R. Shine. "Sources of Mortality of Large Elapid Snakes in an Agricultural Landscape." *Journal of Herpetology* 34 (2000): 121–28.

White, G. *The Natural History of Selborne*, 1789. Portion reprinted in *The World of Animals: An Anthology of Lore, Legend, and Literature*, ed. J. W. Krutch. New York: Simon and Shuster, 1961.

Williams, M. "Them Toad Suckers." *The Mason Williams Listening Matter (Them Poems)*. Sound recording (album), 1969.

Wilson, E. O. *Biophilia: The Human Bond with Other Species*. Cambridge, MA: Harvard University Press, 1984.

———. *The Creation: An Appeal to Save Life on Earth*. New York: Norton, 2006.

———. *The Diversity of Life*. Cambridge, MA: Belknap Press of Harvard University Press, 1992.

Womeldorf, J. A. "Rattlesnake Religion." *Christian Century*. December 10, 1947, 1517–18.

World Health Organization. "Legal Status of Traditional Medicine and Complementary/Alternative Medicine: A Worldwide Review." World Health Organization (2001). http://libdoc.who.int/hq/2001/WHO_EDM_TRM_2001.2.pdf.

Wright, T., ed. *The Historical Works of Giraldus Cambrensis*. London: George Bell & Sons, 1894.

Wyman, L. C. "Navajo Diagnosticians." *American Anthropologist* 38 (1936): 236–46.

Yoder, D. "Folk Medicine." In *Folklore and Folklife: An Introduction*, ed. R. M. Dorson, 191–215. Chicago: University of Chicago Press, 1972.

Yolen, J. *Touch Magic: Fantasy, Faerie and Folklore in the Literature of Childhood*. New York: Philomel Books, 1981.

Yolen, J., ed. *Favorite Folktales from Around the World*. New York: Pantheon, 1986.

Young, M. J. "Images of Power and the Power of Images: The Significance of Rock Art for Contemporary Zunis." *Journal of American Folklore* 98 (1985): 3–48.

Young, P. *Tortoise*. London: Reaktion Books, 2003.

Yu, P.-L. *Hungry Lightning: Notes of a Woman Anthropologist in Venezuela*. Albuquerque: University of New Mexico Press, 1997.

Zahl, P. A. "Nature's Living Jumping Jewels." *National Geographic* 144 (July 1973): 130–46.

Zim, H. S., and H. M. Smith. *Reptiles and Amphibians: A Guide to Familiar American Species*. New York: Simon and Schuster, 1956.

Illustration Credits

Art

Alan D. Crump: Figures 2.2, 4.9, 9.15, 10.3, 11.6, 13.13

Irma L. Crump: Figure 2.3

Helena Guindon: Figures 8.2, 12.5, 14.6

Bronwyn McIvor (bronwynmcivor.blogspot.com): Figures 1.1, 2.5, 3.2, 4.11, 5.1, 6.3, 7.1, 7.9, 8.4, 9.3, 9.5, 11.8, 12.2, 13.1, 14.11

Sheri A. Sanders: Figure 14.10

Photography

Achmad Arifiandy: Figure 6.5

Brady Barr: Figure 14.9

E. D. Brodie Jr.: Figures 3.11, 4.4, 8.10 (*top left, top right, bottom left*), 8.11 (*bottom*), 9.1, 9.11, 11.3, 12.4 (*top, bottom*), 13.10 (*left, right*)

R. C. Clark: Dancing Snake Nature Photography: Figures 1.5 (*top left, top right, bottom left*), 1.6 (*bottom right*), 1.11 (*center left*), 1.13 (*top left, center left, bottom right*), 3.9 (*top, bottom*), 3.10 (*bottom*), 6.7 (*top right, bottom right*), 8.3 (*bottom*), 9.14 (*left*), 9.16, 13.3, 13.17 (*center left, center right*)

Polly Conrad: Figures 7.5 (*left*), 9.14 (*right*)

Alan D. Crump: Figures 1.6 (*top left*), 1.10 (*top right*)

Irma L. Crump: Figure 1.3 (*bottom right*)

Marty Crump: Figures 1.4 (*top left, bottom right*), 1.6 (*top right*), 1.8 (*top*), 1.13 (*top right*), 2.1 (*top*), 2.7, 3.8, 4.1 (*top, center, bottom*), 4.5, 4.6, 5.4, 8.3 (*top*), 8.13 (*center right*), 9.4, 10.9 (*top, bottom*), 11.1, 11.4, 12.1, 12.3 (*top right, bottom right*), 12.8 (*center left*), 13.2 (*top right, bottom right*), 13.9 (*top left, top right, bottom left, bottom right*), 13.11 (*bottom left*), 13.12 (*top, bottom*), 13.16 (*bottom*), 14.1, 14.2 (*bottom right*), 14.8 (*top*)

Lexi Dick: Figure 5.3

Andrew M. Durso: Figures 1.2, 13.11 (*top right, center left*), 14.4 (*center*)

Matthew K. Edwards: Figure 1.4 (*bottom left*)

Lilly Margaret Euvathingal: Figure 13.11 (*bottom right*)

Danté B. Fenolio: Title page; figures 1.3 (*top left, bottom left*), 1.7 (*top left, top right, bottom*), 1.8 (*bottom*), 1.9 (*top right, center left, center right, bottom left, bottom right*), 1.10 (*center right, bottom*), 1.11 (*top left, top right, center right*), 1.12 (*top left, top right, center left, center right, bottom left, bottom right*), 1.13 (*center right, bottom left*), 2.4, 2.8 (*top left, bottom left, right*), 3.1, 3.5 (*top, bottom*), 4.2 (*top*), 4.12 (*left, right*), 5.9, 6.7 (*top left*), 8.1, 8.6, 8.7 (*left*), 8.10 (*bottom right*), 8.12 (*left, right*), 10.4, 10.6, 10.8, 11.5 (*right*), 12.3 (*bottom left*), 12.8 (*top left*), 13.4, 13.17 (*top left, top right, bottom left, bottom right*), 14.2 (*top right*), 14.3, 14.4 (*top*), 14.5, 14.7

Arthur N. Freed: Figure 14.2 (*top left*)

Paul Freed: Figures 1.5 (*bottom right*), 1.6 (*bottom left*), 1.9 (*top left*), 1.10 (*top left, center left*), 1.11 (*bottom right*), 4.7, 4.8, 4.10, 5.2, 5.6 (*top*), 5.7, 6.2, 6.4, 6.6, 6.8, 7.2, 7.4, 7.5 (*right*), 7.6, 7.8, 8.7 (*right*), 8.8, 8.9, 8.11 (*top*), 9.2 (*right*), 9.7, 9.9, 9.12, 9.13, 10.7, 10.10, 11.2 (*top, bottom*), 11.5 (*left*), 12.7 (*top, bottom*), 12.8 (*top right, center right, bottom left, bottom right*), 13.5, 13.14, 13.18 (*left*)

Janet D. Headland: Figure 3.6

Deborah A. Hutchinson: Figure 12.6

William W. Lamar: Figures 3.7 (*bottom right*), 9.2 (*left*)

Jeffrey M. Lemm: Figures 1.11 (*bottom left*), 2.1 (*bottom*), 2.6, 2.8 (*center left*), 3.7 (*top left*), 3.10 (*top*), 4.2 (*bottom*), 4.3 (*top, bottom*), 7.7, 10.2, 14.2 (*bottom left*)

Bill Love/Blue Chameleon Ventures: Figures 6.7 (*bottom left*), 9.10

Karen E. McKree: Figures 1.3 (*top right*), 1.14 (*right*), 13.11 (*top left*)

Joseph C. Mitchell: Figures 3.7 (*bottom left*), 7.3 (*top*)

Akira Mori: Figure 7.3 (*bottom*)

Alexa Nelson: Figures 1.4 (*top right*), 14.4 (*bottom*)

National Park Service/Orlofsky: Figure 14.8 (*bottom*)

F. Harvey Pough: Figure 9.8

Rookery Bay National Estuarine Research Reserve: Figure 13.18 (*right*)

Alan H. Savitzky: Figures 3.7 (*top right*), 5.5, 5.6 (*bottom*), 5.8 (*top, bottom*), 6.1, 8.5, 8.13 (*top left, top right, center left, bottom left, bottom right*), 9.6 (*top, bottom*), 10.1 (*top, center, bottom*), 10.5 (*top left, top right, center left, center right, bottom left, bot-*

Index

Note: Page numbers in bold refer to figures.

Pill of Immortality, 88

Pima/Piman, 173, 252

Pipa pipa, 247

Pituophis catenifer, 79, 177, 180, 279–80

plague, of frogs, 139

Plethodon: *P. cinereus*, 280–81, **281**; *P. vehiculum*, **13**

Pliny the Elder, 83, 84, 134, 136, 143, 190, 210–13

Plutarch, 62

Podocnemis unifilis, **16**

Polo, Marco, 144

Pomo, 180

postage stamps, amphibians and reptiles on, **252**

Prometheus, 110

protagonists, amphibians (proper names): Ch'an Chu, 87–88, **87**, 133; Frog, 70, 111, 121; Frog People, 72–73, 107, 249; Green Frog, 68; Old Toad, 28; Queen of the Stream, 90; Tiddalik, 73; Toad, 68, 112, 117

protagonists, reptiles (proper names): Agadzagadza, 112; Akupara, 31; Antaboga, 31; Apep, 44; Bedawang, 31; Chameleon, 110–11, 112; Cottonmouth, 127; Crocodile, 34; Fafnir, 49–50; Fu Xi, 36; Goanna, 30, 127; Great Turtle, 28; Hiesh, 125; Hydra, Lernaean, 47, 93, 239; Kurma, 59, 253–54; Midgard, 48; Mishekae, 121, 130; Mr. Tortoise, 122; Mrs. Tortoise, 122; Muchilinda, 125; Mud Turtle, 121; Nag, 50; Nagaina, 50; Nagini, 50; Nëwa, 27; Nidhogg, 48; Nü Gua, 36; Ophion, 28–29; Orah, 108–9; Puana, 28; Putri Naga, 108–9; Python, 31–32, 40, 186; Rattlesnake, 127; Sir Monitor Lizard, 35; Snake, 40, **79**, 80, 127; Tiamat, 26–27; Tieholtsodi, 30–31; Tortoise, 106, 121; Turtle, 69, 116–17, 118–19, 122–24; Vritra, 26, 39, 44; Yamata-no-orochi, 48; Yuxa, 102

Protobothrops flaviviridis, **182**, 183

Pseudacris crucifer, 253

Pseudechis porphyriacus, 53–54

Pseudonaja textilis, 53–54

psychoactive drug/hallucinogen, 235, **236**, 237–38, **237**

Psylli, 243

Ptyas korros, 187–88, **189**

Pueblo, 75, 101

Pumé, 28, 40

putrefaction, source of frogs, 137–38

pysanky, 179

Python: *P. anchietae*, **231**; *P. molurus bivittatus*, 262, 264, **264**; *P. regius*, **268**, 277; *P. sebae*, 277

Quechua, 72, 75, 101

"Ragnarok," 48

Rainbow Serpent, 1–2, **2**, 29, 30, 75, 80

Ramstad, Kristina, 279

Rana chensinensis, 203

Ranitomeya, **273**

Ranodon sibiricus, 204

Rawlings, Marjorie Kinnan, 52

religion/spirituality/philosophy, amphibians and reptiles used in, 253–55. *See also* worship

Reptiles and Amphibians (Zim and Smith), 21

Reptilia: Order Crocodilia (crocodilians), 12, **14**, 15; Order Rhynchocephalia (tuatara), 12, **14**, 15; Order Squamata (lizards and snakes), 12, **14**, 15; Order Testudines (turtles), 12–13, **14**

reptilian cult, 55–56

Ressel, Steve, 280–81

Rhabdophis subminiatus, **54**

Rhinella: *R. arunco*, tadpoles, **12**; *R. marina*, **32**, 82, 134, 138, **204**, **228**, 230, **233**, 238, 249; *R. schneideri*, **24**, 36, **36**, 268

Rhinoderma darwinii, 265–66, **266**

Rhinophrynus dorsalis, 81, **81**, 82

Richard III (Shakespeare), 138

Rig Veda, 26, 44, 68

"Ring" cycle of operas (Wagner), 50

rivers: Amazon River, 35; Colorado River, 31, 125; Euphrates River, 27, 28, 74; Ganges River, 74, 159; Gila River, 125; Indus River, 62; Liverpool River, 127–28; Middle Sepik River, 34; Nile River, 26, 28, 57, 67–68, 74, 84–85, 139, 191, 254; Río Içana, 249; Río Uaupés (Vaupés), 35, 241; Tigris River, 27, 28; Yellow River, 74

rod of Asclepius, 93, 209, **209**

Roosevelt, Franklin D., 165, 172

Root-Bernstein, Robert and Michele: *Honey, Mud, Maggots, and Other Medical Marvels*, 200–201

Rovics, David: "The Alligator Song," 192

Rowling, J. K.: *Harry Potter*, 50

sacred, amphibians and reptiles considered, 8, 40, 59, 68, 135, 157, 159, 171, 174, 179, 193, 253–55, 272, 274, 276–78

sacrifice, human, 27, 48, 62, 76–77, 80, 81, 82, 159

Sakalava, 255

salamanders, associated with: ability to harm, 146–48, 150; blacksmith trade, 144; chastity/purity, 144; courage, 144; Devil, 147–48; enduring faith, 144; eternal youthfulness, 148; evil, 147–48, 272; fire, 11, 143–45; healing/health, 145, 148, 204; heraldry, 144; human soul, 144; poison/toxin, 147–48; rebirth, rejuvenation, immortality, 11, 145–46; supernatural powers, 11, 145; witches, 147

79, 177–78, 179, 185, 201–2, 210–11, 240, 256, 278; protection against, 177–78, 210–11

snake-handling, religious, 60–61, 93, 253

snakes: ability to kill, 15, 38, 41, 51–55, 176, 179, 184, 220, 272, 276; ability to restore life, 176, 272; carry messages between people and the gods, 59, 77, **78**, 181; and Christianity, 44–46, 50, 56, 81, 139, 176; fascination with, 56; fear of (*see* ophidiophobia); links between lower and upper worlds, 77, **78**; links between river and sky, 74; and pagan beliefs, 50; portrayed as villains, 46–51; reincarnation of deceased persons, 181; role in ecosystem, **58**, 64

snakes, associated with: abortion/miscarriage, 187; afterlife, 176; bad luck, 176, 180, 221; beauty, 56; chaos, 26, 44, 48; comfort, 56; creative energy, 25–26, 38, 59; cycle of life and death, 26, 43; death, 15, 38, 41, 44, 176 (*see also* death, bearer of); Devil, 15, 41, 44–45, 56, 81–82; disease, 177, 179; divinity, 44; eternity, continuity, 43, 62; ethics, 180; evil, 15, 37, 39, 41, 44–56, 63, 176, 220; female sexuality/vagina, 185–86; fertility, agricultural, 59, 75, 77, 82, 179; fertility, human, 26, 59, 62, 100, 185–87, **187**, 253; good luck, 56, **57**, 178, 180, 221, 231; guardian of the truth, 179; healing/health, 15, 44, 50, 57, 58–59, 92–93, 181, 209, 211, 221, 261; human virility, 184; incarnation of dead chieftains, 176; milk, 57, 62, 176, 180; phallus, 15, 43, 59, 94, 184–85, 186; power, 15, 25–26, 27, 28, 30, 31, 38, **39**, 44, 56, 62, 75, 79, 80, 103, 127, 176–77, 179–80, 202, 221, **231**, **285** (*see also* sexual energy/power); prophesy/divination, 57–58; prosperity, 181; protection, 56, 57, 59, 179, 180, 181, 202; rainbow, 29, 67, 74–75, 79; rain/water, **24**, 30, 36, 67, 74–77, 79–80, 82, 179; rebirth, rejuvenation, resurrection, immortality, 15, 26, 38, 44, 50, 84, 92–96, 98; sexual energy/power, 62, 183–89, **189**; sickness/disease, 82, 177, 179, 221; spirits of the deceased, 176; strength, 26, 56, 183, 202, 207, 243; supernatural powers, 56, 101; thunder, lightning, 43, 67, 75, 76, 80–81; vagina, 102, **103**, 185; vigilance, 15, 42, 48–49, 180; wisdom, knowledge, 41, 50, 58, 60, 62, 95, 178, 221

snakes, species: adder (*Vipera*), general, 95–96, 177, **227**, 240; African rock python (*Python sebae*), 277; African saw-scaled viper (*Echis carinatus*), 258; anaconda (*Eunectes murinus*), 35, 188; anaconda, general, 25, 28, 31, 40, 67, 79, 102; Angolan python (*Python anchietae*), **231**; aquatic coral snake, (*Micrurus su-*

rinamensis), **16**; Asian pit viper (Viperidae), general, 241; asp (*Vipera*), general, 240; ball python (*Python regius*), **268**, 277; blackneck garter snake (*Thamnophis cyrtopsis*), **54**; "blacksnake," 98; black-tailed rattlesnake (*Crotalus molossus*), **126**; "black viper," 62; boa (Boidae), general, 79, 231; boa constrictor (*Boa constrictor*), 53, 102, 217–18, 221, 231, **231**, 241; boomslang (*Dispholidus typus*), 225; brown water snake (*Nerodia taxispilota*), **233**; bull/gopher snake (*Pituophis catenifer*), 79, 177, 180, 279–80; Burmese python (*Python molurus bivittatus*), 262, 264, **264**; California king snake (*Lampropeltis californiae*), **67**; Chinese rat snake (*Ptyas korros*), 187–88, **189**; coachwhip (*Coluber flagellum*), 180; coastal taipan (*Oxyuranus scutellatus*), 257; cobra (Elapidae), general, 39, 50, 53, 55, 56, 58–59, 61, 62, 75, 77, 95, 102, 184, 185, 186, 187, 239, 243–44, **251**, 256; common blacksnake (*Pseudechis porphyriacus*), 53–54; common garter snake (*Thamnophis sirtalis*), **147**; copperhead (*Agkistrodon contortrix*), 60, **60**, 61; cottonmouth (*Agkistrodon piscivorus*), 60, 67, 220, 240; desert cobra (*Walterinnesia aegptia*), 94; desert striped racer (*Coluber taeniatus*), 79; eastern brownsnake (*Pseudonaja textilis*), 53–54; eastern diamondback (*Crotalus adamanteus*), 53, **58**, 61, **103**; eastern hog-nosed snake (*Heterodon platirhinos*), **54**; Egyptian cobra (*Naja haje*), 240; eyelash viper (*Bothriechis schlegelii*), **54**; fer-de-lance (terciopelo, *Bothrops asper*), 201–2; *habu* (*Protobothrops flavoviridis*), **182**, 183; horned viper (*Cerastes*), general, 240; Indian/spectacled cobra (*Naja naja*), **95**, 125, **125**, 243; *jararaca* (*Bothrops jararaca*), 257–58; king cobra (*Ophiophagus hannah*), 53, 141, 243–44, **257**; Mandarin rat snake (*Euprepiophis mandarinus*), **108**; Mexican palm viper (*Bothriechis rowleyi*), ii–iii, **14**; milk snake (*Lampropeltis triangulum*), 180; Palestine saw-scaled viper (*Echis coloratus*), 211; Patagonian lancehead (*Bothrops ammodytoides*), 43; Philippine cobra (*Naja philippinensis*), 94; puff adder (*Bitis arietans*), 27, 62, 225, 277; python (Pythonidae), general, 25, 26, 31–32, 39, 40, 55, 57, 62, 63, 67, 176, 186, 202, 210, 221, 231, 277, 278; rainbow boa (*Epicrates cenchria*), 41, **42**, 64; rattlesnake, general, 42, 59, 75, 76, 77, 79, 101, 102, 178, 179, 180, 188, 214, 222, 240, 241, 253, 259, 278; red diamond rattlesnake (*Crotalus ruber*), **67**; red-necked keelback (*Rhabdophis subminiatus*), **54**; reticulated python (*Malayopython reticulatus*),